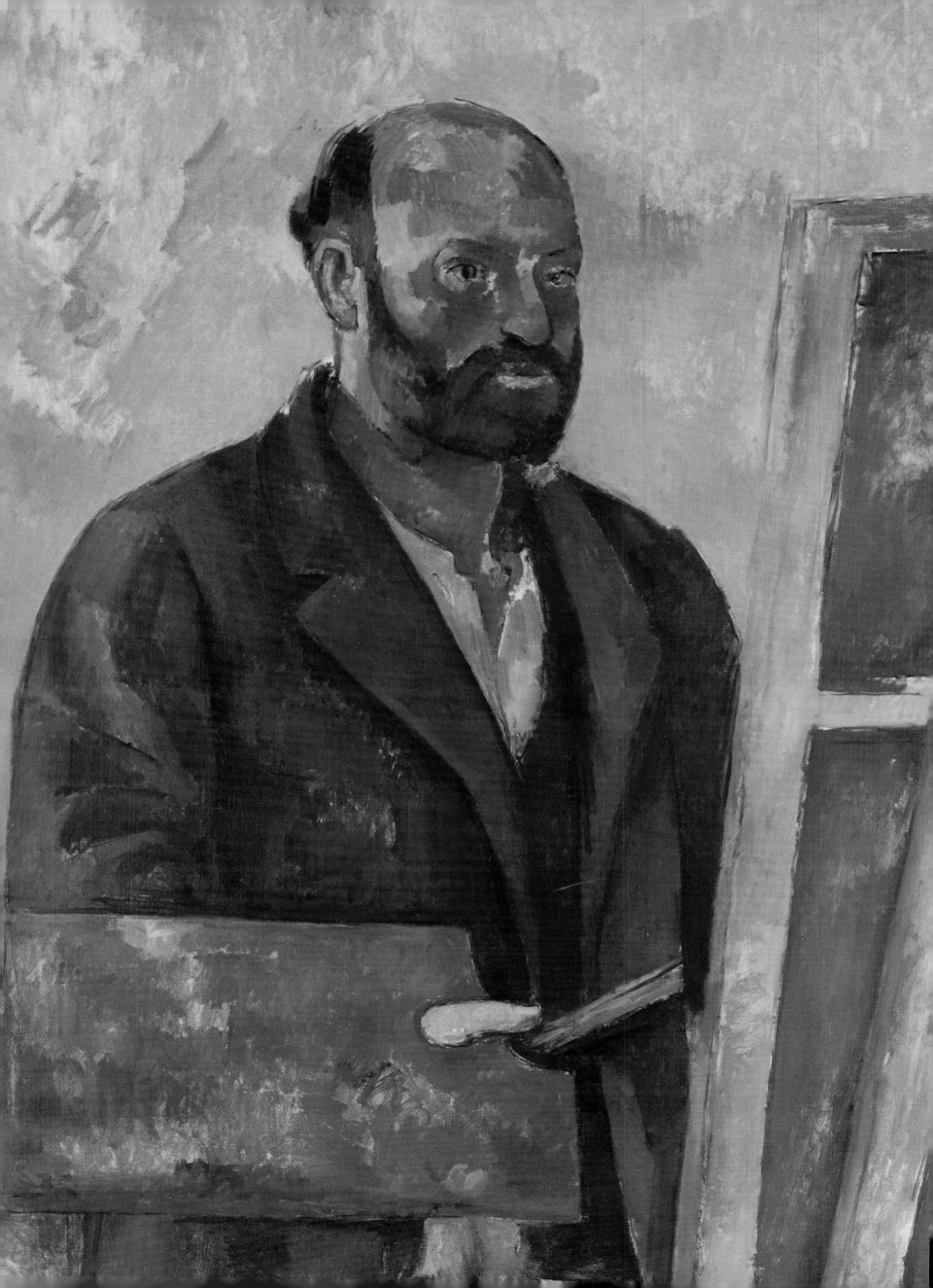

CEZANNE

MICHAEL HOWARD

GALLERY BOOKS
An imprint of W.H. Smith Publishers Inc.
112 Madison Avenue
New York, New York 10016

Published by Gallery Books
A Division of W H Smith Publishers Inc.
112 Madison Avenue
New York, New York 10016

Produced by
Brompton Books Corp.
15 Sherwood Place
Greenwich, CT 06830

ISBN 0-8317-2827-2

FOR MY PARENTS

Printed in Italy

Page 1: *Mountains at l'Estaque*, 1886-90, National
Museum of Wales, Cardiff

Page 2: *Self-Portrait with Palette*, 1885-7,
Foundation E G Bührle Collection, Zurich

Contents and List of Plates

Introduction — 6

The Four Seasons, Autumn — 26
Bather and Rocks — 27
Still Life: Skull with Candlestick — 28
Still Life: Bread and Leg of Lamb — 30
Still Life: Sugar Pot, Pears and
 Blue Cup — 31
The Artist's Father — 32
The Murder — 34
The Negro Scipion — 36
The Rape — 37
Portrait of Achille Emperaire — 38
The Orgy — 40
Young Girl at the Piano — 42
Portrait of Anthony Valabrègue — 44
The Black Marble Clock — 45
The Temptation of Saint Anthony — 46
Paul Alexis Reading to Emile Zola — 48
Pastorale or Idyll — 50
Couples Relaxing by a Pond — 52
Melting Snow at l'Estaque — 54
The Seine at Bercy — 56
Landscape, Auvers — 58
A Modern Olympia — 60
Self-Portrait — 62
House of the Hanged Man,
 Auvers/Oise — 64
Auvers, Panoramic View — 66
Three Bathers — 68
L'Etang des Soeurs, Osny — 70
An Afternoon in Naples — 72
Plate of Apples — 73
Madame Cézanne in a Red Armchair — 74

Still Life with Glass, Fruit and Knife — 76
Still Life with Apples — 77
View of Mont Marseilleveyre and
 the Isle of Maire (l'Estaque) — 78
Self-Portrait — 80
Victor Choquet Seated — 82
Farmyard at Auvers — 83
Self-Portrait — 84
Turn in the Road — 86
Three Women Bathing — 88
Melting Snow at Fontainebleau — 90
The Battle of Love — 92
The Pots of Flowers — 94
Still Life with Soup Tureen — 96
Portrait of the Artist's Son, Paul — 98
Blue Vase — 99
The Artist's Son, Paul — 100
Self-Portrait with Palette — 101
Montagne Sainte-Victoire — 102
Tall Trees at the Jas de Bouffan — 104
The Village of Gardanne — 106
Mountains at l'Estaque — 108
Still Life — 110
Harlequin — 112
Mardi-Gras — 113
Fruit and Vase — 114
Still Life with Ginger Pot — 116
Fruit, Still Life — 117
The Card Players — 118
Dish of Peaches — 120
The Pipe Smoker — 122
Woman with the Coffee Pot — 124
Madame Cézanne in Yellow
 Armchair — 126

Boy in a Red Waistcoat — 127
Village seen through Trees — 128
The Card Players — 130
The Pigeon Tower at Bellevue — 132
Apotheosis of Delacroix — 133
Still Life with Plaster Cast — 134
Portrait of Gustave Geffroy — 135
Woodland Path at the Château Noir — 136
Apples and Oranges — 138
An Old Woman with a Rosary — 140
Pines and Rocks (Fontainebleau?) — 142
In the Park of the Château Noir — 144
Man with Crossed Arms — 145
Millstone in the Park of the
 Château Noir — 146
Portrait of Ambroise Vollard — 148
Still Life with Curtain and Flowered
 Pitcher — 150
The Bathers — 152
Bathing Women — 153
The Large Bathers — 154
The Three Skulls — 156
Rocks and Branches at Bibémus — 158
Flowers — 160
The Château Noir — 162
Mont Sainte-Victoire — 164
Mont Sainte-Victoire — 166
The Château Noir — 168
The Gardener Vallier — 170
Mont Sainte-Victoire — 172

Index — 174

Acknowledgments — 176

Introduction

Since his death in 1906 Paul Cézanne has continued to be one of the most popular and respected of all western artists, and his works have had a most extraordinary effect upon the development of twentieth century painting. He began to paint seriously in the early 1860s, and from the start his paintings were the source of passionate debate and often bitter controversy. Few artists have had their work so variously interpreted by historians or so liberally borrowed by fellow painters.

His works fall into four clearly defined categories; figure groups, still lifes, landscapes and portraits. The way in which Cézanne treated those themes throughout a lifetime totally dedicated to their creation is to embark on a voyage of discovery that reflects two main trends. One of these was a prolonged exploration of a major theme in European painting – the nude figure in the landscape; the other, studied through a variety of different subjects, was a sustained search for a technique that would help Cézanne not to copy nature but to create a parallel to it. In his early work he leaned heavily on the styles of other painters, but his mature style was largely a matter of his own creation, built on a refusal to accept ready-made solutions – even those he had discovered himself.

The robust and even violent nature of Cézanne's early work was gradually replaced, with no diminution of force, by paintings of a more transcendent character. These are the paintings of a visionary, but one with his feet firmly planted on the ground and his senses open to a prolonged examination of reality. He wrote to his son just before his death in 1906:

I must tell you that as a painter, I am becoming more clear-sighted before nature, but that with me the realization of my sensations is always painful. I cannot attain the intensity that is unfolded before my senses. I have not the magnificent richness of coloring that animates nature. Here on the bank of the river, the motifs multiply, the same subject seen from different angles gives a subject for study of the most powerful interest and so varied that I think I could occupy myself for months without changing place, simply bending a little more to the right or left.

This passage illustrates better than any historian's text the huge ambition of this painter, and helps to explain why paintings of nothing more than a few apples on a plate or the criss-cross of branches against a blue sky should be the source of so much critical and popular interest.

Today the massively busy *Route du Soleil* runs close to Cézanne's former family home and the sprawl of modern development has decimated its once extensive grounds; the coast of the Midi has been despoiled by the effects of tourism and huge oil refineries pollute the Rhône delta not far west of where Cézanne painted. Such things have altered not only the landscape in which the artist worked, but also the very atmosphere in which he saw it. Yet despite all these changes, the grandiose silhouette of Mont Sainte-Victoire continues to dominate the cultivated valley of the

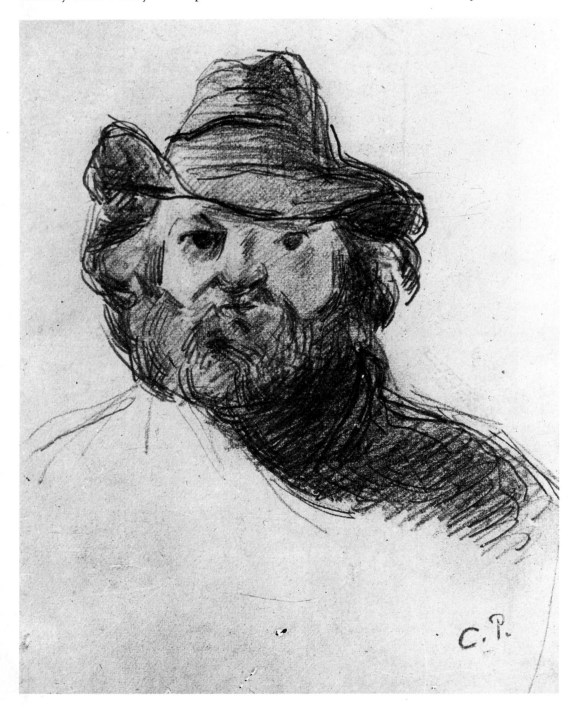

Left: An engaging portrait of the artist by his friend Pissarro.

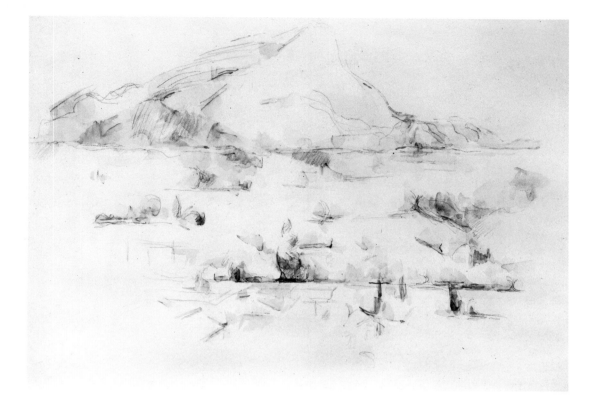

powerful and domineering personality and, as the owner of the town's only bank, was one of the wealthiest men of the community. He never understood his only son's obsession with painting and only slowly came to accept the impossibility of his becoming anything other than an artist. Cézanne's relationship with his father, and everybody else for that matter, was deeply problematic. Despite his family's affluent circumstances, his father kept Cézanne permanently short of funds, a state of affairs that could only hinder his development as an artist, and he was frequently forced in the course of his career to borrow money from his friends.

Arc, suggesting, as it does in the late paintings of Cézanne, the mutability of physical reality.

Cézanne's dedicated examination of his chosen motifs achieves even greater significance given that he worked in an age like our own, when technological advancement was setting up ever more screens between the individual and a direct experience of nature. His obsession with the infinite variations of light, form and color are precious reminders of the importance of first-hand contact with the simple facts of existence, whereas the great historical events of the nineteenth century are left unrecorded in his work; the modern cityscape of Paris, so important to his Impressionist associates, held no interest for this artist. In a letter to his niece, 1 September 1902, he wrote:

Unfortunately what we call progress is nothing but the invasion of bipeds who do not rest until they have transformed everything into hideous *quais* with gas lamps – and, what is still worse, with electric light. What times we live in!

A visit to Provence is an important experience for anyone wishing to achieve a closer understanding of Cézanne's landscape works. They are surprisingly faithful to the landscape, atmosphere and local color of the environment and have fixed forever the popular conception of the locality – it seems impossible to see it in any way other than as an animated Cézanne painting.

Paul Cézanne was born in 1839 in Aix-en-Provence, once a fiercely proud and important centre of cultural and political activity. By the nineteenth century, however, it could only be described as a sleepy provincial town, hidden deep in the southeast corner of the country about 30 miles from the Mediterranean coast. The painter's father, Louis-Auguste, was a

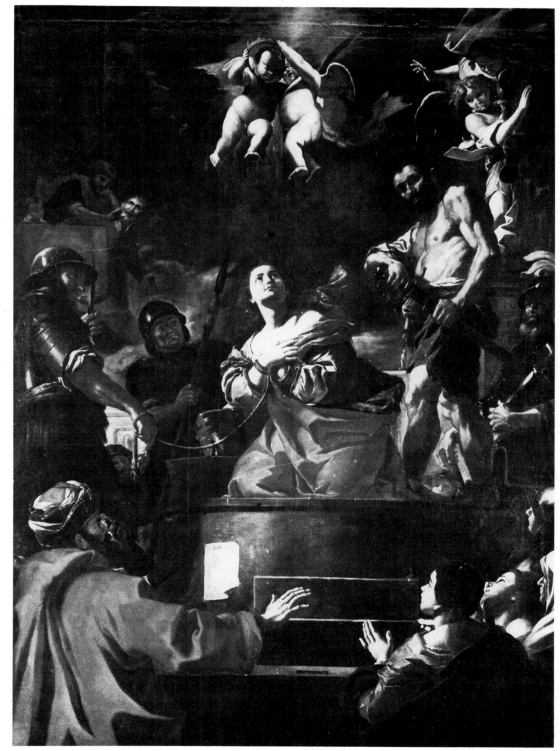

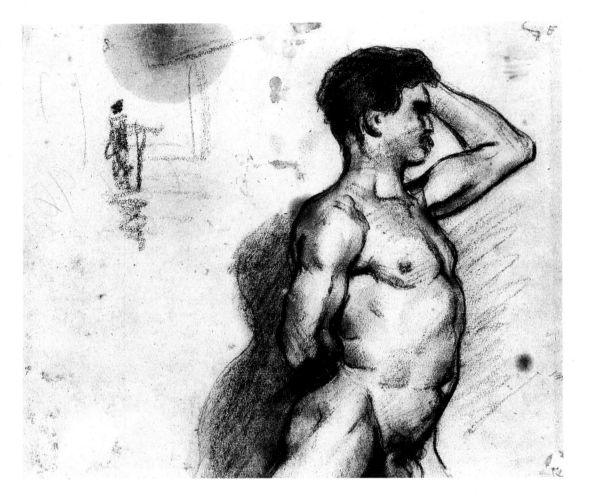

From 1852 Cézanne attended the Collège Bourbon in Aix, where he met and became friends with the future critic, journalist and novelist Emile Zola. Zola's father was a civil engineer and had promoted and supervised the construction of a dam near Le Tholonet, in the mountainous region to the east of the town. Unfortunately he died before work on the project got fully under way, leaving his widow and son in straitened circumstances. The young Cézanne was a diligent and intelligent student and a good companion, whose unpredictable moods and behavior were supported with good humor by his friends. This was without doubt the happiest and most fulfilled period of his life; he and his companions wandered about the neighboring countryside, guns over their shoulders, food and wine in their game bags. By their own admission they were at best ineffectual hunters, spending most of their time dozing under trees or swimming in the pools of the quarries of Bibémus, situated to the west of Aix. Occasionally, it seems, Cézanne thought about art, but his passion for painting was slow to develop and his friends thought of him not so much as a future painter but rather as a budding literary giant. These youthful escapades were to fire his creative work throughout his life, however, and something of their flavor may be caught in Zola's first novel

The Confession of Claude, published in 1866 and dedicated to Cézanne and their mutual friend of the time, Baptistin Baille.

At the age of 19 Cézanne was awarded a second prize for drawing at the local Ecole des Beaux-Arts and, after initial failure, he managed to pass his baccalaureate – something Zola never achieved. Family pressure and his own lack of direction were to result in his enrolling at the local university to study law. Zola was already living in Paris and it was through his influence, and with the help of his mother and sister Marie, that Cézanne gained the courage to confront Louis-Auguste with his ambition to become a painter. After two years of pleas and procrastinations a reluctant permission was wrung from his father and in April 1861 Cézanne followed Zola's example and left for Paris, the artistic center of Europe.

His allowance was only just enough to live on and pay the fees at the Académie Suisse where, morning and evening, he drew from the life in the informal atmosphere for which the Académie was famous. It was here that he came into contact with other independently minded painters, among them Armand Guillaumin and Camille Pissarro. Some of his life drawings reveal a competent use of the academic conventions of the day, while other drawings are executed in a fiercely independent, sometimes even caricatural, manner. From

the beginning of his career Cézanne had decided unequivocally to reject facility in favor of power of expression; he had set his heart on becoming a great as opposed to a merely successful painter.

His lack of security, together with an inability to resolve his artistic ambitions, led to periodic outbreaks of despondency and depression which resulted in the destruction of many early works, including most notably a portrait of Zola that he had begun in his room at 39 rue d'Enfer. Zola wrote to Baille: 'Paul may have the genius of a great painter, but he'll never have the genius to become one'. Cézanne, when in the depths of misery, often threatened to give up his ambition and return to Aix, and in September 1861, despite the efforts of his friends in Paris, he not only returned home but took up a position in his father's bank. The desire to become a painter never left him, however, and he continued to paint at home, while at work he gave ample proof of his complete ineptitude for financial matters. Aided by his mother, he again managed to persuade his father to consent to and finance another attempt to succeed in Paris. Once again he attended sessions at the Académie Suisse, working in his studio or sketching after his favorite masters in the Louvre during the afternoon. His circle of acquaintance now included the young, ambitious painters Frédéric Bazille, Claude Monet, Auguste Renoir and Alfred Sisley. Perhaps to fulfil family obligations, Cézanne entered the admission competition for the Ecole des Beaux-Arts, which he failed. This may well have been a deliberate act on his part, as he was already at this time scathingly critical of official art.

Through his friends at the Académie, Cézanne had become aware of the fierce debates that raged within the avant-garde art circles of the day. Every Friday evening the Realist critic Edmond Duranty held court with a group of like-minded artists and writers at the Café Guerbois, 11 rue des Batignolles (now Avénue de Clichy). The talk would be of the radical work and theories of artists such as Gustave Courbet (1819-78) and Edouard Manet (1832-83), both of whom had challenged establishment art practice not only by their subversion of traditional Salon subject matter but also by their bravura painting styles. Both artists commanded respect among the circle because they had held exhibitions of their work outside the state-sanctioned Salon system. In 1863 Manet's painting *Déjeuner sur L'Herbe* was the focus of public and critical derision when over 4000 works rejected from the Salon were

Right: *Death of Sardanapalus* by Eugène Delacroix painted in 1827. A reproduction of this painting hung in Cézanne's atelier.

Below: *Olympia* by Edouard Manet, 1863.

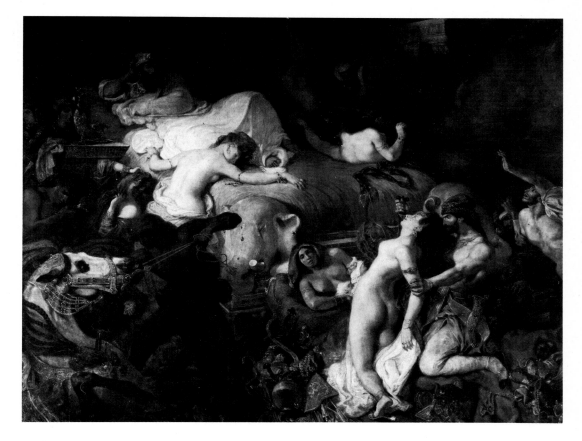

shown at a specially convened *Salon des Refusés*. Somewhere among all those rejected works were hung the first by Cézanne to be publicly exhibited. One can imagine the excitement and pride with which Cézanne led Zola to see these paintings which, unfortunately but hardly surprisingly, elicited no critical response and have not as yet been identified.

Cézanne was uneasy in the atmosphere of the Café Guerbois; by nature a solitary and timid individual, he was an irregular attender at the gatherings and rarely contributed to the discussions. He preferred to keep silent and so to preserve the protective veneer of provincial uncouthness that he cultivated. Apparently Cézanne, never especially adept at social skills, reserved his worst behavior for the arch-sophisticate Manet, once refusing to shake his hand and giving as excuse that he had not washed for some considerable period.

Despite such anecdotes, Cézanne's paintings of this time can be linked to works by both Manet and Courbet. He produced scenes of riverside picnics such as *Couples Relaxing by a Pond* (page 52), reworkings of Old Masters and ambitious

nudes, such as *A Modern Olympia* (page 60), not with the 'licked' gloss-like surface of successful Salon pieces but painted in a deliberately crude manner so as to subvert the staid conventionalized painting of the time. Much of his work at this time seems a commentary on or even a parody of contemporary trends and is shot through with a disturbing sense of the erotic.

Cézanne had introduced Zola to the Café Guerbois scene and when Zola became a columnist for the newspaper *L'Evénement* in February 1866, he must have recognized how valuable his contacts with this particular group of the avant garde could prove. In no time he became a highly visible and vocal member of the group. In the same month that his friend

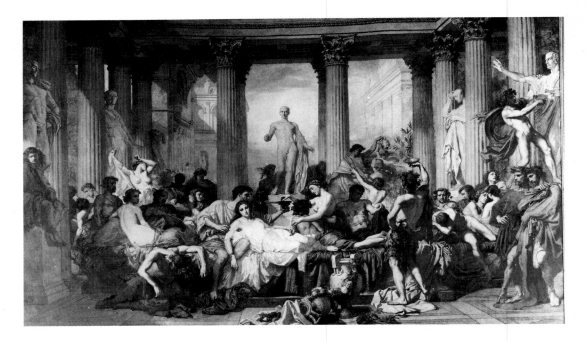

had gained his first job as a journalist, Cézanne arrived in the capital determined to submit to the Salon. As on the last three occasions, his submissions were rejected. Enraged, he wrote directly to the Directeur des Beaux-Arts demanding a re-institution of the *Salon des Refusés*. This was ignored, as was his second letter on the subject. The artist turned to Zola, who had just talked himself into the position of art critic for his paper, and soon a series of outspoken articles appeared damning the art establishment in the plainest of terms. The resulting scandal led to the abrupt cessation of Zola's column and he quickly republished his three articles in pamphlet form under the title *Mon Salon*. Zola's arguments were directed against those who attacked the work of Manet, for whom he had the greatest respect. Although Cézanne's work is only mentioned in passing, an open letter addressed 'To my friend Paul Cézanne' prefaces the work and makes very clear his deep love for his friend and the importance of their shared youth, when 'we told ourselves that outside of powerful and individual life there was nothing but deceit and stupidity'.

Sadly Zola had little critical understanding of Cézanne's art, however, and could not see that the powerful temperament that he sought for in vain in the work of the young artists who flocked around Manet was present in Cézanne's work. Zola felt that his friend was, as he wrote later, *un peintre avorté*, a painter who had miscarried; gifted with the potential for greatness, but cursed with an inability to fulfil that promise.

In Zola's notes for his novels *Le Ventre de Paris* (The Belly of Paris) and *L'Oeuvre* (The Masterpiece), both of which feature the fictional painter Claude Lantier, the writer gives a sharply-focused description of Cézanne that corroborates the visual evidence of his self-portraits. He is described as being tall and thin, 'bearded, with knotty joints, and a strong head. A very delicate nose hidden in a bristly moustache, eyes narrow and clear . . . Deep in his eyes, great tenderness. His voice was loud . . . he was a little stoop-shouldered and had a nervous shudder which was to become habitual'. Cézanne's early work corresponds to the often melodramatic qualities found in Zola's novels and his relationship with the writer cannot be overvalued. In August and October 1867 the magazine *L'Artiste* published a serial en-

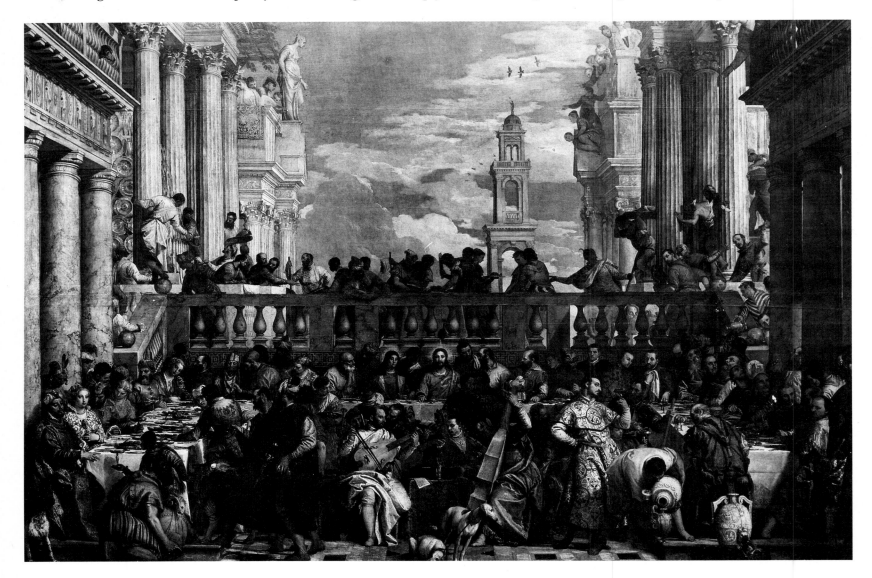

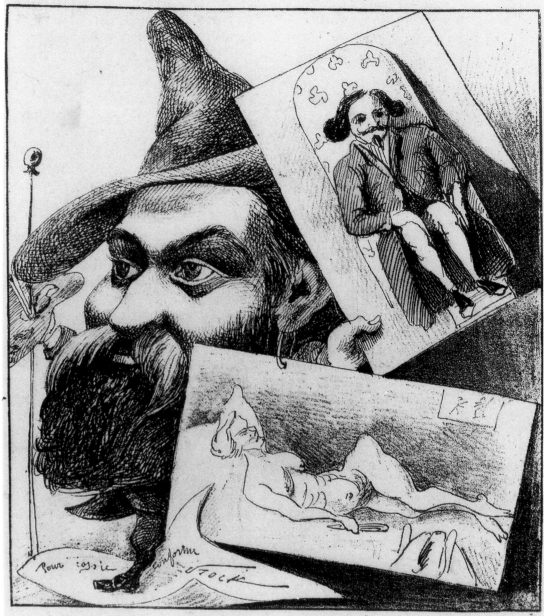

LE SALON PAR STOCK

Incident du 20 mars au Palais de l'Industrie ou un succès d'antichambre avant l'ouverture du Salon

titled '*Un Mariage d'Amour*', later to be re-issued in book form as *Thérèse Raquin*. Many of Cézanne's erotically charged early works such as *The Murder* (page 34) can be seen as powerful visual equivalents to Zola's doom-ridden tales of modern life, although much of the greatness of the painter's final achievement lies in his ridding himself of precisely those romantic elements contained in his friend's novels. In their different ways, both retained their passion for the physical environment and owed equal debts to the shared experiences of their adolescence.

Cézanne's paintings at this time were not only nourished by the complexities of his own personality, his friendship with Zola and his association with the Café Guerbois scene but, most significantly, were fed from his own personal baggage of images and painting techniques, culled from an extraordinarily diverse number of sources. He especially admired the work of the seventeenth century Caravaggesque school (examples of which he had seen in the Musée Granet at Aix) and that of contemporaries or near contemporaries, such as Théodore Ribot, Eugène Delacroix and Honoré Daumier, as well as of earlier artists such as Michelangelo, Veronese, Poussin and Rubens. It is no exaggeration to say that the Louvre was for Cézanne a second home. Like Manet and Delacroix before him, Cézanne felt no shame in widespread appropriation of other artists' techniques or imagery – it was how they learned their craft.

Throughout his life Cézanne maintained the greatest respect for the writings of the poet and critic Charles Baudelaire. One of his favorite poems by the writer was *Les Phares* (The Beacons) which emphasizes the necessity of carrying on the tradition of great painting by deliberately seeing western art as a kind of elevated baton-passing exercise. This particular stanza refers to Delacroix, but its mood perfectly catches the dark splendor of Cézanne's work of the 1860s and early 1870s.

Delacroix, lac du sang, hanté des mauvais anges,
Ombragé par un bois de sapins toujours vert,
Où, sous un ciel chagrin, des fanfares étranges
Passent, comme un soupire étouffé de Weber.

(Delacroix, lake of blood, haunted by evil angels,
Shadowed by a wood of fir trees, ever-green,
Where strange fanfares pass through a stricken sky,
Like a muted sigh from Weber.)

At the Café Guerbois Cézanne met the Provençal *plein-air* painter Paul Gigou, also a friend of the eccentric lover of contemporary art, Dr Paul Gachet. He was five years Cézanne's elder and his landscapes bear a close relationship to Cézanne's work, as do the paintings of another Provençal artist he was friendly with, Adolphe Monticelli. Both these painters worked in a highly-colored impasto style, making much use of the palette knife. Cézanne termed his style of painting *couillard*, which has been variously translated depending, one suspects, more on the supposed sensibilities of the projected reader than on strict grammatical correctness. The word is a graphic term expressing certain aspects of sexual virility.

The Salon of 1870 was the last of the Second Empire and the Batignolles group (as the circle of artists associated with the Café Guerbois was known) fared badly in getting works accepted. Cézanne waited until the last possible moment before delivering his two canvases to the jury for selection. This was his seventh attempt to gain admission and his choice of works was extraordinary and, presumably deliberately, provocative. As the illustration from the *Album Stock* shows, one was the six-foot-tall portrait of his painter friend Achille Emperaire, *Portrait of Achille Emperaire* (page 38), the other was a *Reclining Nude* which may have been of similar dimensions. Unfortunately this painting, which belonged to Gauguin, has been lost, or no doubt our conception of Cézanne's early work would be significantly altered. Such occurrences testify to the way in which our awareness of an artist's production relies heavily upon known or easily available work. The painting of such a nude as the caricature suggests proves Cézanne's high ambition and his deliberate and close identification with the works of Manet and Courbet. The article accompanying the illustration in the *Album Stock* was based on an interview with Cézanne:

The artists and critics who happened to be at the Palais de l'Industrie on March 20th, the last day for the submission of paintings, will remember the ovation given to two works of a new kind . . . Courbet, Manet, Monet, and all of you who paint with a knife, a brush, a broom,

11

Left: A view of L'Estaque from Cézanne's sketchbook, dated 1879-80.

Below: This detail from the self-portrait of the 1870s (page 62) reveals the artist to be as determined and obdurate as any Old Testament prophet.

Vins on the Left Bank, to the east of the Latin Quarter. Here, in insalubrious surroundings on January 1872, Hortense gave birth to a son, named Paul after his father. It was at this time and under these pressures that Cézanne produced the stormily painted *Self-Portrait* (page 62) that marks the end of a prolonged self-directed apprenticeship, and the start of a period which saw the production of a whole sequence of extraordinary masterpieces.

Despite his truculent personality, Cézanne was accepted by a number of the independent painters; crucial to his development as an artist was his relationship with the Creole-born Camille Pissarro, who was eight years his senior. In 1872 Cézanne left Paris to work with Pissarro at Pontoise and a year later he and his family settled at the nearby village of Auvers-sur-Oise. The impact of Pissarro's character and work upon Cézanne was quite tremendous. His respect for the older artist never

or any other instrument, you are out-distanced! I have the honor to introduce you to your master: M. Cézannes (sic) . . . Cézanne hails from Aix-en-Provence. He is a Realist painter and what is more, a convinced one. Listen to him rather, telling me with a pronounced Provençal accent: 'Yes, my dear Sir, I paint as I see, as I feel – and I have very strong sensations. The others, too, feel and see as I do, but they don't dare . . . They produce Salon pictures . . . I dare, Sir, I dare . . . I have the courage of my opinions – and he who laughs best laughs last!'

Despite the cynical tone of this piece of writing, the supposed quotation from the artist has a ring of truth and is corroborated by similar statements in his letter and recorded comments.

From 1863 to 1870, Cézanne spent part of every year in the south, a pattern of behavior that was to remain set for life. The outbreak of the Franco-Prussian war on 18 July 1870 and the resulting *debâcle* of the Commune disrupted the gatherings at the Café Guerbois, as the terrible events affected each of the group in different ways. Cézanne appears to have taken little notice of the war and he quit the capital to continue his work undisturbed in the Midi. It appears that the authorities made some attempt to conscript him but nothing came of it, and he spent the war years painting in the little village of L'Estaque. He took with him Hortense, a young model ten years his junior whom he had met a few months earlier. Worried about his family's reaction to such a liaison, and the possible effect upon his already meagre allowance, he left the family home and lived secretly with his companion at L'Estaque. His landscapes of the area are characterized by a powerful structuring force which yet barely contains the energy that pours out onto the canvas; a force that belongs to the artist and not necessarily to the scene depicted.

When it was safe to do so, Cézanne returned to Paris with Hortense and took up lodgings at 5 rue de Chevreuse, next door to one of his childhood friends, the sculptor Philippe Solari. Soon after, however, as was so typical of him, he moved to the noisy rue Jussieu, opposite the Halle aux

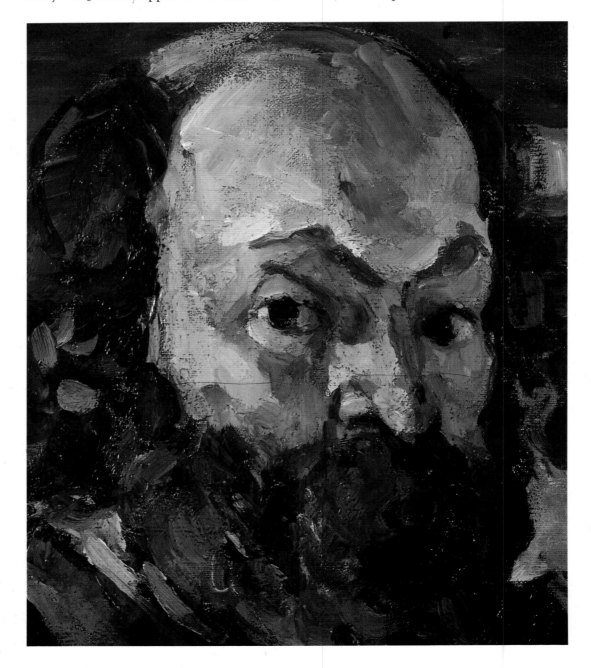

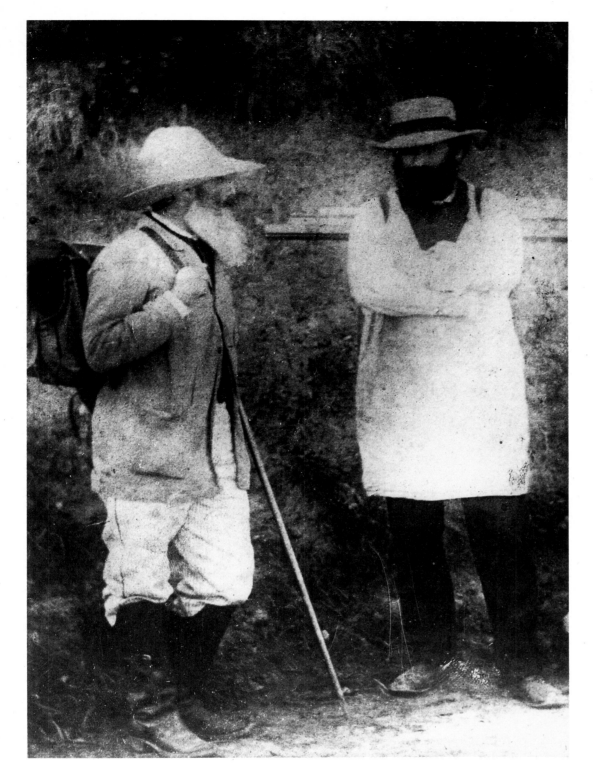

Much though he admired Monet's bold experiments and extraordinary gifts, however, it was Pissarro's work that was to have the most powerful and lasting effect on his working practice. Pontoise was a small market town about 20 miles north east of Paris. The area to the immediate west of the capital around Marly-le-Roi and Chatou has been called the cradle of Impressionism – it was here that Monet and Renoir worked in the last year of the 1860s, producing works such as the *La Grenouillère* paintings. The group of painters centered at Pontoise produced work very different from the *mondaine* images of Parisians at leisure on the banks of the river Seine; instead they painted the agriculturally based community and individuals of the area.

Pissarro had been a pupil of Camille Corot, and the quiet unpretentious strength of that artist's work was the source of his own painting style. He also had a profound respect for the Barbizon painters of the previous generation and had made a close study of Dutch seventeenth century painting. Something of the order and unassuming craftsmanship of Pissarro's work found its way into Cézanne's work of this time, such as *The House of the Hanged Man* (page 64). 'We were always together,' Pissarro informed his son in a letter of 1895 '. . . but what cannot be denied is that each of us kept the only thing that counts, the unique *sensation*'.

The mention of the word sensation is significant and deserves some elaboration. Pissarro confirmed Cézanne's distrust of

wavered; he was, as Cézanne wrote, at once 'humble and colossal.' In 1906, the last year of his life, he identified himself in a catalogue as a pupil of Pissarro's. Pissarro took the younger artist under his wing and introduced him to the joys and pains of *plein-airism*. This was the practice of painting out of doors, rather than producing a polished version of the chosen subject in the studio by reference to sketches. This bridging of the gap between the painted sketch and the final work marks the beginnings of what we now refer to as Impressionism. Needless to say, Cézanne's relationship with Impressionism and the Impressionist painters was as complicated as everything else in his life. He was impressed by Monet's attempts to continue the experiments of Courbet and Manet, an ambition most clearly seen in that artist's *Déjeuner sur L'Herbe* of 1865, and described him as 'only an eye, but my God, what an eye'.

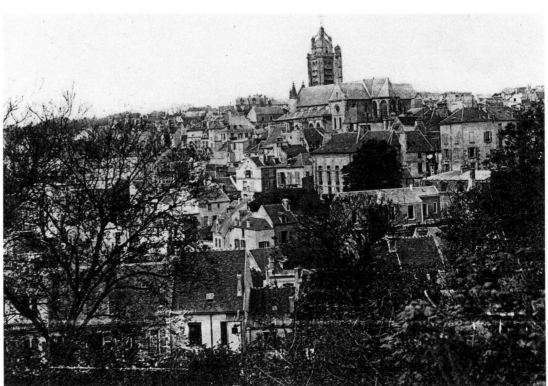

the theoretical in favor of prolonged investigation of visual phenomena, a research program recorded in his canvases. Theory was always to take second place to practice in Cézanne's work. Despite their close association, the attitudes of Cézanne and Pissarro to the landscape were subtly different. Pissarro liberated Cézanne's imagination from the studio-based works of the 1860s and directed his energies towards a concentrated attack on landscape. They set themselves to solve a fundamental artistic problem – how to relate a mass of buildings to a surrounding landscape without destroying the unity of

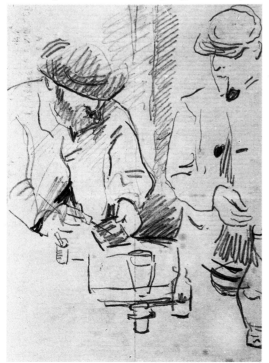

the canvas surface. Pissarro's paintings, however, also express his belief in the village as a living community, fully integrated into its environment, in a way that the recently re-developed city of Paris could never be. Such ideas would have interested Cézanne very little – figures hardly feature at all in landscapes such as the *Farmyard at Auvers* (page 83).

In early 1873 Cézanne moved to Auvers, a little village several miles along the Oise, a river beloved by many of the artists Pissarro and Cézanne admired. Dr. Gachet, the collector and supporter of artists who had been closely involved with the Café Guerbois habitués, lived there. The doctor, who was an amateur artist, has acquired immortality through Van Gogh's poignantly melancholic portrait of 1890. Cézanne became very friendly with him, was introduced by him to etching, and spent two very happy years painting in and around the neighborhood.

In Paris, the Café La Nouvelle-Athènes had replaced the Café Guerbois as the latest meeting place of the Batignolles group, although the change of venue did not mean that Cézanne's presence was any more frequent. The discussions were still centered around new theories of art; but on a more practical level, the group continued their search for a means of getting their work exhibited and sold without having to submit to the compromises necessary for a Salon-based success. Cézanne's abrasive and disruptive manner must have been seen by some of the group as hindering

their efforts. Pissarro took a leading role in these debates and in 1874 it was decided to hold an independent exhibition of paintings, entry to which would be by invitation as opposed to the Salon system of jury selection. Despite some opposition from other members of the group, Pissarro made sure that his friend was included and so Cézanne became one of the original participants in the 'First Exhibition of the Limited Company of Artists, Painters, Sculptors and Engravers'. The exhibition was held in the recently vacated studio of the photographer Félix Nadar, at 35, boulevard des Capucines, situated close to the recently completed Opéra building, the center piece of Baron Haussmann's new Paris. Cézanne was represented by three works, *A Modern Olympia* (page 60) – an affectionate parody of Manet's *Olympia* which was taken from Dr Gachet's collection – and two Pissarro-influenced landcapes, one of which was a motif from Auvers which became known as *The House of the Hanged Man* (page 64) and was bought by Count Doria. Cézanne's paintings attracted the most derisive of the almost totally negative criticism of the exhibition; once again he was singled out for what was seen as his deliberately provocative behaviour, as much as for the oddness of his works.

Shall we speak of M. Cézanne? Of all known juries, none ever imagined, even in a dream, the possibility of accepting any work by this painter who used to present himself at the

Left: *La Sente de la Justice in Pontoise* painted by Pissarro in about 1872.

Below left: An intimate sketch made by Cézanne in 1873 showing Dr Gachet watching the artist etching.

Below: A tiny sketch by the popular artist Gavarni which may relate to Cézanne's paintings of Card Players.

Below left: *Landscape with Trees*, c. 1885-7, shows Cézanne's use of parallel hatching to suggest the tree's form.

Salon carrying his canvases on his back like Jesus his cross.

Comments such as this by E d'Hervilly in *Le Rappel*, 17 April 1874, recall the scabrous attacks on Gustave Courbet, the *bête noir* of the art establishment in the 1850s and 1860s, but such opinions were also held within the Nouvelle-Athènes circle. The Irish writer and former art student, George Moore, wrote in his *Reminiscences*:

I do not remember to have seen Cézanne at the Nouvelle-Athènes, he was too rough, too savage a creature, and appeared in Paris only rarely. We used to hear about him – he used to be met on the outskirts of Paris wandering about the hillside ... His work may be described as the anarchy of painting, as art in delirium.

In a letter to Emile Zola, Duranty gave a sharply observed character sketch of the artist:

Cézanne turned up a short while ago at the little café in the Place Pigalle, in one of those get ups of his: blue shirt, white linen jacket covered with marks made by his brushes and other implements ... He was a hit, but such exhibitions are suspect.

Despite such criticism from both within and outside his circle of associates, Cézanne kept his confidence as a painter, and his belief in the uniqueness of his own qualities remained basically unshaken. Now and later, he was to rely upon his own resources and a small group of patrons and critics who admired his work.

After the close of the exhibition, Cézanne returned to his family home in Aix, leaving his mistress and his son Paul alone in Paris, but he was soon back in the capital and living next to the painter Armand Guillaumin on the Quai d'Anjou, a quieter area than that around the wine warehouses where he had lodged previously. When things were at their bleakest, he received help from an unexpected quarter. 'Pere' Tanguy ran a dingy little colorman's shop in the rue Clauzel, Paris. He had great sympathy for the difficulties of the young Impressionist painters and would sometimes exchange their paintings for painting materials. Renoir, who had a high opinion of Cézanne, persuaded Tanguy to show some of Cézanne's canvases to Victor Chocquet, an ex-civil servant with a passion for the works of Eugène Delacroix. Despite his relatively modest circumstances, Chocquet had built up an impressive collection of works by that artist and the young avant-garde painters. He became Cézanne's most ardent supporter and the subject of some of the artist's most sensitive portraits. According to the critic Théodore Duret:

...he was indefatigable on the subject of Cézanne, whom he placed in the front rank ... People used to make fun of Chocquet's enthusiasm, which they regarded as a mild form of madness.

At the time of his death Chocquet had some 35 canvases by Cézanne in his collection; his support at this critical period must have been of great benefit to the artist and marks a turning point in his career. In the summer of 1876 Cézanne was in l'Estaque, where he painted the view across the bay for Victor Chocquet (page 78). Once again he tried unsuccessfully for the Salon and did not, for reasons that are not altogether clear, participate in the 1876 Impressionist exhibition, but the following year saw 16 of his paintings hanging on the walls of the third Impressionist exhibition. His presence there was mainly due to the enthusiasm for his work shown by Pissarro and the wealthy painter and main organizer of the show, Gustave Caillebotte, who shared Pissarro's faith in the artist. Cézanne's paintings, still lifes and landscapes were mostly taken from Chocquet's collection and shared the wall space with Berthe Morisot's paintings. The critical response to his work was so overwhelmingly unfavorable that he refused to take part in any of the other Impressionist exhibitions, although he continued to send works unsuccessfully to the Salon. In effect this condemned him to almost total obscurity, for without showing at either of these two venues his work remained hidden from the general public.

One young critic, Georges Rivière, was deeply moved by Cézanne's work at the 1877 show and his perceptive comments are worth quoting at length:

Cézanne is a painter and a great painter. Those who have never held a brush or a crayon claim that he does not know how to draw, and reproach him for his 'imperfections' which are only refinements obtained by enormous learning. . . The paintings by Cézanne have the inexpressible charm of biblical and Greek antiquity. The movements of the figures are simple and grand like those in antique sculpture, the landscapes have an imposing majesty and his still lifes, so beautiful, so exact in their relationships of tones, have something of the solemnity of truth. In all his paintings, the artist produces emotion, because he himself experiences before nature a violent emotion which his craftsmanship transmits to the canvas. . .

Cézanne returned to the south of France in January 1878 and on this occasion saw possibilities in the landscape that hit him with the power of a sudden revelation. The weather conditions were very different from the changeable skies so wonderfully recorded in the Normandy landscapes of Monet. In Provence the climatic conditions were much more stable, the atmosphere clearer and the brightness and constancy of the light made objects stand out

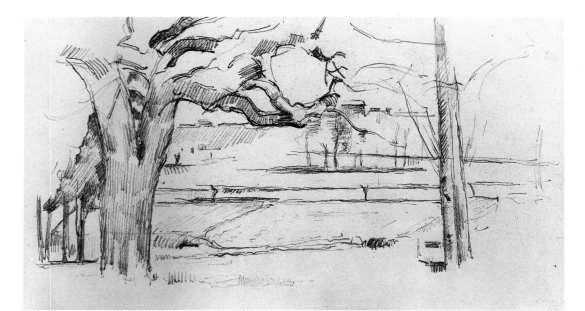

from their setting or, as he wrote in a famous letter to Pissarro, 'like a playing card, red roofs against the sea'. This was the landscape of his childhood, one he knew intimately and studied in the light of his experiences with his mentor, Pissarro. Traditional art theory could not help to capture his sensations in response to the Midi landscape – he was forced to re-examine his own techniques and discover his own way of 'organizing his sensations before nature'. The results are to be seen in paintings such as *Farmyard at Auvers* (page 83) and *Mountains at l'Estaque* (page 108).

Cézanne remained in the south for more than a year; although he brought Hortense and Paul to Provence with him, they did not live in the family home but stayed in Marseilles, where he was able to make surreptitious visits to them on his painting trips. Louis-Auguste Cézanne had no scruples concerning the privacy of his son's mail and when he opened a letter addressed to Paul from Chocquet, which mentioned the artist's dependants, a confrontation between father and son was inevitable. Following a firm but hardly believable denial concerning the existence of his family, Cézanne's allowance was reduced from 200 francs to 100 francs; enough to finance a bachelor existence but too little to support a family or maintain a separate establishment to hide them in. Cézanne's appeals to Zola for financial aid chart the developments of the drama. One of them amusingly documents a momentary change in his father's attitude:

Nota bene. Papa gave me 300 francs this month. Unheard of. I think he has been making eyes at a charming maid we have at Aix. . . What a turn up!

Cézanne's appeals to his friends ceased in November and it would appear that from then on an uneasy truce existed in the Cézanne household.

By spring 1880 Cézanne had moved back to Paris and worked with Pissarro at Pontoise, but in late 1881 he returned to Aix, only to return to the capital a few months later. His ambition to show at the Salon was undiminished despite the usual rejection of the previous year. Through the agency of his friend, the popular genre painter Antoine Guillemet, one of his canvases was accepted on special dispensation, *'pour la charité'*. By posing as the pupil of his friend, he did not have to subject his work to the jury for approval. The painting provoked little critical response; the official Salon entry describes it as a portrait of 'Monsieur L. A.' but it has not as yet been identified. The next public appearance of a Cézanne canvas was seven years later at the Exposition Universelle of 1889; this was the *House of the Hanged Man* which had been originally shown at the first Impressionist show and was at that time part of Victor Choquet's collection. Zola's opinion was generally accepted that Cézanne (now in his late thirties), though full of promise, was not yet ready or mature enough as an artist to fulfil the aims the Impressionist painters had apparently set themselves. Zola was to extend this judgment to include all the Impressionists.

Cézanne spent the next three years working in relative isolation in the south of France, continuing unsuccessfully to submit works to the Salon. Despite constant rejections, he refused to compromise his high ideals by making any concessions to establishment values. Although he had gradually lost touch with most of his Impressionist colleagues, his solitary existence was punctuated by a trip to Paris to attend Manet's funeral and by visits from Renoir and Monet. In early 1885 he was troubled by a brief and apparently one-sided love affair, the details of which are unknown. By June that year, possibly to escape this unhappy *affaire de cœur*, he had left Aix and was staying, accompanied by Hortense and their son, with Renoir at La Roche-Guyon in Normandy and from there he worked briefly at Vernon, close to Monet's home at Giverny. He had frequently stayed with Zola at his home at Médan on the banks of the Seine, but the writer's ostentatious display of his, by now considerable, wealth clashed with Cézanne's still essentially bohemian character; their once close relationship had for some time shown signs of stress. In 1886 Cézanne moved briefly back to Paris and then, restless as ever, he spent the rest of the year with Hortense and their son at Gardanne. Gardanne was a hillside village six miles south of Aix. Initially Cézanne walked there each morning from the Jas de Bouffan, his family home, his painting materials strapped to his back, often sheltering for the night in local farmhouses. It was a very difficult time for the painter, constantly moving between his two families, each of which abhorred the other, and under continual pressure to legitimize his son.

His paintings, however, show nothing of such domestic difficulties. The studies of

Below: Cézanne, as he would no doubt have wished to be remembered, photographed *sur le motif.*

Below right: Cézanne's childhood friend Emile Zola photographed in about 1885 at the height of his fame.

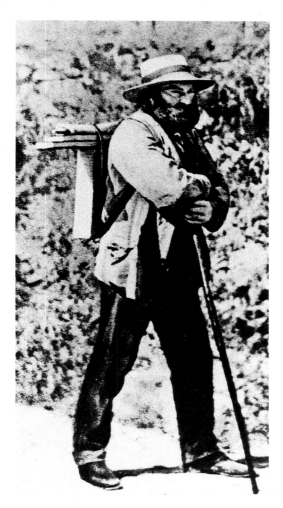

Gardanne (page 106) are impressive renderings of the sculptural structure of the simple buildings that surround the hill. Their box-like forms and relatively restricted coloration have often been cited with reference to the development of Cubism. Many young artists of the Parisian avant-garde subsequently used different aspects of Cézanne's work to develop their own idiosyncratic styles. The paintings of Gardanne were among those that Braque and Picasso, the initiators of the Cubist style, most admired, but the motivation for the creation of their works was very different from that which fired Cézanne, whose prime concern was the problem of resolving his perceptions of nature on the canvas. His attitude towards the landscape was essentially a pantheistic one and he would probably have disapproved of the studio-based work of the Cubists, although he would have admired their courage in finding their own means of expression, for Cézanne considered himself (as did a number of critics) as 'un primitif', that is, a painter whose rejection of conventional ways of depicting the world could lead potentially to a new and vital art. The image of Cézanne as a cool detached geometrician of form was an invention of the 1920s to help develop an artistic pedigree for Cubism.

Despite the relatively unchanging nature of the Provençal climate, painting for Cézanne continued to be a laborious and frustrating business; he worked slowly, building up his paintings stroke by considered stroke before the motif. Like Monet, he was subject to fits of depression and was quite capable of putting his palette knife through a painting in torment at a sudden change of weather which had spoilt the effects he had spent so long scrutinizing. When the weather was unsettled or uncertain, Cézanne would stay indoors and spend hours meticulously organizing still lifes to paint. The art establishment held that still life painting was of a lesser order of significance than the more elevated paintings of historical or mythological subject matter, and it is part of Cézanne's achievement that he raised the status of still life painting to the heights of artistic expression. It may well have been

the acquisition by the Louvre of a number of still lifes by the eighteenth century painter Jean Baptiste Chardin in 1869 that revealed to him the potential of this purportedly lowly genre. Certainly it was his work in this area that had drawn Manet's attention to Cézanne in 1862, and the paintings of Courbet and Manet were certainly the starting point, together with Chardin's work, for Cézanne's own great achievements in the genre, which were to be continued in the twentieth century by Matisse, Braque and Picasso.

His still lifes were arranged and painted with as much care as any other aspect of his oeuvre – and took just as long to complete. As he worked so slowly, his fruit grew rotten and his vegetables withered or sprouted, eventually causing him to resort to artificial versions of the original. During the lengthy period of their creation, Cézanne would seek to give shape to the

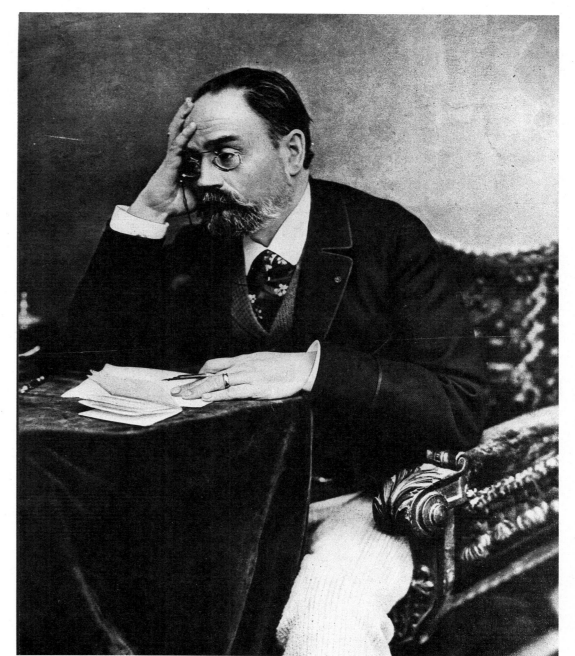

subtle interplay of form, light and color that he observed, bending physical reality until it complied with his own particular aesthetic sensibility.

1886 was an eventful year in Cézanne's life. Zola's novel *L'Oeuvre* (The Masterpiece) was published in book form that year. The narrative traces the tragic life and death of an avant-garde artist, Claude Lantier, whose inability to resolve the conflict between his artistic ambitions and his personal life results in his suicide before he can finish his hugely ambitious masterpiece. Zola's notes for the novel make it clear that Lantier's ambition and personality were based on his close knowledge of Manet and Cézanne. The connection between Zola's book and his published criticism of his painter friends could not be ignored. On 4 April Cézanne acknowledged the copy the novelist had sent him in formal terms. It was to be his final letter to his childhood friend and the two were never to meet again.

Later the same year, on 28 April 1886, Hortense and Cézanne were married in the presence of his parents, who were no doubt relieved that their 14-year-old grandson had at last been legitimized. Years of deceit and complicity had come to an end and the now respectable artist moved with his family into the Jas de Bouffan, which in

Provençal means 'shelter from the wind'. Only six months later his father died, at the age of 88, leaving him and his sister a substantial legacy. 'My father was a man of genius,' Cézanne is recorded as saying, 'he left me an income of twenty-five thousand francs'. Whatever the emotional effect of these traumatic events on the artist's psyche, they did not interrupt his flow of work or change his modest way of life. He spent most of the next year in Aix with his mother, whom he loved deeply, and his sister Marie. His relationship with Hortense had become (what in effect it had probably always been) one of mutual convenience and, although he saw her well provided for, they lived fundamentally different lives. It is ironic, therefore, that while his wife features in many of his works, his mother hardly features at all. Hortense was bored at Aix and felt out of place in the family home, where she was subject to the rule of her husband's aged mother and his sister. She soon departed with their son for Paris. These arrangements seem to have suited Cézanne well and he resumed his characteristic habit of traveling between his beloved Aix and his favorite painting haunts in and around the Ile-de-France.

Right: *Woman Diving into the Water,* c. 1867-70, one of Cézanne's enduring themes.

Below: *Déjeuner sur l'Herbe,* painted by Manet in 1863, one of the most famous images of the nude in a landscape.

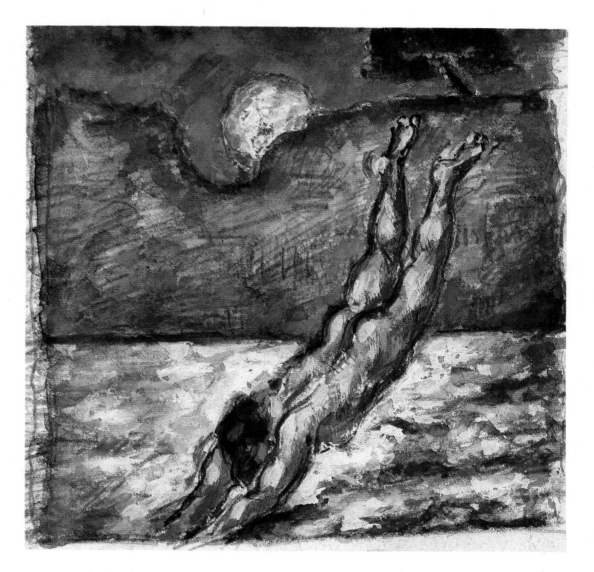

From the start of his artistic career Cézanne had been working, in sketches, drawings, paintings and oils, on compositions of the nude figure in a landscape setting. These paintings were done in the studio from old drawings, photographs and reproductions of the Old Masters. Many artists at the time were tackling such visions of a golden age and, through the example primarily of Cézanne, the concept was to tax the imaginations of the young avant garde of the next century. Cézanne, with his odd mixture of brusqueness and timidity, felt uneasy in the company of the nude model and did not paint from the life; stories abound of his mistrust and, it seems, fear of the female sex. In a small community like Aix, it was impossible for him to get models; there is a delightful anecdote of him coming across a group of bathing soldiers and, transfixed, setting down in his memory the effect of the sunlight on their bodies. The pictures are all very different in technique and atmosphere and remain perhaps the most problematic part of Cézanne's oeuvre. His smaller canvases of the subject have a convincing vitality, something of the very stuff of life. Towards the end of his life he spent many years working on three large canvases (pages 152-5), each of which is singularly different from the others, although all are hierarchic and magisterial in tone. Perhaps, among other things, they chart an old man's continuing dialogue with the masters of the past he loved so much and

remain unfinished, over-worked or underworked because, like any good conversation, he did not want it to stop.

In 1889 Cézanne was invited by the critic Octave Maus to exhibit with the Belgian group of artists known as *Les Vingt*. In the winter months of that year he journeyed down to the Jas de Bouffan and renewed his friendship with Renoir, who was staying at Cézanne's brother-in-law's estate at Bellevue near Aix. Despite his now comfortable circumstances, Cézanne made no attempt to visit Italy or Spain. In the summer of 1890, possibly to please his wife, he and his family left Paris and the Louvre for his only excursion beyond the borders of France, spending five months touring the Jura and Switzerland, although the picturesque qualities of the Swiss landscape do not seem to have appealed to him.

In the winter months of 1896 Cézanne fell ill and, on his recovery, he returned to the family home in Aix to find his mother also seriously ill. She died in October of the following year. Typically, Cézanne did not attend the funeral 'because', according to Emile Bernard, 'he had to work, although no-one perhaps had loved her or wept for her as he had'. It is possible that her death may have had something to do with the reintroduction of the skull as sole subject for at least three of his oils at this time (page

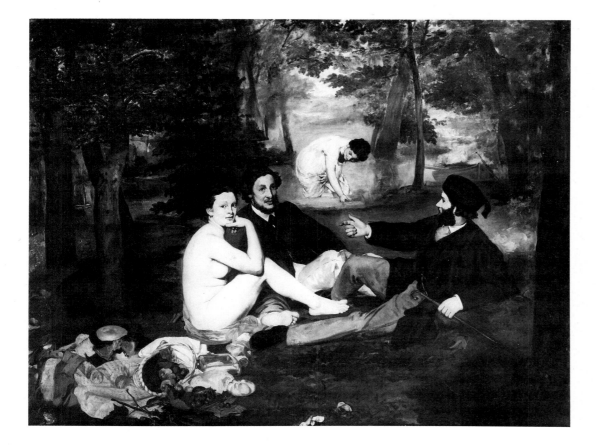

Right: Page of Studies for *Mardi-Gras,* c. 1888. (page 113).

Below: *Portrait of a Woman* including a still life by Cézanne (reproduced on page 76), painted by Paul Gauguin in 1890.

156). For Cézanne, as for many artists, a still life could be endowed with a symbolic or allegorical meaning, although the precise significance of his chosen objects, be they skulls, apples or the prosaic contents of a Provençal kitchen, is still a matter for debate.

In January 1894 a shrewd dealer, Ambroise Vollard, opened his gallery on the rue Lafitte in Paris. His ambition was to make a name and fortune for himself as a dealer in contemporary and avant-garde art. He was to be a decisive influence upon Cézanne's life and was responsible as much as anyone for the creation of the Cézanne legend. Once again Cézanne had occasion to be grateful to Camille Pissarro for he, together with Monet and Renoir, acted as adviser to the dealer, recommending Cézanne's work to him, and Vollard agreed to give him a one-man show at his gallery, at which 150 of Cézanne's works were exhibited. Vollard was a celebrated raconteur whose amusing and informative anecdotes, published in his various writings, have brought a sense of immediacy and vitality to this period in the history of modern art. In 1899 the dealer, at his own request, subjected himself to the ordeal of sitting to the artist for his portrait. The sessions stretched over three months and, after 115 sittings, Cézanne abandoned the portrait and left for Aix with the comment, 'I am quite pleased with the front of the shirt' (page 148).

Cézanne, in characteristic fashion, stayed away for the opening. Pissarro wrote to his son Lucien, his faith in his old friend entirely vindicated:

The dilettantes are astounded and misunderstand everything, but it is great painting nonetheless. It has a great delicacy, diversity and classicism. . . My own enthusiasm pales against Renoir's. Even Degas has fallen for the magic of this sensitive savage, Monet, everyone.

Needless to say this was not a view shared by all. A few new defenders and collectors were attracted to Cézanne's art, but the canvas which had been placed in the gallery window had to be removed for fear of the crowds, who gathered to gawp at what one critic called 'the nightmarish imagination behind these atrocious paintings, which have over-stepped the limit of ordinary practical joking'. Vollard became the artist's major dealer, taking over from 'Père' Tanguy who had died in 1894. On Cézanne's departure Vollard bought up the entire contents of his studio.

Cézanne had lost touch with many of his old friends, but in the last decades of the century he slowly began to renew his ties with his Impressionist colleagues, although his prickly nature made such relationships difficult to sustain over any prolonged period. He had always remained friendly with Renoir, and had stayed with Monet at Giverny in 1894 (where he met Rodin, for whom he had the greatest re-

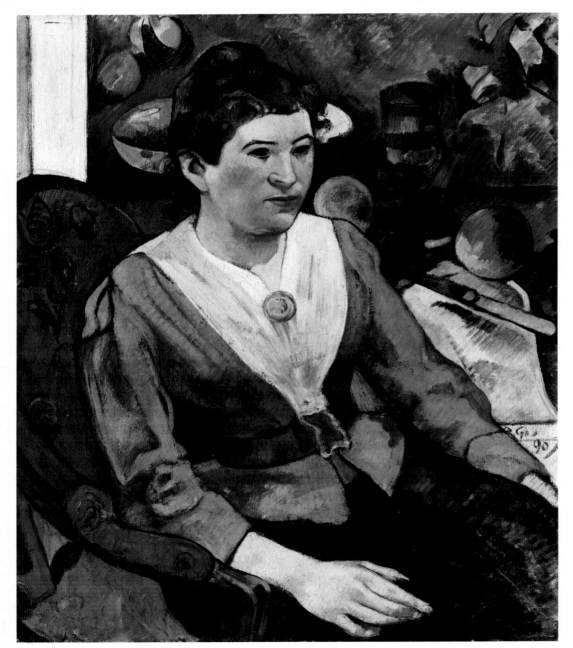

spect; on the occasion of their meeting the sculptor shook his hand and Cézanne, deeply moved, burst into tears). None of these friendships, however, could take the place of the one that he had renounced so completely and the news of the unexpected death of Zola profoundly affected him. As he grew older and his physical ailments became more pronounced (diabetes had been diagnosed in 1891), he became more and more content with his own company. He had met Van Gogh and Gauguin previously and both had been profoundly affected by his art. When Cézanne met Van Gogh in 'Père' Tanguy's little shop behind Notre-Dame-de-Lorette, the Dutch artist showed him some of his own canvases; Cézanne's ambiguous response to them was that he certainly painted 'like a madman'. He had no time for the work of Gauguin, whose highly self-conscious search for a modern style of painting was completely at odds with Cézanne's own researches. He referred contemptuously to the artist as a 'maker of Chinese images', a reference to the *outré* decorative qualities and deliberately obscure subject-matter of Gauguin's work. Cézanne could never agree with an artist whose work was so distant from the world of perceptual experience. Gauguin, on the other hand, was well aware of the intensity and importance of Cézanne's achievement and had once written to their mutual friend Pissarro:

Has Cézanne found the exact formula for a work acceptable to everyone? If he discovers the prescription for compressing the intense expression of all his sensations into a single and unique procedure, try to make him talk in his sleep.

Obviously his plea was unsuccessful and he reverted to a more practical way of learning Cézanne's secrets – he began to collect his paintings, such as *Still Life with Glass, Fruit and Knife* (page 76).

During the 1880s and 1890s commentators and painters associated Cézanne's work with the diverse work of the Symbolists. Recent writers have demonstrated that the difference between Symbolism and the paintings of the so-called Impressionists was not as great as might seem from today's viewpoint. Young ambitious painters began to seek out the master, whose self-imposed 'exile' from the Paris art scene added to the mystery and attractiveness of his work. Despite Cézanne's dismissal of the works of Gauguin and Van Gogh, young artists like Emile Bernard and Maurice Denis began to imitate aspects of the work of the Hermit of Aix.

As he had always done, Cézanne painted for himself and for a small circle of admirers, and continued to let his paintings go at very low prices, even though his prices on the art market were beginning to escalate. It must have caused him much sadness that the people of Aix were never able to accept what must have appeared to them the very peculiar habits of the banker's son, and it seems that the growing critical regard in which he was held in Paris only confirmed their prejudices. Henri-Modeste Pontier, the principal of the Aix art school and director of the local museum, the Musée Granet, swore that as long as he lived no painting by Cézanne would enter the collection. In Paris things were changing. On his death in 1894 it was discovered that Caillebotte had bequeathed his collection of Impressionist paintings to the state. The bequest was initially refused and the resulting fiasco was entitled *L'Affaire Caille-botte*. After three years tortuous negotiation, part of the collection was accepted and thus two of Cézanne's paintings entered the Luxembourg and now form the nub of the Musée d'Orsay collection of Impressionist paintings. In 1900 the National Gallery of Berlin acquired a canvas by Cézanne but was forbidden to show it by express order of the Kaiser.

Vollard continued his shrewd marketing of the artist and in his *Reminiscences* he recounts several amusing stories of his journeys down to Aix, where he sought out canvases by Cézanne. Cézanne himself was careless about the fate of his own work, and apparently would often leave his paintings in fields and hotel rooms, or give them away, to coachmen, doctors and various local people. In July 1899, at the sale of Chocquet's collection, the *House of the Hanged Man* was sold for 6200 francs to Count Isaac de Camondo, adviser to the

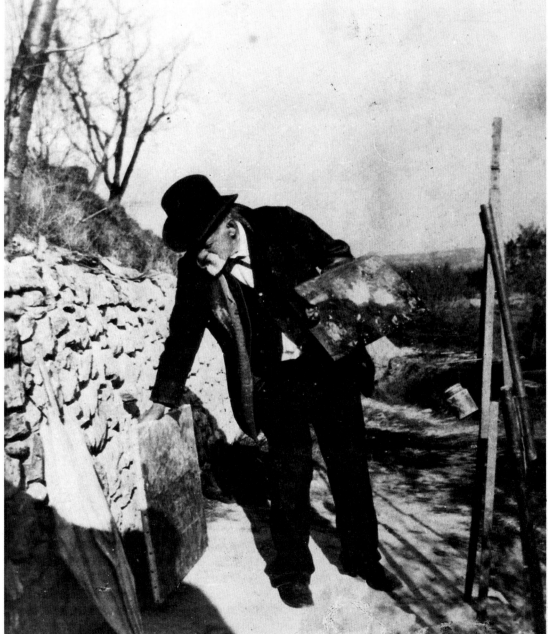

Below: *Hommage à Cézanne*, painted by Maurice Denis in 1900. As the Cézanne still life shown here once belonged to Gauguin, this work may be seen as a double tribute to both these inspirational artists. The original Cézanne is reproduced on page 76.

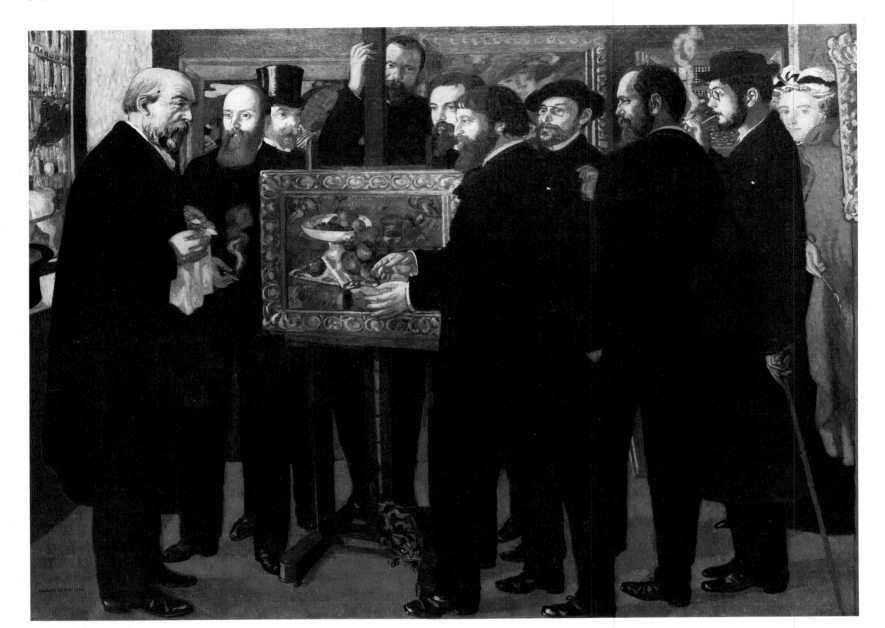

ex-King of Serbia. By this time most of the Impressionist painters had become bankable propositions, although Cézanne's canvases were still not fetching as much as those by Monet or Renoir. One of the major dealers in Impressionist works was Paul Durand-Ruel. On the advice of Monet he bought up many *Cézannes* at the sale of Victor Chocquet's collection. A little later Monet caused a sensation when he bought one of Cézanne's canvases for 6750 francs. Like Caillebotte, Degas and Gauguin, his collection contained superb examples of Cézanne's work, amongst which were numbered *Melting Snow at L'Estaque* (page 54) and *The Negro Scipion* (page 36), which Monet referred to as *'un morceau de première force'*.

The race to control Cézanne's work was on. One suspects that the artist himself observed the haggling and maneuverings with a certain detachment and wry humor. 'There's no escaping people's trickery', Cézanne said, 'it's all a matter of robbery, vanity, infatuation, rape and someone grabbing one's work'. His adored son looked after his business affairs with the proverbial shrewdness of the Provençal; like his grandfather he had a keen head for business and Cézanne turned a blind eye to the fact that Paul not only took a 10% commission charge from himself, but also received the same percentage from Vollard. He negotiated not only with Vollard, who until that time had enjoyed a monopoly on Cézanne's work, but also with the dealers Bernheim-Jeune and Durand-Ruel.

Cézanne's desire for official recognition had never abated and, amazingly, he even hoped to be awarded the prestigious Légion d'Honneur. Despite the intervention of the influential critic Octave Mirabeau, M. Roujon, Director of the Beaux-Arts, responded. 'I will give an award to anyone you like, Monet, Sisley, Pissarro, but not Cézanne. You see, I have to comply with public taste, not anticipate it'. The Director was a little behind the times. After Vollard's show Cézanne's work became more accessible and from 1899 there was hardly a year when examples could not be seen in independent group shows in either Paris or Brussels.

Cézanne was deeply affected when Maurice Denis gave physical form to his high opinion of the master in a painting entitled *Hommage à Cézanne* shown at the Salon des Indépendants of 1901. The canvas depicts Cézanne's *Still Life with Glass Fruit and Knife* (page 76), which had been part of Gauguin's collection, surrounded by the painters Odilon Redon, Paul Ranson, Pierre Bonnard, Edouard Vuillard and Maurice Denis and his wife. This act of worship is set in Vollard's shop; the owner's familiar features may be seen on the bearded gentleman supporting himself on the upright of the easel. The painting was bought by the novelist André Gide.

Publications concerning Cézanne's work were beginning to appear in the 1890s. In 1891 Emile Bernard, former collaborator with Gauguin, published an article on the artist in which he declared that Cézanne's art was 'one of the greatest

attempts of modern art in the direction of classical beauty', whereas Gustave Geffroy's article 'Paul Cézanne', which appeared three years later in *La Vie Artistique*, stressed the artist's attempt to 'realize' nature. In 1894 Bernard left for Egypt and the Near East. On his return ten years later he immediately sought out the painter he admired so much. He stayed over a month at Aix and talked with Cézanne every day. Their conversations (considerably tidied up, one suspects) were published in 1907, as was Maurice Denis' essay on the artist, and both publications had an immense impact on young painters working in Paris at the time. Cézanne still thought of himself as a kind of Impressionist; he warned the young painters against the Neo-Impressionists and against the example of Van Gogh and Gauguin. He walked and talked with old friends or new young admirers, and from

1896 until about 1900 the friendship of a 23-year-old poet, Joachim Gasquet, gave him much pleasure. The highly-flavored account of their conversations that the poet published later is, like the texts of Denis and Bernard, the source of some of the most familiar of the statements made by the artist, including the infamous remark concerning the cylinder, sphere and cone, which is so often quoted out of context and was probably meant as practical advice, as familiar to any artist then as now, on how to visualize the simple structures that lie beneath the often complex forms of things.

In 1903 Madame Zola put her late husband's collection up for auction and ten Cézanne canvases achieved relatively high prices. The early painting *The Rape* was bought for 4200 francs and a portrait went for 950 francs, while two still lifes achieved 3000 and 900 francs respectively. These

amounts stung *Le Figaro* to publish an outraged article entitled 'The Love of Ugliness'.

As Cézanne grew older, his visits to Paris became less frequent and his commitment to the landscape of his birthplace grew ever stronger. He even turned away from locations beyond the immediate vicinity of the town. The village of l'Estaque, for so long a favorite motif, was abandoned as it became increasingly industrialized. Instead he began to focus his attention on the grey mass of Mont Sainte-Victoire five miles to the east of Aix and the valley of the Arc which it dominates. Between 1895 and his death he produced countless paintings of the mountain, his interpretations varying from an analytical, closely ordered study (page 166), to later extraordinarily densely painted, tapestry-like compositions (page 172) in which the mountain lurches out of the landscape like some mythical beast.

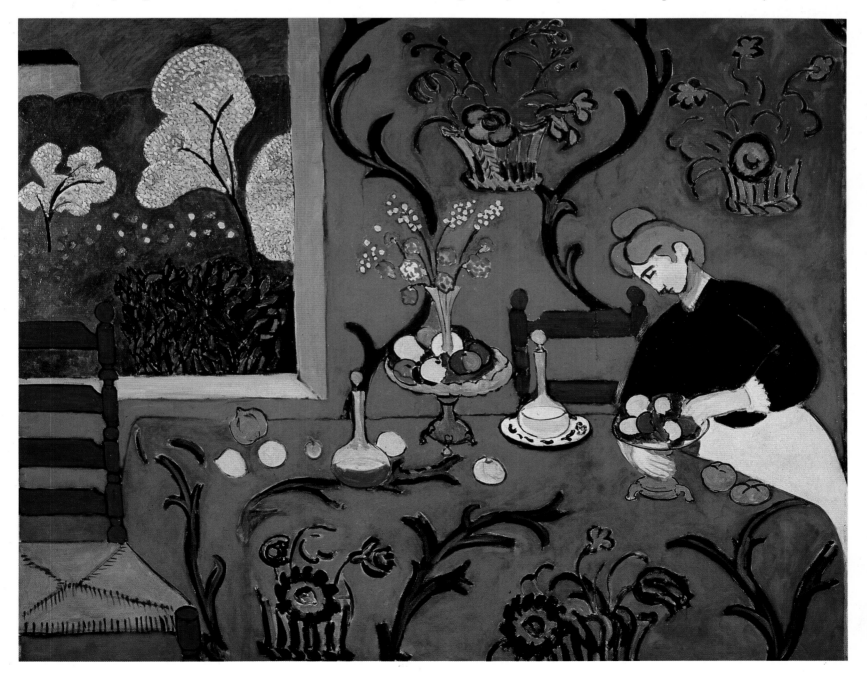

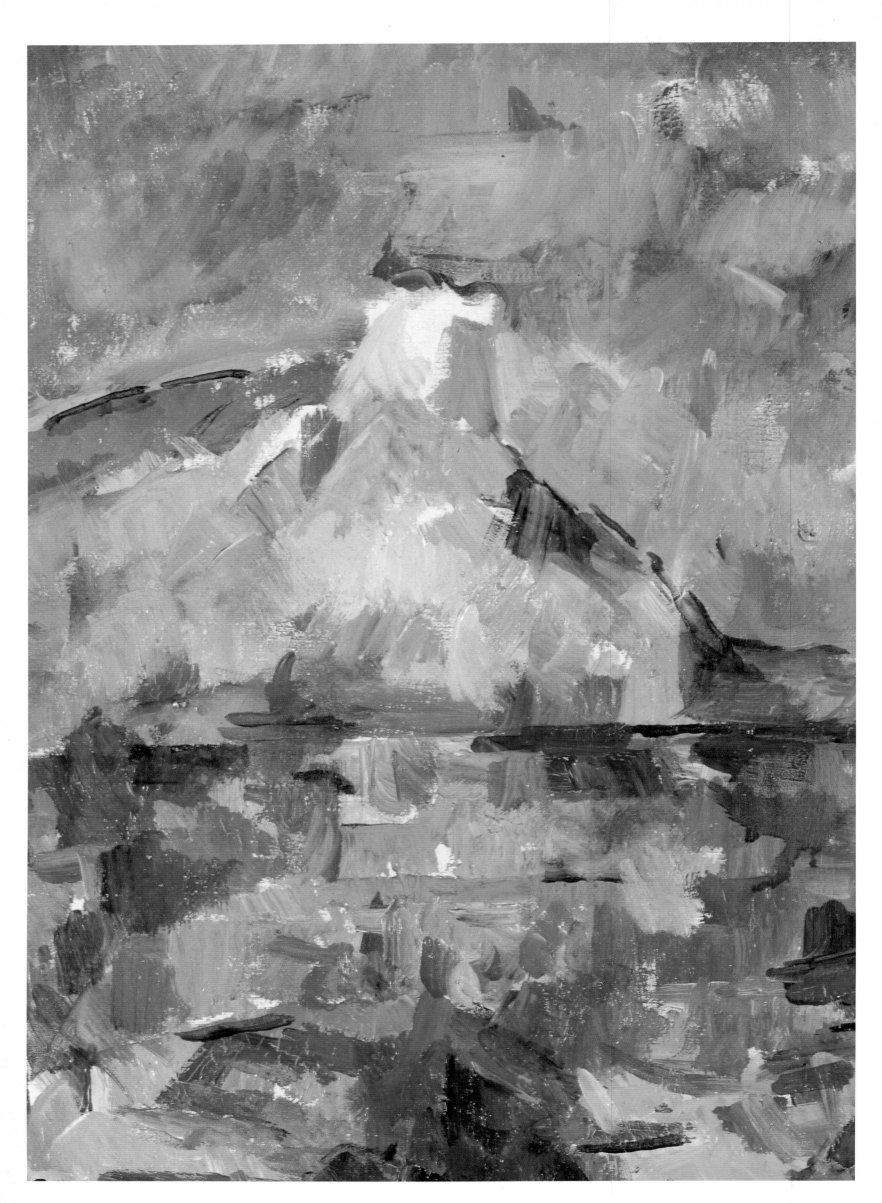

Others have the stillness and limpid magic of a Chinese painting on silk (page 164); a perfect distillation of sensory experience expressed by single veils of color floating on the creamy white of the canvas priming.

Over the years Cézanne began to make greater use of watercolor, and gradually the transparent qualities of the medium began to show itself in his oil paintings. He would leave bare areas of canvas within his paintings, just as he used areas of white paper to suggest shifts in distance and the modifying affects of the atmosphere in his watercolors. His brushmarks, a study in themselves, often take on a square, ragged or jagged patch-like shape, once again reminiscent of the full, thinly-washed marks of a watercolor brush. These, laid on sparsely or over each other in countless revisions, add much to the varied quality of the artist's late work.

In 1899 the Jas de Bouffan, which had been the inspiration for so many of his paintings, was sold and Cézanne was left without a base in his beloved landscape. His sister Marie arranged for him to move to a small apartment in the centre of Aix, at 23 rue de Boulegon. This was conveniently close to the Cathedral so that, as was his practice, he could attend Mass every morning. His day-to-day affairs were closely monitored by Marie who, aware of her brother's instinctive generosity, warned his housekeeper Madame Brémande to allow him to carry only fifty-centime pieces, so that he would be unable to squander the family fortune on the beggars who sat on the steps of the Cathedral of Saint-Sauveur. He had a studio on the fourth floor of the building, under the roof, with a large window looking out to the north, but did not find this arrangement to his liking and continued to search for more suitable studio premises. He obtained permission to paint in the grounds of a large property on the road from Aix to Le Tholonet, which offered magnificent views of Mont Sainte-Victoire and the surrounding landscape. Cézanne was obsessed by this property and attempted without success to acquire it, although he was given the use of one of the rooms in the west as a studio. The house was known as 'Le Château Noir', a misleading name, for in reality it is a farmhouse constructed out of the local orange-yellow stone. It became a motif in its own right; its Gothic windows and its setting, half hidden among the pines, formed the basis of some of Cézanne's most impressive paintings (page 162).

In November 1901 Cézanne acquired a piece of land about half a mile north of the town that commanded an impressive view of the Cathedral. Here he had a modest building constructed, Les Lauves, which was to be his main studio space until the end of his life, in a street now known as the rue Paul Cézanne but then called the rue des Lauves. Every morning he would set out from the rue de Boulegon and walk to his studio. His diabetes continued to cause him problems, he suffered intense headaches which may have had some effect on his eyesight and, indefatigable hiker that he was, he began to experience difficulty in walking. As a result his housekeeper would bring his lunches out to Les Lauves and a coachman was engaged to drive him to and from his sites. His relationship with his wife remained as distant as ever; when, during the winter of 1901-2, she made a visit to Aix, he was barely civil to her.

On 15 October 1906, while painting on the road to Le Tholonet which is now sometimes referred to as the Route Cézanne, he was surprised by a violent thunderstorm. He collapsed and was forced to endure its effects for several hours until he was discovered by two men, who brought him back to his residence in a cart. There seemed to be no particular cause for concern about his condition for the next day, as was his habit, he set out to work at Les Lauves. He was working on the portrait of his gardener and general handyman, Vallier (page 170), when he collapsed. He died on 22 October 1906, aged only 67, at the height of his powers and well aware of the potential significance of his discoveries.

The development of Cézanne's reputation continued unabated. In 1904 a whole room at the Salon d'Automne was dedicated to his work, while in 1905 Cézanne had ten paintings there and was represented again at the same venue in the year of his death. In 1907 there was a major retrospective, organized by Vollard, of his works, consisting of paintings and drawings. This was supported a little later by an exhibition of 79 watercolors at the Gallery Bernheim-Jeune. The shows, together with a growing body of publications concerning the artist and his work including Bernard's articles of 1904 and his edition of a selection of Cézanne's letters in 1907, were to consolidate the artist's position as one of the major painters of the period and an immensely significant influence on twentieth century art.

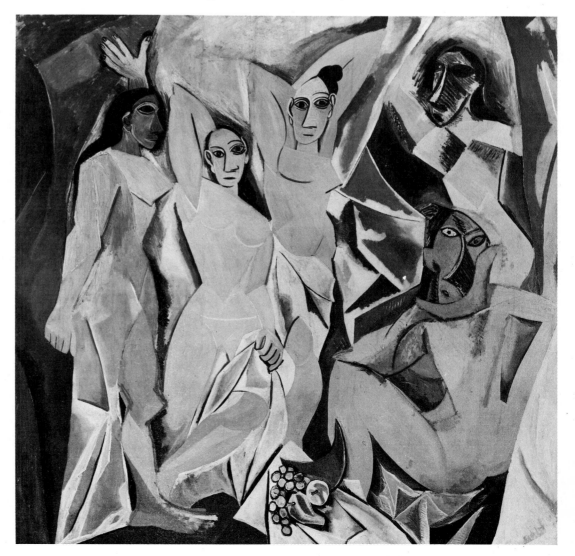

The Four Seasons, Autumn,

c. 1860-2
Oil on canvas
123¾×38¼ inches (314×97 cm)
Petit Palais, Paris
Venturi 6

This is one of four images forming a decorative cycle of paintings produced by the young Cézanne for the family home at the Jas de Bouffan, which Cézanne's father had acquired in 1859. They were to remain *in situ* throughout Cézanne's life and were left on the walls when the property was sold in 1899; they now form part of the collection of the City of Paris. They were hung in the dining room together with a portrait of his father and other early works.

The paintings are very different in style from anything that survives from Cézanne's early years and, notwithstanding their pleasing decorative quality, may well have been conceived as parodies on the formal art of the time. The conception of the figures may well refer to the early nineteenth century painting *Ossian Singing a Funeral Lament* by Paulin Duqueylar, which hung in the Musée Granet at Aix. On the lower right of this composition there is a large carefully executed signature; not the name of the artist, as one might expect, but that of Ingres, the arch-representative of the academic tradition, whose grandiose and rather creaky canvas *Jupiter and Thetis*, painted in 1811, was the pride of the local Museum Granet. Such an action suggests that the artist was less than totally serious in the painting of the work, but this possibility should not blind us to the unexpected beauty of this somewhat naively drawn canvas. The ironic reference to Ingres does not detract from the ambition and scope of the painting. It is grandly conceived and executed with a breadth and liveliness of finish that does the young artist credit. The *recherché* quality, clean colors, clarity of drawing and general composition recall the mystically inspired canvases of the painters connected with the School of Lyons, which flourished in the middle of the nineteenth century. When compared with the relatively little-known works of that school, Cézanne's painting loses something of its peculiarity. The theme of the Four Seasons is common in western art and is a perfect choice for a decorative cycle destined for an opulent family interior.

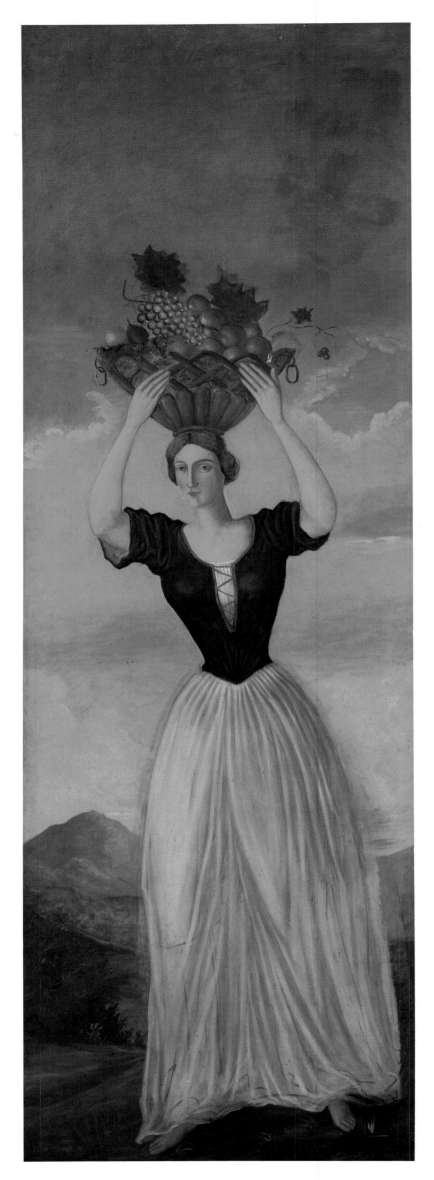

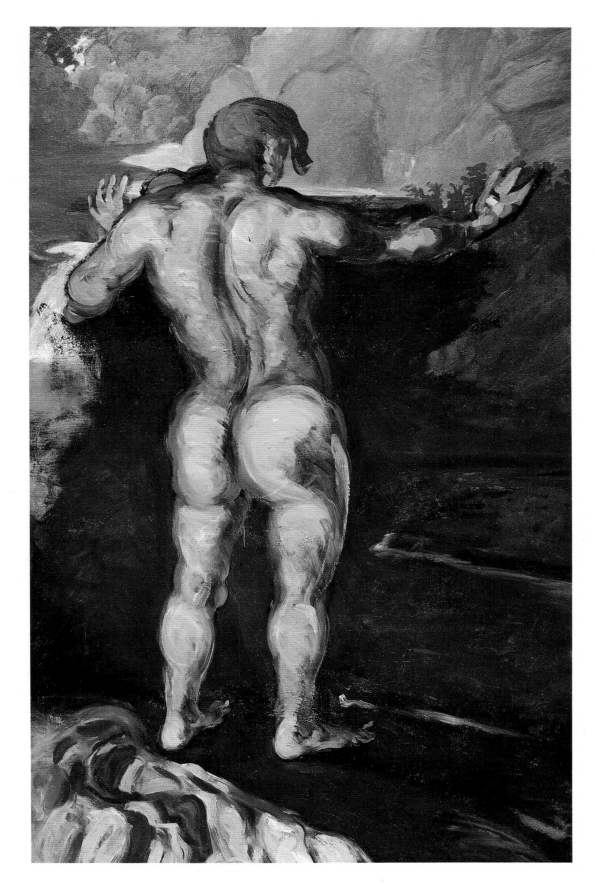

Bather and Rocks, c. 1864-8
Oil on canvas
66×41½ inches (167.6×101.7 cm)
Chrysler Museum, Norfolk, Virginia
Venturi 83

This powerful standing figure was originally part of a larger canvas. Cézanne inserted the figure into a highly decorative, conventionally painted, escapist landscape that he created for the recently acquired Jas de Bouffan, the seventeenth century house that was to be the Cézanne home for nearly 40 years. As Sir Lawrence Gowing has pointed out, the posture of this figure probably derives from Courbet's infamous female nude of 1856, which so disgusted the Emperor Napoleon III that he took his horsewhip to her ample buttocks. Courbet apparently made it known that he wished he had painted the work on thinner canvas so that he could have sued the Emperor for damages. It cannot be known for sure whether or not Cézanne knew this painting, but the closeness of the borrowing makes it seem very likely. He would have been struck not only by the physical presence of the main figure, but also by the manner in which Courbet had subverted the expectations of his audience by producing an up-to-date version of a hackneyed classical theme: nymphs in the forest observed unaware by the spectator. As we now know, the theme of the nude in the landscape was to become one of the principal obsessions of Cézanne's life. Like some of his mature bathing paintings, the sex of this figure is left unclear; despite the imposing articulation of the muscles, the breadth of hips suggests that she might well be female. The figure is drawn rather than painted, the swirling brushmarks willing the body of the bather to take on sculptural form.

Still Life: Skull with Candlestick,

c. 1866

Oil on canvas
18¾×24¾ inches (47.5×62.5 cm)
Private collection, Switzerland
Venturi 61

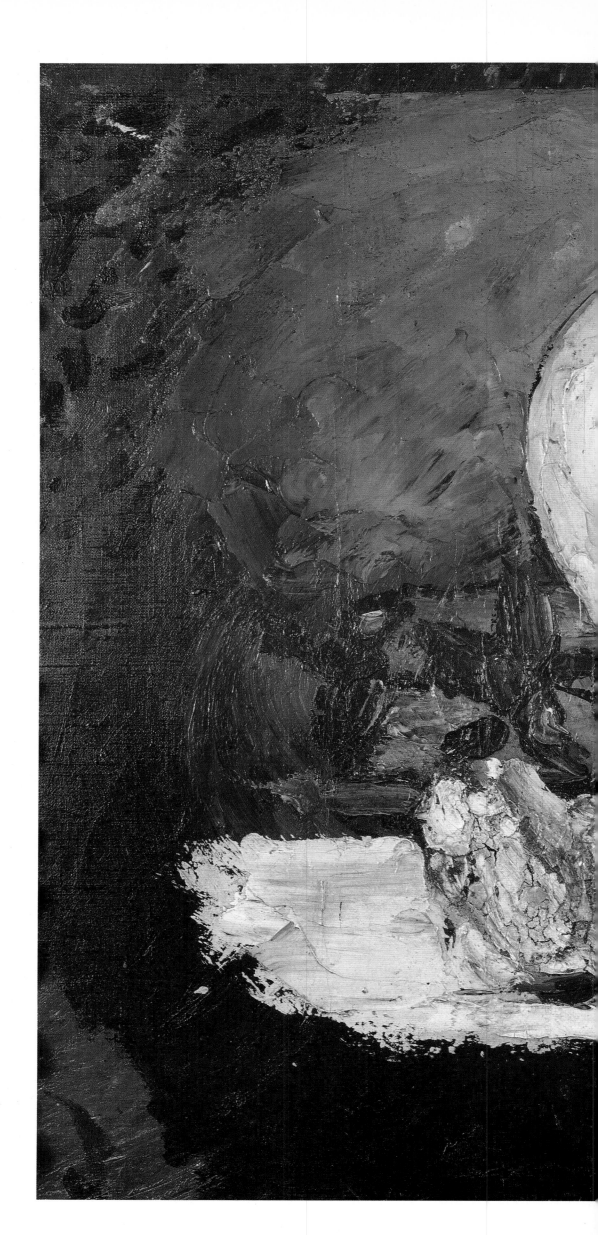

The skull and candlestick, the flower and
open book laid out emblematically on a
table top, make it clear that this still life
should be interpreted as a *momento mori*.
Paintings that act as a reminder of the
briefness of human existence were a com-
mon enough theme and this subject would
have suited Cézanne's sometimes rather
morbid turn of mind, fed as it was by the
romantic poetry of Hugo and the sterner
stuff of Baudelaire. Its earthy richness and
bravura handling make this rather stilted
composition sing; only Courbet amongst
French painters could handle a palette
knife with such freedom and assurance.
The crusty surface of the painting and the
rough edges of the objects depicted are the
result of Cézanne's use of the palette knife.
This implement tends to create sharp tran-
sitions of color and tone and perfectly suits
the artist's preference for abrupt move-
ments from light to dark, which enhance
the dramatic effect.

The picture was painted for a German
musician who had come to Aix and who
shared Cézanne's passion for Wagner. The
chromatic harmonies of the skull and
candlestick are contrasted with the fleshy
pink of the flower (in color and handling
so reminiscent of Manet). It has been said
that avant-garde painters in the 1860s had
a choice before them; either to imitate the
flat simplified areas of tone that were asso-
ciated with the paintings of Manet, whose
Olympia was derided as flat as a playing
card, or to imitate the sculptural 'billiard
ball' effects of Courbet's work. In
Cézanne's paintings of the 1860s he was
attempting a brilliant synthesis of the two
approaches, presented with a physical
force that he was later to term *couillard*,
implying sexual power.

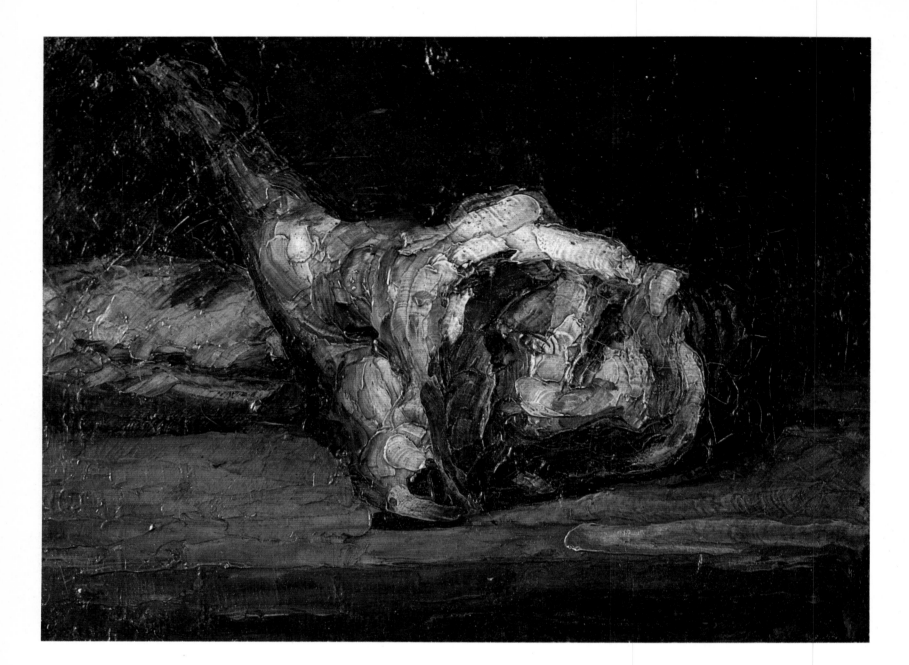

***Still Life: Bread and Leg of
Lamb,*** 1865-7

Oil on canvas
10¾×13¾ inches (27×35 cm)
Kunsthaus, Zurich
Venturi 65

Goya is not a name that occurs with any
great frequency in the Cézanne literature
and yet, faced with this particular painting,
comparison with the Spanish master is in-
evitable. Excepting the muted presence of
the bread, nothing distracts the attention
from the unnerving contemplation of dead
flesh. The palette knife technique, so often
used by second-rate painters as a means of
easy effect, is here used to its full potential.
The knife action tends to draw the oil to
the surface of the pigment, causing it to
yellow over a period of time, and even this
has affected the image advantageously.

The dragged horizontal swathes of green
painted over a dark ground lift and break

up into smaller cursive movements as the
painter's hand echoes the spiraling forms
of the dead animal's anatomy. The red sug-
gests congealed blood; the green and
yellow tones the fat and skin; overlapping
impastoed paint creates highlights which
glisten in the half light; slightly healthier
looking versions of yellows and ochers are
used for the bread on which the leg of lamb
rests. Cézanne could not have seen the
Goya *Still Life with Sheep's Head* for, as Sir
Lawrence Gowing points out, the painting
did not enter the Louvre Museum until
1824, but he would have been familiar with
Rembrandt's *Flayed Ox* which had been
hanging in the Louvre since 1671.

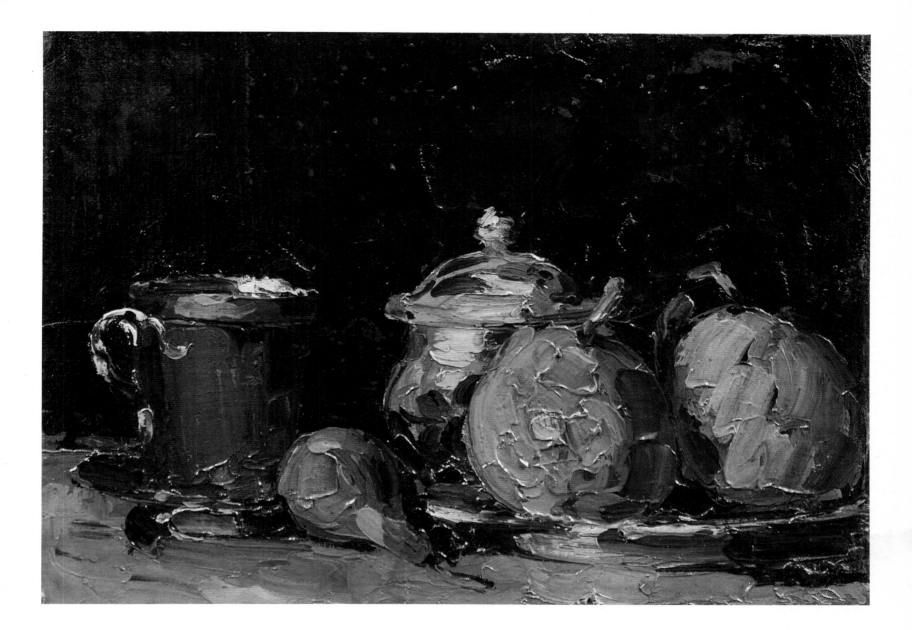

Still life: Sugar Pot, Pears and Blue Cup, c. 1866

Oil on canvas
11¾×16¼ inches (30×41 cm)
Musée d'Orsay, Paris
on deposit with Musée Granet, Aix
Venturi 62

The buttery impasto of Cézanne's paintwork meshes together this beautifully phrased composition. The objects depicted are seen in close focus, as if the painter's nose was only a few inches away from the sharply drawn edge of the plate. This viewpoint allows only the slight ellipse of the coffee cup to be discerned. Despite the physical closeness of the objects to the canvas surface, the forms are described without any surplus detail. The delicate variations of pressure from the artist's brush or knife create a richly modeled surface. A simple horizontal division distinguishes the plane of the table top from the background. The objects are dramatically lit and seen against a generally unrelieved darkness. The forms are full, fat and rounded and have a pleasing physical presence. The curved forms bulge sensually, held in check by the assertive geometry of the coffee cup and the constraining horizontals and verticals of the canvas edge.

Such freshness and boldness of handling, such freedom of color and extremes of light and dark, can be found in the dramatic works of Cézanne's painter friend from the Midi, Aldophe Monticelli. Despite its small format, Cézanne obviously held this painting in high regard as it appears prominently placed in his 1866 portrait of his father (page 32). The fact that it appears there unframed suggests that it may not in reality have hung in that position and that the artist included it in his portrait simply because he was pleased with its effect.

The Artist's Father, 1866

Oil on canvas
78⅛×47 inches (198.5×119.3 cm)
National Gallery of Art, Washington
Venturi 91

The production of any painting takes time; it is therefore no surprise that so many early portraits in an artist's career represent members of his family or close friends. Equally, the sitters for these informal portraits are often shown reading or engaged in some similar activity that demands little movement, or movement of a repetitive nature. The portrait shows Louis-Auguste, Cézanne's authoritarian father, reading a newspaper, seated in the flowered armchair that the artist would use again in the portrait of his painter friend, Achille Emperaire (page 38), with which this portrait may be compared.

The sensitivity and strength of Cézanne's characterization of his father owes something to the bold simplifications of Daumier's style. He is shown sitting slightly to one side of the large chair, which is distorted the better to show its enclosing of his father's form. Louis-Auguste holds a newspaper at an angle close to his face, to catch the light that falls from the right of the picture. The newspaper is, as can be clearly read from the boldly stenciled lettering, L'Evénement. Cézanne's father was a republican and the artist has substituted the present paper for his usual reading material because his friend Zola had recently begun to work for L'Evénement and had already published some articles in it. These articles, while not mentioning Cézanne, were an attack on the conservativism of the Salon jury and a defence of new painting as embodied in the work of Edouard Manet. Behind the armchair can be seen one of Cézanne's still lifes (page 31); whether it actually did hang in the family home or whether Cézanne has simply included it in the painting as a reference to his own work it is impossible to say.

The painting is a brilliant example of the power and fluency of Cézanne's palette knife work; the block-like wedges of thick pigment define the hierarchic forms of figure and chair. The surroundings are kept to a minimum. Simple contrasts of tone, together with a dramatic use of horizontals and verticals, serve to enclose the strong rounded forms of the sitter, which in turn envelop the softly modulated gray of the journal.

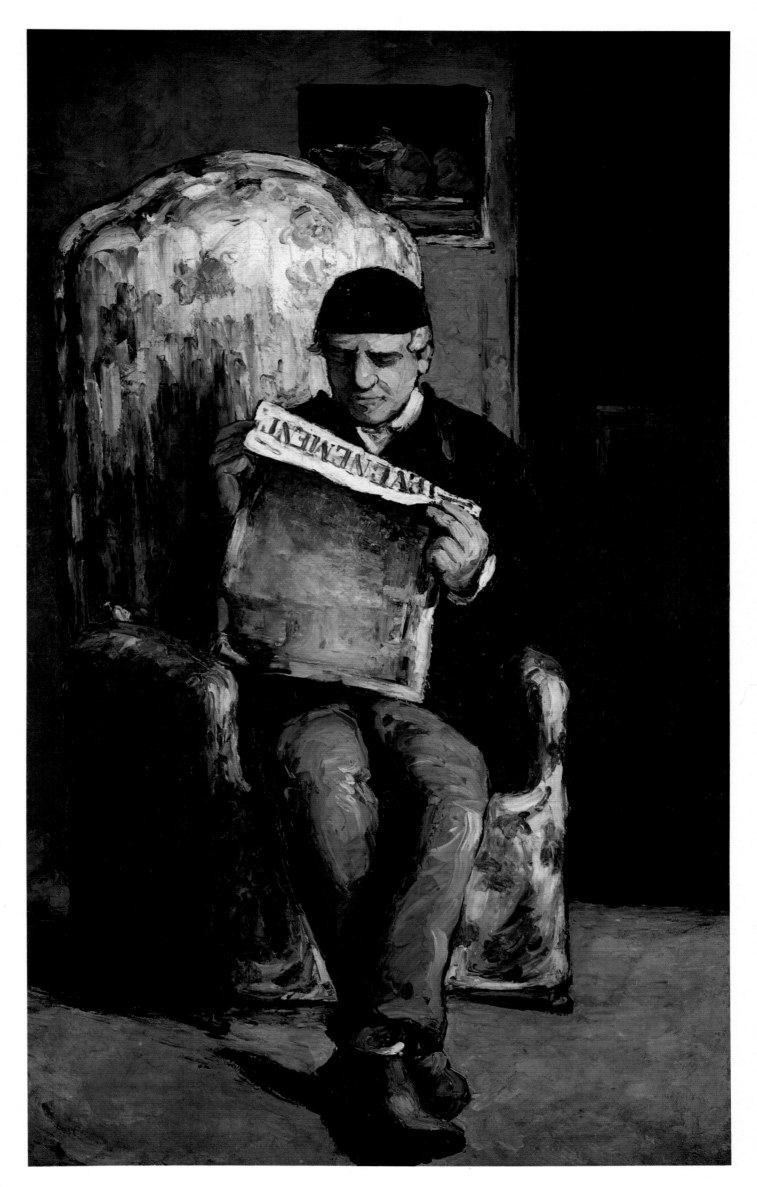

The Murder, 1867-70

Oil on canvas
25¼×31¾ inches (64×81 cm)
Walker Art Gallery, Liverpool
Venturi 121

Scenes of sexual violence were common in the Salon throughout the nineteenth century; indeed such scenes are a recurrent theme in western art, as a visit to any art gallery will prove, but few artists have managed to depict the horror of a vicious attack on a fellow human with the force and realism that Cézanne has managed to capture in this small canvas. The composition may well derive from a popular print or may be the result of the artist's sympathy for Baroque art, but to a modern audience this painting has all the economy, tension and atmosphere of 1950s *film noir*.

Cézanne's predilection for such subjects was shared with his friend Emile Zola, whose novels are famous for their powerfully imagined scenes of physical violence. Between August and October 1867, Zola's novel *Un Mariage d'Amour* was serialized in *L'Artiste*, and later published in book form as *Thérèse Raquin*. The narrative is set in Paris and revolves around the adulterous affair between a peasant's son and the wife of a Parisian shopkeeper – their physical desire for each other leads to the brutal murder of the shopkeeper and their own suicide, enacted before the dead shopkeeper's chairbound deaf and dumb mother. The melodramatic, even farcical, elements of Zola's story are absent from this particular example of Cézanne's 'black' painting.

The low horizon line and rushing diagonals endow the figures with a monumental stature. A descending diagonal rehearses the inevitable fall of the upheld dagger, gripped in the fist of the male assailant whose face is hidden by his upraised arm. The victim, like some latter-day Baroque saint, is pinioned down by a female accomplice, whose arched back and heavy form must surely come from Jean-François Millet's peasant paintings. Movements within the painting criss-cross in an awkward compositional structure that owes nothing to naturalism; all academic accuracy of drawing or perspective is sacrificed for effect. The recumbent figure's armspan is of prodigious proportions. Yellow ocher, dirty white and vibrant blue are the only colors that relieve the gloom of the vividly imagined empty landscape, upon which the dark sky closes like a lid.

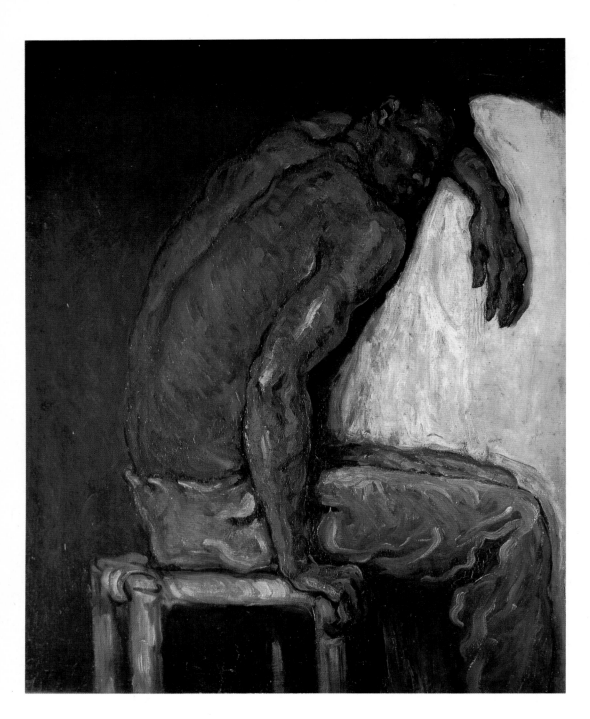

The Negro Scipion, c. 1867

Oil on canvas
42¼×32¾ inches (107×83 cm)
Museu de Arte, São Paulo
Venturi 100

This painting once held pride of place in Monet's collection. It hung in the artist's bedroom at Giverny and its owner referred to it as '*un morceau de première force*'. Scipion was a life model at the Académie Suisse and it is tempting to surmise that the pose originally held may have been that of the black slave featured waving to the distant ship in Théodore Gericault's painting of 1819, *The Raft of the Medusa*. If this was the case, then Cézanne chose to paint not the pose as held but the model resting, fallen into an easier and more sustainable position, with his upraised arm supporting his head.

The structure of the painting is remarkably simple. The model inclines forward as if to avoid the upper canvas edge; the bent arm and the diagonal of the dusky back are set against the extraordinary silhouette of yellowish-white drapery which is painted on top of the dark ground. Cézanne's liking for echoing forms may be clearly appreciated in this uncluttered painting. The

supporting hand, bent at the wrist, corresponds with the angular structure of the stool and the clearly defined contours of the model's buttocks and knees; while the arc of the back is repeated in the model's right arm and the magnificent black band that the artist has left visible between Scipion and the enigmatic white shape. Marvellously free rippling movements of richly impastoed paint suggest the texture and form of the model's body.

The pose for Scipion also recalls a painting in the Musée Granet at Aix that Cézanne would have known from his youth, *Le Camoëns on his Deathbed at the Hospital at Lisbon*, by Lestang Parade. This rather feeble canvas shows a negro leaning against the deathbed in a pose similar to that used here. The search for an exact source for a pose is futile, however; the painting does not bear a one-to-one relationship to any other image but rather serves to highlight the complex nature of artistic creation.

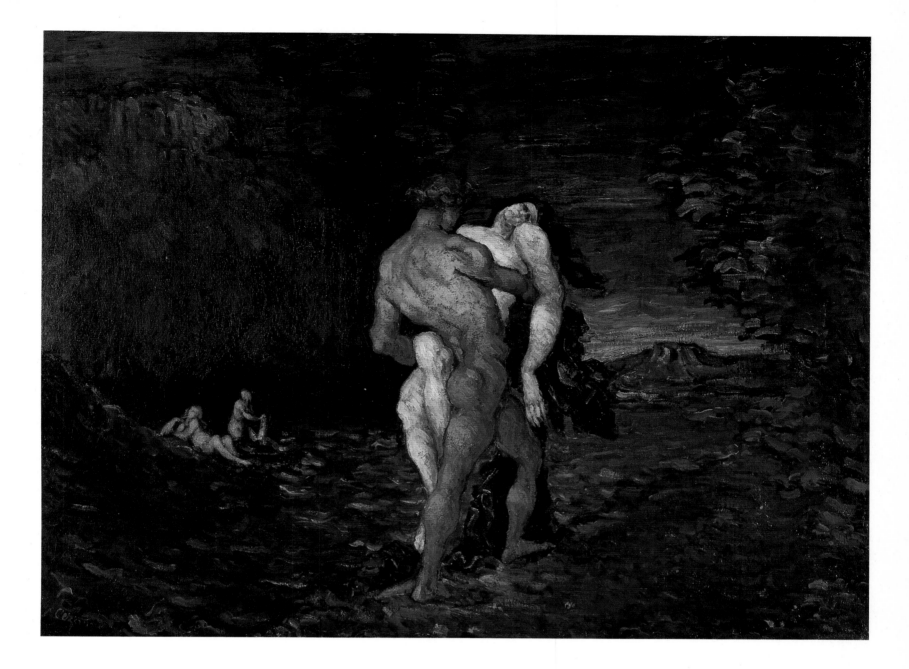

The Rape, c. 1867

Oil on canvas
35⅝×46 inches (90.5×117 cm)
Fitzwilliam Museum, Cambridge
Venturi 101

According to the art historian Mary Lewis, the subject of this painting is the abduction of Persephone by Pluto, the king of the underworld. The landscape setting is very stagey, the trees, mentioned (as Dr. Lewis points out) in Ovid's version of the legend, introduce a series of formal and coloristic resonances that play off against the principal figures of the composition. The spectator's gaze follows the figures to a distant mountain range which is recognizable as being Mont Sainte-Victoire, possibly appearing for the first time within Cézanne's oeuvre.

This is the closest that Cézanne came to producing a conventional history painting, although the emphatic distortions of the two major figures mark the work unmistakably as his. The rich orange-yellow glow of the muscular male figure contrasts dynamically with the corpse-like pallor of Persephone. The rich color contrasts come from Cézanne alone, but the pose of the two figures owes much to his study of the Old Masters. The male figure suggests the angel of Delacroix's mural *Jacob Wrestling with the Angel* at the church of Saint-Sulpice in Paris, finished in 1863.

The strain of carrying his victim throws Pluto's shoulders back and creates the stress evident in the vertical at the base of his back and the taut curve of his buttock. The sense of physical effort is continued by the strong contours of his leg and his enormous foot, its toes splayed out onto the receiving earth. Persephone's arm hangs limply down in the time-honored *Pietà* pose, creating a perfect foil for the tension shown in her abductor's body.

The painting was produced for Zola, which may account for the inclusion of the familiar mountain and would no doubt have reminded the author of their shared interest in classical literature, and the happy times they spent in the countryside around Aix.

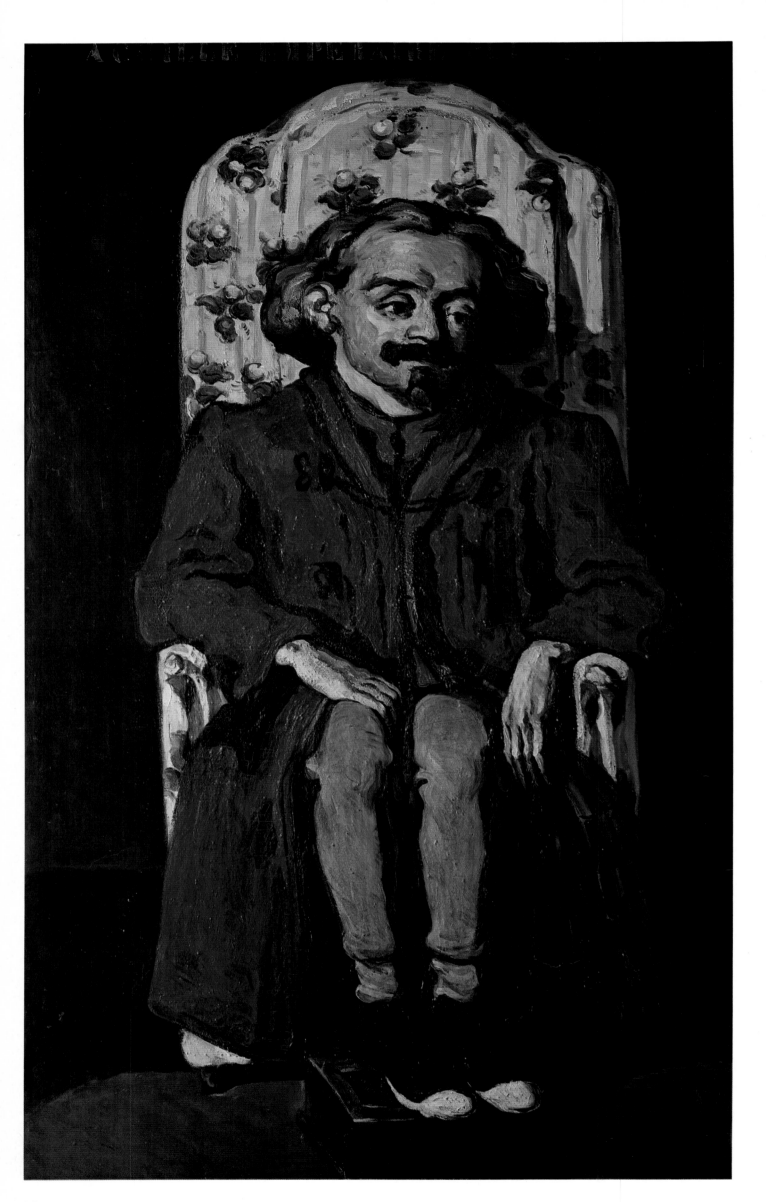

Portrait of Achille Emperaire,

1868-70

Oil on canvas
78¾×48 inches (200×122 cm)
Musée d'Orsay, Paris
Venturi 88

One of the great portraits of western art, this painting of Cézanne's friend Achille Emperaire has the humanity and dignity of a portrait by Velasquez. Nothing distracts the viewer from a direct confrontation with the sitter, who turns his head away slightly to facilitate our gaze. As with the earlier portrait, *The Artist's Father* (page 32), both the size and frontality of the painting contribute to its effect, and at least some of its power is owed to its physical presence as a wall of pigment.

Achille was an artist friend of Cézanne, who studied with him at the Aix Academy. Although little is known about his life and work, Cézanne held him in high regard and obviously deeply valued his friendship; the more so, perhaps, because of their shared lack of official success. Stenciled letters declare the name and profession of his friend, and suggest a pun on his name; certainly the painting has more than a slight similarity to Ingres' 1806 painting of the Emperor Napoleon I.

A comparison between this portrait and that of Cézanne's father is revealing. As has often been observed, both models are shown seated in the same armchair. The ease and casualness of the father's outstretched legs, feet resting on the floor and almost touching the lower edge of the canvas, makes a poignant contrast with Cézanne's depiction of his friend. Achille was a cripple and the setting of his feet on the little box, the angular disposition of his hands that seem robbed of all strength, add much to the appeal of this arresting and sensitive portrait. Even a cursory examin-

ation of the two paintings shows how the artist has manipulated the scale and placement of the chair to enhance our awareness of the sitters' personalities. In both portraits the chair imparts an almost regal presence to the sitter; a sense of informal ease dominates the portrait of his father, whereas in the case of Achille the role of the chair is definitely at once protective and supportive. The almost unbroken symmetry of the composition suggests the work of Matisse, one of the greatest twentieth-century admirers of Cézanne. The frontality of the composition, the repetition of the rounded horizontal shape that forms the top of the chair, the use of simple contrasts and the reduction of colors, as well as the contrast between pattern and simple areas of relatively flat color, are all hallmarks of Matisse's work.

The turn of the head away from the viewer and the contemplative gaze reinforce the sitter's air of dignity and suggest his intelligence. The subtle characterization is counterpointed by the stenciled lettering that matter-of-factly declares his name and profession. It is one of the relatively few canvases that Cézanne signed, probably because it was to be submitted to the Salon. Unfortunately, as with so many of the artist's canvases, it was rejected, together with a large nude (which has since been lost).

This painting was admired by the Symbolist circle and its presence may be felt in one of Gauguin's major Tahitian paintings, *Anna the Javanese* of 1893-4, now in a private collection in Switzerland.

39

The Orgy, 1868-70
Oil on canvas
51¼×31⅞ inches (130×81 cm)
Private collection
Venturi 92

Cézanne was fond of this painting and made sure that it was included in his first one-man show of 1895; it was painted some 25 years earlier, when Cézanne was about 30. This vision of excess has been fed by the artist's adolescent fantasies, his love of Veronese, Rubens and Delacroix, and his knowledge of the work of lesser artists popular at the time, such as Thomas Couture. Couture's *Romans of the Decadence* of 1847 (page 10), now in the Musée d'Orsay, has become for a modern audience the epitome of the sterility and pomposity of much academic art. The subject has recently been identified as belonging to Gustave Flaubert's novel *The Temptation of Saint Anthony,* which includes a detailed description of the feast of Nebuchadnezzar, builder of Babylon. The context helps to explain this extraordinary scene, particularly the splendid mass of uplifted drapery, a common enough compositional device, used to fill an empty space with color and movement and to add a dramatic edge to a painting. However oddities of composition remain; for instance, the continuation of the architecture behind the canopy is largely left to the imagination.

The painting glows with rich contrasts of thickly applied high-toned color. The golden yellow of the architecture, the Veronese-inspired shimmer of drapery and the blue of the sky act as a foil to the reds, blues and greens that edge the bizarrely imagined table top.

This picture operates as a kind of caesura in Cézanne's art. It is at some remove from the heavy darkness of his earlier work and its subject matter, being a kind of bacchanal, looks foward to his continuing experimentation with the nude, culminating in the large paintings of bathers which occupied him much during his final years.

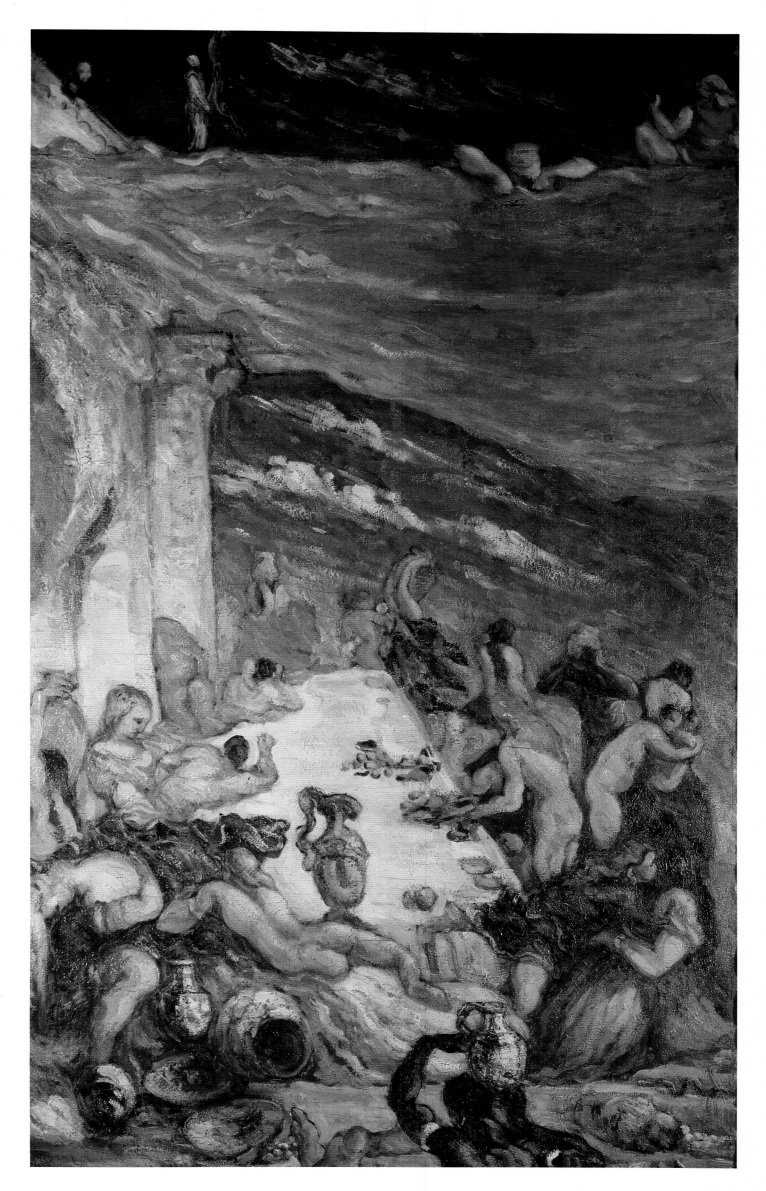

Young Girl at the Piano: Overture to Tannhäuser,

c. 1869-70

Oil on canvas
22½×36¼ inches (57×92 cm)
Hermitage Museum, Leningrad
Venturi 90

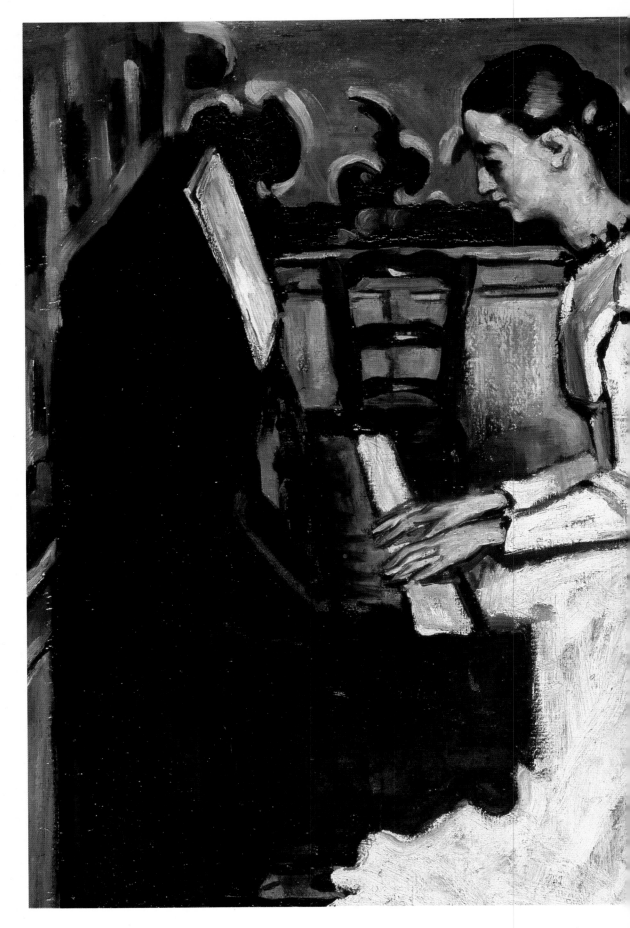

The wallpaper indicates that the setting of this intimate scene is the Jas de Bouffan, Cézanne's family home in Aix. The identity of the figures, however, is uncertain. The most striking feature of the painting is its closely-knit design. The pattern of the wallpaper creates a lyrical movement across the canvas in a manner that we associate with the later paintings of Gauguin and Matisse. Both these artists were, like Cézanne in this particular painting, concerned with expressing in visual form the abstract evocative qualities of music. The intangible but undeniable correspondence between the visual arts and music has held great interest for writers and artists throughout the nineteenth and twentieth centuries and was one of the mainsprings of Wagner's conception of art. The title of the painting is a reference to Wagner's opera *Tannhäuser*. The composer was one of the most important cultural figures of the latter part of the nineteenth century and his influence upon the arts was all-pervasive. His work had become known to Parisian audiences from early 1860 and had been the subject of an article, re-issued subsequently in pamphlet form, by Charles Baudelaire, a great admirer of the composer. Cézanne's passion for the music of Wagner and the ideas associated with it was shared by Heinrich Morstatt, a German musician resident in Aix.

This is the third version of the subject that Cézanne attempted; in earlier versions, Cézanne's father was depicted seated in the familiar flowered armchair to the right of the picture. The armchair, which here appears much smaller in scale than in the two large portraits in which it also figures, acts as a framing motif to hold the complicated system of overlapping rectangles in check. The intimate bourgeois atmosphere of intense concentration was to be expressed in a similar format many times in the 1890s by the painter Edouard Vuillard.

Pictures of figures making music were a common subject amongst avant-garde painters of the period. The 1860s had witnessed a renewed interest in Dutch seventeenth-century painting, which held an obvious attraction for those artists seeking a more suitable art for their epoch than the grand models held up for imitation by the *peintres d'histoire* who showed at the Salon. The repetitive actions of the piano player and sempstress would have made the actual painting of the picture a relatively painless affair for the artist and models alike.

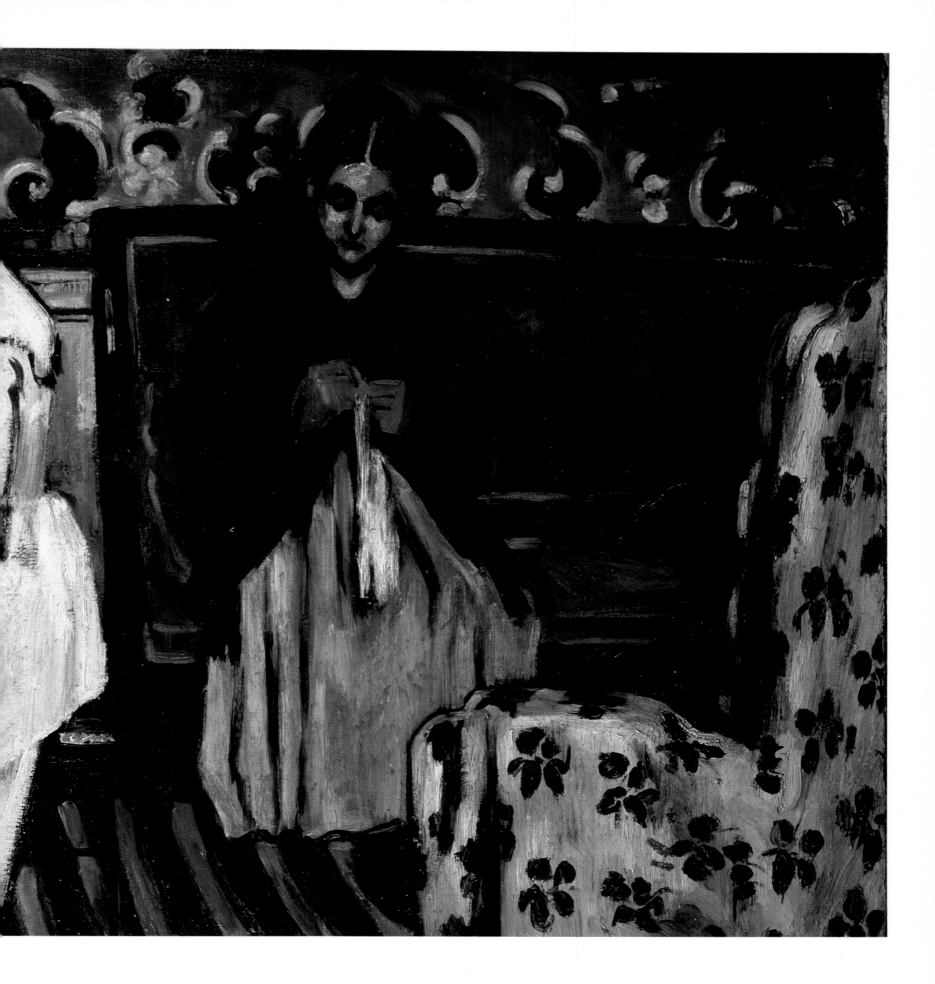

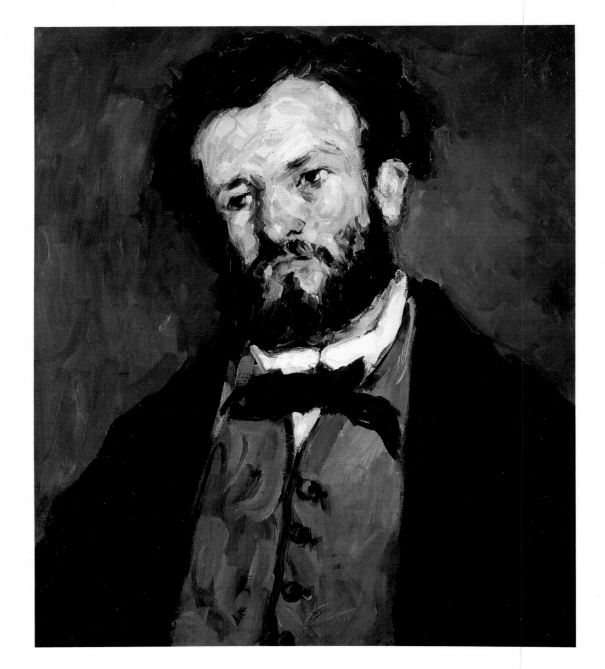

Portrait of Anthony Valabrègue,

c. 1869-71

Oil on canvas
23⅝×19¾ inches (60×50 cm)
J Paul Getty Museum, Malibu, California
Venturi 127

The development of the informal male portrait was one of the great legacies of the nineteenth century; previously portraits were normally restricted to the rich and famous but, with the development of a bourgeois art market, images of the middle class proliferated. The Impressionists were particularly interested in this genre, not least because friends did not require payment and were normally willing to put up with the discomfort of posing. Cézanne painted a number of portraits of his childhood friend Anthony Valabrègue, who lived in Paris and was to become a protégé of Zola. The blond tonalites and broad confident handling are the closest that Cézanne came to the work of Edouard Manet, but there is a vigor and rawness to the short strong dabs of paint that could only belong to Cézanne.

The triangular formation of the sloping shoulders emphasizes the bearded head and high forehead of the sitter. The simple device of the black tie marks a directional shift that tilts Valabrègue's head to the left. There is a pleasing directness and lack of pretension about the relaxed and unguarded attitude of the sitter. The expression is thoughtful and sensitive but, in the final analysis, indecipherable – which perhaps makes it all the more attractive to a modern audience. The features are strongly defined, each broad stroke perfectly phrased to build up a sustained rhythm of planes which describe the structure of the head.

Following the example of Manet, Cézanne has worked '*à premier coup*', that is, he has attempted to paint the portrait as directly as possible, wet paint worked into wet paint, each brushmark counting directly towards the final image. This technique, though difficult, imparts a vitality and a convincing sense of immediacy to a painting. Throughout the work, certain areas show how this technique has been used to great effect. The gray painting of the background merges on the left-hand side of the sitter's face to give a sense of recession to the painting, whereas the right-hand side, being nearer the painter, is more sharply defined.

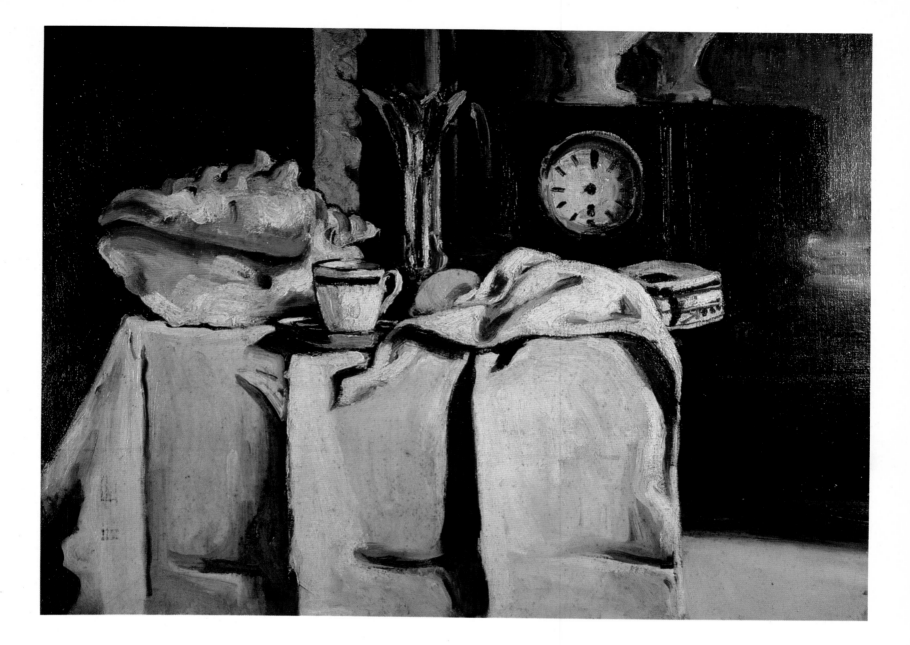

The Black Marble Clock, 1869-70

Oil on canvas
21¾×29¼ inches (55.2×74.3 cm)
Private collection
Venturi 69

A magisterial composition which defies definitive analysis. On a simple mantlepiece the artist has brought together an odd amalgamation of ordinary objects, including the blue-black time-piece of the title. Each of the individual elements was obviously chosen for its painterly qualities, the cool yellow of the lemon, the reflective qualities of the mirror, the flat whiteness of the cloth and the unforgettable color and shape of the shell. At each viewing a new set of pictorial resonances may be discovered: the monumental balancing of black and white shapes within the rectangle of the canvas, the repetition of the horizontal line, the subtle alternation of organic and inanimate objects, the firm geometrical lines of the clock against the palpable rise and fall of the cloth.

Sir Lawrence Gowing has quite convincingly solved the problem of the missing clock hands. He argues that the reason for their non-inclusion was that the artist's breadth of handling simply excluded anything so relatively small in scale. Furthermore, even the suggestion of an exact time would distract from the serenity and stillness inherent in the picture. Incidentally, the solemn grandeur of the time-piece is entirely the invention of Cézanne, who has used the mirror reflexion and the shadow of the mantlepiece and table cloth that hangs before it to extend its bulk to its present dimensions. The painting was commissioned by Zola, who also owned the clock of the title.

The Temptation of Saint Anthony, c. 1869-70

Oil on canvas
21¼×28¾ inches (54×73 cm)
Foundation E.G. Bürhle Collection,
Zurich
Venturi 103

Gustave Flaubert was one of Cézanne's favorite writers; as a young man he would probably have read the extracts of Flaubert's novel *The Temptation of Saint Anthony* that were published between 1856-7 (the complete version of the book was not available until 1874), and its heady eroticism and ostentatious erudition would have had great appeal for the young Cézanne and his friends.

The painting's nightmarish *tenebroso* effect reveals the painter's allegiance to the work of the Venetians and the Romantic painters and poets of his own century. A number of other versions of the subject exist, but this particular painting bears the closest relationship to the series of *Bathers* which Cézanne began work on in earnest from 1875 and continued to develop throughout his life. Delving into an artist's psychological make-up is a dangerous business, but, as with many other works of the period, it is safe to assume that Cézanne was putting his fantasies, pleasant or otherwise, into physical form. It is not surprising that the anxieties he felt in his dealings with the outside world and, indeed, his inner world should reappear in the form of visual metaphor.

The painting is cast in the same mould as *Couples Relaxing by a Pond* (page 52) and his countless other images of bathing women. In these a controling male presence is always assumed; it is either the artist who paints the picture, the viewer of the picture (who in the nineteenth century would have been presumed to be male), or a male figure within the painting. These men, real or painted, are allowed the privilege of enjoying the private spectacle of young women bathing, unaware of being observed. In this painting the male presence, in the form of the hermit, is brazenly confronted by the objects of the viewer's voyeuristic gaze. In Cézanne's later paintings the male intruder becomes increasingly rare, until he is excluded altogether. This process of elimination can be seen under way in his *Three Bathers* of about 1877 (page 68). In this work two of the three women react to an almost invisible male presence to the right of the canvas. Gradually, over a period of years, the aggressive sexual overtones of these canvases were be sublimated until the gender of the bathers themselves becomes problematic (page 152).

Such interpretations may have only a limited interest and one can also appreciate in the picture the dramatic deformations of the human form, the *brio* of its brushwork and, not least, the unintentionally melodramatic qualities of the scene as a whole. The formidable woman who addresses her attentions to the saint is based on the central female figure of Bellona, goddess of war, in Ruben's *Apotheosis of Henri IV*, c. 1621, in the Louvre. This figure fascinated Cézanne; he drew her many times and she makes frequent appearances in his work. Cézanne declared that the Baroque master was his favorite painter. Another of his heroes who also admired the Flemish master was Eugène Delacroix, whose *Michelangelo in his Studio* of 1850 may have been the inspiration for the pensive nude on the right of the canvas. Delacroix had written the following lines on Rubens in his journal which, although not published until 1893, could well be applied to Cézanne's work of this time '. . . for all . . . his unwieldy forms, (Rubens) achieves a most powerful ideal. Strength, vehemence and brilliance absolve him from the claims of grace and charm'.

The Temptation may be seen as a manifesto declaring Cézanne's allegiance to the poetry of Baudelaire, the music of Wagner and the artistic creations of Courbet and Manet.

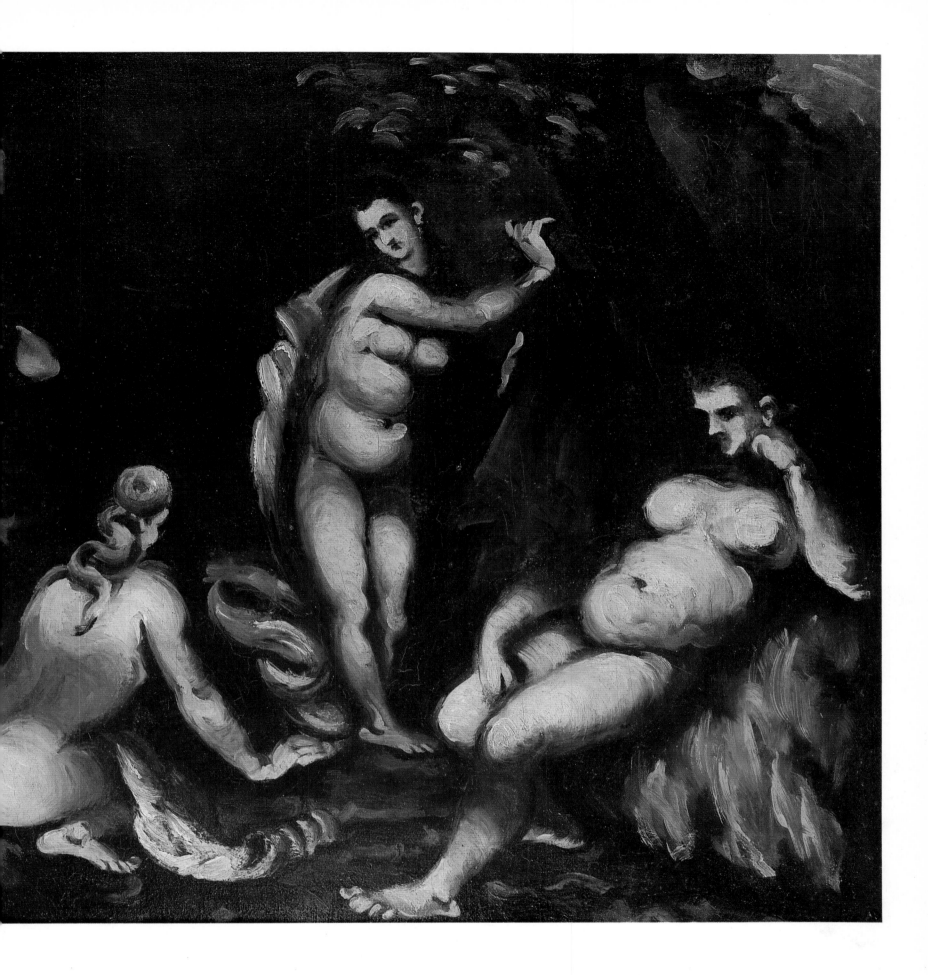

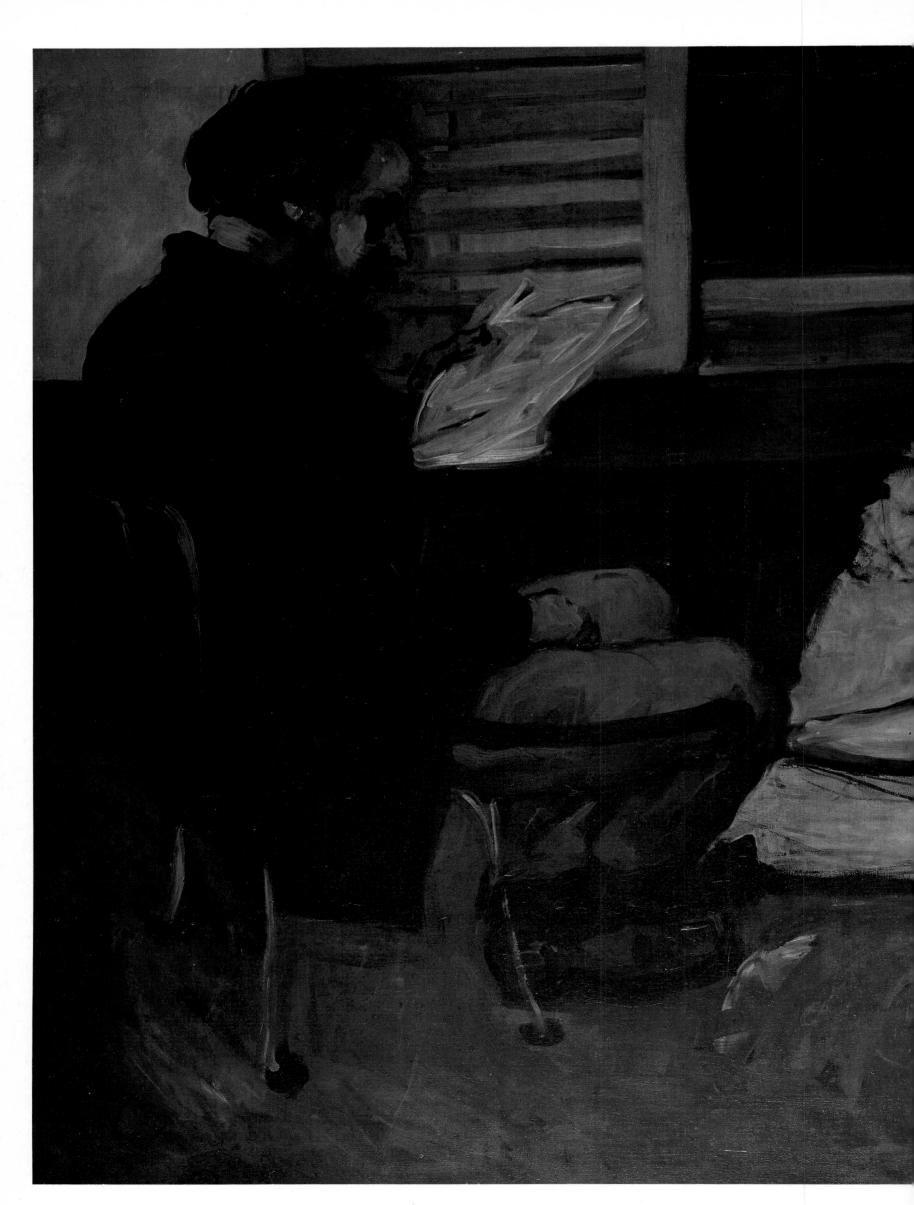

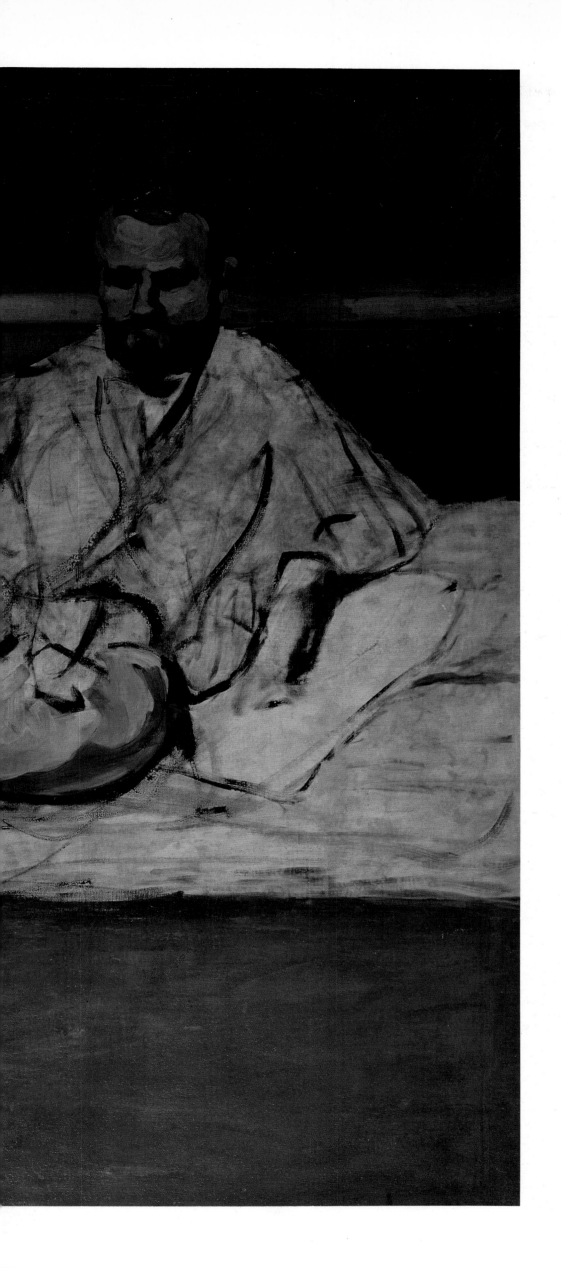

Paul Alexis Reading to Emile Zola, c. 1869-70

Oil on canvas
51¼×63 inches (130×160 cm)
Museu del Arte, São Paulo
Venturi 117

This work was painted for Emile Zola and features the writer lounging in his Paris garden like some oriental despot. He is being read to by his acolyte and friend Paul Alexis, who was also a friend of the artist. Zola had published *Thérèse Raquin*, his first novel, in 1867, just at the time he was posing for Manet's portrait of him, which now hangs in the Musée d'Orsay. Cézanne's informal and unfinished portrait was only discovered in 1927, on the death of Zola's widow. She had grown to dislike Cézanne and had never liked his work. Although unfinished, the painting captures a sense of the intensity of the writer's creative vision that is lacking in Manet's more famous work. Zola's head, eyes deep in shadow, breaks the horizontal line of the window sill; his friend, concentrating on his reading, is placed against the vertical line of the shutter. As it stands, the painting is a harmonious arrangement of browns, ochers, grays, dark blues and greens, enhanced by the dense black of the window area. On the floor, almost obliterated by the artist, lies perhaps what was originally another piece of paper.

The couch and Zola's torso reveal the priming of the canvas, and clearly show the looseness of the drawing that formed the basis of Cézanne's composition. Many of the final forms seen in the finished part of the painting were obviously improvized upon an equally loose foundation of ambiguous lines. As the composition evolved Cézanne was prepared to modify his original ideas accordingly, improvizing directly on the canvas. While the strong diagonal that is marked by Paul Alexis's lower leg and Zola's right side is a formal device used to balance the two parts of the picture, it would, had Cézanne continued with the painting, have given rise to problems with the situating of Zola's body.

Pastorale or Idyll, c. 1870

Oil on canvas
25½×31⅞ inches (65×81 cm)
Musée d'Orsay, Paris
Venturi 104

A very different riverside scene from those painted at about the same time by Monet and Renoir, this picture is, like those by Courbet and Manet, a studio-based work. It is part of a tradition that links their work with paintings of similar subject matter by artists like Giorgione, Rubens and Watteau. The boat has taken the artist away from the hustle and bustle of the city to this secluded spot, which could be parkland, coast or riverbank. Whatever the geographical location, its function is unmistakable; it is clearly a kind of latter-day Cythera – an isle of love. Cézanne has turned his back on the bitter-sweet poignancy of Watteau's famous versions of the subject to produce one more suitable to his robust nature. He has been unable to resist the inclusion of the boatman who, whether friend or hired hand, smokes his pipe, his back turned to the Rubenesque beauties who flank the artist. As in Manet's *succès de scandale,* the *Déjeuner sur L'Herbe* of 1863, the male figures are shown clothed in contemporary dress, while the female figures are naked and in sexually provocative poses developed from the work of the Old Masters.

This composition is one of the oddest of Cézanne's oeuvre. The artist's head is placed adjacent to the line dividing water from sky and marks one angle of a triangle formed by the sail of the boat, the rise of the bank and the back of the inclining bather. The bathers themselves are lit by an unnatural light which isolates their bodies from the darker ground and exaggerates the theatrical quality of the work. These features intensify the almost surreal and dream-like quality of the painting and make it clear that it is entirely a product of the artist's imagination. The obviously phallic forms of the tree, its reflection and the wine bottle that breaks the line of the bank to meet it have given much delight to observers of a Freudian turn of mind. Considering the forthright handling of the paint and the palpable fleshiness of the figures, this painting may be considered a representative example of the artist's *couillard* manner.

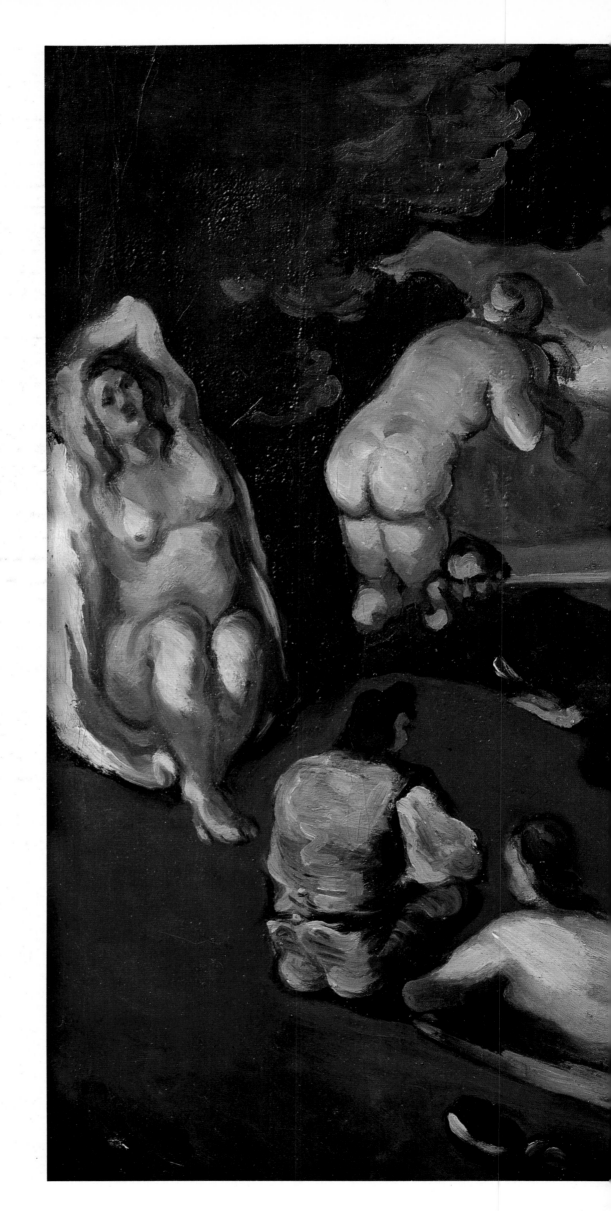

Couples Relaxing by a Pond,

c. 1870

Oil on canvas
18½×22⅛ inches (47×56.2 cm)
Museum of Fine Arts, Boston

This painting is one of Cézanne's relatively few interpretations of 'la vie moderne'. Courbet and Manet, whose work had profoundly impressed Cézanne, had both been fired by the criticism of Baudelaire and had set out, in their different ways, to find a means of painting actuality in a style as modern as their chosen subjects. Such ambitions were shared by Monet, Renoir and Degas, as well as many other of the avant garde of the time with whom Cézanne came into contact at the Café Guerbois. For a while it seemed as though he might pursue the path well worn by his colleagues and produce images of fashionable and working life. In its subject matter this painting belongs to a group of nineteenth-century works that includes among others Manet's *Fishing* (c. 1858-60), Renoir's *Luncheon of the Boating Party* (1881) and Seurat's well known masterpieces the *Bathers at Asnières* (1883-7) and the *Grande Jatte* (1886). Like a latter-day Watteau, a group of people, probably townsfolk, idle in their summer finery on the banks of a river, the informality of their poses contrasting with the rigid formalism of the painting's composition. The painting is clearly a studio production patched together from contemporary fashion plates, drawings of his friends and his own ever-fertile imagination. Perhaps, like the scenes celebrating sexual and sensual pleasures which made up a substantial part of his early work, these are also fantasies but in this case of a fulfilled and happy bohemian life on the banks of the river Seine.

Cézanne was unsure of his direction and was picking up ideas from the discussions he overheard. Shortly after this painting was completed, Pissarro was to lead him away from the artificial life of the city to the quieter more stable truths of the countryside of the Ile-de-France. *Couples Relaxing by a Pond* is then very much a transitional painting; what marks it as a production by Cézanne is its defiant crudeness of expression, and the lack of any form of a traditional notion of 'finish.'

Melting Snow at l'Estaque, 1870-1

Oil on canvas
28¾×36¼ inches (73×92 cm)
Private collection, Switzerland
Venturi 51

Much of the dynamism of this canvas comes from the powerful diagonal that splits the composition into contrasting halves. The slanting directional marks that give form to the steep snow-covered hillside contrast with the more horizontal marks that describe the firmer ground beyond. The sense of almost vertiginous instability is the product not only of the brushwork, which emulates the sliding rush of the snow, but also of Cézanne's chosen viewpoint, and the cunning disposition of trees and foliage that sweep the eye to the crux of the composition. This area, where the road meets the houses, introduces architectural forms as a stabilizing element within the composition. The red roofs, with their lighter yellow-orange accents, are laid on with a square brush and act as an anchoring point for the olive and yellow-greens of the swirling foliage, painted in tight curls of paint. A single area of red undergrowth in the top left-hand corner makes a visual link with the red roof at the bottom right of the picture and further suggests the movement of the melting snow.

L'Estaque played a major role in Cézanne's personal life and in the development of twentieth century art. Attracted by its associations with Cézanne's work, Georges Braque made a visit to this small fishing port to the west of Marseilles and in 1906 painted a number of canvases that, with the works of Picasso, were to mark the beginnings of Cubism. Unlike those twentieth century masters, however, Cézanne never lost his belief in the primacy of direct visual experience. Soon after this picture was completed, the directness of expression we see here was exchanged for a more contemplative view of the landscape brought about through his prolonged contact with Camille Pissarro. This painting marks the point in Cézanne's career when, under the influence of Pissarro, he was beginning to rein in his unbridled sensuality through confrontation with the landscape.

The Seine at Bercy, 1873-5

Oil on canvas
23⅝×29½ inches (60×75 cm)
Kunsthalle, Hamburg
Venturi 242

This was painted at a deeply troubled time in Cézanne's life. He had recently taken lodgings at the Quai de Bercy, where visitors to his studio were appalled at the noise from the nearby quayside. The mood of the picture is considerably gayer than his earlier works, however; touches of bright color and a certain niavety of drawing endow it with an irresistible charm. It is one of Cézanne's very few cityscapes; soon after it was completed Cézanne abandoned the city, the inspiration of many of the avant-garde artists of the time, for the quieter ambience of the small towns and villages of the Ile-de-France and the south of France. A band of densely massed cloud echoes the shapes of the trees and rises to create a simple backdrop to the superstructure of the boat. This painting has an added attraction that makes it distinctive within the artist's oeuvre – it features carts, horses and workmen. Normally Cézanne's landscapes are remarkable for their lack of human presence, which makes this delightful canvas all the more precious. The exceptional vigor of touch and the fragmented paintwork create a sense of liveliness that was later imitated by the Fauves painters Derain and Vlaminck, in their ambition to create a new art unprejudiced by traditional concerns.

57

Landscape, Auvers, c. 1873

Oil on canvas
18¼×21¾ inches (47.4×55.7 cm)
Philadelphia Museum of Art
Venturi 157

By an intense study of the visible, Cézanne cast into doubt the traditional schemes of representation and in their place developed, through his obsessive dedication to the motif, an art that mediated between his own perceptions of exterior reality – his '*petits sensations*', and the means by which such sensations were given form – his art. In this painting of Auvers, one can see the beginnings of the quest to renew the tradition of painting. No one scheme of representation is relied upon; he questions every brushmark, to the extent that some of his marks, especially to the left of the canvas, seem to be thrown down by chance, as if in desperation at the impossibility of creating a painting equivalent to his ambitions.

The painting is a miracle of coloration. Variegated greens mark the color and structure of the foliage, tints of yellow ocher describe the walls of the houses, and the roofs are formed of firmly placed touches of blues and browns. The sky is richly modeled with blues of various strengths broken by strokes of white. Like almost all his landscapes, no sign of human activity disturbs the strict organization of the picture space.

Recession is avoided by the piling up of planes, which obscure the horizon and deny the traditional illusionistic tricks of perspectival depth. The rather clumsy disposition of the foliage draws the viewer's attention to the presence of the canvas surface and the status of the painting as something created on that flat surface, framing the simple geometric shapes of the architecture and landscape within the canvas edges. Each color is applied with a vigor and strength which corresponds to the rustic nature of the subject and suggests the artist's love of the world around him. The painting makes a fascinating comparison with his other landscape motifs of the time and looks forward to his later, more sophisticated use of many of the stylistic features present in this unusual painting.

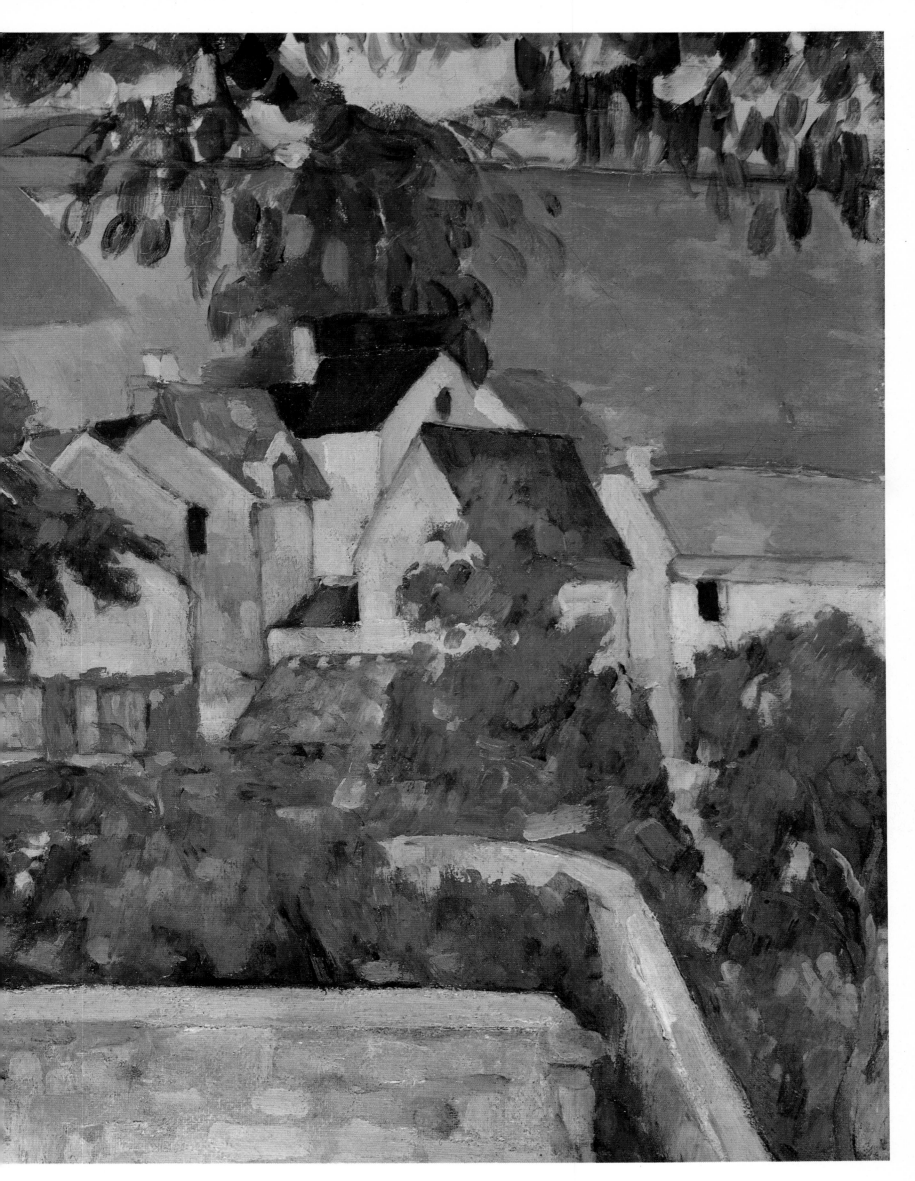

A Modern Olympia, 1873

Oil on canvas
18⅛×21⅝ inches (46×55 cm)
Musée d'Orsay, Paris
Venturi 225

Manet's great painting *Olympia* (page 9) inspired numerous artists to produce their own versions of the subject. Cézanne's small oil sketch is one of the most charming. It is very lightly painted and there is a story that its first owner saw Cézanne working on the painting and, realizing the artist's tendency to overwork his canvases, snatched it away from him.

Cézanne's homage to Manet's *Olympia* is partly a parody of the original, delicately laced with gentle humor, and partly a fantasy picture involving the artist himself. Instead of an ice-cool painting, this is a passionate one; the black maid, instead of offering her mistress a bouquet of flowers still wrapped in their paper, as she does in the original, is given the much more dynamic role of revealing Olympia's dazzling beauties to the seated male, who is none other than Cézanne himself, gazing fervently, hat in hand, at this bounteous vision. The professional hauteur of Manet's *Olympia* is rejected in favor of an inviting and openly erotic nude of Rubensian proportions. The Baudelairean black cat, symbol of lasciviousness and promiscuity, has been exchanged for a be-ribboned lap dog, referring to the original source of Manet's painting, Titian's *Venus of Urbino*, in which a dog is used as the symbol of faithfulness and devoted service.

The reference to Manet marks a shift from Cézanne's early angst-ridden images of sexual frenzy, drunkenness and violence, inspired by the masters of the seventeenth century, to an art dedicated to the expression of his relationship with perceived reality, which at the same time would equal in profundity the art of the Louvre.

Self-Portrait, 1873-6

Oil on canvas
25¼×20½ inches (64×52 cm)
Musée d'Orsay, Paris
Venturi 288

This powerful portrait marks the end of one stage in Cézanne's artistic and personal life and introduces another. It is unusual within Cézanne's oeuvre in its deliberate revelation of the artist's personality. Few painters have scrutinized the physical facts of their visage as Cézanne did and yet it is only rarely that he registered his emotions as part of the final image. This is partly due to his laborious and controlled technique – it is difficult to preserve an animated expression over the length of time that Cézanne needed to produce his paintings; but, more importantly, his own reticence led to the preservation of a certain distance between himself and the viewer. His most common stance in a self-portrait is the one shown here, turned three-quarters to the viewer, the lower part of his body cut off by the canvas edge.

The acuity with which Cézanne has caught his momentary expression has led to a number of fanciful readings of the painting. The handling may be *farouche* but the expression is surely quizzical. The artist raises his eyebrows at his own reflection in the mirror. His bulky form fills the lower half of the canvas, enlivened by an inverted blue wedge. The upper half, seen against the landscape, centres on his familiar dome-shaped head. The painting on the wall, reversed in the mirror, is by his friend Guillamin, This portrait is more empirical in approach than earlier works and marks the direction that his art was to take for the rest of his life.

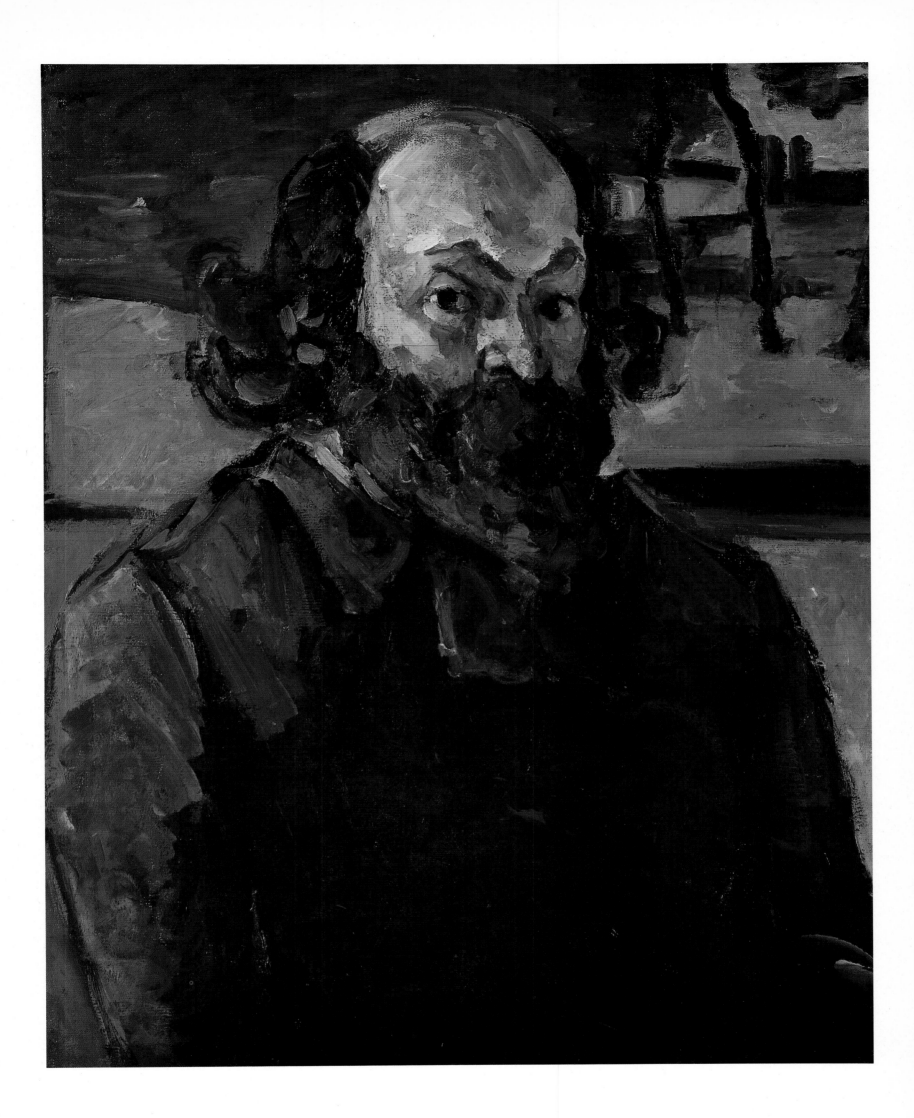

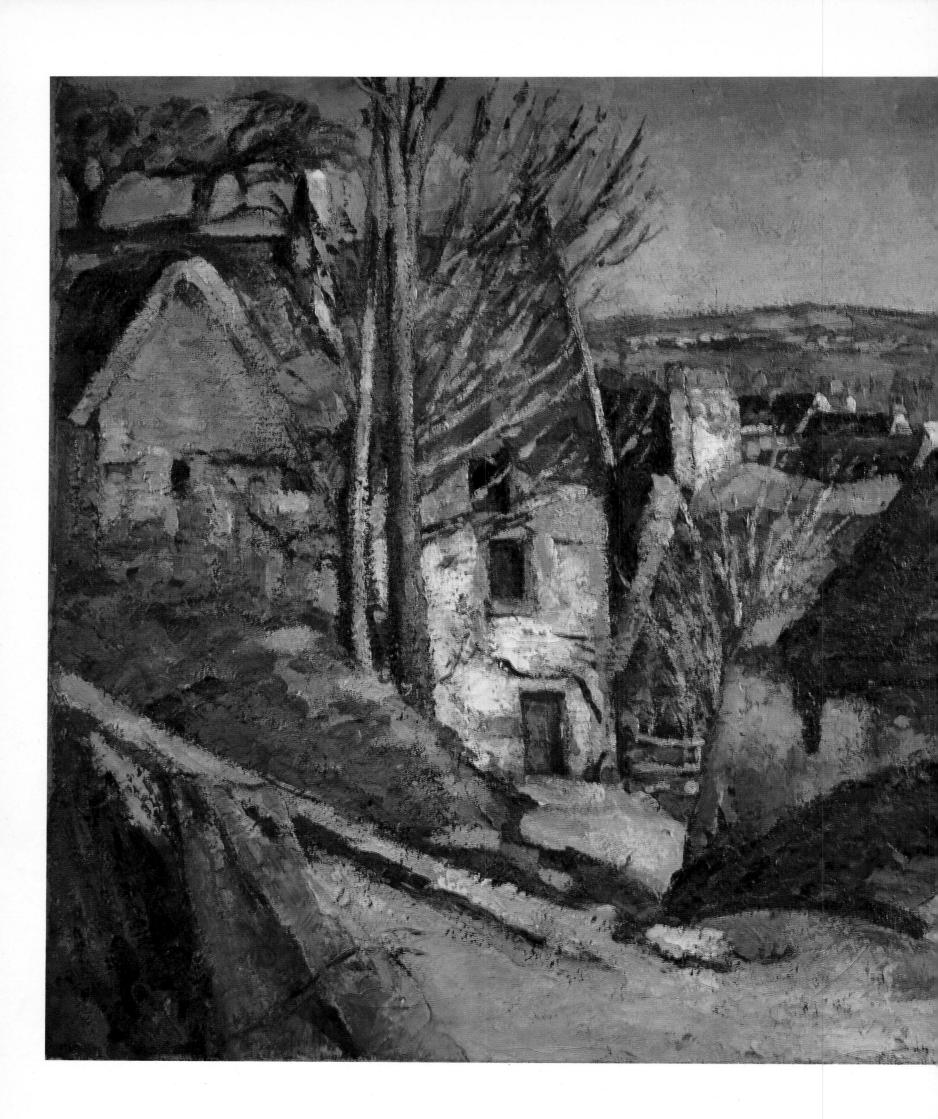

House of the Hanged Man, Auvers/Oise, 1873-4

Oil on canvas
21⅝×26 inches (55×66 cm)
Musée d'Orsay, Paris
Venturi 133

The rather macabre title was not Cézanne's but, despite the blue sky and the rich autumnal coloration, there is an undeniable air of melancholy about the scene, suggested by the lack of any human presence and the blank windows of the house. It was painted *en plein air* at Auvers-sur-Oise and probably completed in the studio, and is one of three that Cézanne exhibited at the first Impressionist exhibition in 1874. It reveals the influence of Pissarro, whose example had introduced Cézanne to the potential of painting directly from nature. Pissarro's influence may be seen not only in the subject depicted but also in the painting's construction. Pissarro taught Cézanne to replace tonal modeling by the study of colors and to sustain a light tonality across the entire canvas. The fractured brush and palette-knife work and solid, almost marquetry-like construction, while owing something to the work of his friend, are handled with Cézanne's distinctively artisan-like manner. He had long since decided to reject the smooth modeling and easy tricks of traditional painting for an art that would be more in keeping with his own powerful love of the landscape.

Every painting by him bears signs of his struggle to retain an originality of expression. Every inch of this canvas is covered with a crusty surface of thick opaque paint, showing evidence of repeated overpainting. His handling of the palette knife has created effects entirely suitable to the character of the rustic subject before him. His treatment of the branches of the trees suggests the beginning of his ability to capture, in a medium that is physically fixed, a sense of movement and atmosphere. It is interesting to compare this early work with those paintings he produced of the Château Noir in the 1890s (pages 136, 162).

Cézanne has established his composition with the bold juxtaposition of a few simple shapes, articulated by a framework of directional movements. This strong structure locks the objects into place. The composition owes much to Corot and Pissarro and their re-interpretation of the work of Dutch seventeenth-century landscapists. Normally a village scene would evoke feelings of comfort and security to a city dweller, but Cézanne has understated any elements of the picturesque. Seen from a high vantage point, looking out over the roofs to the distant horizon, the roadway dips sharply, one track veering up to the left and the other disappearing out of sight, only to open up again at the blue door of the central house.

This is one of the few canvases that Cézanne signed, which suggests that he regarded it as finished and hence fit to be exhibited. The red paint that describes his name is, after the practice of Courbet, set against its complementary green. For once the artist's optimism was not misplaced – the painting was bought at the first Impressionist show by Count Doria, and later passed into the hands of Victor Chocquet.

Auvers, Panoramic View, 1873-5

Oil on canvas
25¾×32 inches (65.2×81.3 cm)
Chicago Art Institute
Venturi 150

This panoramic view of Auvers-sur-Oise was painted while the artist was staying with his friend Dr Paul Gachet. It is easy to trace the influence of his mentor Camille Pissarro in this and other works of the period. Like Pissarro and Pissarro's teacher, Camille Corot, Cézanne has chosen a high viewpoint and kept the forms of the architecture as simple as possible, the better to integrate them into the landscape setting. Later in life Cézanne said 'It took me thirty years to learn that painting is not sculpture', and in this painting we can observe him moving away from Courbet's use of light and shade to model forms, in favor of a more calculated manner in which color itself works with other compositional elements to create a sense of space and atmosphere while preserving the harmony of the canvas surface. Cézanne was never really one of the Impressionist group, although like them he believed that the primacy of the individual's contact with nature should be the motivating force of a painting.

The blues, reds and ochers of the steeply pitched roofs are repeated in the coloration of the foliage, the distant fields and sky. The sky itself is quite lightly brushed in, allowing the earth color of the ground to contrast markedly with the rest of the painting, which is strongly worked in a dense series of overlaid brushmarks. These choppy marks in the lower left suggest the growth of vegetation and the rise of the landscape, but are used in the rest of the painting as a structuring device marshaling the variations of perceived color into a series of tightly ordered units, each mark subtly modulated to act in accord with its neighbor until a complete harmony across the entire painting is achieved. No single architectural form is allowed to dominate the composition. The town is enclosed by a set of diagonals formed by the bank on the left and a grouping of three sets of trees to the right, which lead the eye to the distant road high on the upper left of the painting. The cathedral-like mass of the trees two-thirds up the right-hand side balances the tall white building on the opposite side of the canvas. Within these limits the town nestles deep in the folded landscape.

Like most of Cézanne's canvases, this one is unsigned and has perhaps not been fully resolved. The warp of the canvas can clearly be seen through those areas of the painting that have only received initial attention from the artist, whereas other areas, notably the middle and lower right, are thickly encrusted with paint. Unlike Pissarro's work there is no sign of human activity, beyond the topographical facts of the cultivated fields, and unlike the work of Monet and Renoir there is no concern with capturing fleeting effects of light or of a momentary sensation. Already something of the monumentality and timelessness of museum art appears in the complicated pattern of shapes and colors that make up this surprisingly small canvas.

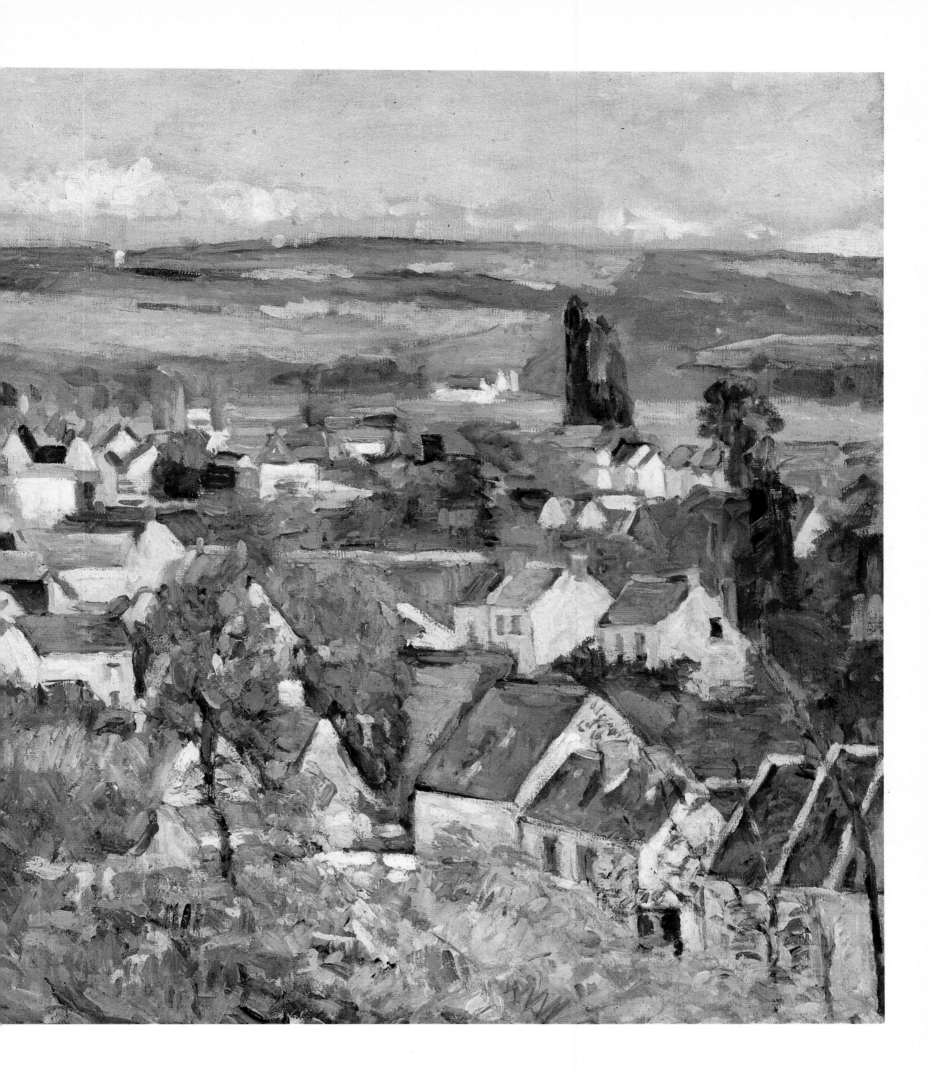

Three Bathers, c. 1875-7

Oil on canvas
7½×8¾ inches (19×22 cm)
Musée d'Orsay, Paris
Venturi 266

This tiny painting belies its size, containing the seeds of the monumental figure compositions of Cézanne's later years. At first sight it looks deceptively simple in composition and meaning. Two poplars emphasize the structural solidity of the crouching bather, whose pose has been developed from that of the familiar crouching Venus. Her companions react violently to a barely visible male intruder on the left-hand side of the canvas. An implausibly placed tree echoes their forms and introduces a triangular movement, the apex of which is formed by the head of the standing nude. These separate sculptural ideas are welded into a single compositional unit of great power.

A more exact title for the painting would be 'Nymphs Surprised', a common enough subject in the Salon of the time. Cézanne has half obliterated the male intruder, implying that even in his imaginative compositions he was moving away from subjects that suggested an explicit narrative. Most of his bathing scenes were to consist primarily of single sex groupings. Certain mythical stories, such as that of Acteon in Ovid's *Metamorphoses*, may be hinted at within his works or, in the case of the male groupings, he may refer to such examples as Michelangelo's lost work the *Battle of Cascina*, known through drawings, copies and prints, which features bathing soldiers surprised by an enemy attack.

The yellows, blues and greens that make up the schematized landscape setting occur also in the short boldly-placed marks of paint that describe, with immense subtlety, the forms of the three women. The vibrancy of the color and the vitality of the mark-making are sustained across the canvas. The foreground, midground and background, clearly demarcated, and the regularly placed brushstrokes create a surface weave of sensuous beauty. Aerial perspective is rejected in favor of a frieze-like motif that complements the theatrical gestures of the figures.

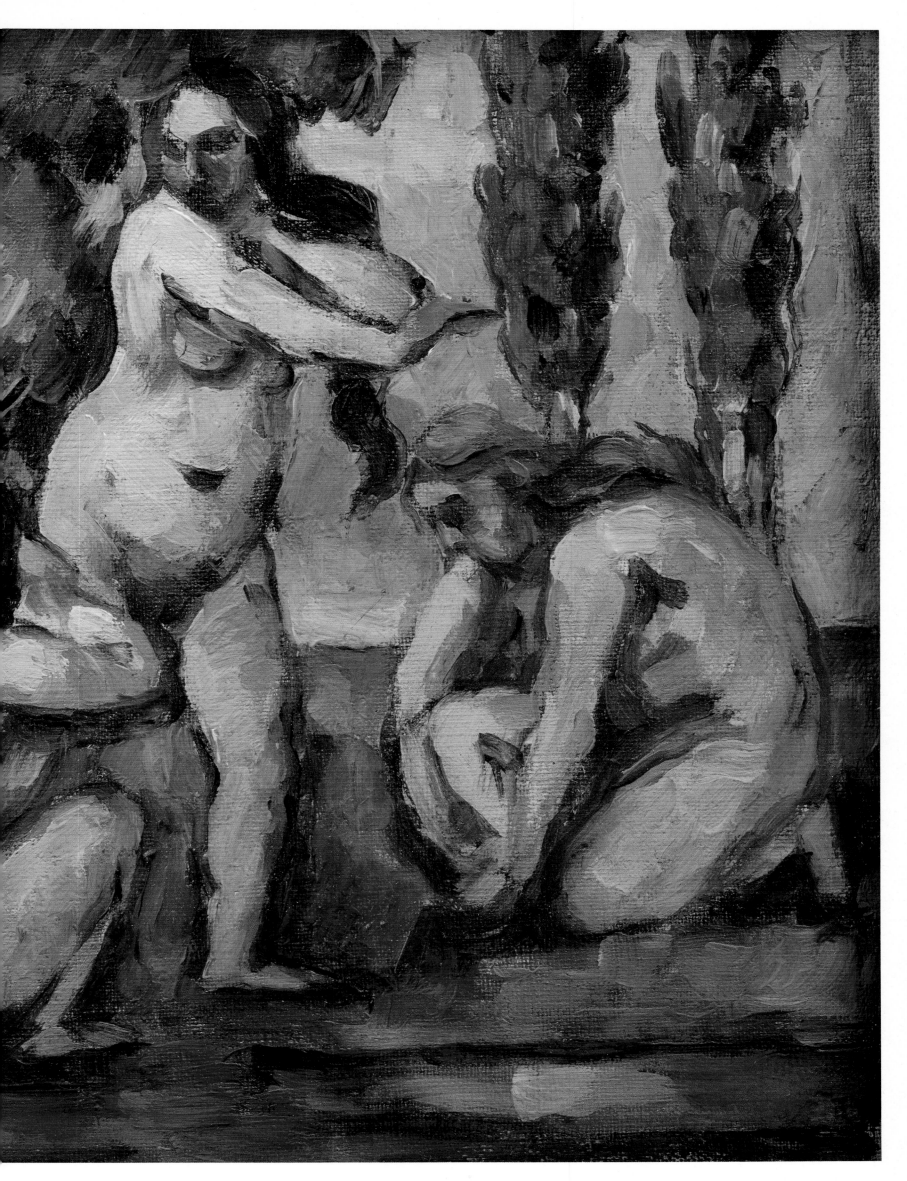

L'Etang des Soeurs, Osny, 1875-7

Oil on canvas
22½×27⅞ inches (57×71 cm)
Courtauld Institute Galleries, London
Venturi 174

This painting belonged to Camille Pissarro and may well have been painted in his company. It differs markedly from Pissarro's canvases, however, and shows how far Cézanne was prepared to move from the conventions of Impressionism. It is much more schematically painted than Pissarro's works of the period and contains liberal amounts of black. The diagonals of the foliage were laid on with a palette knife and suggest not so much the natural forms of the individual leaves but rather the overall structure of the branch formation. This falling mass of dark greens contrasts markedly with the lighter tones of the opposite bank of the lake, creating a convincing illusion of distance while not disturbing the harmony of the canvas surface.

The painting owes a great deal to Courbet, not least in its use of the palette knife. Knife painting gives a canvas a broken irregular quality, although the paint itself may be thin, creamy or delicate in texture. It can be a remarkably sensitive instrument and in this painting we see that the artist has moved away from his *couillard* technique to a much more restrained method. This allows ridges to develop and the paint surfaces to remain visible under the pigment laid on with the knife, creating exciting textural variations. If handled badly, this technique can lead to the cracking of the paint surface, but in this case the speed with which Cézanne has worked has allowed the paint to form one skin and thereby preserve its original freshness of finish.

The painting is unusual in that Cézanne was not normally interested in capturing fleeting effects of light, but preferred more general light effects that were more in keeping with his method of work. He has rejected Courbet's traditional use of *chiaroscuro*, in favor of abrupt transitions from light to dark. This rejection of *chiaroscuro*, by Cézanne and others, was one of the primary reasons why their painting appeared clumsy and unfinished to their contemporaries. Soon after the completion of this canvas Cézanne, like Pissarro, abandoned the palette knife technique and returned to the more traditional brush.

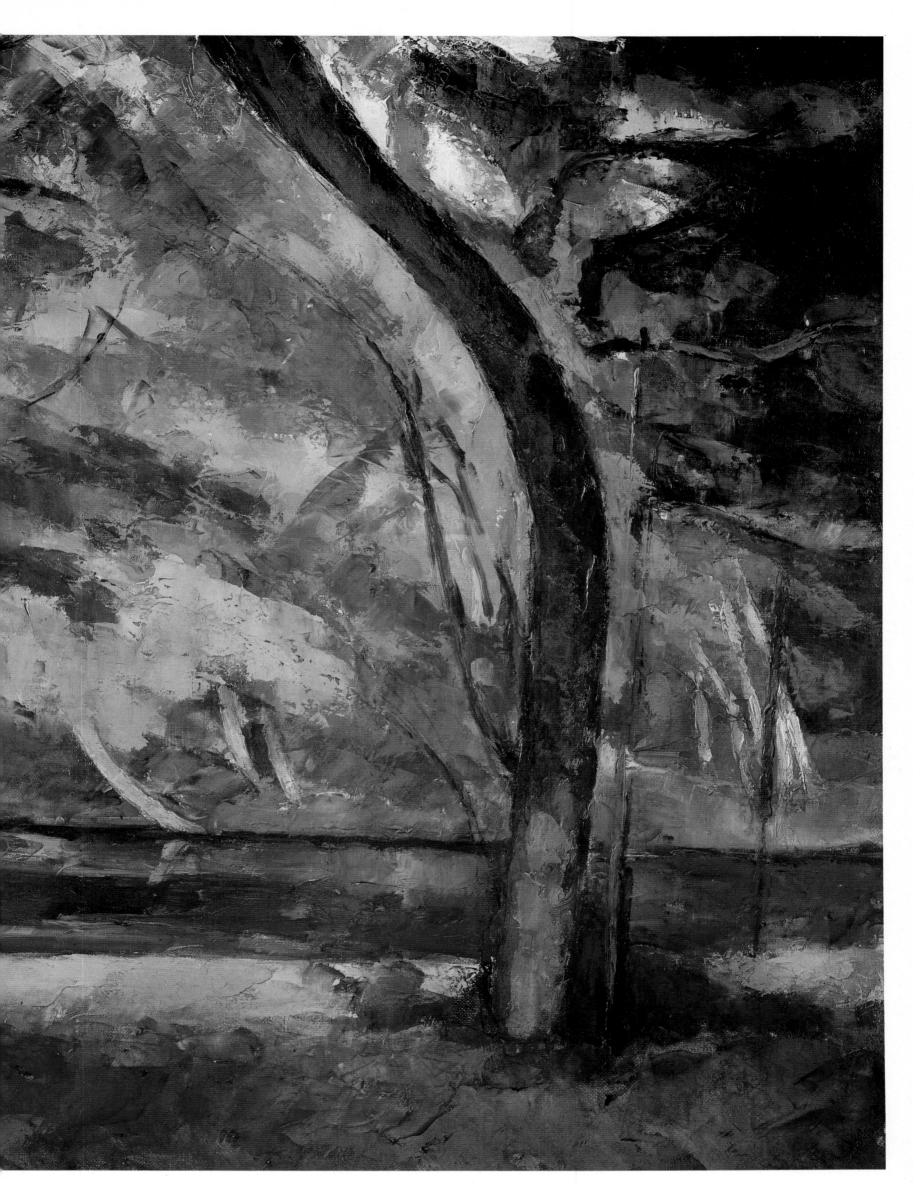

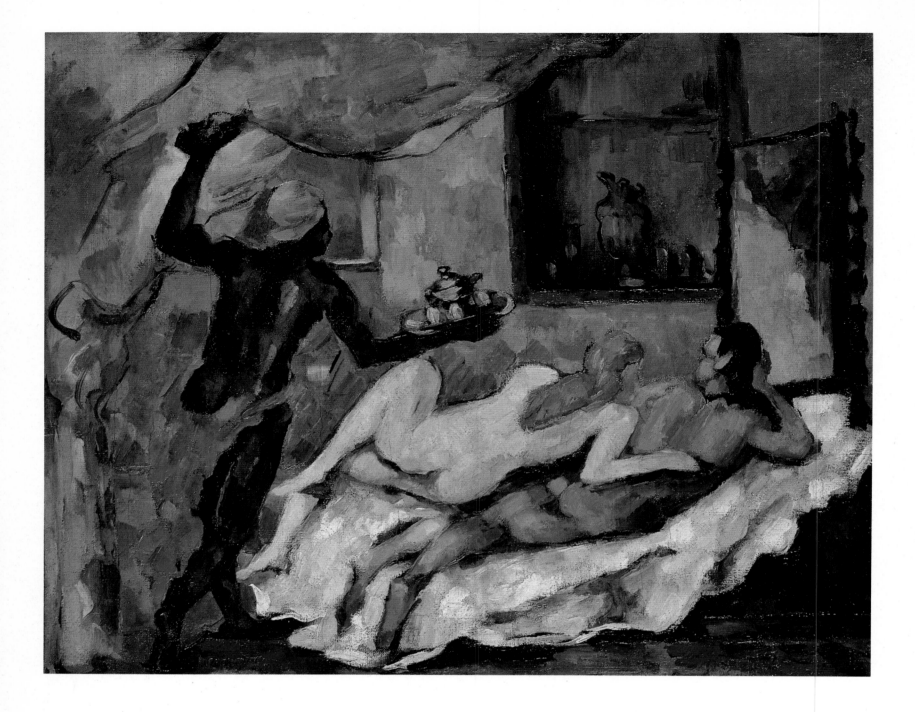

An Afternoon in Naples, c. 1876

Oil on canvas
14½×17¾ inches (37×45 cm)
Australian National Gallery, Canberra
Venturi 224

The title was not Cézanne's invention; it was supplied by his friend Armand Guillamin and serves to emphasize the erotic and festive mood of the picture. It is only one of many such scenes that feature among Cézanne's early drawings, watercolors and paintings. The servant raising the curtain to reveal the embracing couple suggests, as does the rich coloration of the painting, the influence of Eugène Delacroix, particularly his *Femmes d'Algers* of 1834. It may be that this painting was one of the canvases Cézanne submitted with his usual lack of success at the Salon of 1867. The casual intimacy of the sprawling figures may give the painting an added attractiveness to a modern viewer but one can readily understand why the Salon jury would have found it unacceptable, lacking as it does any moral or historical reference to render it palatable. Such sexually explicit works could be seen in the oeuvre of Tintoretto and other Old Masters represented in the museums of Europe, but their very status kept them safe from moral censure.

While equally titillating subjects were produced by successful Salon painters, these were rendered acceptable by the academic rigor of their technique and the historical or mythological references which were clearly expressed in their titles. Cézanne's painting exults in its rejection of the polished surfaces and academic drawing of such painters. It is an exercise in the judicious placing of clean color and the delightful harmonies of the varied flesh tones. The raised curtain begins a falling movement that may be traced through the body of the servant, the outstretched arms and the reclining figures. They are supported by the clean crispness of the sheets that cover the low bed. A mirror, suggestively placed, reflects the swathe of curtain, its tone dropped by several degrees, which leads the eye back into the centre of the composition – the bed.

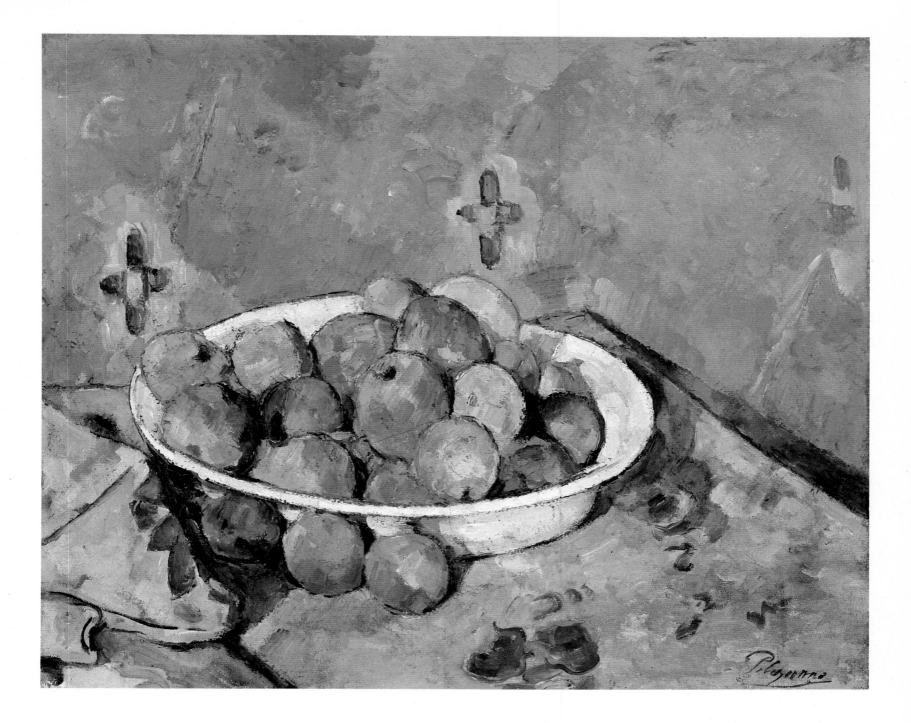

Plate of Apples, c. 1877

Oil on canvas
18⅛×21⅝inches (46×55 cm)
Chicago Art Institute
Venturi 210

The whole canvas is covered with a thick surface of highly worked paint, suffused with strong color which appears to emanate light. It has the strength and solidity of a piece of well constructed masonry. The asymetrical nature of the composition, with its sharp table corner breaking into the flatness of the wallpaper, is contradicted by the self-evident brushmarks that surround it, forcing that part of the table up against the canvas surface. Cézanne has risked all to give the incredibly richly colored spheres of fruit the *éclat* of sudden revelation. Strong short strokes of paint are laid down in a thick mesh of robust color to create a surface texture of an almost edible richness. The single plate of fruit sits on a sky-blue tablecloth patterned with a few summarily indicated blue flowers. The plate is built up with numerous separate blue-gray tones, the apples are chromatic melodies of yellows and reds except for three green ones which stand out from them against the olive yellow wallpaper with blue flowers.

The painting appears deliberately crudely worked in what may well be an attempt to produce a still life without the usual harmonious balance of a Chardin. Unlike traditional paintings of the genre, no soft-edged shadows confuse the clarity of vision that the artist presents to the viewer; instead the painting is knotted together by the sustained brilliance of its high-keyed color and the recurrent pattern of brushwork. Cézanne only very occasionally signed his work and then only if he were expecting to exhibit it. In this case it would suggest that the artist felt satisfied with the painting and considered it finished; he may even have had a buyer in mind. The idea of finishing a work, that is, bringing it up to a degree of finish acceptable to the art market, was something that Cézanne felt to be the antithesis of all he strove for in his art.

Madame Cézanne in a Red Armchair, c. 1877

Oil on canvas
28½×22 inches (72.5×56 cm)
Museum of Fine Arts, Boston
Venturi 292

With the recent translation into English of Rainer Maria Rilke's *Letters on Cézanne*, it has become possible to enjoy that most sensitive of poet's reactions to Cézanne's paintings. He first saw them at the 1907 retrospective exhibition in Paris. On the last day of the exhibition, Rilke stood in front of this work to memorize it. Later he wrote a description of it that listed each of the color harmonies and contrasts in detail: '. . number by number . . . each daub plays its part in maintaining the equilibrium and in producing it'.

The portrait is of Cézanne's partner, Hortense, whom he finally married in 1886. Her hands lock together in a gesture of special significance to the artist. Later in life he used it as an example of how each part of a painting should fit together organically and exactly, without any weak links to destroy its completeness. Hortense's dress, like that of a Velasquez Infanta, spreads along the bottom edge of the canvas, creating a solid base to support the figure who sits, leaning slightly to one side, on an upholstered red armchair worthy of Ingres. She is given no elevated role to play, surrounded by none of the accoutrements of fashionable life. With pasty applications of opaque paint Cézanne has built up the magnificent architecture of her dress and housecoat. Greens, violets, grays and blues interweave across the striped fabric of her dress; occasionally a touch of vivid green is introduced to contrast with the muted resonance of the armchair. The dull gold of her dress, set at the closest plane to the viewer, is also used to describe the wallpaper that is seen behind her. Hortense's face is viewed from the front, placed slightly off the central axis of the picture, and is painted in broad slabs of opaque pigment. The red of the back of the armchair flanks either side of her head, balancing the greens that are daringly used in the modeling of her features with the flesh tones and giving a convincing sense of actuality without any loss of coloristic splendor. Small wonder Rilke was impressed.

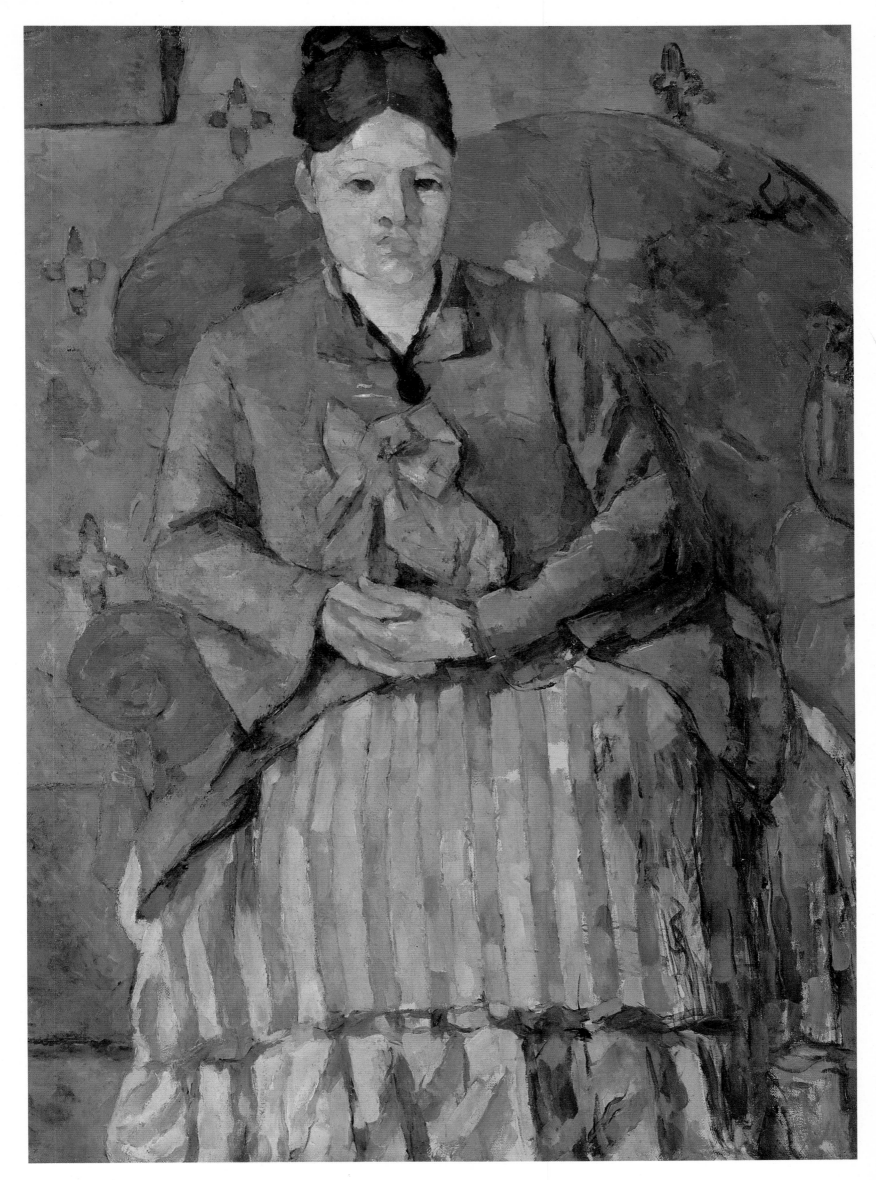

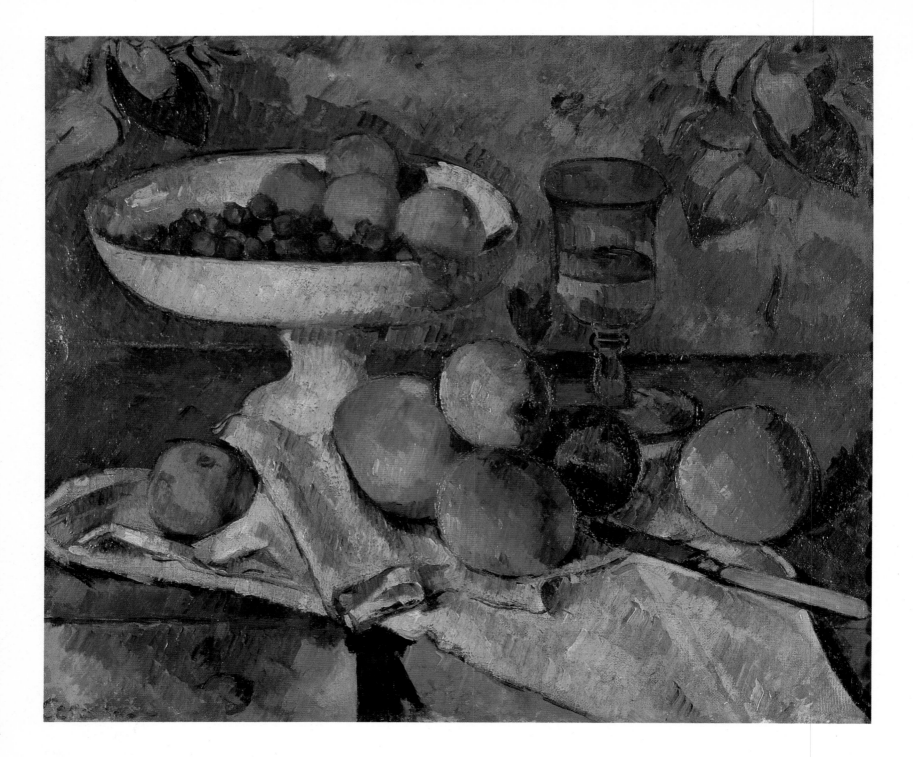

Still Life with Glass, Fruit and Knife, c. 1877-89

Oil on canvas
18⅛×21⅝ inches (46×55 cm)
Private collection, Paris
Venturi 341

Paul Gauguin bought at least six Cézanne canvases, of which this was one, from Ambroise Vollard during the years 1881-4; he studied Cézanne's work intently in the hope that he could learn from them the secret of modern painting. His letter to Pissarro quoted on page 21 indicates the regard with which Cézanne was held in the Post-Impressionist circle of painters, whether or not Gauguin was wholly serious.

It may have been the La Caze donation of Chardins to the Louvre in 1869 that provided Cézanne with the stimulus to paint still life. Be that as it may, the genre suited his artistic personality very well. He could

arrange the elements before him at his leisure to satisfy his sense of color, form and texture. Still life raised none of the problems that a living model might present; fruit did not complain of long sessions nor did it shift position, and it could easily be replaced by fresh or even artificial equivalents. A confrontation with an apple did not give rise to the emotional problems he suffered in the presence of the naked model. Originally considered a minor art form, still life could, for an artist like Cézanne, serve as a perfect testing ground for ideas and techniques. His results, like those of Chardin before him, gave this genre a significance and importance equal with any other form of artistic expression.

The painting is built up in a series of small diagonal strokes which cover the canvas surface in a rich weave of texture and color. Each brushmark relates both to the visual sensation it aroused in the artist and to its neighbors within the canvas. Gradations of light and shade are not

denoted by means of an imagined tonal range but through the subtle modulation of color. Cézanne evokes the physical presence of these objects so powerfully that the deformation of the traditional rules of perspective pass almost unnoticed. In order to make his painting a stronger cohesive whole, the artist has not hesitated to distort the shape of the objects in order to relate the elements of the painting more closely. A closer examination reveals the extent to which Cézanne has twisted and manipulated their shapes in order to express their physicality. Both fruitbowl and glass are set off-centre on their stands, and the ellipses that describe them have been flattened out and drawn upward to enable the viewer to see into their bowls.

The painting appears in the background of the *Portrait of Marie Derrien* of 1890. Maurice Denis copied it when it was in the collection of Dr Viau and made it the focal point of his famous painting of 1900, *Homage to Cézanne* (page 22).

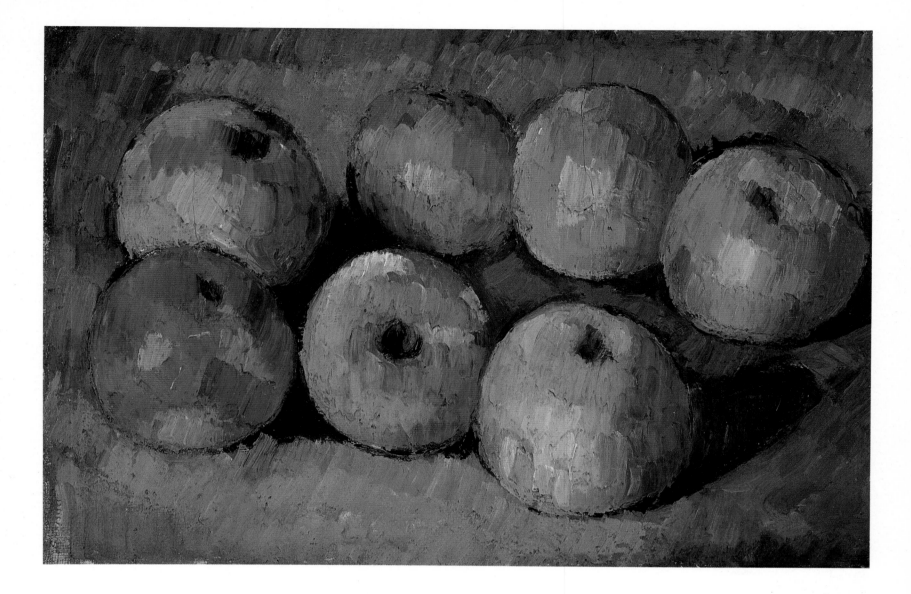

Still Life with Apples, c. 1878

Oil on canvas
7½×10⅝ inches (19×27 cm)
Fitzwilliam Museum, Cambridge
Venturi 190

During the early to mid 1870s Cézanne began to paint a number of small canvases, representing a limited number of apples or pears grouped almost to fill the entire canvas area. The fruit, though seen from close quarters, is not recorded in fine detail and background or circumstantial elements are kept to a minimum. In this example nothing intrudes upon our contemplation of the apples and their relationship with each other and the ground on which they rest.

Variegated tones of yellow ocher are laid down with an uncompromising, regularly-phrased series of parallel hatched strokes which surround the almost symmetrical forms of the seven apples. The effects of light are generalized; rather than representing the effects of a particular moment, Cézanne has emphasized their rich coloration and tactile values, qualities that were particularly important to the artist. Compared with a similar still life by Courbet, for example his 1871 canvas *Still Life with Pomegranate* in the National Gallery, London, Cézanne's dissatisfaction with *chiaroscuro* as a means of describing form can be clearly noted. The apples and the background fuse into a pattern of interrelated hues; dull earth colors have been abandoned in favor of a relatively narrow range of colors which, skilfully juxtaposed and mixed, create a sense of modeling that does not cause dark shadowy areas to spoil the effect of the painting. Cézanne's brush has touched the apples on the left of the canvas with separate dabs of red and green; complementary colors which work with the yellows to model the roundness of the apples. He makes only the slightest of concessions to modeling strokes; few of his marks extend the short dabby movement and yet the physical presence of the fruit sings out loud and clear.

One of the most surprising and rewarding of the hundreds of texts concerning the work of Cézanne is the essay written in 1929 by the writer and painter, D H Lawrence, '. . . Cézanne's apples are a real attempt to let the apple exist in its own separate entirety . . . I am convinced that what Cézanne himself wanted was true-to-life representation. Only he wanted it *more* true to life. And once you have got photography it is very, very difficult thing to get representation *more* true-to-life: which it has to be'. This small painting, together with others by the artist, belonged to Edgar Degas, who no doubt would have agreed with the view expressed by Lawrence.

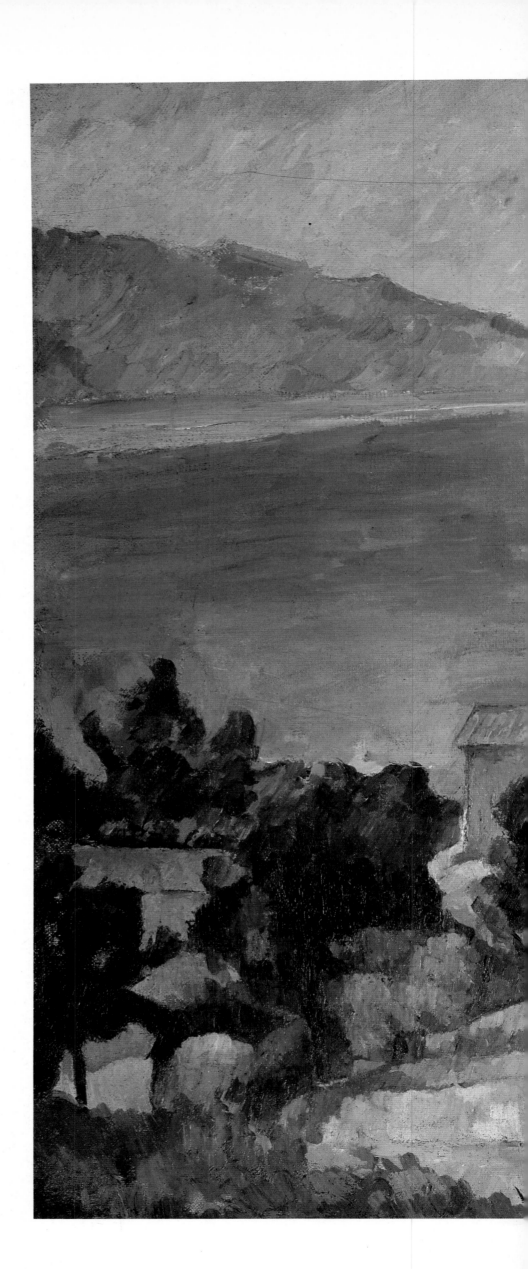

View of Mont Marseilleveyre and the Isle of Maire (l'Estaque),

1878-82

Oil on canvas
21¼×25⅝ inches (51×62 cm)
Memorial Art Gallery of the University of
Rochester
Venturi 408

Cézanne wrote of this view, 'It's like a playing card, red roofs against the blue sea . . .' and in the same letter referred to the unchanging nature of the pines. Like his later paintings of the Château Noir (page 168), he has chosen a view that makes the buildings stand proud of their immediate surroundings, against the blue of the sky or sea. Cézanne was very particular in his choice of motif; the charms of Aix held no interest for him and, with the exception of the paintings of l'Estaque, he rarely painted the sea. It is interesting to compare this painting with his earlier painting of l'Estaque, of 1870-1 (page 54) which is built upon a similar diagonal basis.

The houses in the present example are simplified and, as so often in Cézanne's work, are almost featureless but carefully articulated. Their regular cuboid structures pick up some of the greens that are used to describe the freer forms of the trees. The simple step-like composition is punctuated by the thin verticals of the trees, which are phrased against the larger blocks of the buildings. The relative complexitity of the foreground is perfectly complemented by the open area of the sea, built up in horizontal touches, its strength of color matching the *éclat* of visual experience. As sometimes happens, particularly in places like the south of France, the effect of the sun on the sea has reduced it to a single plane of color which here contrasts markedly with the yellowish tones of the sky. Unusually for Cézanne, the forms of the distant mountains are softened in accordance with the principles of aerial perspective.

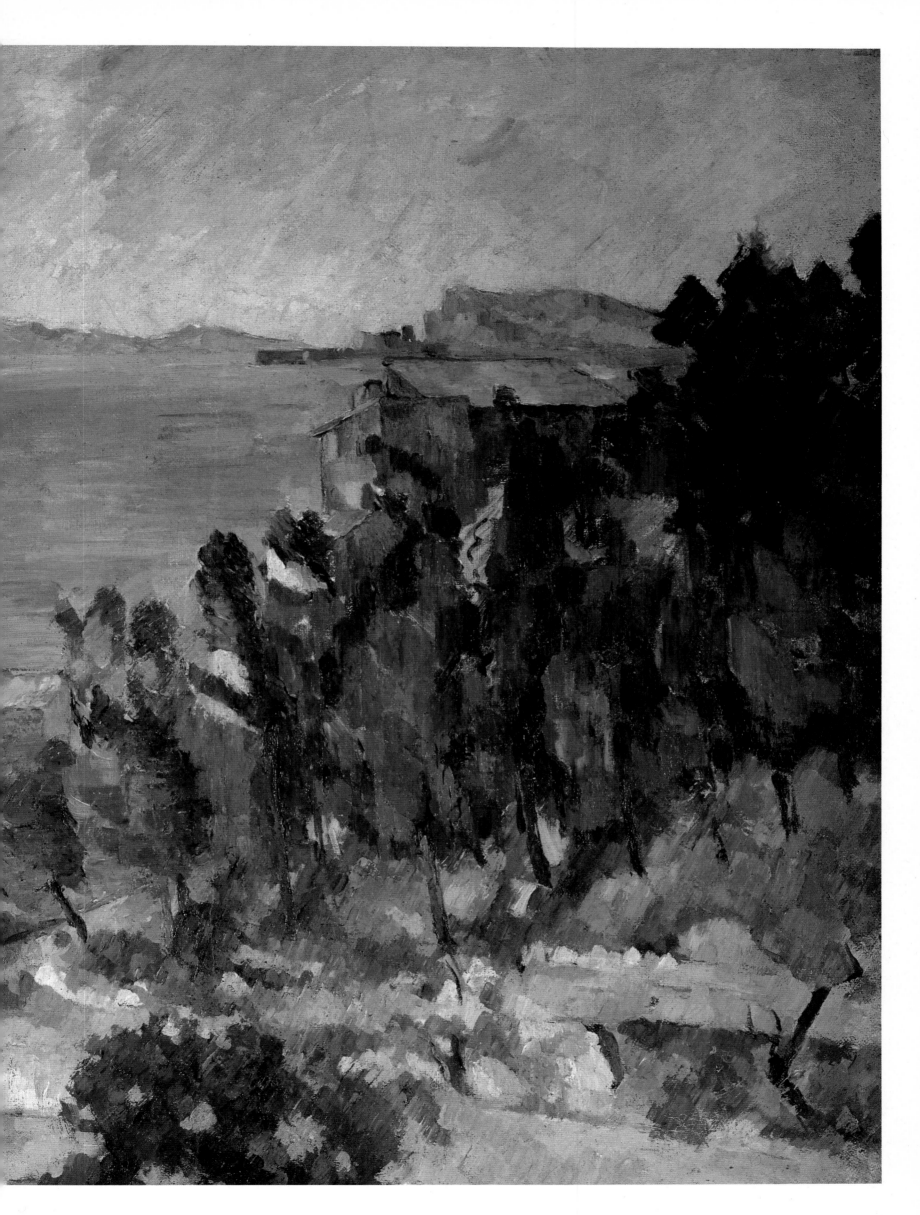

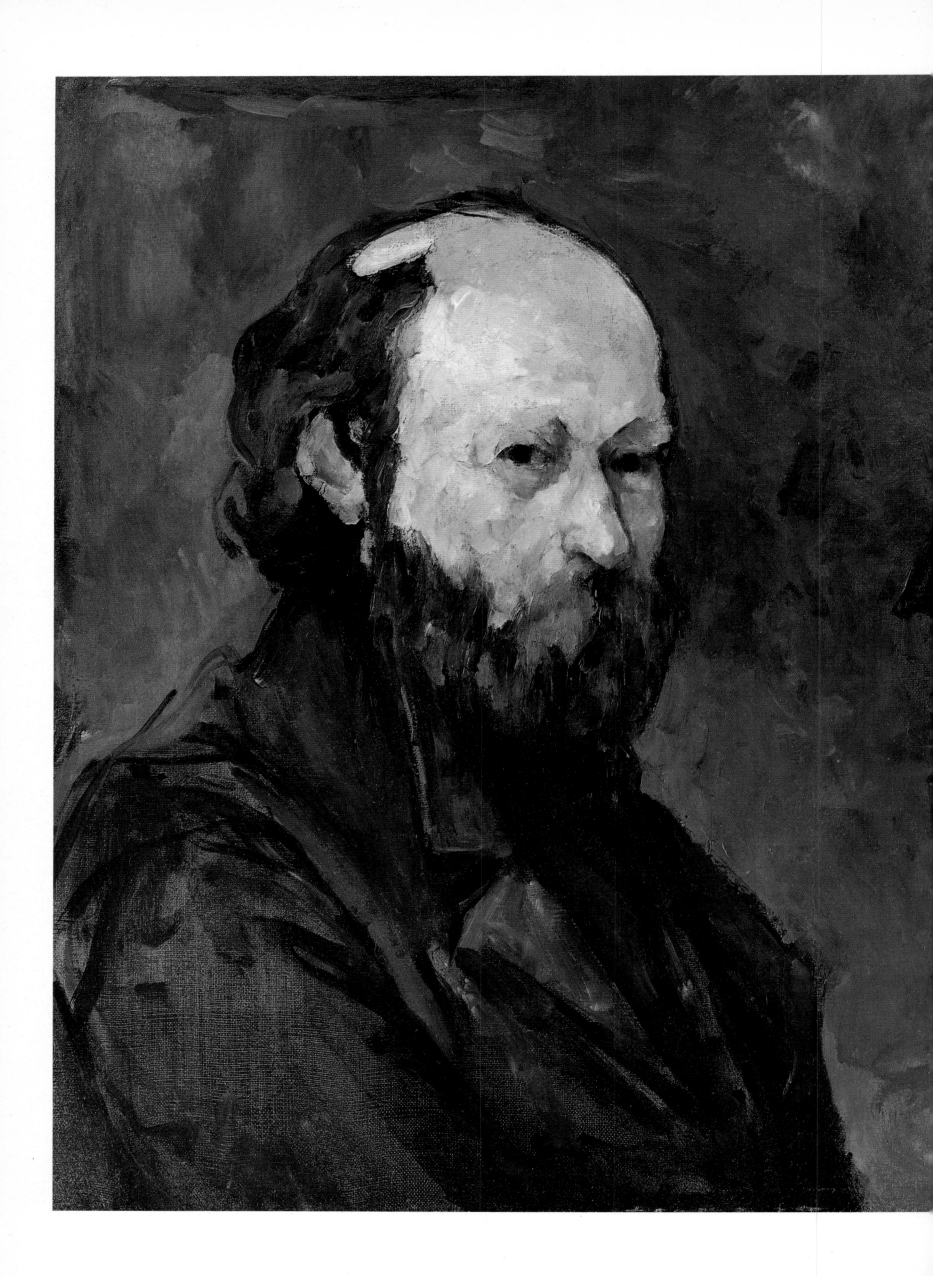

Self-Portrait, 1878-80

Oil on canvas
23¾×18½ inches (60.3×46.9 cm)
Phillips Collection, Washington
Venturi 290

The field of portraiture was a most profitable one in the nineteenth century; painters who worked in the genre were expected to flatter their subjects, surrounding them with luxurious objects or endowing them with the cool aristocratic hauteur of a Velasquez. Nothing, however, could have induced Cézanne to take the path of the professional portraitist. His portraits are of friends or family, professional models or, as here, himself. Taken together Cézanne's self-portraits, and there are about twenty surviving, show him in surprisingly different moods. They are normally in this position, the head turned three-quarters towards the mirror, and nearly always make a feature of his penetrating gaze, often with the right eye with its heavy lid given special attention. This example is one of the dourest of Cézanne's self-images; the coloration is sombre and the palette limited to dark browns and ochers. The background moves from cool tones on the left to a warmer red-dish area that envelops the figure and helps articulate the subtle twists of movement discernable in Cézanne's pose.

The fluency of his drawing is particularly visible in the fluid build-up of dilute lines that mark the structure and shabby bulk of his coat. The sketchy structures of the folds are painted over an area of canvas colored by some previously scraped down paint, and are laid in with a rapid, sure touch which suggests the supporting structure of Cézanne's body beneath the heavy garment. Broad, open areas close up as we move across his coat to the far profile of his shoulder and the dark material flows into the more broken forms of his beard. His face looks like that of some bitter apostle, serious, self-reliant and firm in the face of adversity. By this time Cézanne, although still known for his bohemian ways and anti-social behavior, had already informed his mother in a letter that he had the strength other painters lacked to fulfil his chosen goal, whatever the odds.

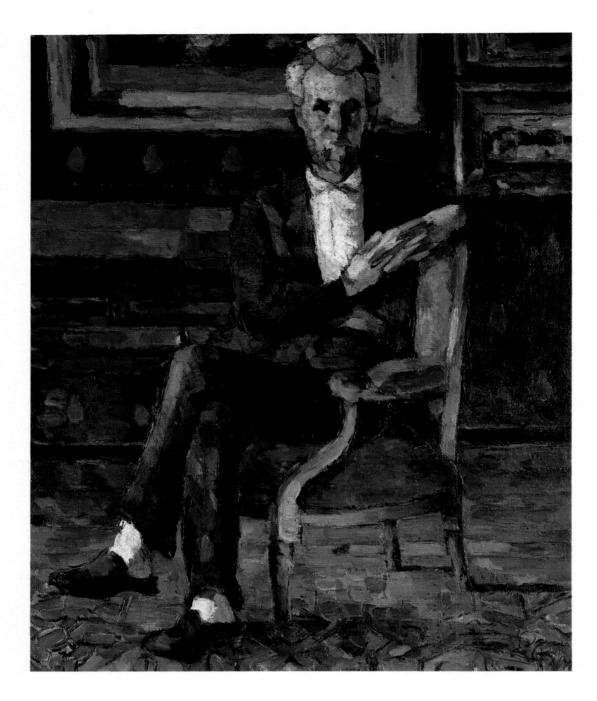

Victor Choquet Seated, 1879-82

Oil on canvas
18⅛×14⅞ inches (46×38 cm)
Columbus Museum of Art, Ohio
Venturi 283

Cézanne became acquainted with Victor Choquet (1841-91) through their mutual friend Renoir and they soon became firm friends. Chocquet was an early patron of the Impressionists and collected works not only by Cézanne, but also by Renoir, Monet and Pissarro. Renoir painted the portrait of this ex-civil servant set against a single small sketch by Delacroix, and Cézanne in this painting has followed Renoir's example but has included three elaborately framed works from Chocquet's collection. This portrait takes its place in a body of portraits painted by Cézanne and his associates that identify the chosen sitter with his own particular environment.

Chocquet is shown parallel with the picture frame with his body turned at a sharp angle to face the viewer. This awkward pose is matched by the angularity of the picture frames and the form of the arm-chair in which Chocquet sits. Cézanne has chosen a rather unusual format for his painting; the picture surface is jointed together in bands of horizontal or vertical strips of color. This compositional device is echoed both in the interlocked hands of the sitter (a favorite motif of the artist's), and the marquetry of the large desk. Cézanne's arbitrary use of shadow allows him to ignore the physical properties of light and shade in order to introduce a series of horizontal movements across the picture. The coloration of the canvas consists of clear bright tones that are gathered in groups throughout the canvas area; the reds, yellows and light grays give this rather odd canvas a bright and cheerful quality that corresponds to the friendly relationship between painter and sitter.

A study of Chocquet's head was exhibited at the third Impressionist exhibition, which featured sixteen of Cézanne's works, most of which were taken from Chocquet's own collection. Apparently the collector was present every day the exhibition was open, in a vain attempt to convince the public of the value of the exhibits.

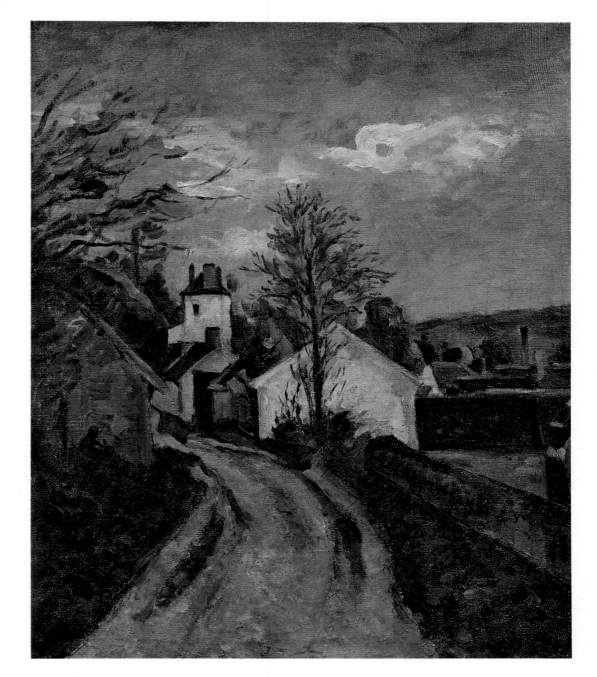

Farmyard at Auvers, 1879-80
Oil on canvas
25½×21¼ inches (65×54 cm)
Musée d'Orsay, Paris
Venturi 326

Cézanne's deliberate search for an art beyond the clichéd conventions of his time led him to create some extraordinary compositional devices. In this example the corner of two farm buildings are reduced to formalized notations, which frame the central band of the farm and bracket the frieze of trees that arcs over its roof. The band of creamy gray on the right receives the same intensity of light as the wall and door of the middle building, while the area on the left, picking up the green of the grass and foliage, marks the muted effect of reflected light. Both forms contrast with the delicacy of the trees pierced by the blue of the sky. The emphatic horizontal of the roof with its red tiling is locked securely into the vertical of the right-hand wall. Its coloration effectively sets off the green of the grass and foliage. In the rest of the composition the artist has carefully avoided the strictly horizontal. The ground falls away towards the foreground and the buildings are pinned into place by the repeated diagonals of the tree in the courtyard, its shadow and the farm implements resting against the wall. The application of the diagonally-placed parallel touches of thick pigment becomes gradually less dense, less formally structured and more responsive to the forms described, as the viewer's eye moves from foreground to sky. The strong parallel movements of the yard, building and hill are counterpointed by the verticality of the featureless forms of the two walls flanking the sides of the canvas and the sensitively observed forms of the trees.

Pissarro must take responsibility for leading Cézanne away from the studio and into the open air, and the two painters often worked side by side; but despite Pissarro's concern with the landscape, his own perception of his art practice rested essentially upon his interest in people, and his paintings always reveal his deep love for humanity. Such direct emotional engagement with people was impossible for Cézanne to achieve – even had he wanted to. The doors of the farm buildings remain firmly closed. Cézanne was not concerned with the economic realities of agricultural life, nor with the seductive possibilities of rural charm, and still less with the biblical references that artists such as Jean François Millet and, later, Van Gogh would find in such subjects. Instead, as so often in Cézanne's work, the prosaic activities that must have kept such buildings in constant animation, hens, chickens, goats and ducks, are singularly absent.

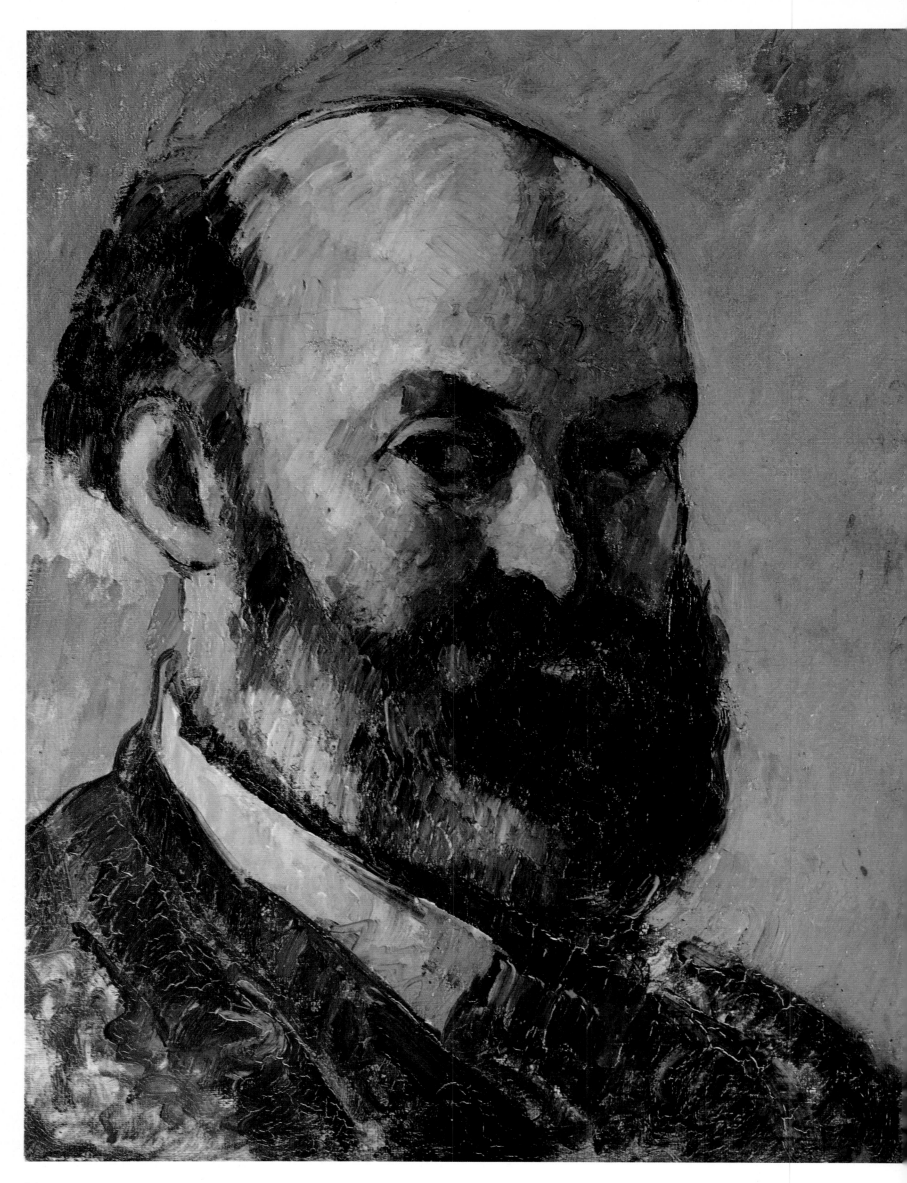

84

Self-Portrait, c. 1879-80

Oil on canvas
13¼×9⅝ inches (33.5×24.5 cm)
Oskar Reinhart collection 'Am
Römerholz', Winterthur
Venturi 367

Cézanne was one of the most patient of artists; his chosen manner of painting was painstaking and laborious, as this self-portrait clearly shows. Each mark is the result of much consideration and the portrait reveals little of Cézanne's personality beyond his habitual reserve. The reason that he painted over 20 self-images was not so much to explore his own psyche but probably rather because few people would put up with the many sessions and exacting requirements expected of his sitters.

Every brushstroke contains a precise tonal or color value which plays its role in the overall harmony of the painting, a harmony equivalent to that found in nature. Any notation found to be incorrect was modified with another mark until that harmony was re-established. This quest for a natural harmony led the artist to develop a 'constructive stroke' that he applied to his work in all genres. In this portrait the thin dilute paint used to establish the composition remains in its original state in the lower left-hand corner of the painting. The

rest of the canvas is over-laid with thicker applications of opaque paint, with only the most limited variation in direction, each separate brushmark establishing a separate pictorial fact. The whole canvas is wrought with an equal intensity, the cool colors of the background invading the contour of the far shoulder, holding it back in space, while the pale grays mixed with blues in the beard and collar tend to push these areas of the picture out of the canvas space. Cézanne's drawing is incisive, imposing his own pictorial order upon the vagaries of natural form. Hardly a contour line remains unbroken by some modifying mark. His familiar dome-shaped head, structured with a range of yellows, reds and greens, contrasts with the muted blues of the background which sets it forward in space. His features are strongly modeled by the parallel hatchings of reds and greens to suggest the half shadows, while the deep shadows, particularly around the commanding right eye, are firmly established with the gray-black coloration of the beard.

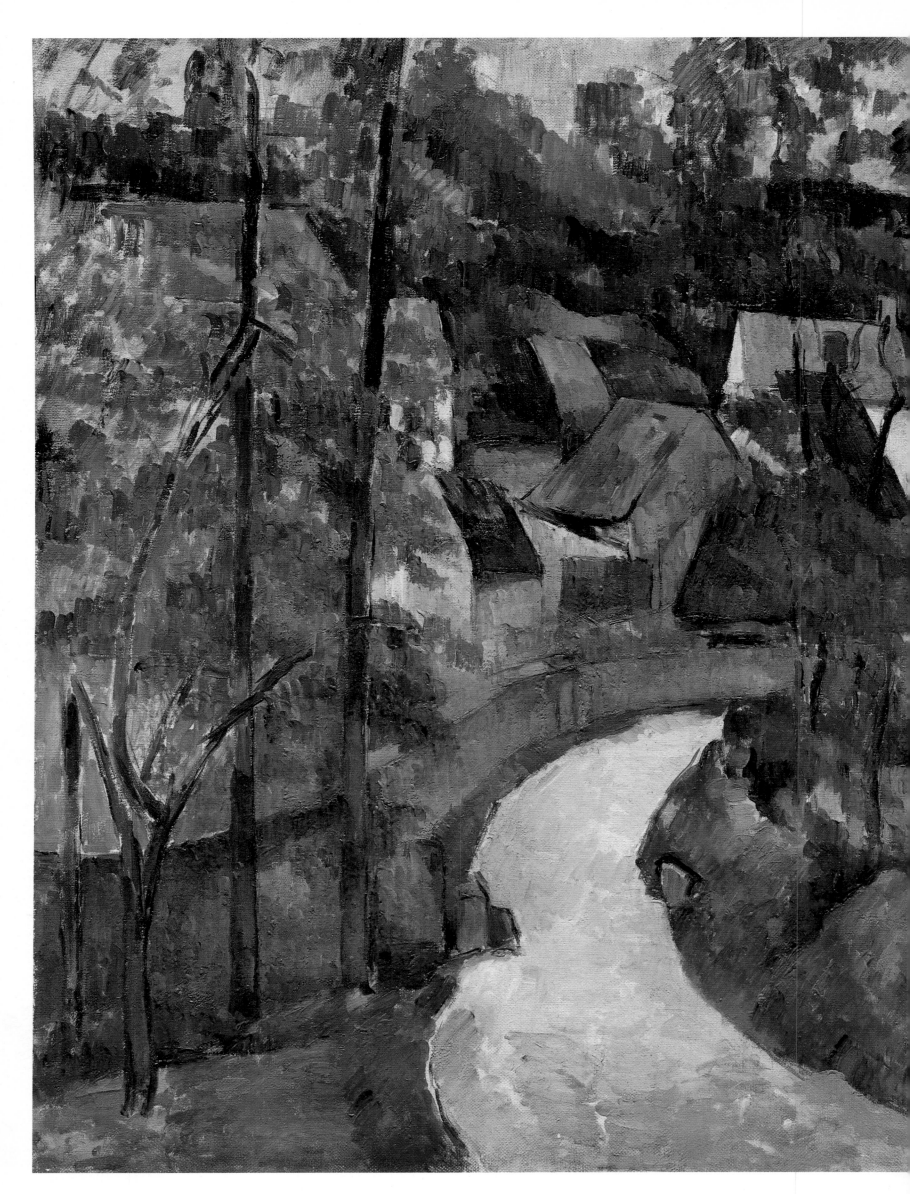

Turn in the Road, 1879-82

Oil on canvas
23⅞×28⅞ inches (60.5×73.5 cm)
Museum of Fine Arts, Boston
Venturi 329

This painting was part of the collection of Cézanne's work formed by Claude Monet. It may have been painted while Cézanne was staying with Pissarro at Pontoise from March to December 1881, and Richard Brettel has suggested that the village depicted may be that of Valhermay, situated on the banks of the river Oise, midway between Auvers and Pontoise. Some time during this period Cézanne was visited by Gauguin, who wrote the famous letter to Pissarro quoted in the Introduction. In the next few years Gauguin bought several Cézanne canvases and adapted his method of using separate parallel brushstrokes to several of his own paintings. Method is almost too strong a word here to apply to the sensitive modulations that mark each of Cézanne's brick-like strokes, and the delicacy with which they are placed on the canvas, building a mosaic that shimmers with the tremulousness of actuality. Any Cézanne canvas contains areas of paintwork that defy logical explanation and are the result of spontaneous improvization. The large wave-like form of the road leads into the village, which has a distinctively toý-town quality. Many of the buildings are half hidden by the broken verticals of the trees; a single red roof sings out against a bed of dark green, stabilizing the small dab-like marks that cover the canvas surface. Cézanne's lack of interest in traditional means of suggesting a sense of distance can be appreciated in the horizontal layering of his composition and his avoidance of any kind of aerial perspective.

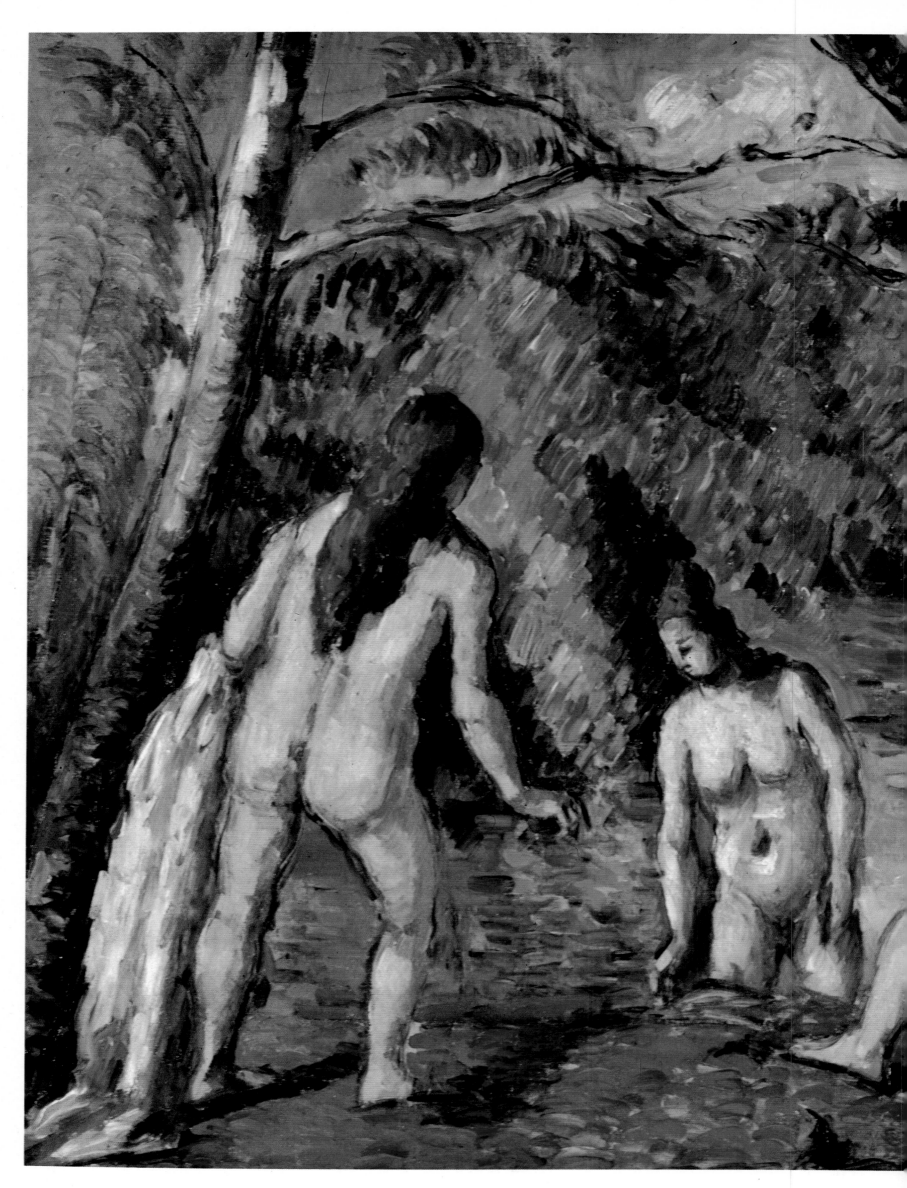

Three Women Bathing, 1879-82

Oil on canvas
19¾×19¾ inches (50×50 cm)
Petit Palais, Paris
Venturi 381

Henri Matisse bought this painting with part of his wife's dowry in 1899; 37 years later he gave it to the City of Paris and it now hangs in the Petit Palais. He accompanied his gift with a letter to the Director of the museum in which he made clear its significance to his own work: 'I have drawn from it my faith and perseverance . . . it is rich in color and surface, and seen at a distance it is possible to appreciate the sweep of lines and the exceptional sobriety of its relationships'.

The work was painted about 1879-82; Cézanne rarely dated his paintings so it is difficult to be more exact. Given that part of Cézanne's reputation rests upon his many paintings of the nude, it may come as a surprise that he felt profoundly ill-at-ease in the presence of the naked model. Most of his mature work in this genre was done from sketches and drawings after the Old Masters. The painting is far removed from the open eroticism of his earlier nudes and marks his deep reverence for the achievement of the past masters of European art. He renounced the tawdry exploitation of the nude familiar in the works of successful contemporary painters such as Cabanel or Bouguereau, and the period from the mid 1870s until the end of his life is one of profound and personal meditation on the act of painting through the exploration of this time-honored subject.

In the final two decades of his life Cézanne began his series of monumental Bathers which occupied him, alongside his still life and landscape painting, until his death. Here the powerful forms of the women are framed by the two leaning trees and the modulated color and brick-like brushstrokes do not record the sensations of a perceived landscape, but are used to create a framework to support the sculptural mass of the three figures. By these means, Cézanne builds up a painting powerful and dynamic enough to inspire the equally innovative works of Matisse.

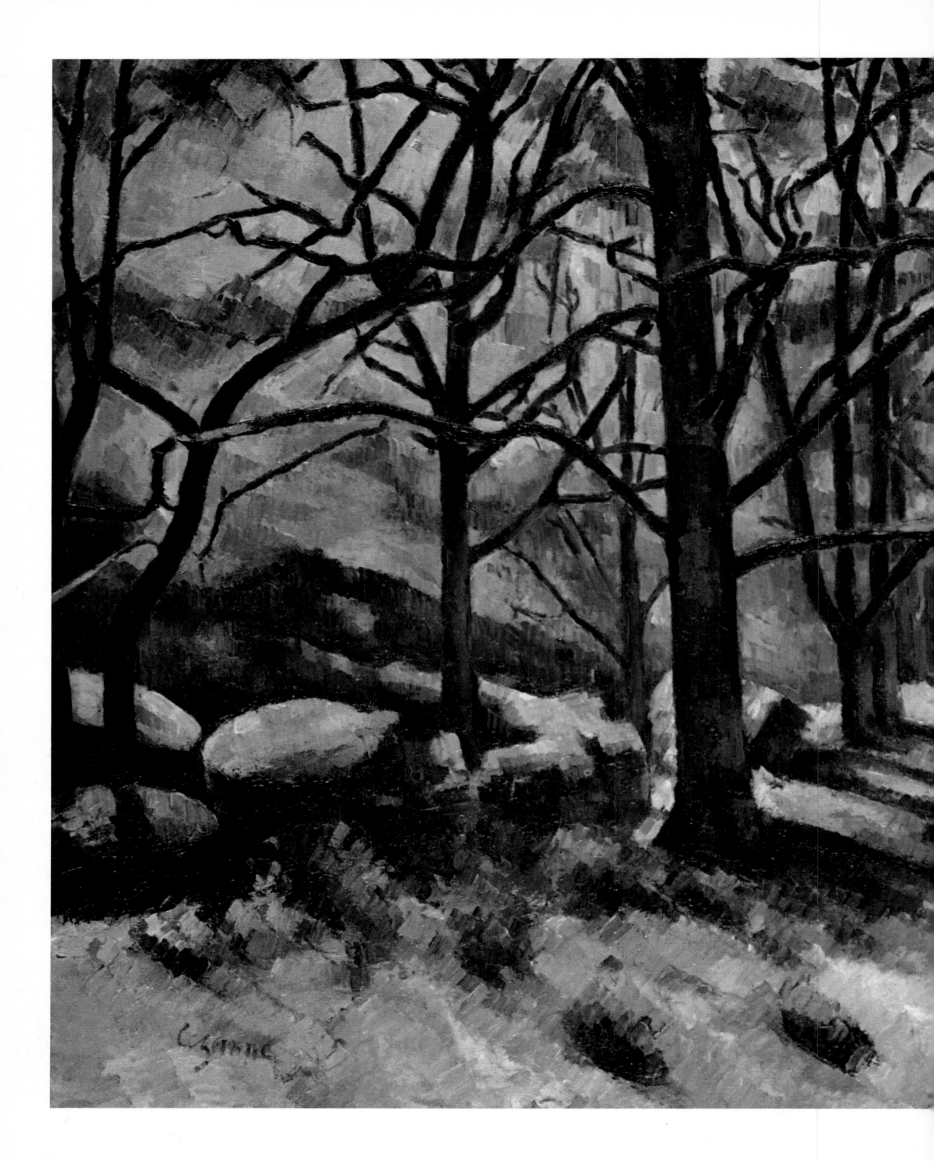

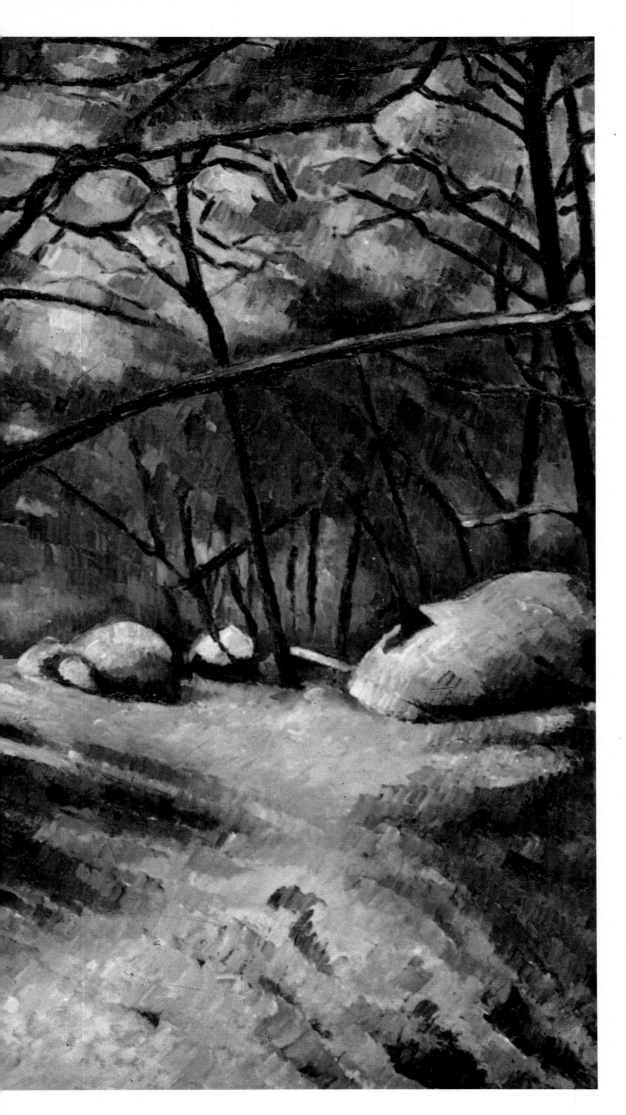

Melting Snow at Fontainebleau,
c. 1879-80

Oil on canvas
29×39⅝ inches (73.7×100 cm)
Collection, Museum of Modern Art,
New York
Venturi 336

This canvas was bought by Monet for
6,750 francs in 1895. It represents the in-
terior of the forest of Fontainebleau and
was probably painted in the winter of 1879.
A photograph of the scene was discovered
among the painter's effects. The relation-
ship between the painting and the photo-
graph is so close that it is clear that the oil
was based as much upon the photograph as
on Cézanne's personal confrontation with
the landscape. Evidence such as this sup-
ports the case for not accepting over-
simple explanations of artistic creation. An
examination of the two images establishes
that Cézanne used the photographic one to
expose the essential forms of the scene he
had witnessed. The effect of the painting
owes something to Cézanne's condensa-
tion of complex natural phenomena to the
limited tones of a monochrome flat image.
The natural forms are straightened out by
the artist to strengthen his composition,
and the bare branches stand out clearly
from the orange-yellow touches that make
up the sky area. The blues of the snowy
landscape, juxtaposed with those of the
sky, create a startling contrast of cool
colors. Separated touches of color create
an animated surface of tightly packed
strokes, each one a subtly different value
from its neighbor, giving a sense of soft
modulation by which the artist creates an
almost mechanical ordering of natural dis-
order.

The Battle of Love, c. 1880

Oil on canvas
14⅞×18¼ inches (37×46 cm)
National Gallery of Art, Washington
Venturi 380

Throughout the trials and tribulations of his life, Cézanne felt within himself the potential to become a great painter, a view that was shared by a number of his friends and contemporaries. For him, such an ambition could only be achieved by reference to the Old Masters and the time-honored themes they examined. One of the greatest of these themes was the nude in the landscape, and Cézanne spent a lifetime examining and re-examining this subject. The artists he admired, Michelangelo, Poussin and Rubens, had all contributed to the development of the theme, producing sublime variations of it; the problem was how to continue a tradition that had become hackneyed, reduced to the near-pornography that was the fodder of the Salon. Courbet and Manet had shown in their work how this tradition could be subverted and thereby given a new lease of life, and many young artists took up the theme, each treating it according to his own interests. Cézanne was not particularly interested in producing images of Parisian bathers in their fashionable costumes at La Grenouillère; instead he took the great legends that had furnished the Old Masters and treated them in a generalized manner, the better to integrate them into their landscape setting. Hence his ambition to 're-do Poussin after nature', to make landscape something as significant as history painting and to endow history painting with the vitality and immediacy associated with the landscape. His memories of bathing expeditions with his friends Zola and Baille crystalized in his imagination as a paradise lost that could be regained through his painting and in his many returns to his native Provence.

This particular example was once owned by Renoir who, after his initial enthusiasm with Impressionist painting had faded, took up the theme of monumental figure painting, although with very different results. The spirit of this painting has something of the violence and sexual energy of Cézanne's earlier work, but its frieze-like composition and cool tonalities, to be repeated in his later bather paintings, hold any melodramatic tendencies firmly in check. In its general conception and mood, this painting contains much that was used to great benefit by later artists such as Picasso and, above all, Matisse.

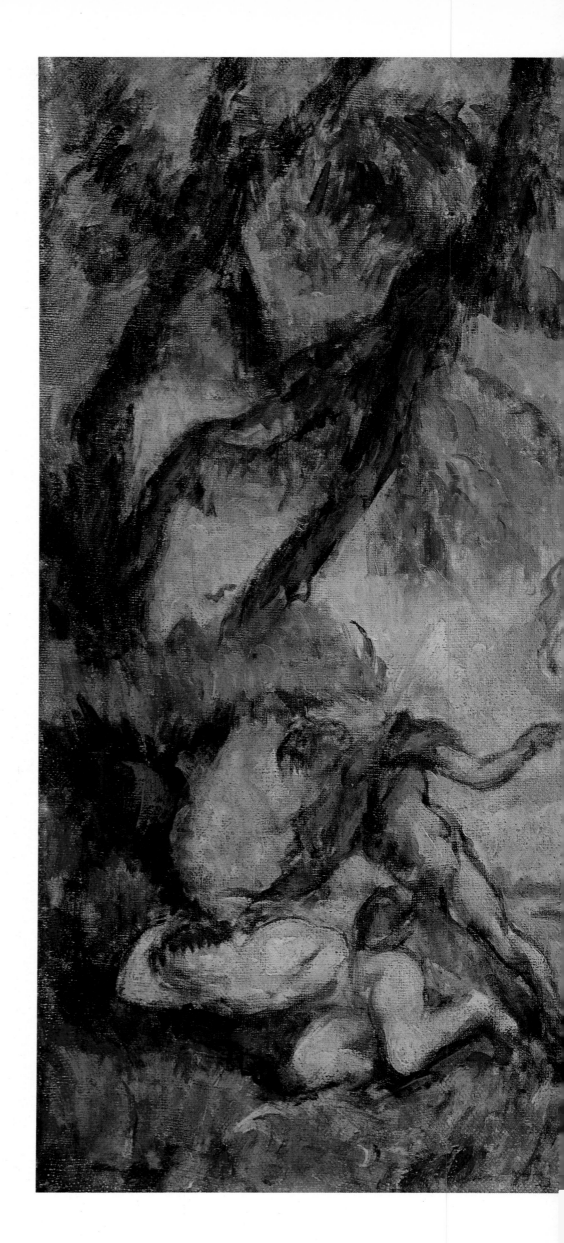

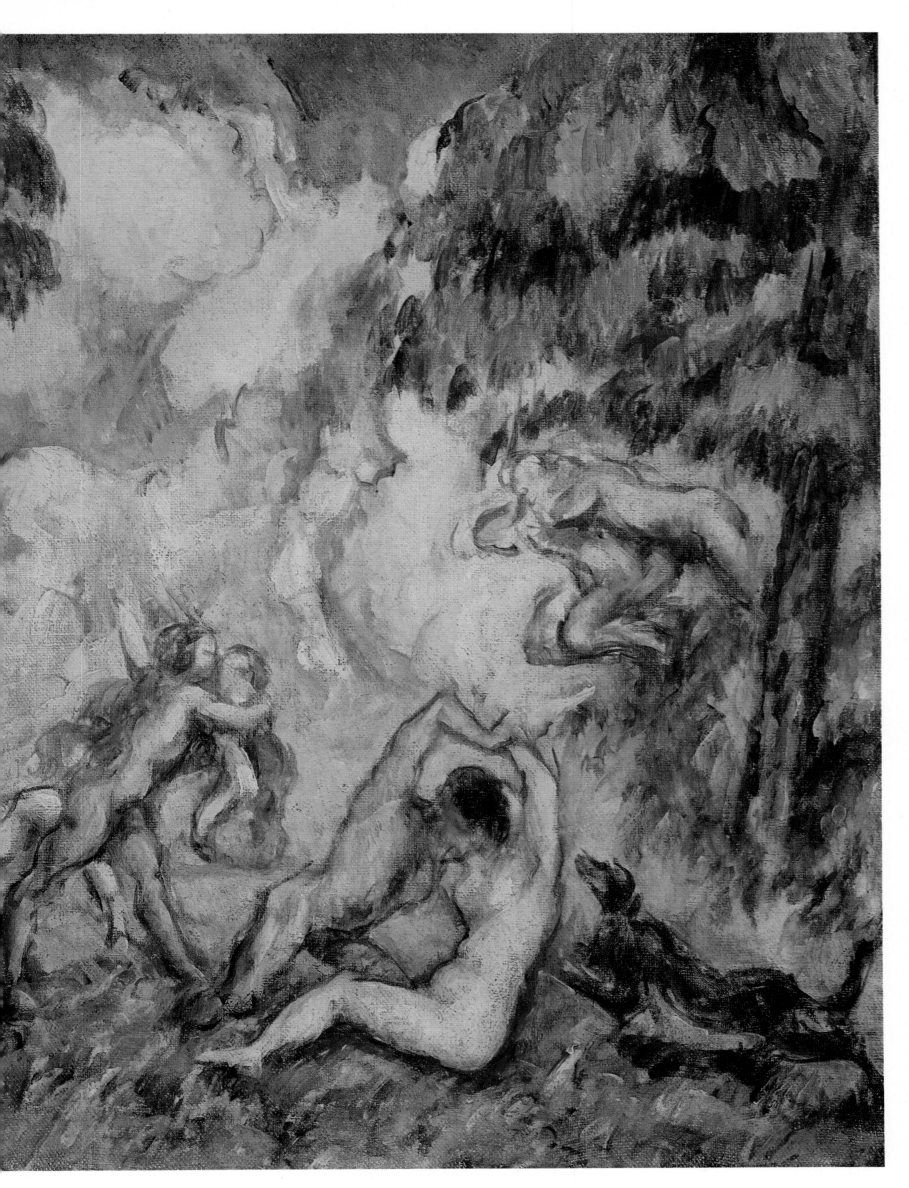

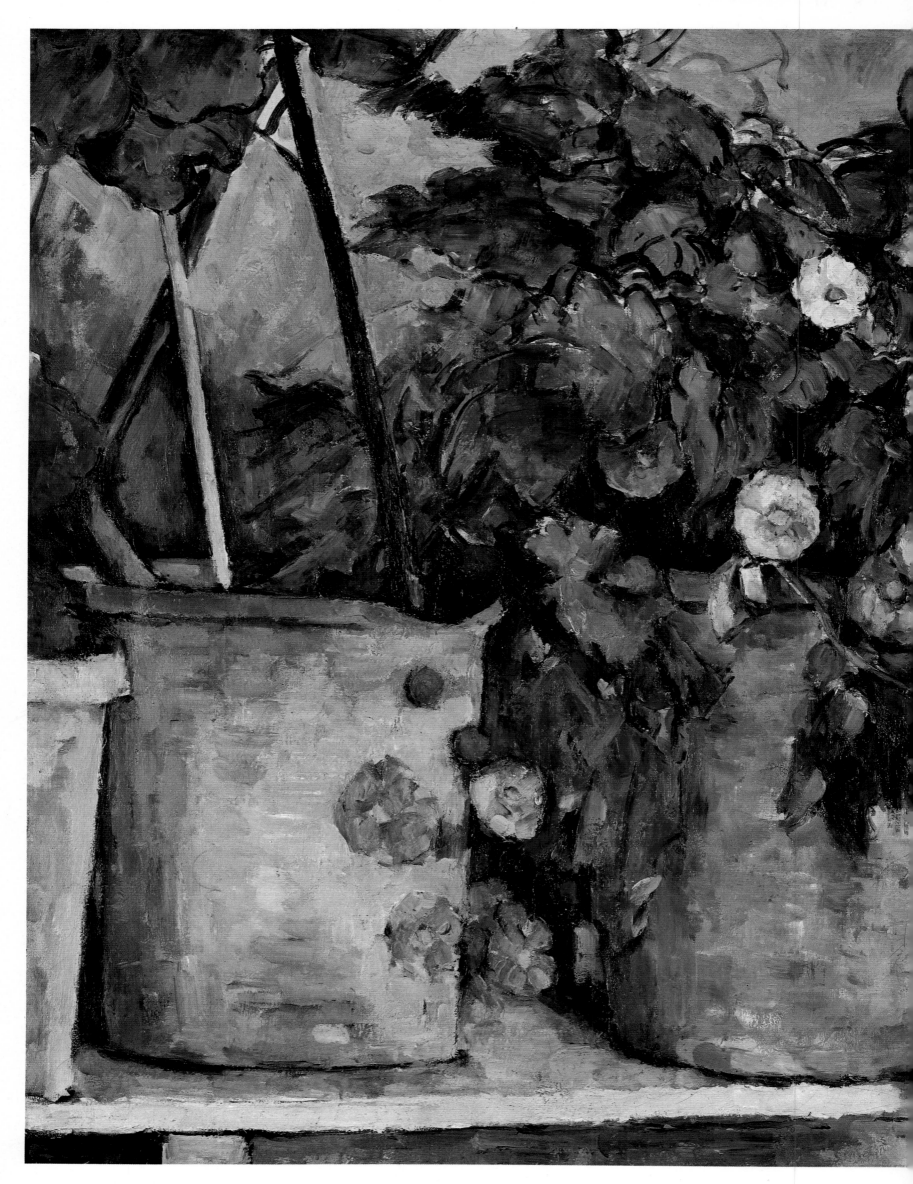

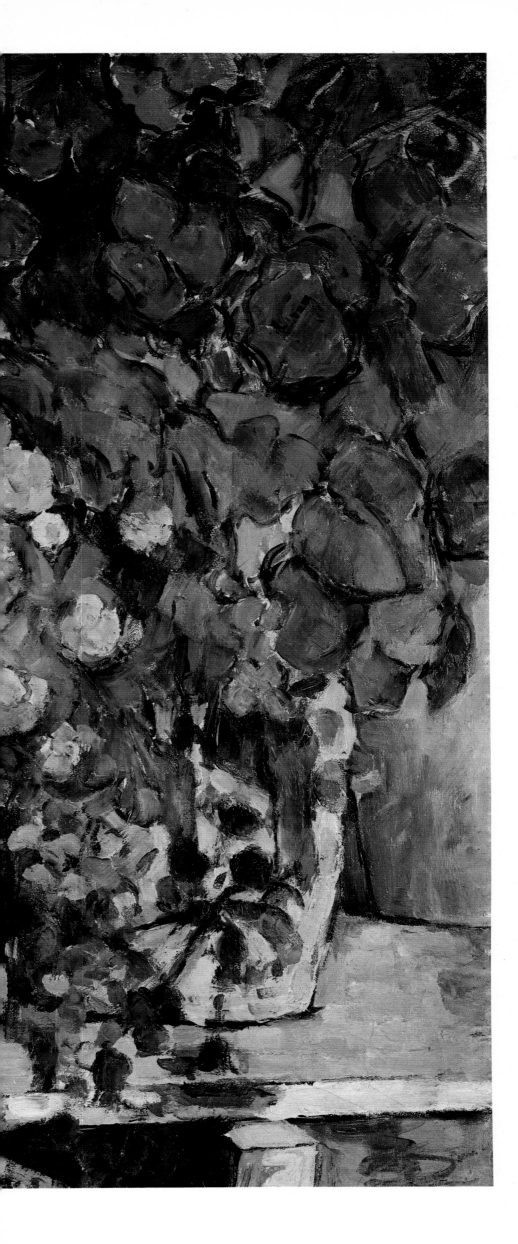

The Pots of Flowers, c. 1881-3

Oil on canvas
18⅛×21¼ inches (46×54 cm)
Private collection, Switzerland
Venturi 198

One of Cézanne's great artistic passions was for the work of Eugène Delacroix. In the middle of the 1840s Delacroix had produced a number of stunning flower-pieces that impressed Cézanne and had also influenced the work of Courbet and Degas. The canny dealer, Ambroise Vollard, seeking to court Cézanne and knowing his love for the artist, made him a gift of a Delacroix flower-piece in watercolor.

This particular flower-piece is more prosaic than any of the flower paintings produced by his contemporaries and is devoid of any romantic or allegorical overtones. He even fails to provide the usual wealth of color and form normally associated with the depiction of a mass of different blooms. Instead he presents the viewer with a rough wooden shelf, possibly in a potting shed or against a garden wall, with a number of simple plant pots placed in a line along its length. The cylindrical forms of the terracotta pots are established on the left-hand side of the canvas and then are gradually embellished by a modest cascade of petunias – simple pink blooms.

This painting featured in the epoch-making 1910 show at the Grafton Gallery, *Manet and the Post-Impressionists*, organised by Roger Fry, which marked the first large public showing of these artists in England.

95

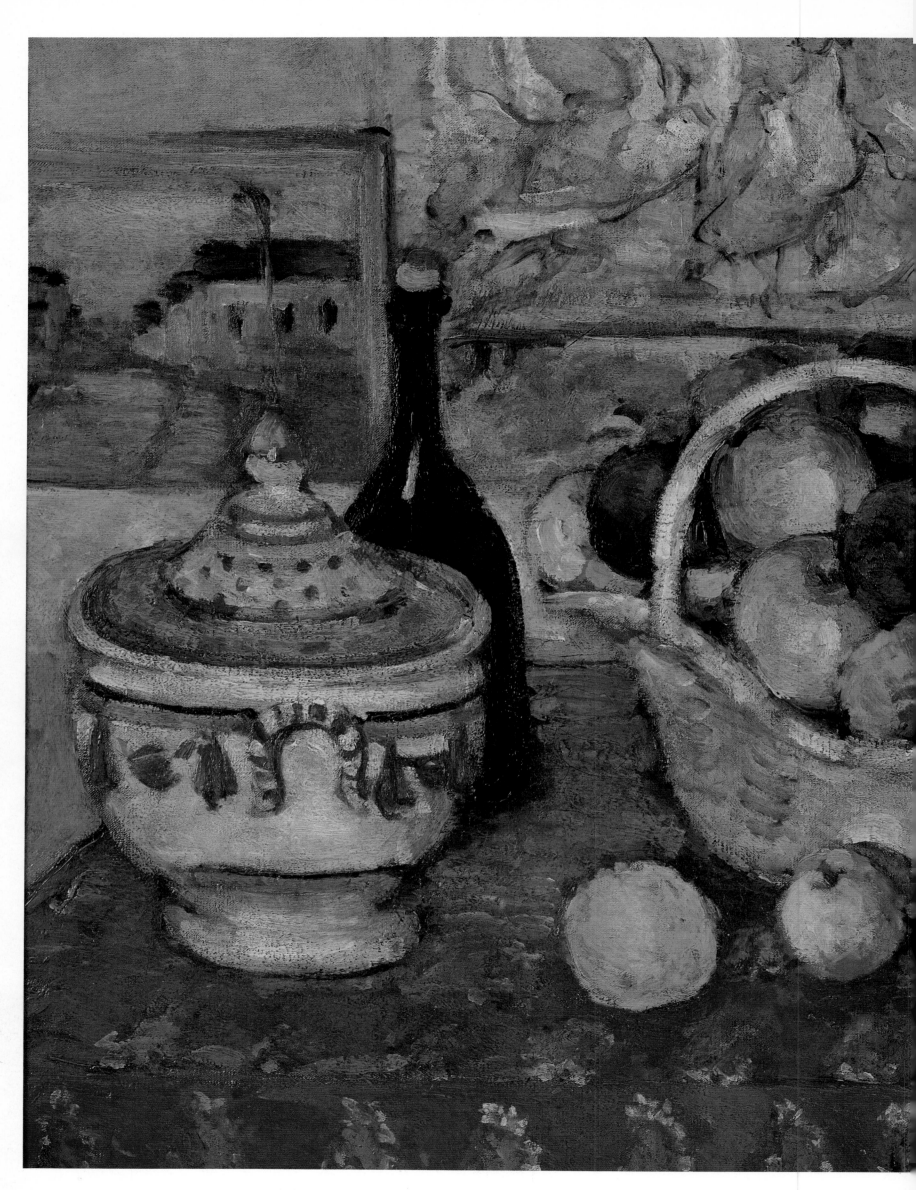

Still Life with Soup Tureen,
1883-5
Oil on canvas
25⅝×31⅞ inches (65×81 cm)
Musée d'Orsay, Paris
Venturi 494

Here Cézanne has built up a surface of dense pigment, each brushmark applied with equal power throughout the composition. His supreme skills as a decorative artist are sometimes neglected in favor of his obvious analytical powers. The rich, rugged surfaces of this still life have the same appeal as a well-mortared wall; the rich, clean colors the same rustic charm as the simple objects they describe. Here there is no pretension of any kind, just an incomparably joyous response to the sensual pleasures of the world. The emphasis of the picture creates a visual metaphor for the sense of taste and renders the edible visible. Cézanne presents a gathering of the attainable pleasures of food and drink, and glories in their simple structures, their weight, texture and color. As so often in the artist's works, the table surface is tipped to push the objects towards the viewer.

The blue shadows that fall on the wall at the lower right of the picture are repeated on the red patterned table cloth; oddly, the soup tureen is left unaffected by the laws of light and shade; its clean lines and solidity remain intact. Three pictures hang on the wall behind the table, two landscapes and a painting of a gaggle of geese; the geese add a welcome element of humor to the painting, and the colors of all three images pick up and form a counterpoint to the colors used elsewhere in the composition.

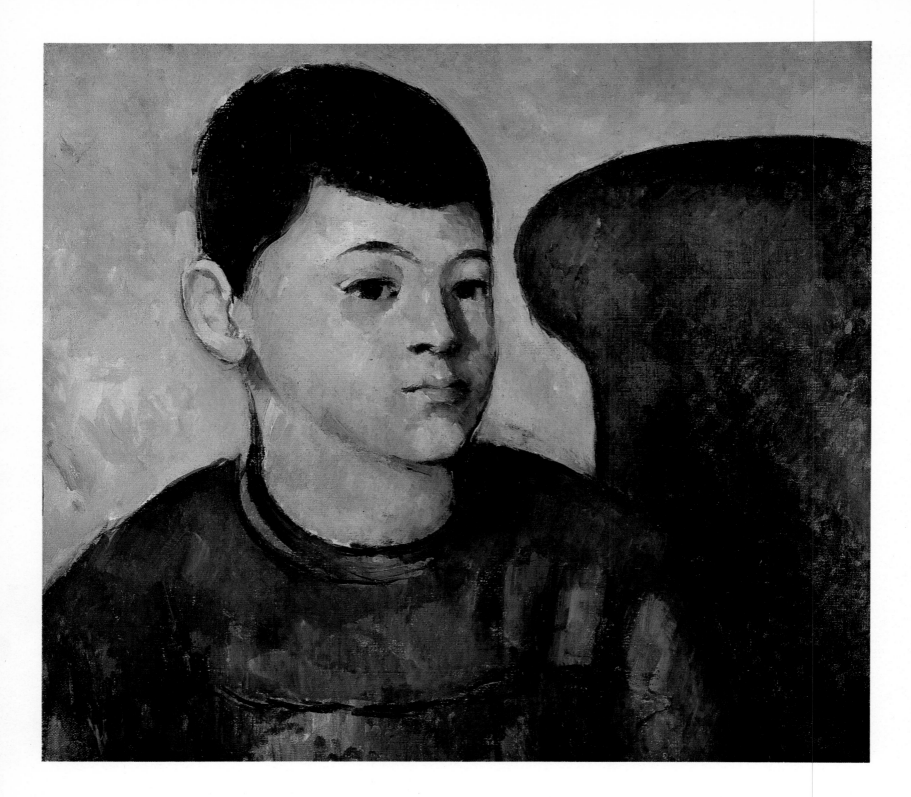

Portrait of the Artist's Son, Paul,

c. 1884

Oil on canvas
13¾×14⅞ inches (35×38 cm)
Musée de l'Orangerie, Paris
Venturi 535

The cool tonalities and the way in which the boy's head and shoulders balances the back of the armchair make this simple portrait one of the most appealing of all Cézanne's works. The artist reveals nothing of the young teenager's personality. Everything is reduced to essentials, the complex structure of the head radically simplified to an almost geometric series of rounded forms which echo and flow into each other. The arch formation of the shoulders supports the column of the neck and the blue/green of the boy's jumper is extended in an ambiguous fashion into the background, while adjacent to it the pale creamy green of the background infiltrates the collar area. Below the ear, the area of greatest tension in this quietly poised painting, a single dark patch breaks the contour of the neck, its distinctive silhouette leading the eye to the accents of green that dance above the shoulder. Pentimenti to the right of the boy's chin indicate Cézanne's decision to drop the line of the shoulder to correspond better with the line of the armchair and the broken curves drawn across his son's chest.

The care with which Cézanne has avoided any kind of highly charged atmosphere in this picture makes it ironic that it was precisely this format and compositional arrangement that Gauguin adopted for some of his most melodramatic portraits.

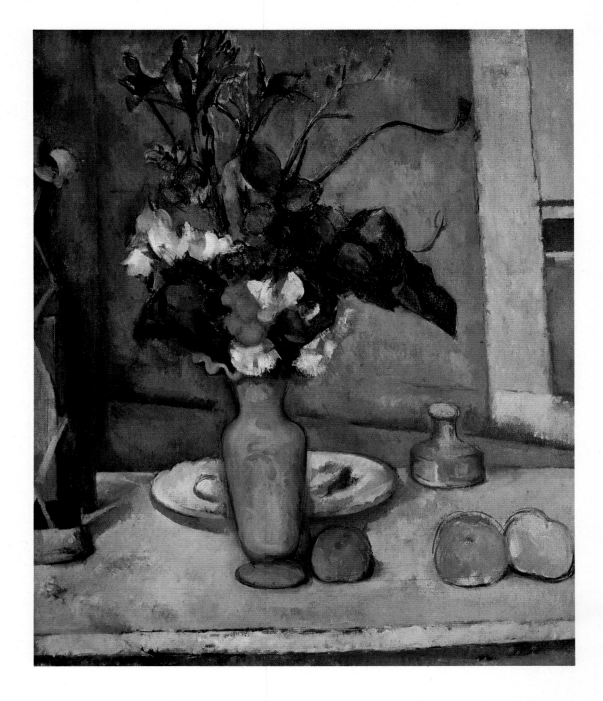

Blue Vase, c. 1885-7

Oil on canvas
24×19⅝ inches (61×50 cm)
Musée d'Orsay, Paris
Venturi 512

This famous painting is an exquisite harmony of blues and ochers. The blues range from the dense coloration of the irises to the blue-white of the carnations, while the warm tones shift from the blood red of the dado rail and the rose to the pale, watered-down orange of the fruit. It has been noted many times how Cézanne has set this blue vase so curiously off-balance. Every other element strains to hold it upright; the major verticals lean into the picture to bracket it within the variegated blue of the studio wall, while the conflicting diagonals balance the spread of foliage and petals that splay from the frill-shaped top of the vase. The plate behind the vase seems to have been pulled apart, the better to echo the base of the vase and, perhaps, to persuade the viewer subconsciously to reform it, so falling into the trap of thinking that it is an object that can be reconstituted

and not merely artfully arranged in pigment laid on canvas.

Cézanne's delight in the humble beauty of flowers and the edibility of fruit is clearly evident in this work. The subjects of his still lifes ache to be handled or consumed and, in their effort to achieve this end, sometimes suffer distortion. The magical qualities of Cézanne's technique and color control may be appreciated in the way the body of the vase detaches itself from the table top, plate and studio wall. Its contour lines are not one but many. Vertical striations of blue delineate the surface of the vase; as it slips away from our sight the bounding line, on first viewing so absolute, breaks into a plethora of separate sensory notations. On the right of the vase, below its shoulder, a strong trace of white asserts itself, obliterating the fine traceries of blue that shimmer about its fullness.

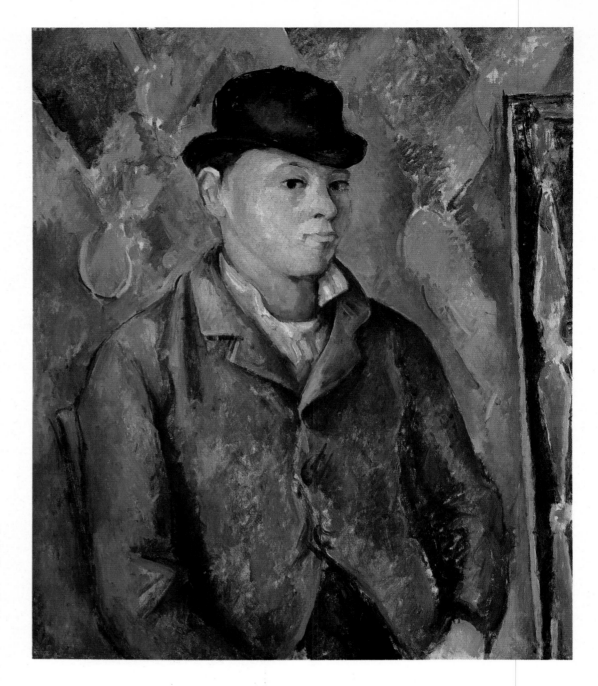

The Artist's Son, Paul, 1885-90

Oil on canvas
25¾×21¼ inches (65.3×54 cm)
National Gallery of Art, Washington
Venturi 519

Some three years after this portrait was
completed, Paul dressed as a harlequin to
please his father (page 112) but here he
wears the everyday clothing of the period,
although the patterns and coloration to be
found in the theatrical costume are already
here in the wallpaper and screen that sur-
round him. The screen, which appears in
several of Cézanne's paintings, acts as a
geometric and coloristic counterpoint to
the soft malleable folds of Paul's loosely
brushed-in form.

Cézanne has made use of one of his favo-
rite poses, one shoulder set at an angle to
the canvas surface and the head placed at a
slight diagonal, at variance to the set of the
shoulder, thus causing the neck muscles to
form a straight edge, set off against the soft
folds of the sitter's clothing and the arched
formation of the jaw. The artist has caught
the jaunty cockiness of his son's expres-
sion, the pertness of the upper lip. The
round form of the head slips effortlessly
into the hat, despite the fact that, at the
stage at which Cézanne has left the paint-
ing, the rather battered profile of the crown
has been set directly in line with the edge of
neck, making the hat several sizes too
small or the head several sizes too big. In
fact, this serves to push the features out
from the canvas plane into the imagined
space that separates the viewer from the
subject. Open displays of emotion are rare
in Cézanne's work but, looking at this can-
vas, it comes as no surprise to learn that
Cézanne deeply loved his son, and sup-
ported his idle way of life until such time as
he could earn a living from selling his
father's work.

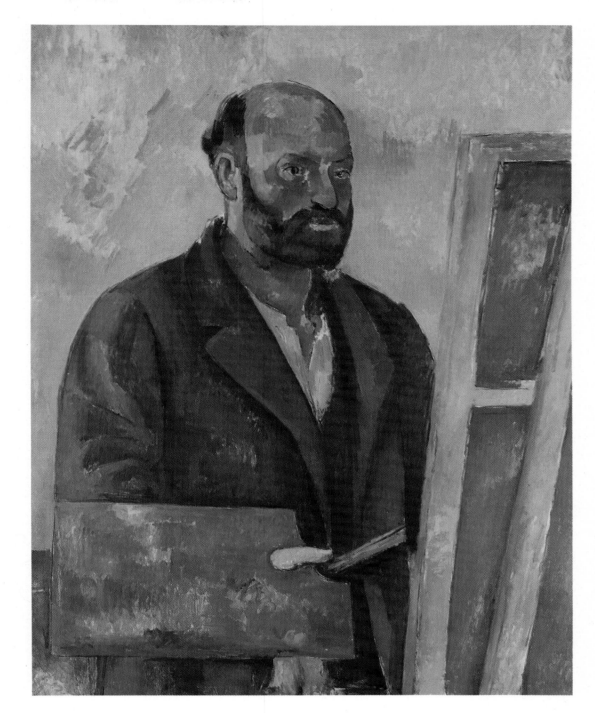

Self-Portrait with Palette, 1885-7

Oil on canvas
36¼×28¾ inches (92×73 cm)
Foundation E.G. Bührle Collection,
Zurich
Venturi 516

Rigorously structured, this formal 'self-portrait as artist' is the closest Cézanne ever came to a formulaic painting. The neatness with which he tucks the palette edge into the bounding silhouette of his tombstone-shaped figure is perhaps a little forced, but the positioning of the palette so that it stands up against the canvas surface reflects what must surely be one of the major themes of this painting – the essential artifice of the painter's craft. In almost heraldic fashion, the artist displays his palette to the viewer, his thumb and brushes indicating the canvas, the very one that we are examining. Cézanne presents himself to his audience as an artist in the way that so many twentieth-century painters were to do and openly displays the tools by which his art is fashioned.

The painting was produced with the aid of a mirror and something of the flattening characteristics of its reflective surface have found their way into the composition. The mirror reflexion also gives the impression that Cézanne was left-handed, which of course was not the case. The familiar dome-shaped cranium of the artist is repeated in the rounded forms of his shoulders. Although Cézanne seems not to have admired Ingres particularly, he shares with that artist an obsessive need to wilfully distort the human form. He delighted in the supporting function of the shoulder and the articulation of the neck and head, as they emerge from the containing layers of clothing.

Montagne Sainte-Victoire, 1885-7

Oil on canvas
26⅜×36¼ inches (67×92 cm)
Courtauld Institute Galleries, London
Venturi 454

Mountain peaks have often been used as
metaphors for spiritual attainment, moral
purity and as testing grounds for the limits
of human endurance. In a sense Mont
Sainte-Victoire adopted these roles for
Cézanne. It was in his series of canvases
depicting the mountain range that he
realized his greatest achievement in land-
scape painting.

Cézanne was a deeply religious man,
and had been a practising Catholic from at
least the 1880s; however his belief in God
was not restricted by the tenets of the
Catholic church but tended toward pan-
theism, encompassing the whole of nature.
This depiction of the mountain is relatively
earthbound. The valley of the Arc is laid
out before the artist; its cultivated fields,
distant houses and viaduct state clearly the
civilizing presence of man on the land-
scape. The foliage of the pine unfurls
across the sky like a banner, following the
undulations of the distant mountain's sil-
houette and weaving the foreground into
the far distance in a series of harmonious
patterns.

Mont Sainte-Victoire had originally
appeared disguised as the entry to the
underworld in *The Rape* of c. 1867 (page
37) and, a little later, as a modest stabiliz-
ing element in *The Railway Cutting* of 1871.
From the late 1870s Cézanne became
aware of its potential as a motif and paint-
ings, drawings and water-colors of its gray-
blue mass begin to occur in his art. No less
than 100 versions of it in various media are
known to exist.

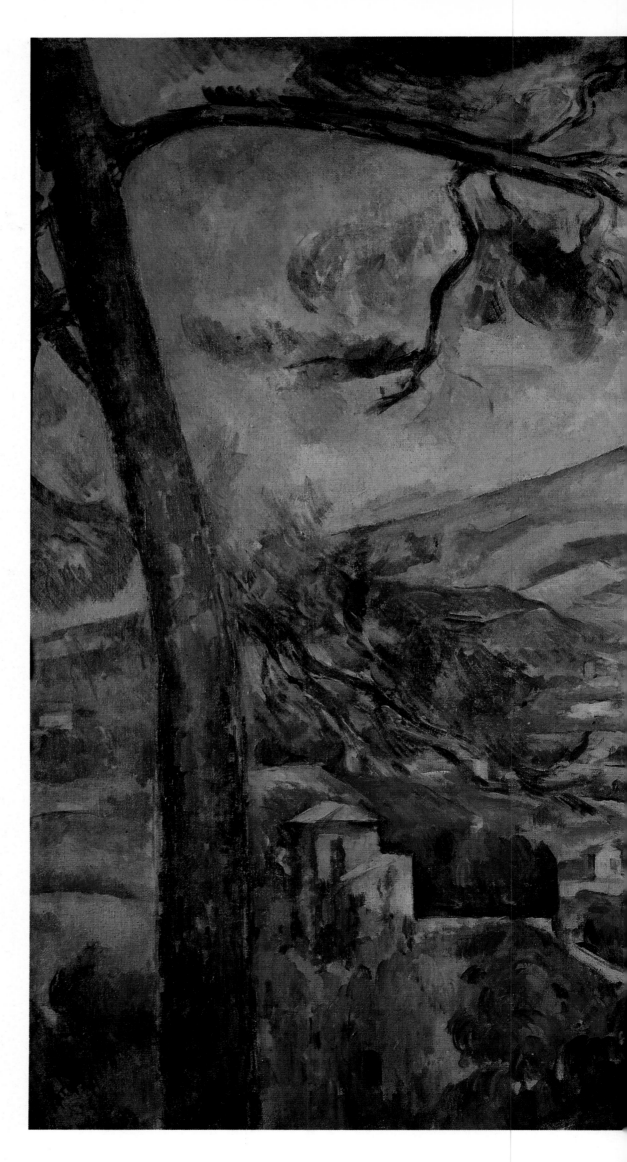

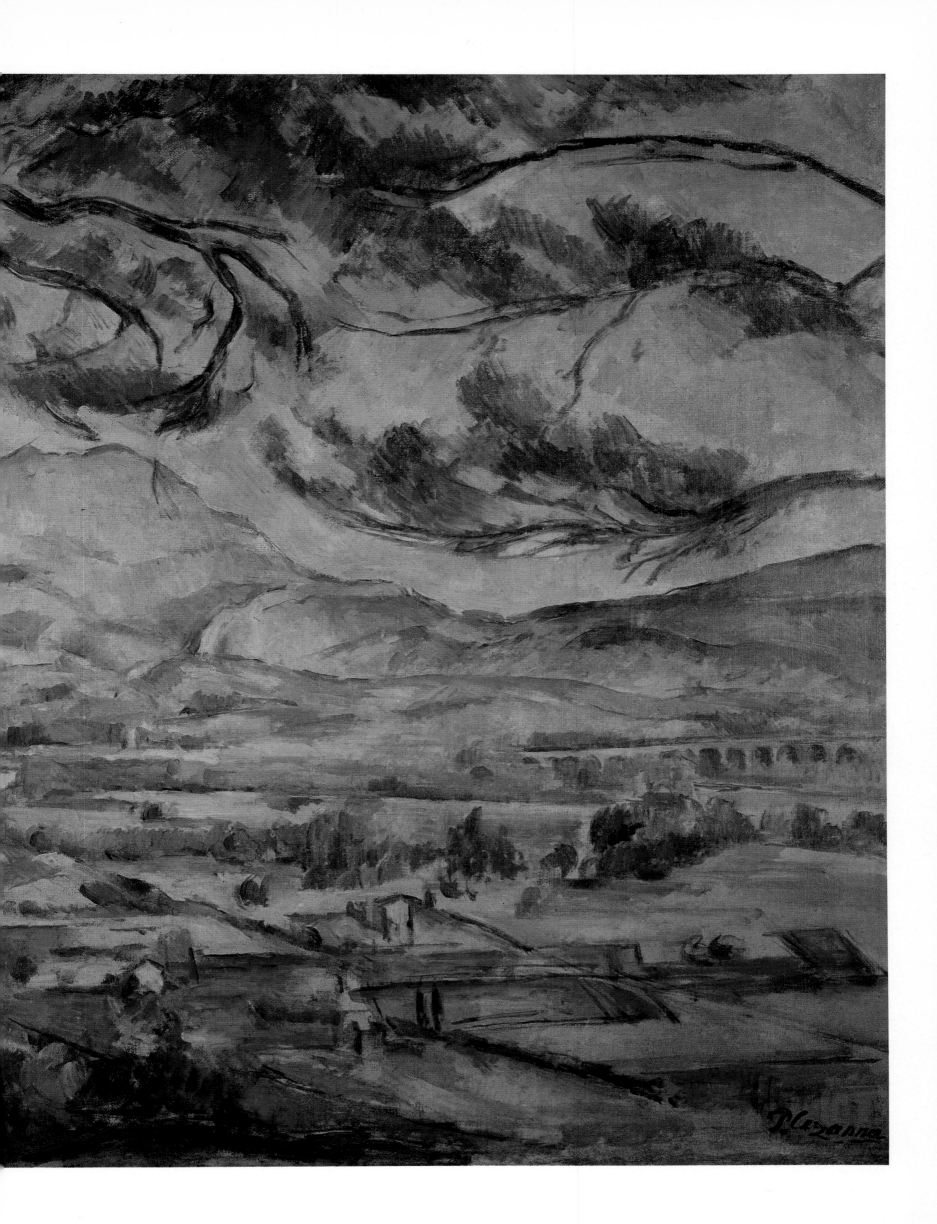

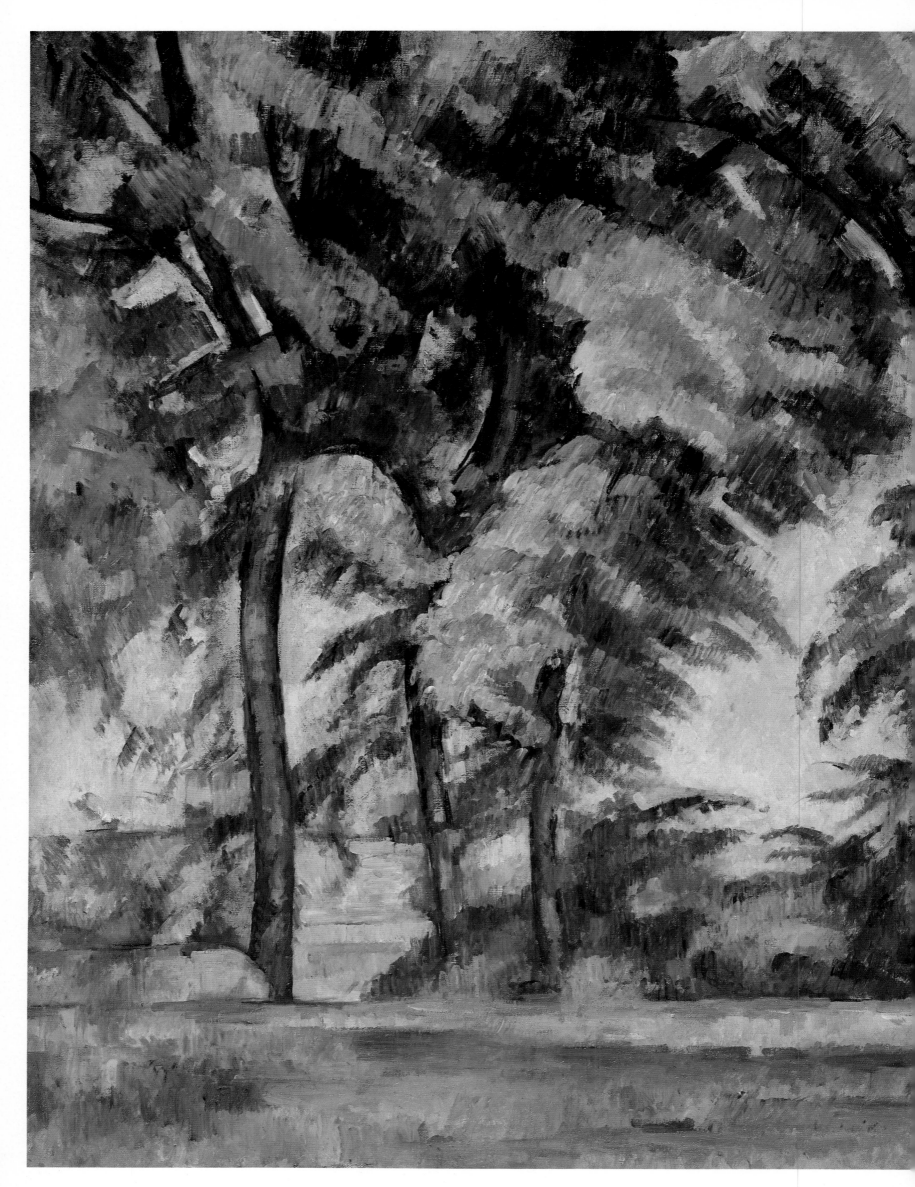

Tall Trees at the Jas de Bouffan,
c. 1885-7

Oil on canvas
25¾×31⅞ inches (65×81 cm)
Courtauld Institute Galleries, London
Venturi 475

Cézanne's bold use of a sustained regular stroke brings every element of the trees forward to the viewer; the relative lack of finish gives the whole image a refreshing sense of immediate revelation common to real experience. Qualities of recession and distance are abandoned in favor of a frieze-like presentation which is animated by the coloration and rhythmical movement of the leaf-laden branches. Painterly means are used to suggest the basic structures of nature, which are usually only revealed after a prolonged examination. At first sight Cézanne's palette seems limited and his composition simple. In fact, while the browns and ochers, blues and greens are true to the local color of the scene (essentially the trees are brown, the leaves green and the sky blue), each color contains innumerable hues within it.

The wall and building situated to the left of the canvas is balanced by similar coloration on the right-hand side, but the buildings described here fall away into the far distance, pushing forward the group of tall trees. The red-browns of their trunks stand out strongly against the green of the foliage and the pale blues of the sky. The low horizon line further emphasizes the monumental stature of the trees; a number of horizontal bands are broken by the vertical structure of the trees and modified by the sweeping movements of their foliage. The strong arabesques that define the major movements of the tree's canopy are made up of hundreds of separate brushmarks, the movements of which parallel the path of the breeze as it moves through the branches.

The Village of Gardanne, 1885-7
Oil on canvas
36¼×29⅜ inches (92×74.6 cm)
Brooklyn Museum, New York
Venturi 431

The dominance of the major buildings of the village are subordinated to the overall pictorial design. Cézanne has focused his concentration on the scene as a whole, and lightly sketched in the main architectural and natural elements in thin blue or black paint before beginning to build up his image. No central theme dominates the composition; our eyes, with those of the artist, wander across the entire visual field presented, enjoying the coloristic and volumetric relationships that this distinctive scene offers the viewer. A relatively limited color range helps establish the compositional unity of his design. Cézanne later described the process of painting to his young friend Joachim Gasquet, interlocking his hands to demonstrate the coherence and strength of his painting technique; nothing that is not essential for the coherence of the picture is admitted; every element plays its part in the harmonious ordering of the composition to make it as strong and whole as the natural world he loved so much.

The architecture is ruthlessly simplified, the rich ochers and warm reds set off the tapestry-like effect of the variegated shapes and shades of green that half hide the buildings. The distant mountains and the shadows are washed in thin blue or lilac. The high viewpoint above the olive trees, looking across at the steep hill surrounded by box-like houses, has allowed the artist to animate every part of the picture area. The surface has not been covered entirely with pigment. The cream priming of the fine canvas and the light calligraphic underdrawing may be clearly seen, enabling us to appreciate Cézanne's slow and gradual progress towards 'realization' of his subject.

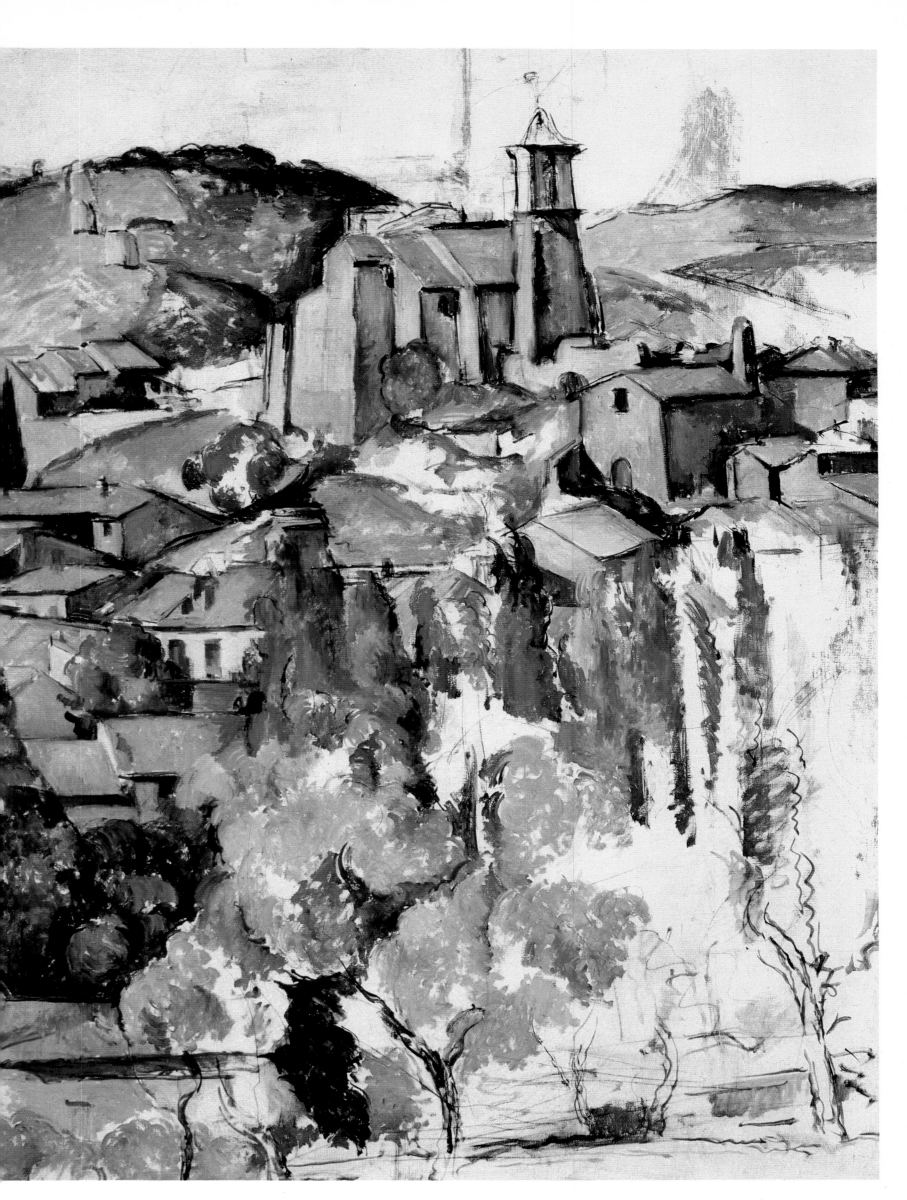

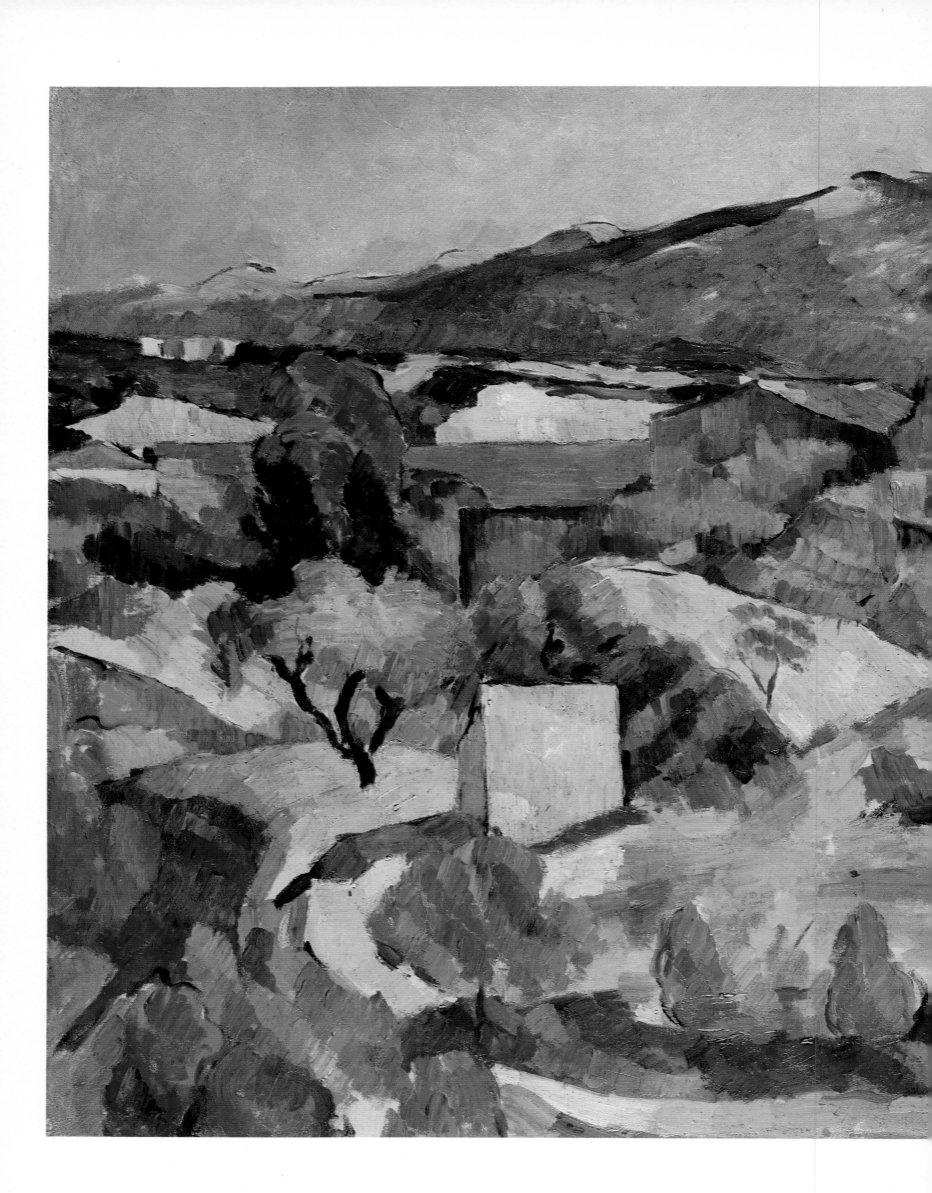

Mountains at l'Estaque, 1886-90

Oil on canvas
21¼×28¾ inches (54×73 cm)
National Museum of Wales, Cardiff
Venturi 490

Cézanne has stood with his back to the coast looking across the ocher landscape towards the mountainous region of the '*chaîne de l'Estaque*', which separates Marseille and the coastal area from the region of Aix. The picture was painted on cream-colored, prepared paper which was later mounted on canvas. Painting on such a support was common practice with many eighteenth and early nineteenth-century landscapists, who produced sketches on these easily portable supports, painting the final version of their landscape on canvas in the studio. The 'unfinished' nature of this painting suggests that it was painted entirely in the open air. The cream of the background is used as a color in its own right and supplied the highlights that Cézanne may have intended to apply at some later date. The same practice of using the ground as a positive means of modeling may be found throughout his work, and often the most thinly painted area of a canvas represents an area of special pictorial significance.

The composition is boldly formed within the rectangle of the painting area and, through a system of steps as carefully charted as anything Poussin invented, the artist leads us down the roadway, behind the building and on into the distant countryside via a series of related arcs that take us into the depths of the landscape. This strong compositional order is matched by the strictness of his color application. The cool colors aid a sense of recession, the warm colors appear to advance towards the viewer; by a skilful juxtaposition of blues and oranges, Cézanne gives the picture a convincing sense of distance without sacrificing anything of the work's strong pictorial order.

Cézanne's use of clear bright colors and generalized forms renders his landscape easily comprehensible, with each separate element linked to the whole by a subtle balance of repeated shapes and echoing forms. The scene may be read naturalistically and enjoyed as an evocation of the heat and glare of the Provençal landscape or, at the same time, may be appreciated for its rich surface pattern of color and texture.

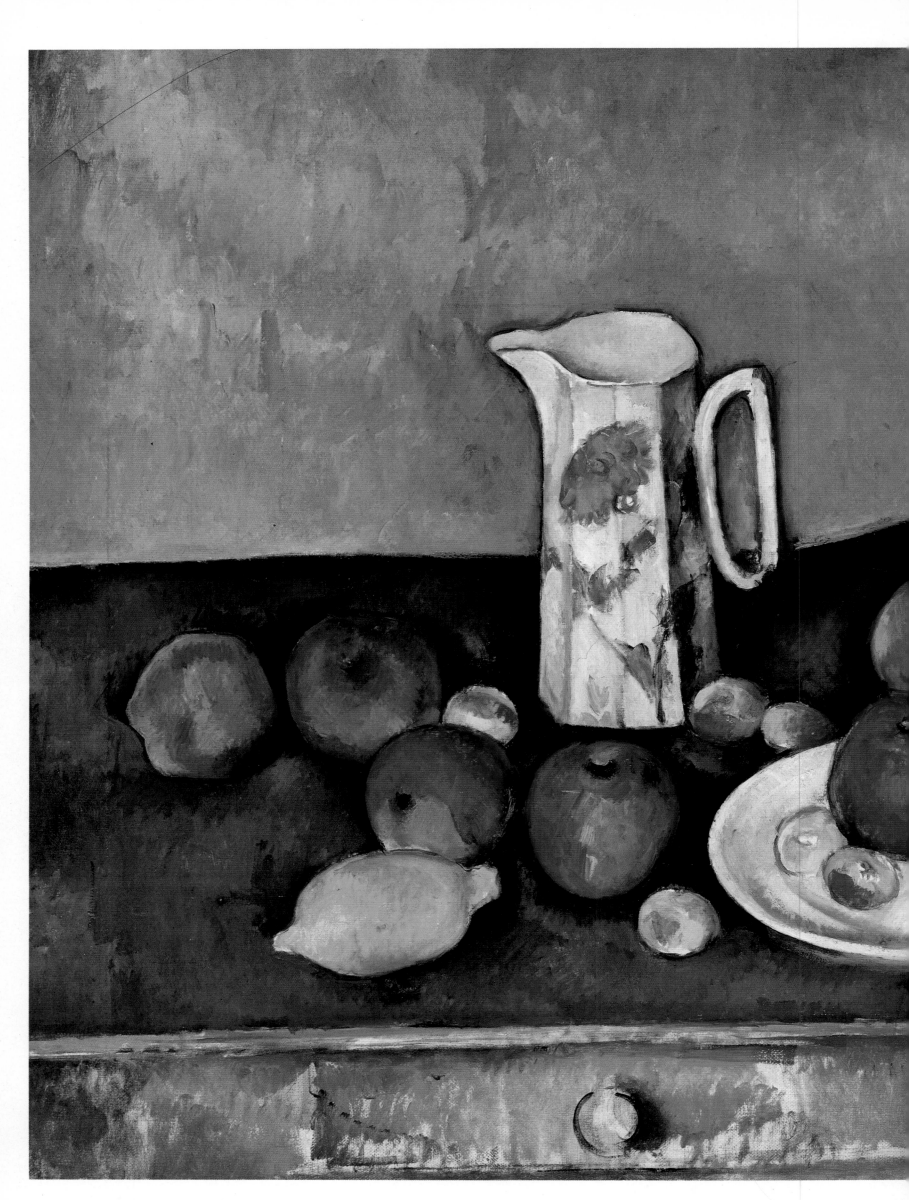

Still Life, 1886

Oil on canvas
28¾×23⅝ inches (73×60 cm)
Nasjonalgalleriet, Oslo
Venturi 593

The strong physical presence of these objects contrasts markedly with the ambiguity of their surroundings. The broad band of the dado rail intercepts the rectangle of the table top at the precise point where the silhouette of the white milk jug breaks the horizontal of the table edge. The table top is lifted up towards the canvas plane, while the side of the table is presented at eye-level; these opposing viewpoints are reconciled by Cézanne's strong pictorial design and the repetition of forms sprinkled throughout the composition. The circular knob of the cupboard is echoed in the small rounded fruit, while the distinctive shape of the lemon recurs in the pattern of the jug and again in a variant form in the contour of its rim. A small bunch of violets balances the painted flower on the jug and picks up the faded blues of the wall. The table top is painted in a variety of directionally placed patches of modulated earth colors, with touches of red and blue enlivening the contours of the fruit.

Still life was a popular and saleable genre in the nineteenth century. Cézanne, uninterested in the commercial aspects of his profession, was fascinated with the genre for other reasons. The same team of objects feature again and again in his still lifes; he must have regarded them as old friends. Unlike his human subjects, they did not move or shift position. Cézanne was a slow worker and often his fruit would wither and rot before his picture was completed – hence the use of silk flowers and wax fruit in some of his paintings. The violets in this picture could well be artificial. Equally important to Cézanne was the relatively prosaic nature of the genre. He could settle down before a still life and not be disturbed by the awesome significance of his subject matter, something he could not do with his paintings of bathing figures. Still life painting depends on a one-to-one confrontation with simple physical facts in a setting controled by the artist, and does not therefore carry the same intellectual connotations as an allegorical figure composition.

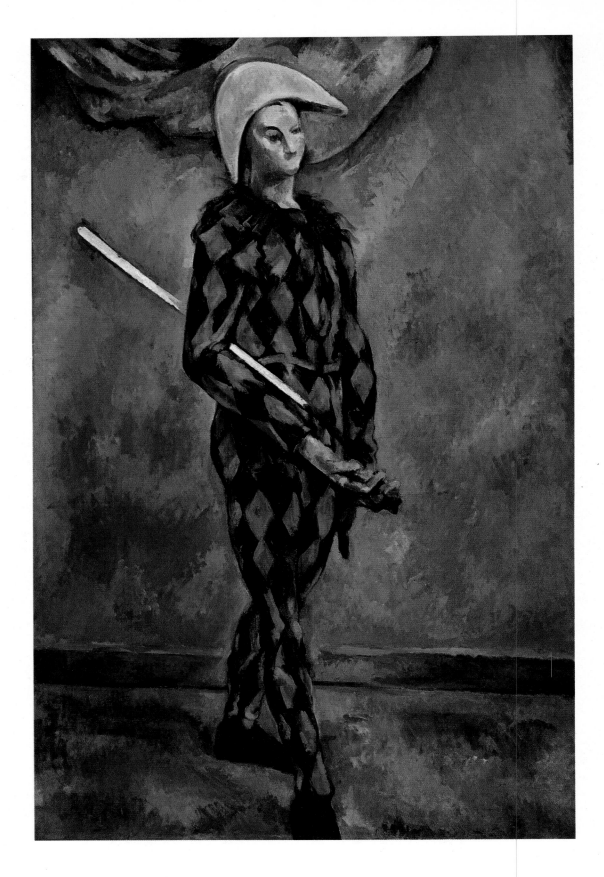

Harlequin, c. 1888-90

Oil on canvas
39¾×25⅞ inches (101×65.7 cm)
National Gallery of Art, Washington
Venturi 554

This is one of the few costume pieces that Cézanne painted. The figure of the harlequin and the *Commedia dell'Arte* characters of which he was one fascinated French poets, writers and painters from the eighteenth century onwards. They feature prominently in the work of Watteau, Daumier and popular artists of the day like Thomas Couture and were to play a major role in the work of the young Picasso.

Three versions of this single figure composition survive, each in a similar pose, although this is the only one to make use of a white baton. Against a mottled background made up of muted mauves, greens and blues stands the elegant figure of the harlequin, dressed in a distinctive red and blue-black costume. His attenuated form and the decorative qualities of his costume distract the viewer's attention from the elegant deformations of the young man's anatomy. His hands, at the end of impossibly elongated arms, are clasped before him, fingers interlocked. Unlike any of his contemporaries, Cézanne refused to suggest any kind of narrative in order to enrich his composition. This is no harlequin strutting the stage but a model, posing in the artist's studio, dressed in this costume and kept in this pose by the desire of the artist. Yet the off-set gaze of the acrobat and, above all, the freely applied patches of modulated color that cover the canvas surface suggest an elegiac mood far more strongly than the more overtly sentimental canvases of Cézanne's contemporaries.

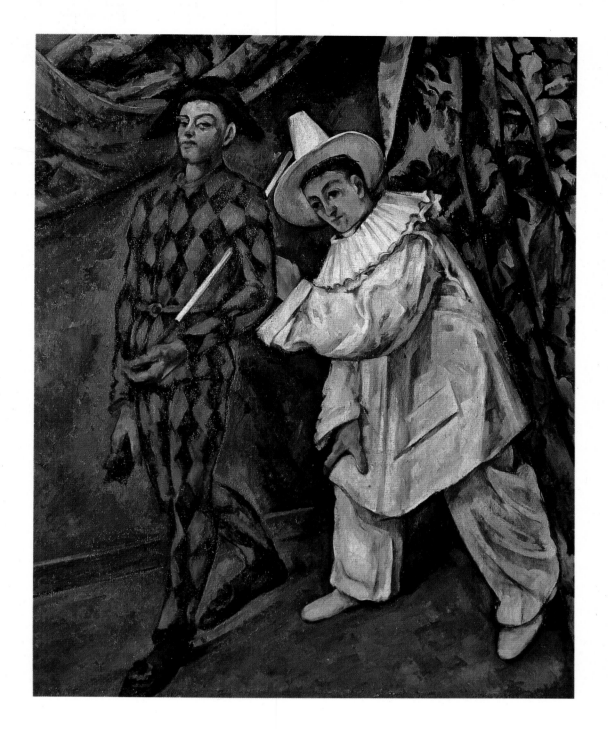

Mardi-Gras, c. 1888

Oil on canvas
15⅜×34¼ inches (39×87 cm)
Pushkin Museum, Moscow
Venturi 552

Here the artist has commandeered the previous painting of the single harlequin and introduced it into this more ambitious canvas. His son Paul is the model and the additional pierrot figure, posed by his son's friend Louis Guillaume, introduces a note of drama into the picture which is sustained not only by their magnificent costumes but also by the gulf that separates their two expressions. Paul gazes down on the spectator with a rather supercilious look which is at odds with the more open expression of his friend. The relationship of the two figures is intriguing, the actions of the pierrot ambivalent; the pose seems clearly adopted for the convenience of the artist rather to further any kind of narrative. The abrupt juxtaposition of the two

figures sets up a series of *frissons* that are impossible to resolve, however often we return to this enigmatic canvas. The title *Mardi-Gras* suggests that the two young men are on their way to a carnival, and before leaving have spontaneously struck the attitudes their fancy dress has suggested to them.

This painting is an expression of the artist's desire to produce major figure compositions equal to the works he admired in the Louvre (the most obvious examples of this ambition are his Bather compositions). There is no record of how he regarded this canvas; possibly he found the motif of the card-players, which he was working on at the same time, a less theatrically charged subject to develop.

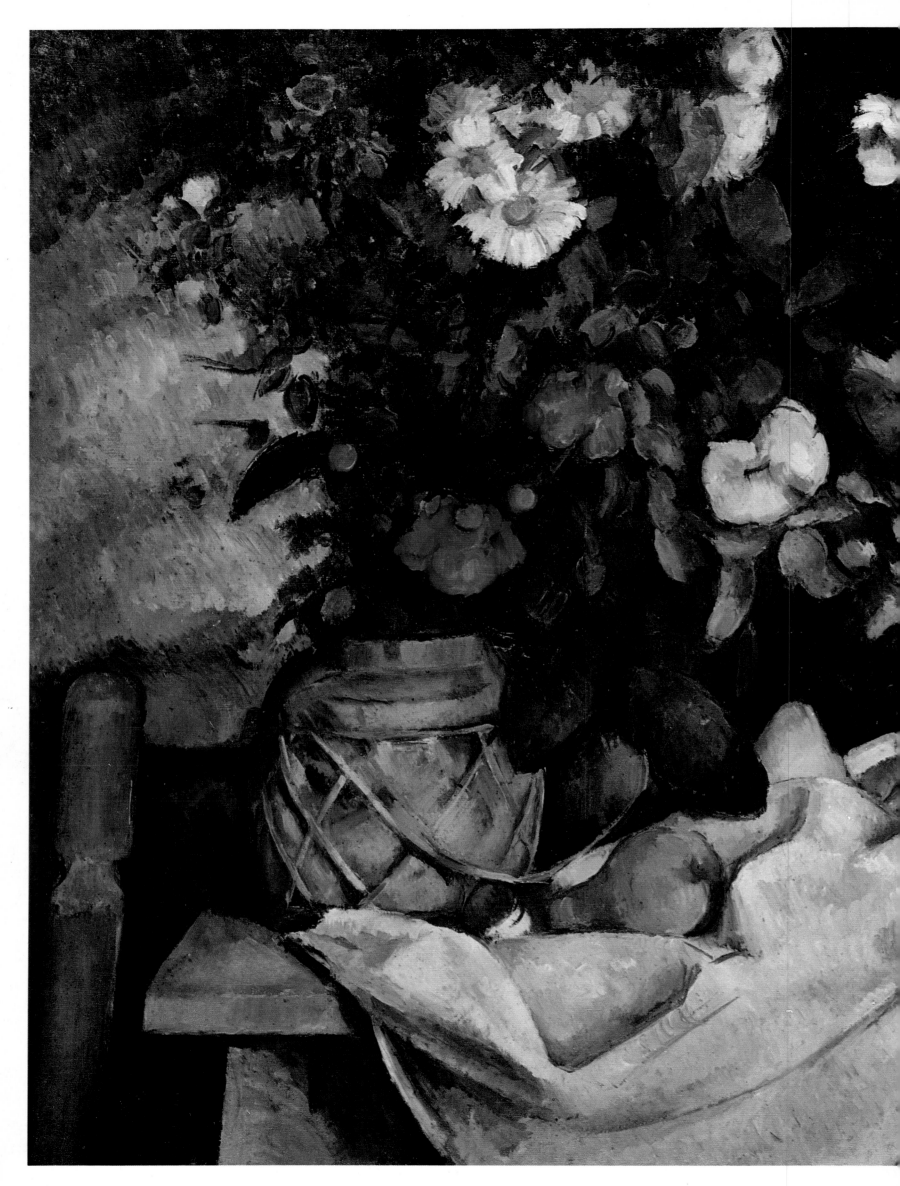

Fruit and Vase, c. 1888

Oil on canvas
24¾×31⅛ inches (63×79 cm)
Nationalgalerie, Berlin
Venturi 610

The familiar ginger pot is seen against a splendid spray of simple flowers, their delicate petals and leaves contrasting with the round solidness of the fruit that lies among the carefully organized drapery. To the left of the canvas the background is painted up to the flower heads, defining their contour lines, and as the eye crosses the lilacs, pinks, reds and greens of the flowers, the coloration of the wall shifts to echo the green of the foliage before developing into cool lilac tonalities. The back of the chair continues the ocher of the rim of the pot and the color of the table, while the deep blues of the bottom right-hand corner balance the dark tones of the empty upper left of the composition.

Like Degas, Cézanne had admired Delacroix's paintings of flowers (see Introduction) and has here made use of his disposition of forms and colors to create a rich and complex interplay of formal values. As in so many of his still lifes, artifice is clearly evident; the drapery is held up by an unseen support to create a balance for the bulk of the ginger pot. A major diagonal intersects the line caused by the fall of light green foliage and is continued through the secondary fold in the drapery that moves towards the bottom right of the picture. Deep in the heart of the flower arrangement, strong blues silhouette the blood red and soft pink of the blooms.

115

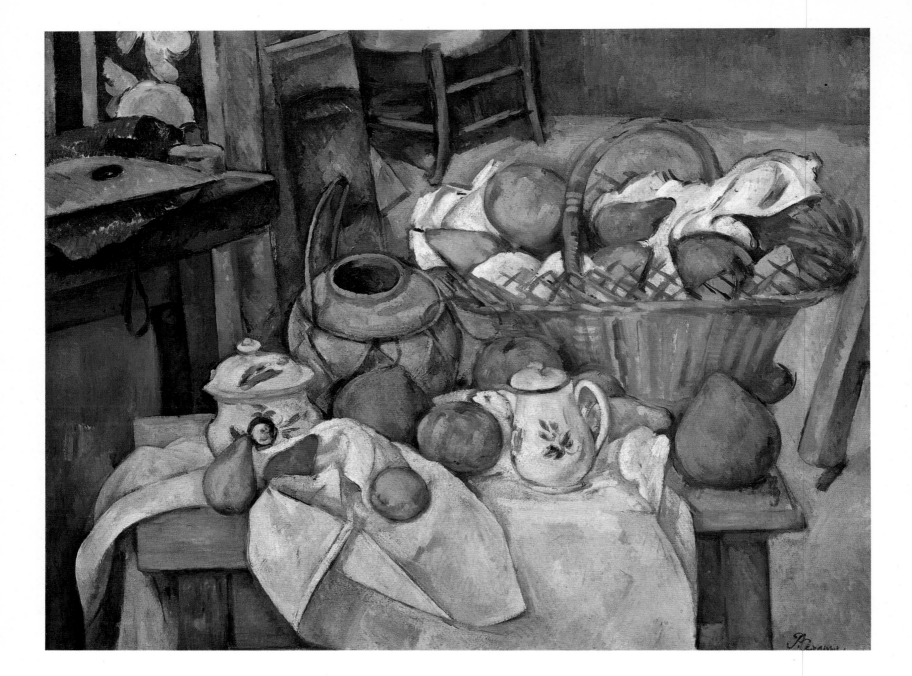

Still Life with Ginger Pot,

c. 1888-90

Oil on canvas
25½×31⅞ inches (65×81 cm)
Musée d'Orsay, Paris
Venturi 594

These objects are presented to the viewer with a complete disregard for the traditional rules of perspective. The wicker basket laden with fruit is precariously balanced on the corner of the table; next to it a ginger jar is in a similar predicament. The size of the objects seems to swell or diminish at the artist's will, according to their function within the composition. The viewer is encouraged to feast his eyes on this rich array of sensual delights. A progression of forms circulates around the control motif, moving across the open space to the far corner of the studio, where a chair breaks the sharp angle at the convergence of the two walls. A decorated screen, a table, a canvas and the chair track this diagonal, which leads into the horizontal of the far wall; an unspecified leg with its odd shadow acts as a *repoussoir* to stop the still life tumbling out from the canvas edge.

One of the pleasures of looking at a Cézanne painting lies in exploring the series of relationships which the artist portrays, both those organized between the objects laid out before him and those that must have developed in his own mind during the picture's creation. Cézanne said that 'painting is not the servile copying of objects, but the discovery of harmony among numerous relationships'. His tremendous appetite for visual sensations necessarily led him to distort the traditional means of representation which, in western culture, tends to set the objects represented into the middle distance of the canvas space. The relative frontality of his early still lifes from the 1860s (pages 30 and 31) has been exchanged for a higher viewpoint and for a manner of painting more in accord with his own experience and reactions as he painted the objects before him.

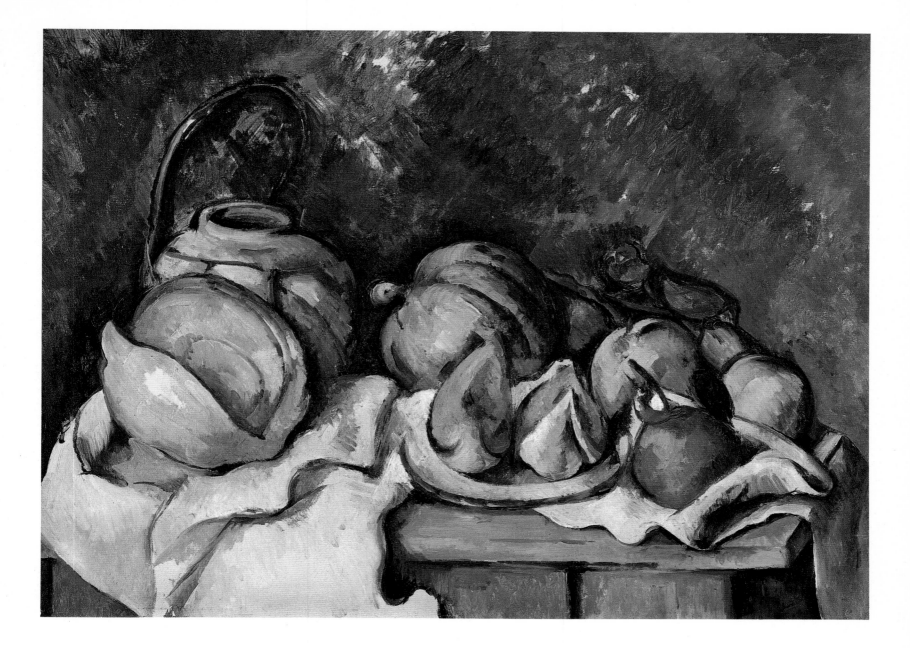

Fruit, Still Life, 1890-4

Oil on canvas
13×18⅛ inches (33×46 cm)
Private collection on loan to National
Gallery, London
Venturi 595

Within this firmly structured composition, shapes rock against each other like boats in a harbor. The curvilinear forms of the fruit and ginger pot are set against the rectangular geometry of the table. Warm and cool colors are juxtaposed to create a complicated series of color relationships.

The loosely painted background is laid in with strong diagonally-based zigzag movements, suggesting a soft, malleable space which enfolds the objects on the table as surely as the drapery upon which they rest. The ginger pot picks up, in lighter pitch, the cool tones of the background and establishes the roundness and fullness that is the *leitmotif* of the composition. The dilute nature of Cézanne's paint is evident in the drips that may be discerned in several places across the canvas. The blue lines that define the contours are firmly stated and used to emphasize the linear rhythms that flow through the picture. The drapery is rarely a clean white but is built up with varied strengths of blues, yellows, reds and greens.

Cézanne's still lifes are filled, as one might expect, with the produce of the locality, easily available from the markets of Aix, and so to an extent may be read as celebrations of Provençal life.

The Card Players, c. 1890-2

Oil on canvas
17⅝ × 22½ inches (45 × 57 cm)
Musée d'Orsay, Paris
Venturi 559

On either side of a bottle of wine the two men sit, arms resting firmly on the table, hands enclosed around their cards. This work, like its partner in the Courtauld Institute collection, is more discreetly painted than the later version (page 130); the descriptive attitude of the latter is exchanged for a more generalized and timeless interpretation of this age-old pastime. Cézanne has eliminated any unnecessary detail from the picture, reducing the composition to its absolute essentials; nothing disturbs the inner concentration of these two men locked together in some strange social ritual. Their forms are grandly conceived, their bodies reduced to the simple cylindrical forms that so impressed the twentieth-century artist Fernand Léger, who saw Cézanne's work for the first time in 1910. He admired their apparent solidity and the strange shifting of forms, and introduced these features into his own work.

The overall impression of the composition is one of symmetry, but nowhere in the painting does any one form directly balance another. The apparent restraint shown in his colors is deceptive, as patches of lilac and green work together with the priming of canvas to enliven the sobriety, while areas such as the tablecloth have deep within them touches of strong color. Cézanne's delicate and sensitive placing of his colors, and the subtlety of his compositional sensibility give his canvases of the card players an indefinable aura that we associate with the intimate works of Rembrandt and Vermeer.

Many possible sources have been suggested for this work; one of the most intriguing is a small vignette (page 15) by the illustrator Gavorni in his *Masques et Visages* published in 1860. Whether Cézanne would have been familiar with this tiny image tucked away in a popular book of contemporary mores is debatable. Its significance lies rather in the undeniable, if fortuitous, formal parallels between the two.

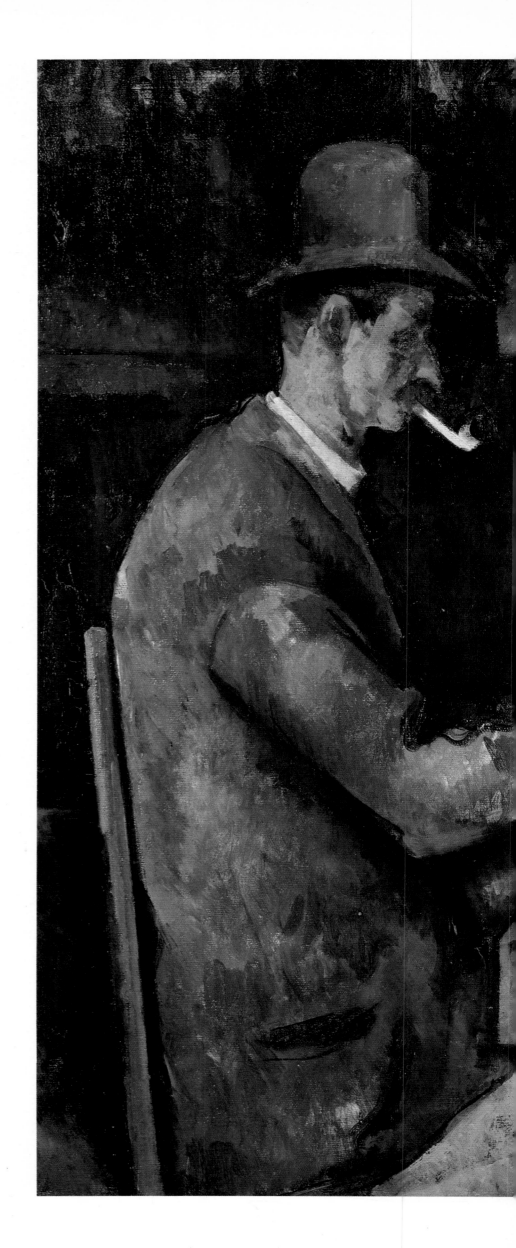

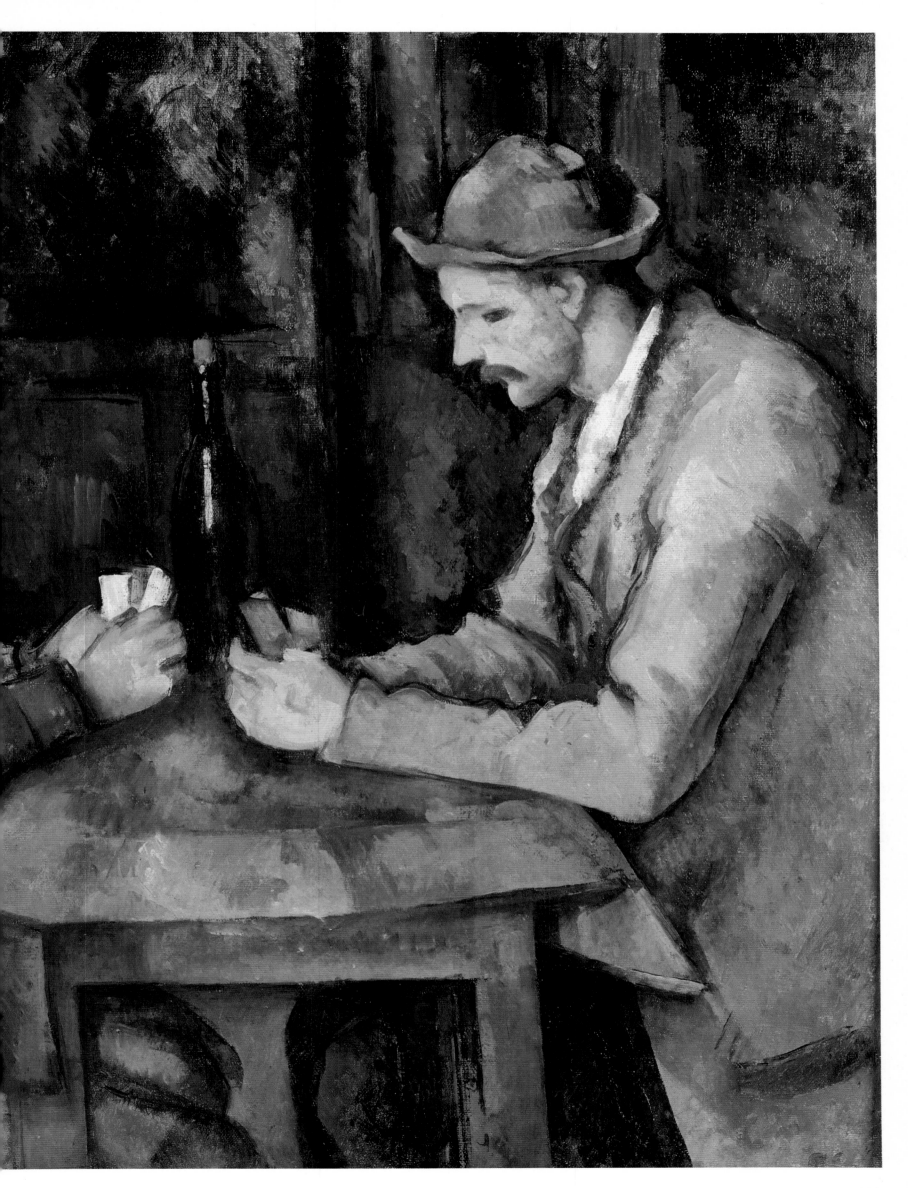

Dish of Peaches, c. 1890-4

Oil on canvas
12⅝×16⅛ inches (32×41 cm)
Oskar Reinhart Collection 'Am
Römerholz', Winterthur
Venturi 607

This is a copy of a picture attributed to Lau-
rent Fauchier, a seventeenth century Aix-
ian painter, which hung in the Musée Gra-
net at Aix and was also copied by
Cézanne's friend Achille Emperaire. A
simple subject: seven peaches set, together
with their leaves, on a dish placed on a
table next to some drapery; behind them
the wall and its dado line. The blue wedge
could represent the shadow of the table or
could equally well be the result of a de-
cision by the artist to narrow the area of the
table top to its present dimensions. A close
examination of this area shows how
Cézanne, with a number of nervously
drawn lines, stated and re-stated the blue
contours until he was satisfied that it was
in accord with the rest of the composition.
Traces of the original brown coloration of
the table top may be seen inside the blue
area.

Despite the relative thinness of the paint
surface and the tremulous nature of the
drawing, this painting has the power and
authority of the artist's early work. The
range of tones achieved within a limited
color range is surprising, the maroons and
violets, lilacs and blues act in sympathy
with the greens to push the luscious
yellows and incandescent reds of the fruit
to a fever pitch. The sensual curves of the
peaches are repeated in the folds of the
blue cloth and foliage, the white of the edge
of the plate lifting the fruit towards the
viewer. It is possible that in this painting
Cézanne used coins to tip the plate, as was
his practice, to expose as much of the fruit
as possible. The plate arcs round the lower
portion of the painting, the fruit and leaves
and the grouping of the seven peaches
further suggesting its shape. Dark blue
overpainting reinforces the shadows and
modeling of the fruit, and the same color is
worked out from the various contours to
link with the blue wedge in the back-
ground. Any sense of spatial recession is
achieved by overlapping forms and not by
traditional *chiaroscuro*. The concentration
and saturation of the color in the center of
the composition focuses all attention on
the luminosity, soft firmness and rotundity
of the fruit.

120

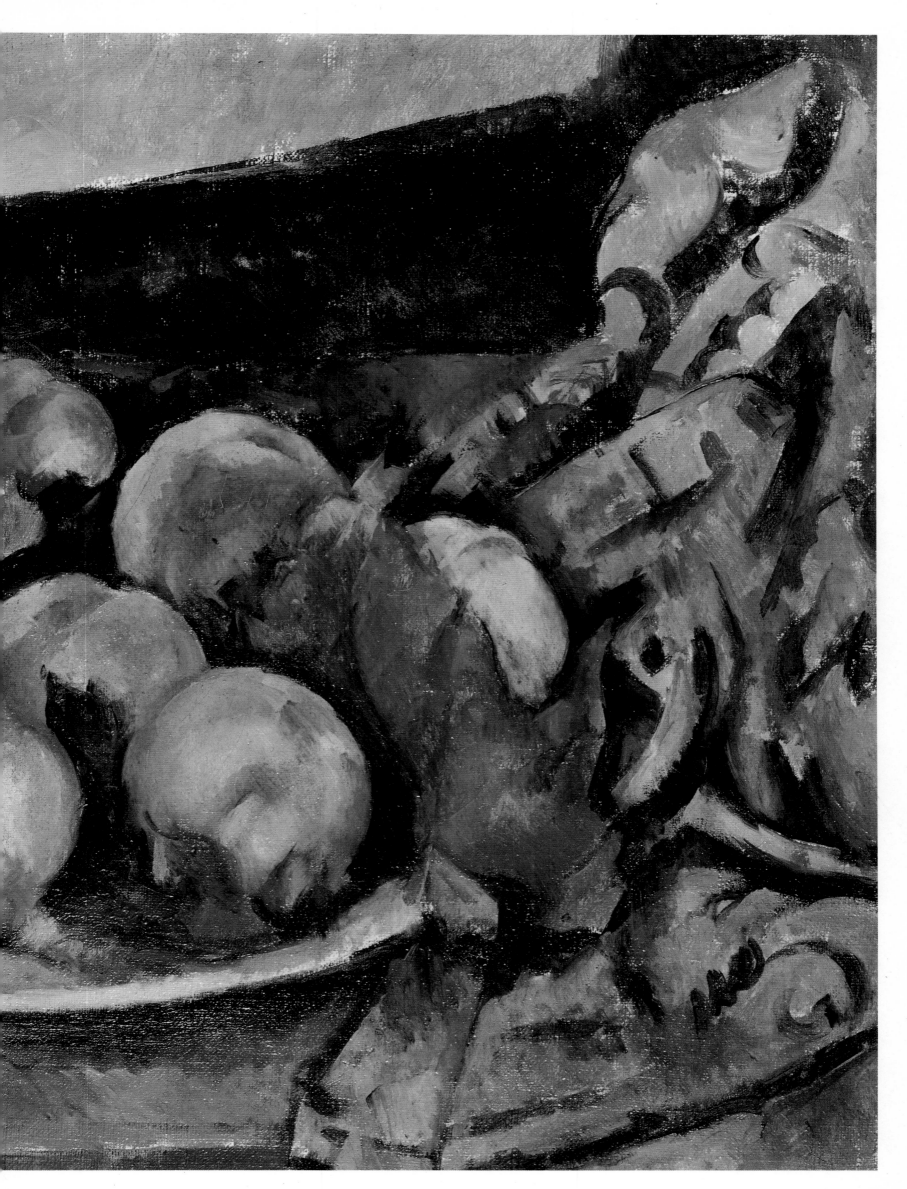

The Pipe Smoker, 1890-2

Oil on canvas
36¼×28¾ inches (92×73 cm)
Pushkin Museum, Moscow
Venturi 686

Cézanne's backgrounds are never mere backdrops against which the major motif of the composition is placed, but are always conceived as an integral part of the total image so that the whole picture works together as a harmonious unit. Colors, forms and marks relate with each other across and within the picture area. In common with other artists of the time, Degas and Gauguin in particular, Cézanne enjoyed making reference to his own paintings within his compositions. Obviously in his studio, paintings, and the whole paraphernalia of his profession, were there within his visual field and would have offered enticing formal ideas to introduce into his picture. In this example, part of a painting of bathing figures may be seen above the smoker's head. Theodore Reff has shown that the still life so convincingly placed upon the table is in fact a painted image; the table, or as much as we can see of it, is bare, and the bottle, drapery and fruit are part of a canvas tacked on the wall – its folded-down top right corner can be seen to the side of the man's head. The still life in question is dated 1869-70 and is now in the Nationalgalerie, Berlin.

The sitter is as yet unidentified but may well be one of the peasants who posed as card players, versions of which Cézanne was working on at the time, Cézanne obviously made use of such readily available models, but he also seems to have had a certain empathy with such figures. They are never condescendingly treated, and their lowly status within the tight rural community is never referred to by such devices as the picturesque introduction of farming implements. Instead they are given a moral depth, a capacity for thought and reflection, that can also be found in the work of Rembrandt. Obviously some of the apparent seriousness of expression is due to Cézanne's painstaking working methods, but there is something more than intellectual vacancy reflected in this portrait and others like the *Man with Crossed Arms* (page 145) and *An Old Woman with Rosary* (page 140). Interestingly Cézanne often, as here, left the eyes relatively undefined, which generalizes his sitters so that they take on a monumental stature.

The painting is a wonder of color harmonies, the varied hues of Cézanne's favored color range are used in all their astonishing diversity throughout the picture area. The detail of the bathing figures is pink-blue and the curtain yellow, the apples are green-yellow, the peasant's hat is violet, his jacket blue with yellow-brown and reds. The small area of shirt may serve as an example to show the wealth and subtlety of Cézanne's harmonies. Against these endless variations the strong white of the smoker's pipe stands out; but even that is modified by a blue stroke of paint that interrupts its contour.

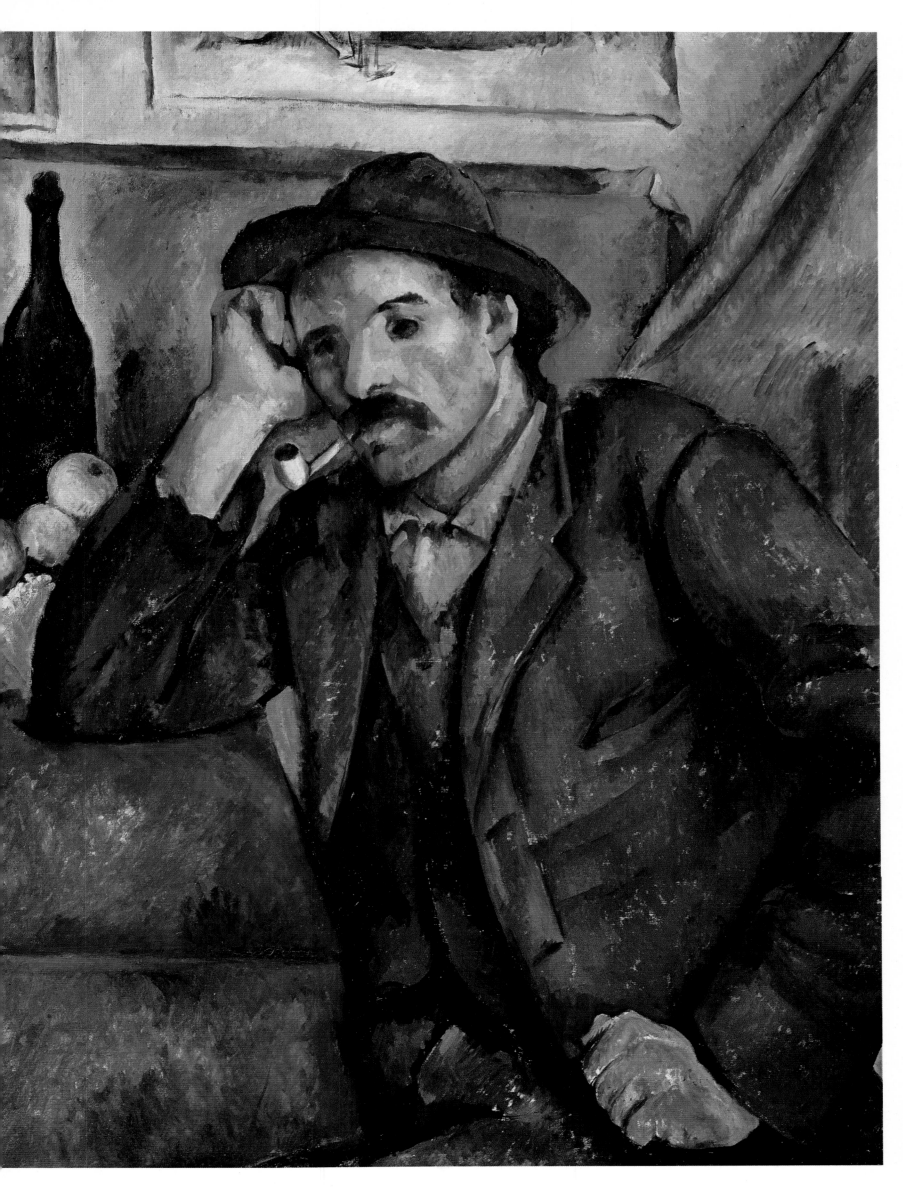

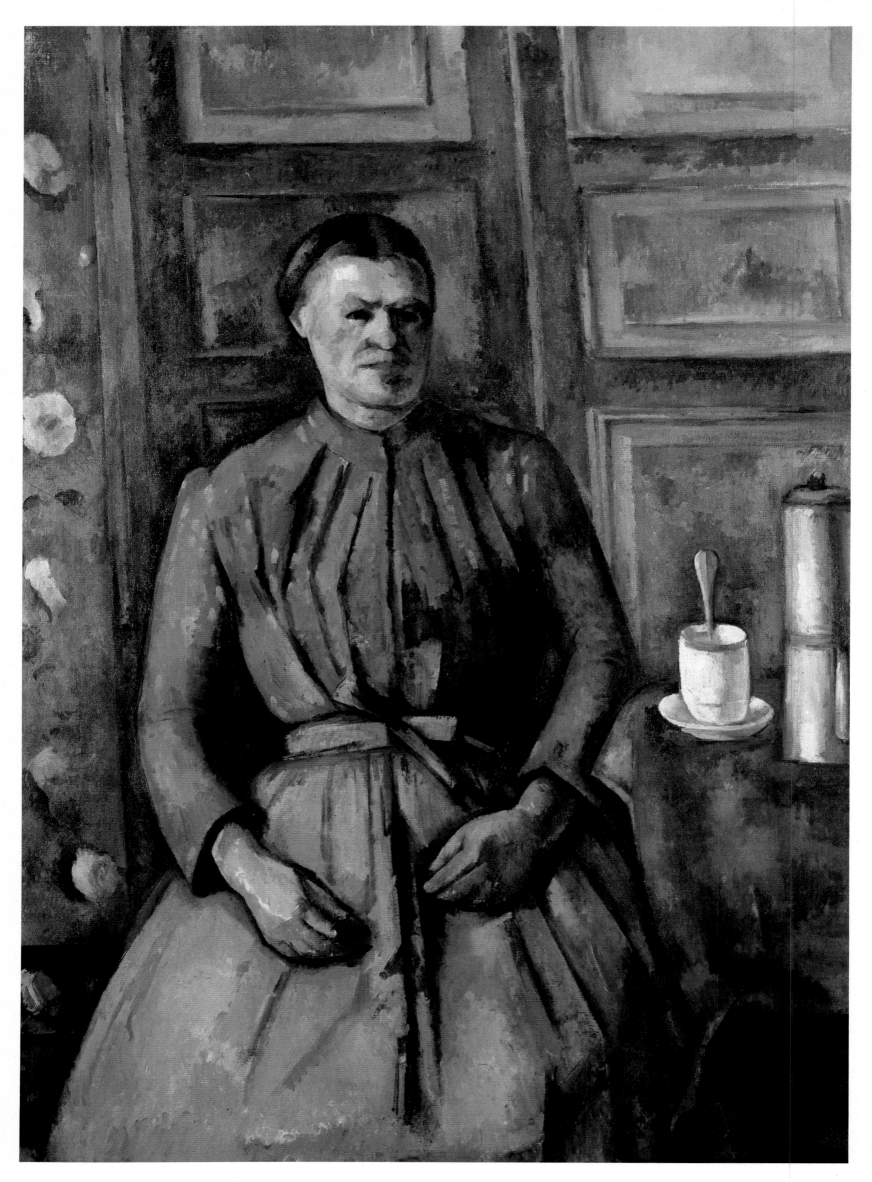

Woman with the Coffee Pot,

1890-4

Oil on canvas

51¼×38¼ inches (130×97 cm)

Musée d'Orsay, Paris

Venturi 574

A formidable painting of a formidable woman. The monumental scale of this canvas conveys a strong sense of the physical presence of this particular woman, seated at a table upon which are placed a coffee pot and a single cup. In other circumstances the subject could easily have become a charming genre scene of a working woman stopping in the course of a busy day to take some refreshment. The model was probably a servant at the Jas de Bouffan, and Cézanne has made much of the stillness of her normally busy hands. The objects on the table serve as painterly devices to emphasize the bulk and erectness of the seated figure.

It is a strictly formal painting and the constructed space between painter and model unfolds in a scroll-like manner. Cézanne looks down upon the woman's lap and an almost vertical line, broken at the waist, leads from the base of the canvas through the space between her heavy hands to the closed features of her face. Her bulk is firmly established by the bracket-shaped pleats which run from waist to collar. The table top, with its crisp fold, lies parallel with the folds of her skirt. The shift from the horizontal to the vertical is pronounced by the upright nature of the spoon in the coffee cup and the coffee pot

itself. Cézanne has abandoned the clichés of single viewpoint perspective, which tends to throw the model back from the spectator, in favor of a system of his own making which is much closer to experience.

There are two things in a painter, the eye and the brain. The two must co-operate; one must work for the development of both, but as a painter: of the eye through the outlook on nature, of the brain through the logic of organized sensations which provide the means of expression.

The meaning of this well-known statement, which may be sensed in any one of his mature paintings, could apply to the distortions apparent in this portrait. Cézanne's so-called distortions are simply departures from a set of out-worn conventions that had become mistaken for the truth. A geometrically correct rendition of the paneling behind the figure would lack the visual impact of Cézanne's painting of it, which allows it to respond dynamically to the fullness of the figure seated before it. By the development of such means of expression, Cézanne was to liberate future artists from the chains of convention and give them the opportunity of discovering new ways of recording the way they perceived the world.

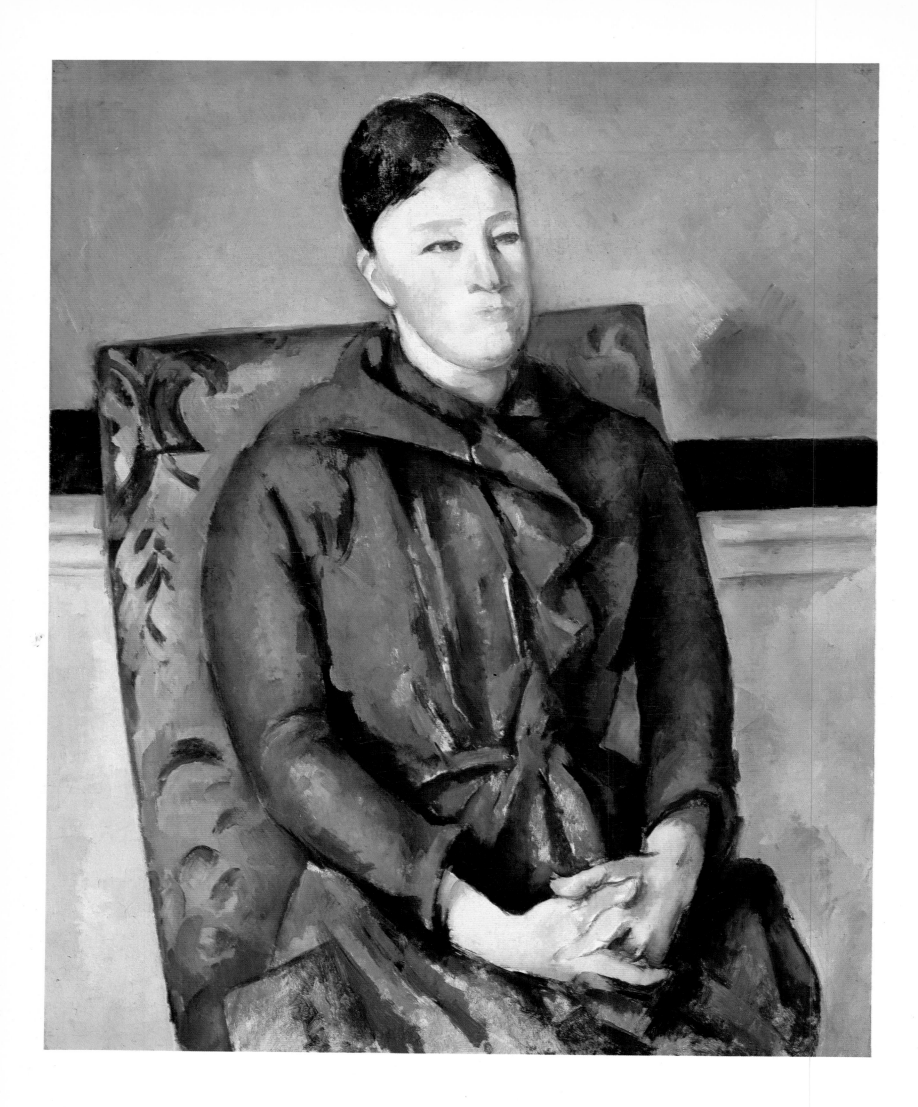

Madame Cézanne in Yellow Armchair, 1893-5

Oil on canvas
31⅞×25½ inches (80.9×64.9 cm)
Chicago Art Institute
Venturi 570

Hortense Fiquet met Cézanne in Paris in 1869. She was a life model aged 19 and he was 11 years her senior. Their relationship was an odd one and it is difficult to gain a clear picture of their life together but Cézanne painted her portrait many times. He attempted to keep his liaison with Hortense a secret from his father, on whom he depended for his allowance; his position became even more difficult after the birth of their illegitimate son, Paul, in 1872. Cézanne's mother and sister helped to conceal matters from his father but, inevitably, the true circumstances became known to him. After a bitter confrontation the couple were married in the presence of his parents at Aix in 1886.

Early in his career Cézanne had painted from fashion plates and in many of his later portraits of his wife he makes great pictorial use of her fashionable outfits in terms of color, shape and texture. In this painting she is shown in a voluminous red dress, seated on a yellow upholstered armchair with her hands clasped before her. The background is simple and continues the geometric format of the chair. Within this simple structure are set the full rounded forms of Hortense; her head is balanced by the linked hands that gently rest on her lap. The folds of her dress and the articulation of her body are echoed in the selective featuring of the patterns on the armchair. The wall, the chair and the sitter are each firmly identified and enclosed within their own contour lines, as if pasted on to each other. The three major components of the picture are each keyed with a separate color. In the hands of some artists such drastic simplifications of drawing and composition could become mechanical and formulaic but, in Cézanne's case, the delicacy of touch and the vigor of his mark-making keep the painting alive. The shadows cast by the sitter's right arm are recorded in a dark mass of paint; elsewhere the effects of the light are largely under-stated. Hortense's face is drastically generalized and heavily worked; her features are almost oriental. The sense of repose evident in the picture is a tribute to the affection that Cézanne felt for Hortense and to the patience of the model, who must have suffered many tedious hours posing for her painter husband.

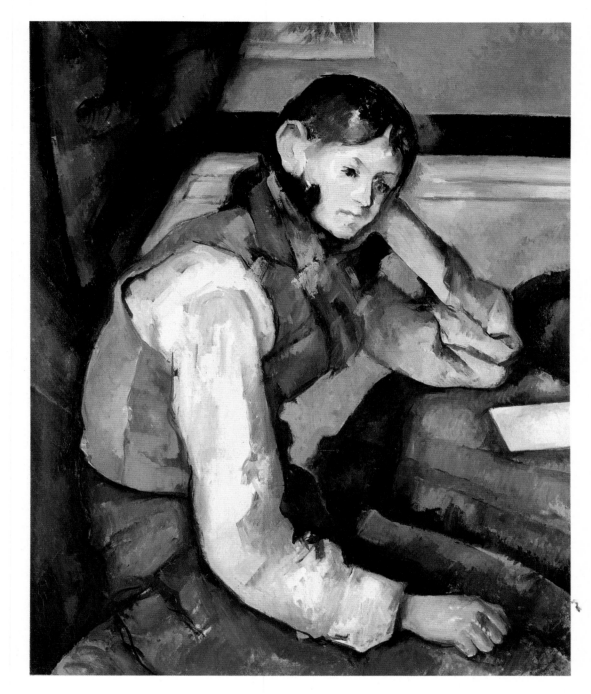

Boy in a Red Waistcoat, 1890-5

Oil on canvas
22¾×25¼ inches (57.9×64 cm)
Foundation E G Bührle Collection, Zurich
Venturi 685

This pose is a familiar one in western art, and has associations, deriving from Dürer amongst others, with melancholy (Van Gogh was to use a similar pose in his portrait of Dr Gachet to suggest the depressive and melancholic nature of his friend). The pose also has a much more prosaic significance, however, and is as familiar in early photography as it is in provincial portraiture; it is a convenient way for the model to remain relatively still over a prolonged period of time.

The distance between the shoulder and the head suggests that the artist took a high viewpoint and was positioned fairly close to the model. The boy's torso is locked into his space by a series of enclosing shapes. Only his abnormally long right arm resting on his lap breaks the framing motifs, to create the dominant directional movement that leads the viewer's attention to his pale face and to the extraordinary ear that occupies such an important compositional point of the picture. The triangular movement is completed by the supporting arm, which rests close to a white rectangle perhaps representing a letter and hence explaining the boy's pensive expression. The portrait contains some marvellous juxtapositions of color, most noticeably the red of the waistcoat against the blue of the trousers and the delicate blue-green of the boy's cravat.

Unusually in Cézanne's work, the directional movement of the dado line that passes behind the boy's head is left undistorted. Normally, as in *Madame Cézanne in Yellow Armchair* painted at the same period, the artist breaks the continuity of the background to act as a metaphor for our stereoscopic vision, and to add a certain visual drama to his composition. In this painting the lightening of the pigment to the right of the head detaches the sitter's form from the background, while the hair at the back of his head merges into the dark brown band of the dado line.

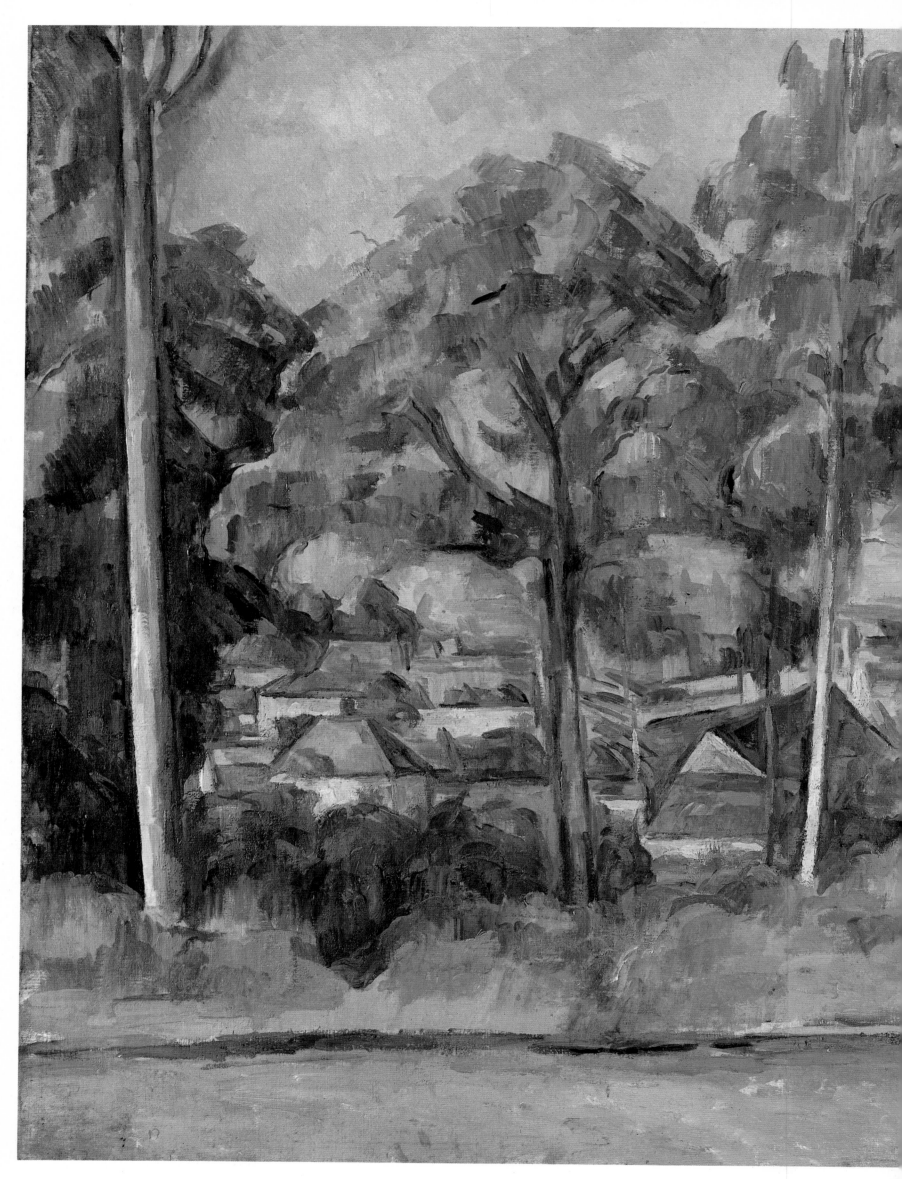

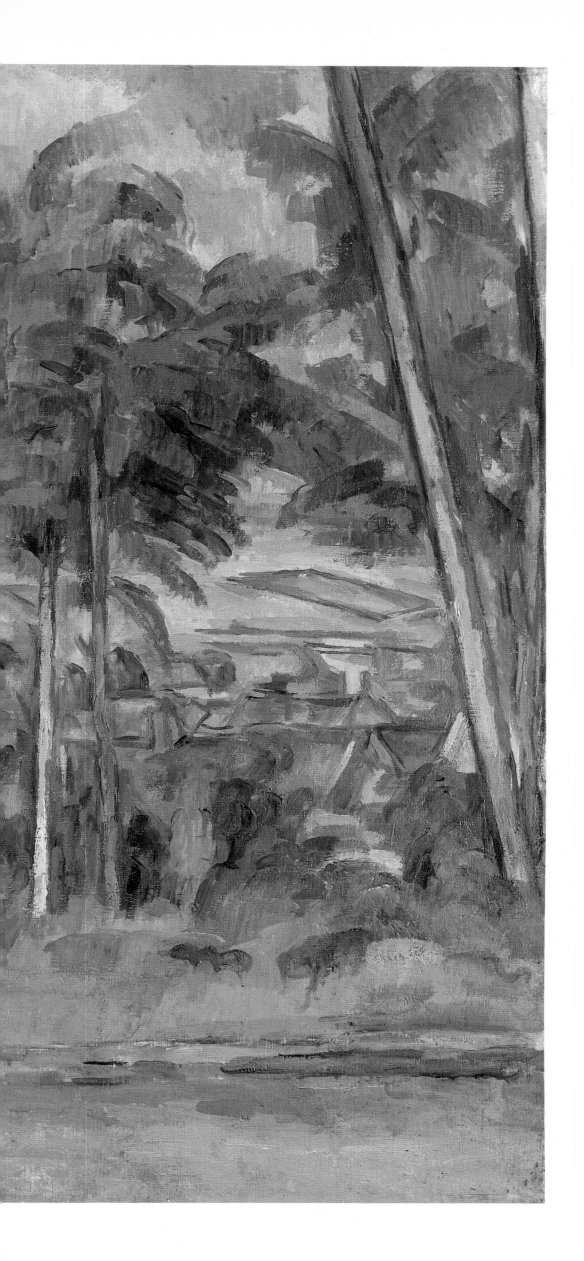

Village seen through Trees,

1890-1900
Oil on canvas
25½×31⅞ inches (65×81 cm)
Kunsthalle, Bremen
Venturi 438

Distant views seen through a screen of trees were a popular motif for landscape artists in the nineteenth century. From the mid-century onwards the example of Japanese prints, and particularly those by Hiroshige, had shown how simply the complexities of such a view could be rendered. Cézanne found this kind of motif irresistible and his use of it was to be imitated some 15 years later by Braque and Derain. Its attraction for an artist can easily be appreciated. The roadside location offers a firm horizontal structure from which rise the verticals of the trees. The trees themselves break up the blue of the sky and split the buildings seen between their trunks into simple masses. The view of the village is in the mid-distance, far enough away for the finicky details of the architecture to be lost and the basic forms, tones and colors to be grasped.

Cézanne was working on his series of Bathers at this period and it is possible to see in this and related paintings the gradual ordering of landscape elements that he used as the context for his monumental figure groups. The trees are radically handled, their forms stripped of any kind of irregularity that would disturb the overall rhythm of the painting. Large, clearly defined movements in the trunks and foliage enclose the village that shelters beneath its branches. The rigor of the drawing is matched by the richness and variety of the colors, based on saturated oranges, ochers and blue-greens. The paint is firmly applied with a full brush set down with varying pressure, giving the canvas a rich variety of surface texture.

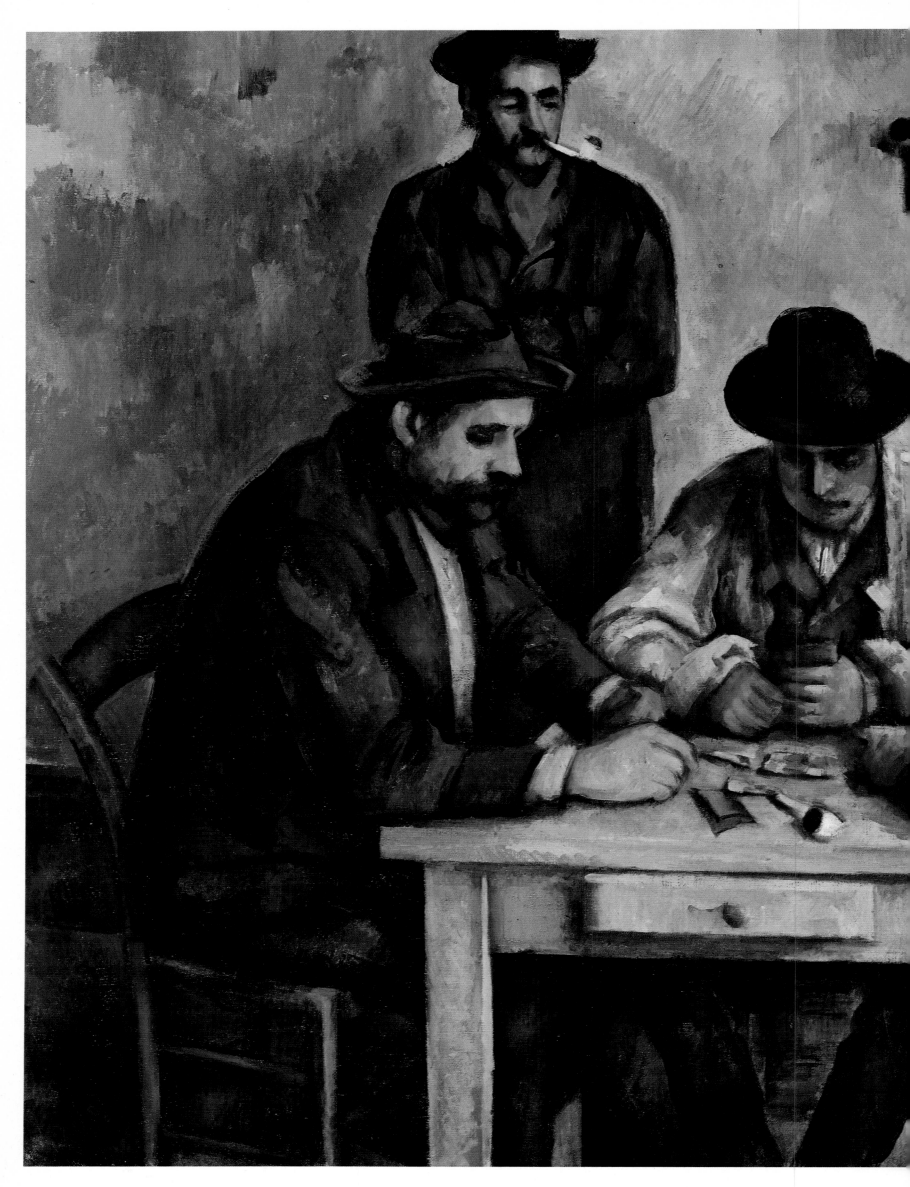

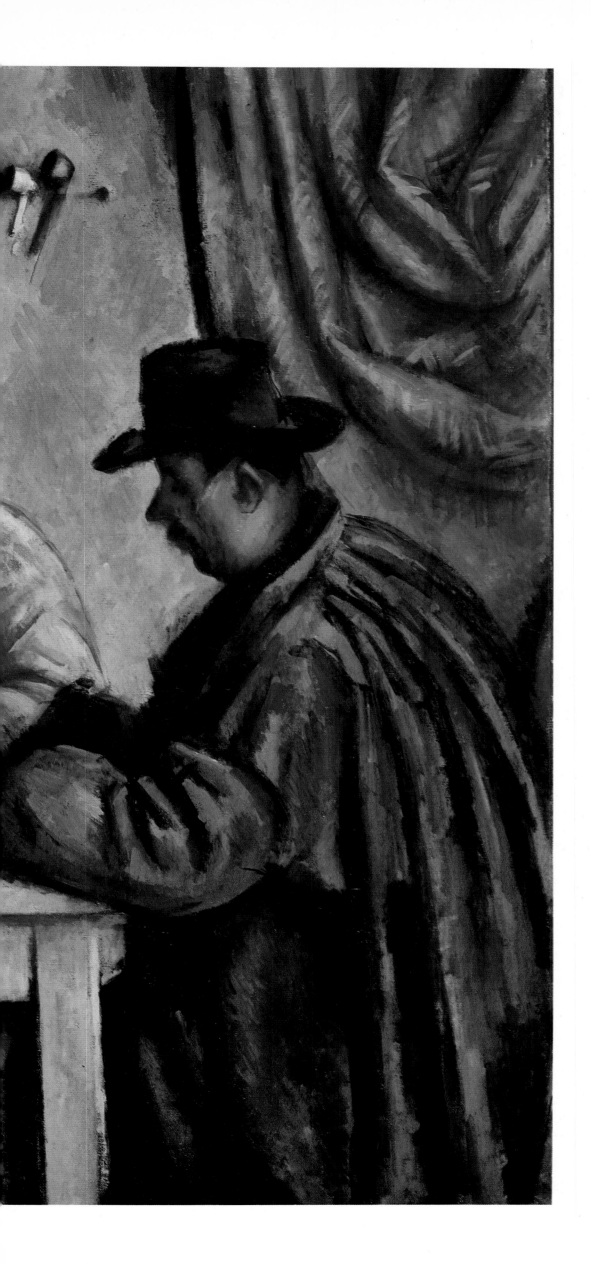

The Card Players, c. 1892

Oil on canvas
25½×32⅜ inches (65×82 cm)
Metropolitan Museum of Art, New York
Venturi 559

In painting this work, Cézanne was determined to produce a masterpiece in the manner of those artists that he admired so much in the Louvre. His paintings of the *Harlequin* (page 112) and the *Mardi Gras* (page 113) and his series of bathing figures also reflect this high ambition. It is in this context that the different versions of the card players should be seen, and Cézanne brought to bear on their creation all the patience and concentration that were the foundations of his art. The models were his gardener at the Jas de Bouffan, Alexandre, and several farm laborers, who were delighted to be paid money to pose for the artist even if privately they thought him a harmless maniac.

There is a stagey quality to this version of the subject which is the result of its anecdotal overtones. The curtain and rather schematic handling of the background give this painting a decorative quality that lacks the *gravitas* of his other versions of the same subject (for example page 118). Around a central table three men concentrate on their card game, their shoulders hunched and their heads bent down the better to examine their cards. A standing man, pipe in mouth and sporting a brilliant red neckerchief, observes the game. Cézanne expresses the heavily solidity of these simple men by his repetition of the exaggerated forms of their clothing. Throughout the work a limited number of forms and colors are repeated to create a highly unified and decorative composition.

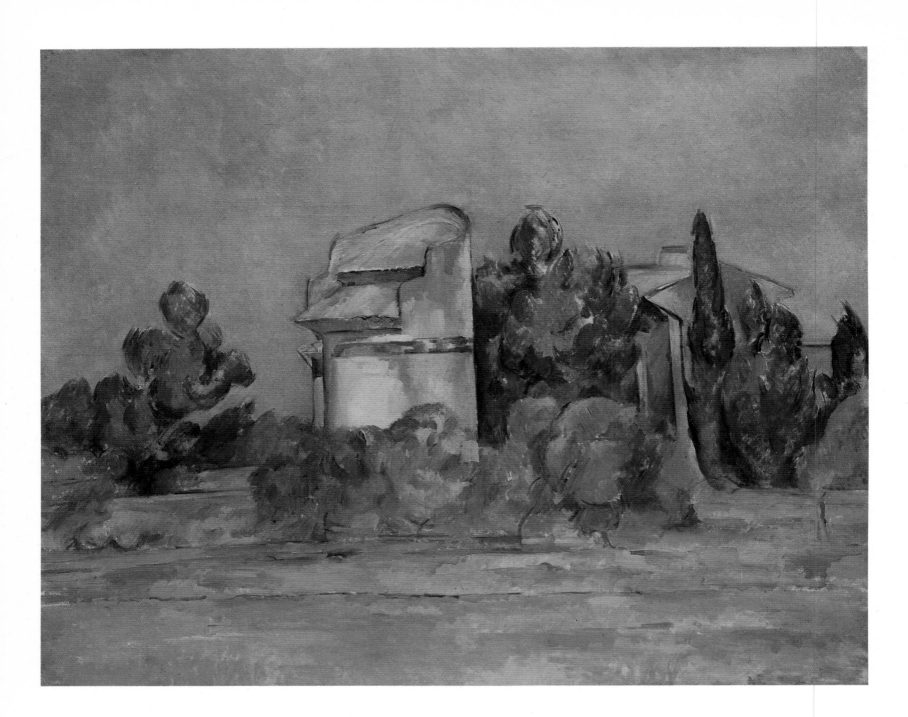

The Pigeon Tower at Bellevue,

c. 1894-6

Oil on canvas
25¼×31½ inches (64.1×80 cm)
Cleveland Museum of Art, Cleveland,
Ohio
Venturi 650

Cézanne's obsession with structure and form is apparent in his development of a piece of relatively ordinary vernacular architecture into this strange-looking edifice. The rounded form of the pigeon tower stands separated from the surrounding buildings; the horizontal striations of the ground and the curves of the foliage surround and encase its broken cylindrical form. The other buildings are given a very subordinate role, mere supports to the building which is Cézanne's central concern, one side cut clean by the green of the trees that edge on to it, the other sent back into space by the pale blues that make up the sky. The atmosphere is serene, the landscape is undisturbed, no people, animals or even pigeons upset the geometrical order of the composition. Cézanne's pictures do not permit such awkward intrusions into his carefully poised organizations of 'natural' phenomena. This realization underlines the artificiality of Cézanne's art and makes it all the more surprising that such a rarified art can be so profoundly moving.

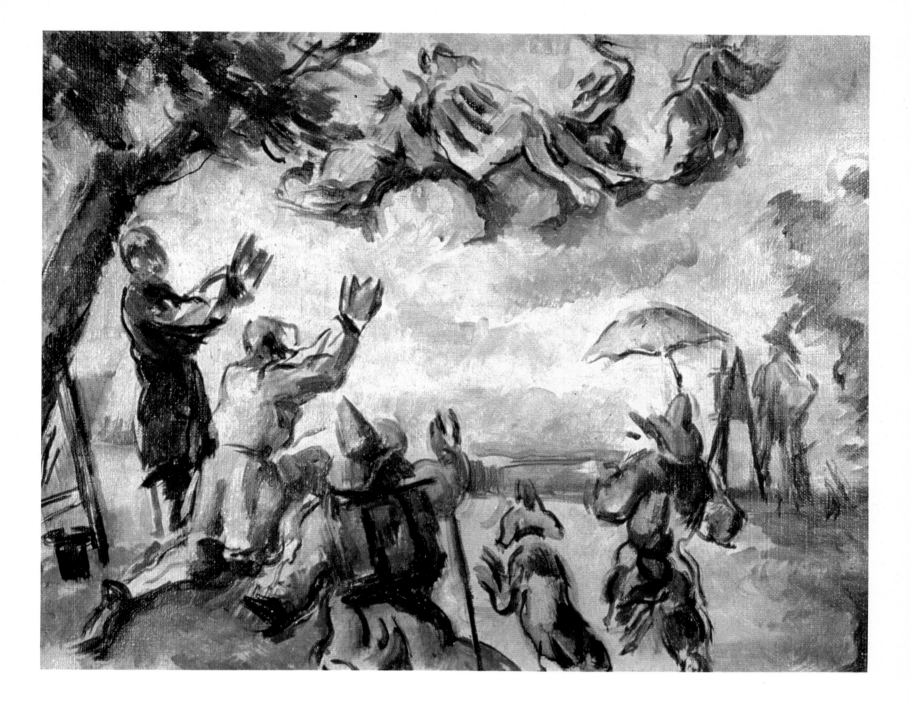

Apotheosis of Delacroix, c. 1894

Oil on canvas
10⅝×13¾ inches (27×35 cm)
Musée Granet, Aix-en-Provence
Venturi 245

Cézanne copied the work of Eugène Delacroix many times throughout his career; he owned three paintings by the master and also an unspecified number of prints. He was attracted to the coloristic brilliance of Delacroix's technique, his ordered compositions and the erotic and violent aspects of his subject matter. Delacroix was a great admirer of Rubens and the Venetians, and saw himself as an heir to their tradition. His art was seen as being diametrically opposed to that of Ingres, for whom Cézanne held no great opinion. In 1827, Ingres had painted his *Apotheosis of Homer*, an academic set piece to which this painting may be considered a riposte. Cézanne would already have had the opportunity of reading Delacroix's critical writings on Poussin and Michelangelo, and in 1893 extracts from the painter's *Journals* had been published. One of Cézanne's favorite writers, the poet and critic Charles Baudelaire, had written a laudatory article in 1863 on the artist, which Cézanne much admired. As with Cézanne, official recog-

nition was slow to come to Delacroix, whose personality and art were as complex as Cézanne's own.

Cézanne had long been interested in painting his own homage to the master, but in a letter of 1904 he made reference to an actual canvas of this subject. This canvas repeats a watercolor made in the mid-1870s, in which Cézanne and his friends watch the body of Delacroix being lifted to the skies rather in the manner of Rubens' *Apotheosis of Henri IV* of c. 1621. The figures witnessing this fantastic scene were identified by Emile Bernard as follows: at the canvas, Cézanne's old friend and teacher Camille Pissarro; standing under the tree, Cézanne's great patron and recently deceased friend (whose admiration for Delacroix equalled his own) Victor Chocquet; to the right, a painter whom Cézanne thought unrivaled, Claude Monet; and finally, next to the barking dog (which represents critical opinion), is Cézanne himself, seen from the back and dressed for an expedition 'sur le motif'.

133

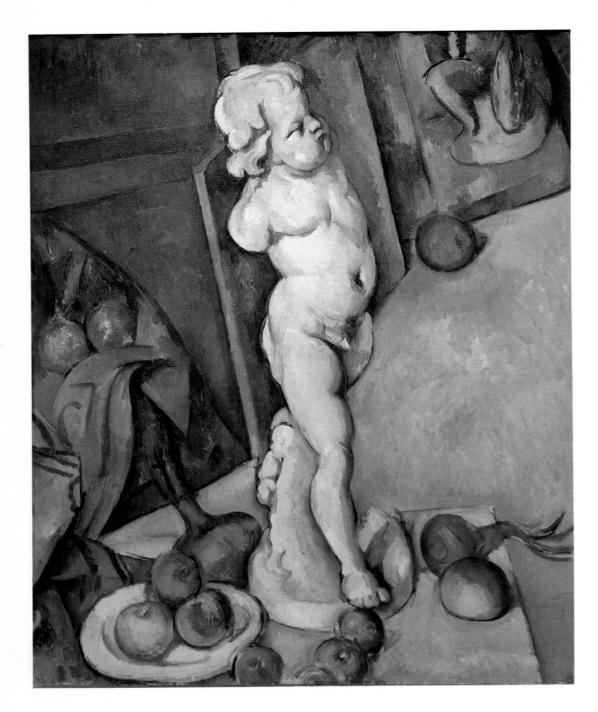

Still Life with Plaster Cast, 1895

Oil on canvas
27⅞×22¾ inches (71×57 cm)
Courtauld Institute Galleries, London
Venturi 706

The still life genre allows the artist an unparalleled power over his chosen objects; he can group them according to his will, carefully choosing them for their shape, texture and color. In this case Cézanne has set up a still life in his studio centered around the brilliant whiteness of a plaster cast taken from a statuette of a Cupid.

The vertical form of the Cupid stretches almost the entire height of the canvas; its construction reflects the artist's scrutinizing gaze as he explores its complex structure. The surrounding objects are organized around this central motif and are affected by it. A whole system of echoes

and contrasts revolve around the lightness and form of the central area of the plaster cast. The plate repeats the shape of the base of the statuette, the canvas leaning against the studio wall frames it and the sharp perspective of the wall pushes the figure out from the canvas surface. Other elements, the sharply delineated contour lines of the painted drapery and the edge of the canvas resting against the wall, reinstate the essential flatness of the picture surface. As if to demonstrate the complicated nature of the task he has set himself, Cézanne has included in his composition a painting of an *écorché*, a flayed figure exposing the muscles and tendons, which would have been familiar to any art student of the period. The play between the real and the painted continues in his depiction of the real fruit resting on the table in the foreground, which is echoed by the painted fruit of the

canvas on the left-hand side of the painting. The drapery on which the plate rests is almost indistinguishable from the drapery in the painted still life. The scale of the picture is suggested by the dado-line which runs around the walls of the studio.

The color harmonies are especially subtle, the ripe reds and golds of the fruit stand out against the blues, tans and ochers that fill the rest of the painting. The cream of the prepared paper on which it is painted modulates the warm and cool colors that describe the ambiguous floor space and re-appears throughout the composition as a tonal value in its own right. By twisting the accepted rules of pictorial composition, Cézanne has created an image startling in its aura of actuality which parallels the complexity of our relationship with the exterior world, available to us only through our senses.

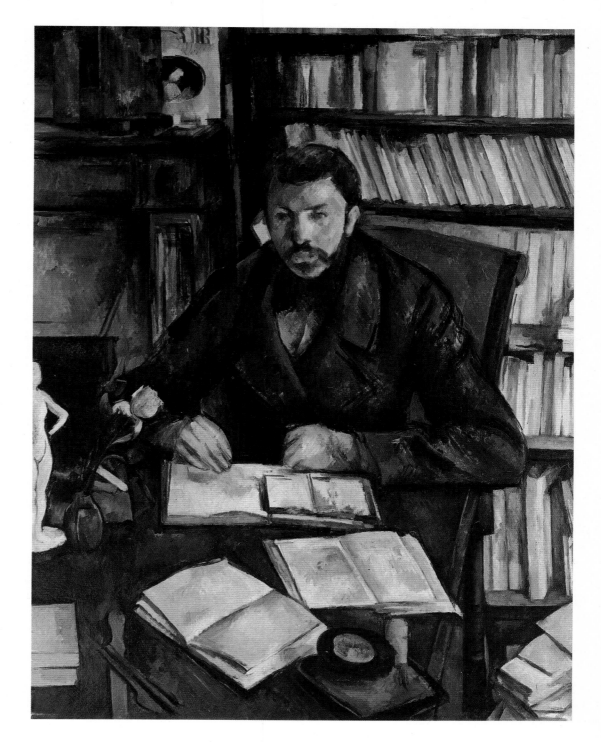

Portrait of Gustave Geffroy, 1895

Oil on canvas
45⅝×35⅛ inches (116×89 cm)
Private collection, France
Venturi 692

Gustave Geffroy wrote a sympathetic article on Cézanne's work in *Le Journal*, which was published on 25 March 1894. Cézanne was flattered at this support from a distinguished critic who was also Director of the Gobelins Tapestry Workshop, and wrote to him suggesting that they meet. Their relationship developed to the point where the artist expressed the desire to paint Geffroy's portrait, but the experience was not a happy one. From the beginning of April until mid-June 1894 daily sittings took place. The painting is unfinished and the reasons for its abandonment have never been satisfactorily explained, but perhaps it may have been due to the political differences between the two men. Geffroy was of the Left whereas Cézanne, although not a follower of any particular party, was something of a reactionary, and Geffroy's derogatory comments about the future Prime Minister of France, Georges Clemenceau, evidently sent Cézanne hurrying back to Aix. He was persuaded to spend another week on the portrait, but it was never completely finished.

Geffroy noted that Cézanne worked on the whole canvas at the same time, leaving the head until last, which perhaps accounts for the slight tension that exists between that area and the rest of the painting. The portrait bears many similarities to Degas' 1879 portrait of Edmond Duranty which, having been shown at the first and fifth Impressionist exhibitions, would have been known to the artist.

The Geffroy portrait has a powerful upward movement running through it. The viewer's eye scans the flat top of the table, zig-zagging across the open books (perhaps the notes and source material for Geffroy's study on the left-wing revolutionary, Louis-Auguste Blanqui), and moves up to the massive triangular form of the sitter. Geffroy's head is firmly placed in the center of the canvas, four-fifths of the way up the painting. In the bookcase, the spines of his books create a changing series of diagonals that run through the right-hand side of the canvas, serving to give a sense of movement to the whole. The coloration is fairly restricted and low-key, except for the vivid orange-red that appears at intervals across the canvas.

Woodland Path at the Château Noir, 1895-1900

Oil on canvas
31¼×25⅜ inches (79.5×64.5 cm)
Galerie Beyeler, Basle
Venturi 1527

How little paint is actually on this canvas, and yet the illusion of actuality is complete. 'I cannot achieve the intensity which is revealed to my senses,' Cézanne wrote to his son in September 1906, 'I have not that magnificent richness of color with which nature is endowed'. Direct experience was all to Cézanne; he rarely attempted to capture the immediacy of a moment but rather sought the essence of the landscape, through the prolonged contemplation of nature as revealed to his particular sensibility. His techniques were acquired over a lifetime dedicated to the search for painterly equivalents to visual experience. Perhaps for reasons connected with his time-consuming method of working, many of his canvases may be considered 'unfinished', but such judgments are contradicted by the evocative power of the works that fall into this category.

Here a woodland path makes a tri-angular wedge into the distance until it becomes impossible to distinguish between the forest floor and the surrounding foliage. Light touches of line indicate the presence of the trees, but in reality there is hardly any drawing at all, the structuring principle being the *mêlée* of color planes that spread over the surface of the canvas.

The lines are merely punctuation points that presumably would, in the course of time, have been obliterated with paint. Between the patches of paint, the pale cream of the canvas remains visible and adds atmosphere to the scene, suggesting the spaces between the planes that record not so much the forms of the landscape as its spatial organization. As so often with Cézanne's paintings, we are aware of the effort of will not to indulge in descriptive detail. He hated the slick polished surfaces of academic paintings and all his life had avoided conventional notions of finish. Throughout his career he held to his hard-won belief that conventional means of representing his experience had to be avoided at all costs. The painting may not be finished in the ordinary sense of the word, but it is complete.

One can believe the reports of the laborious nature of Cézanne's technique; that he might wait ten minutes between each stroke. An open weave of paint fills the canvas from side to side, corner to corner, and top to bottom, flooding the picture with the painterly equivalents of his sensations. The open areas suggest air, light and movement; nothing is fixed, everything is endlessly mutable.

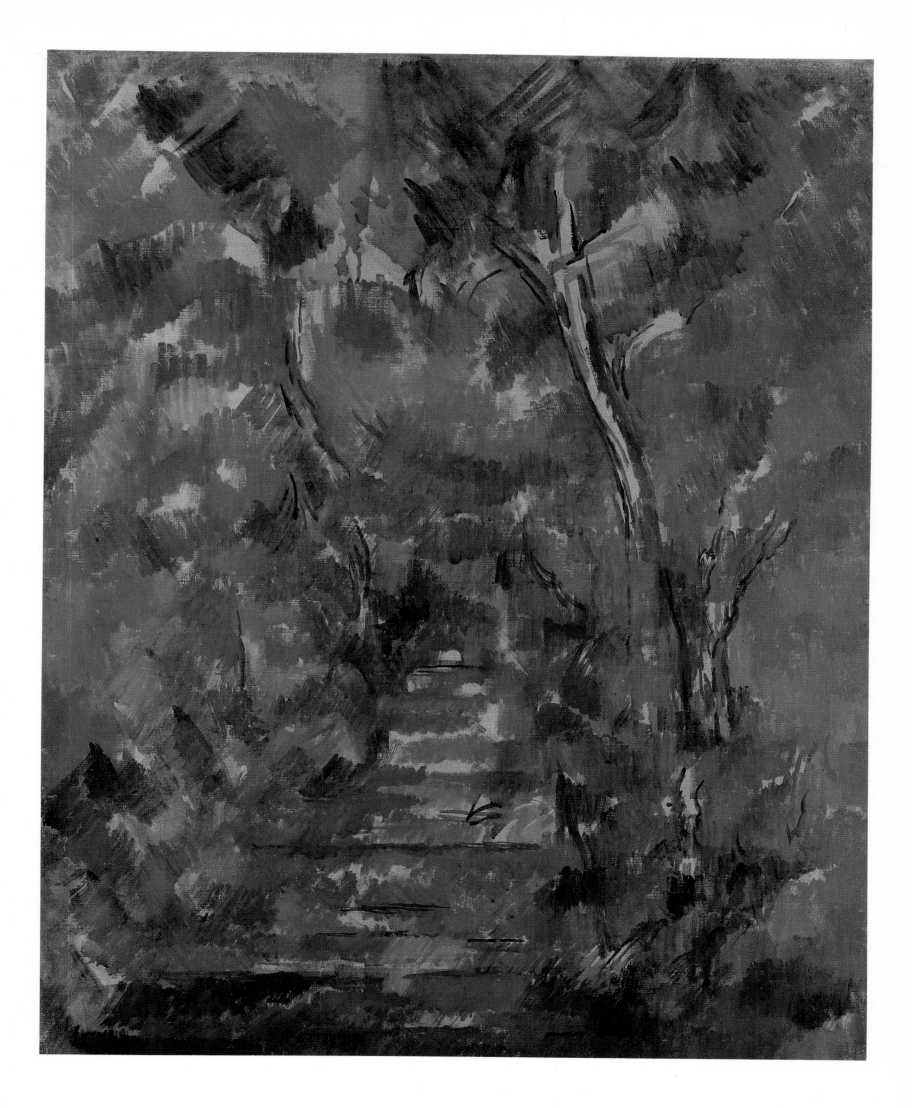

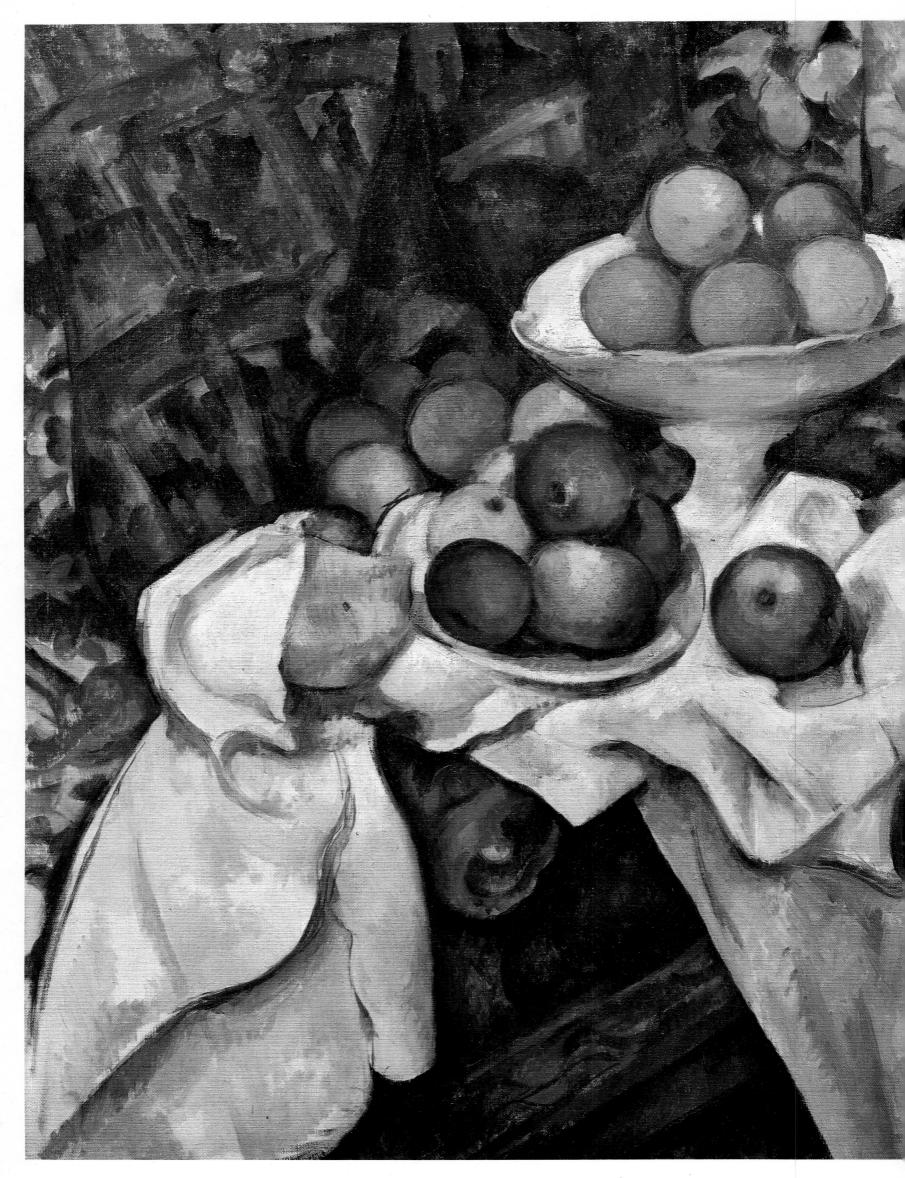

Apples and Oranges, 1895-1900

Oil on canvas
28¾×36¼ inches (73×92 cm)
Musée d'Orsay, Paris
Venturi 732

This painting is among the most majestic and richly colored of all Cézanne's still lifes. Much of its effect is owed to the sequence of ellipses repeated in the table cloth, plates, compotier and milk jug. All these objects are painted in a brilliant white that causes the rich reds, yellows and oranges of the fruit to resonate, and separates them from the more muted versions of the same colors that make up the background, table and drapery. The complicated structure of the painting focuses on the glowing coloration of the almost perfectly circular apple at the centre of the picture. The two great opposing diagonal movements of the table surface and the table cloth cross this lone piece of fruit. From this single object the levels of the various forms rise and fall, spilling out beyond the confines of the canvas surface. Just as the drapery and table cloth undulate and fold back upon themselves, so does the space that contains them. The deformation of the table top is extreme; the direction of its lower edge is clearly visible, culminating in a leg that splays out from its expected position and leaves the viewer to speculate fruitlessly as to where the other edges of the table surface might be.

The use of drapery to disguise expressive or structural anatomical distortions has long been common artistic practice; the work of Michelangelo and the artists and sculptors of the Baroque period abound with examples of such devices. Cézanne has simply taken this convention and applied it, as Chardin had done in the eighteenth century, to the painting of still life. Cézanne's method of using coins to raise the edge of the plate enabled him to show the contents of the plate and compotier to their best pictorial advantage. The freedom of Cézanne's spatial distortions allows the fruit to push out from the middle distance, to enhance the illusion that the viewer is within grasping distance of it.

An Old Woman with a Rosary,

c. 1896

Oil on canvas
31⅞×24 inches (81×61 cm)
National Gallery, London
Venturi 702

There is a deep human sympathy at work in this powerful Rembrandtesque portrait of an old woman, locked in her thoughts and clutching her broken rosary beads. Her expression lends some credibility to the story that the model had once belonged to a convent but, losing her faith at the age of 70, escaped by means of a ladder and was found by the artist wandering the countryside. Cézanne took pity on her condition and allowed her to live in his house, the Jas de Bouffan, where she helped with menial tasks. The painting was found by Joachim Gasquet lying neglected near a stove and Cézanne gave it to him as a gift. The careless treatment suffered by the work has left traces of steam damage in the lower left-hand corner. In the last years of his life Cézanne made many portraits of ordinary people which may in part have been due to their easy availability as models, as many were his own employees who could be relief upon to suffer the discomforts that the artist found it necessary to impose upon his sitters.

The portrait bears evidence of much reworking. The washes of color have been built up to some considerable thickness and, as a result, the dominant lines which describe the pose have shifted their positions as the work progressed. This may be seen most dramatically in the left shoulder area, where the artist raised the line of the woman's back and shoulder several times until it was fixed in its present position. This has the effect of emphasizing the downward tilt of the head and giving a more dramatic weight to the woman's originally rather meagre physique. The deep blues and blacks are lifted not only by the ochers of the face and hands, but also by the beautifully realized cotton bonnet. The Rembrandtesque quality of the painting owes something to its subject matter and to the dramatic distribution of light and dark. The light falls upon the woman's face and hands, her clenched fists closed over the apparently broken rosary.

Cézanne was a practising Catholic in his later years, though fiercely anticlerical in youth, and some of the power of this portrait stems from his identification with the subject; as he had found his faith, so this woman, perhaps, had lost hers.

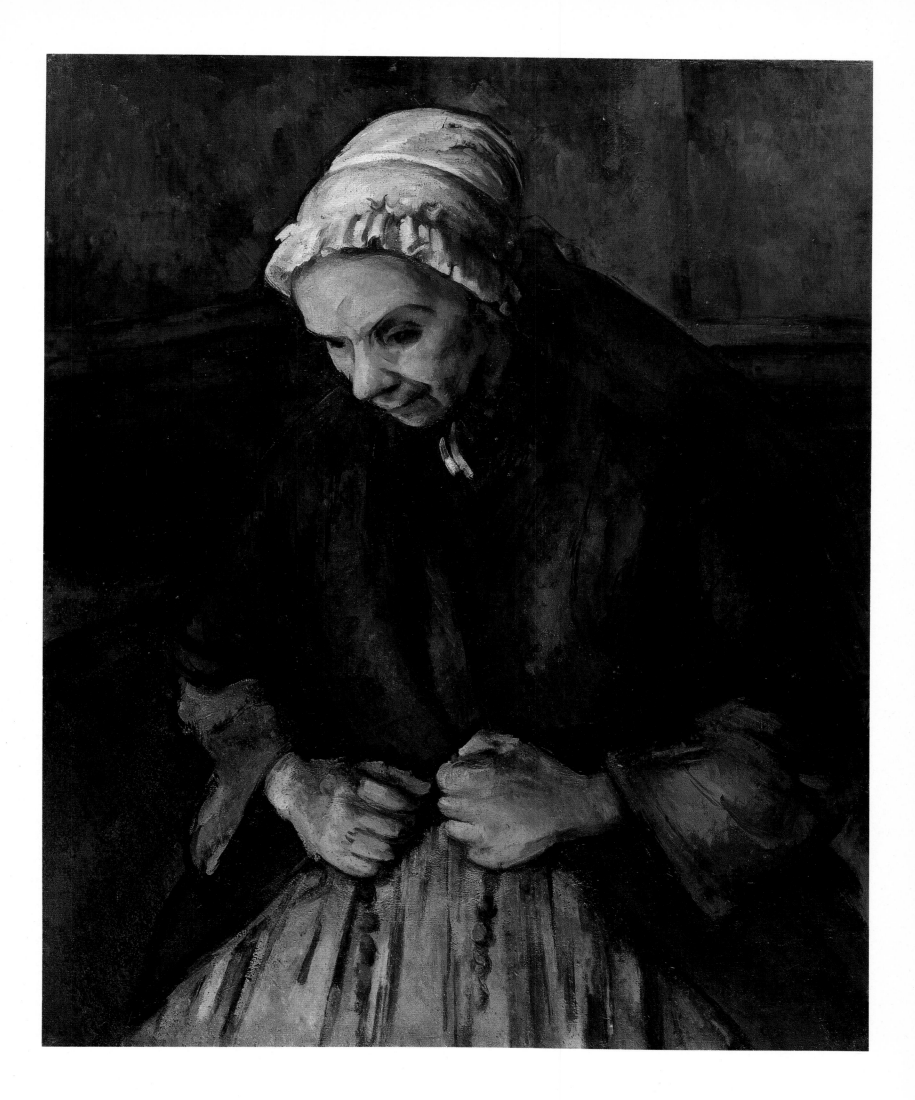

Pines and Rocks
(Fontainebleau?), 1896-1900

Oil on canvas
32×25¾ inches (81.3×65.4 cm)
Collection, Museum of Modern Art,
New York
Venturi 774

In the exhibition of 1978, *Cézanne: The Late Work*, John Rewald dated this canvas to around the year 1897, and suggested that it might represent the rocks and pines of the forest of Fontainebleau. From the falling diagonal of the rocks spring the verticals of the trees, neither their roots nor foliage allowed to disturb the geometrical severity of their construction. Around them dance Cézanne's distinctive parallel hatchings, small dabs of varied modulations of violet, green, red and blue laid on the canvas in thinly washed touches. The effect is very different from the almost claustrophobic paintings of some of his other woodland scenes. In this example, as in many of his watercolors, the sensation gained from looking at the canvas is of the open space between thin uprights, with the intensely blue sky piercing the green canopy of the trees and enveloping the scene in an infinite play of reflected lights. This highly visible structuring is very different from the traditional recessional devices normally used in landscape painting. The scaffolding of the trees reaches all parts of the canvas and creates an impression of the forest enfolding the artist/viewer. This device had been used by Dutch seventeenth-century painters and, more recently, by the painters of the Barbizon school, particularly Théodore Rousseau, whose most characteristic work was produced in the forest of Fontainebleau.

The intense coloration of the canvas is held in place by the gridwork of the pine trees. Above the rocks a small, inverted triangle suggests the flat plains and distant horizon line. Its low placement serves two functions; it increases our awareness of the height of the pines and introduces cool blue tones into the heart of the painting. Like so many of Cézanne's works, the liveliness of the canvas is achieved not only through compositional and textural devices, but also by the opposition of cool and warm tones that push and pull against each other throughout the canvas area.

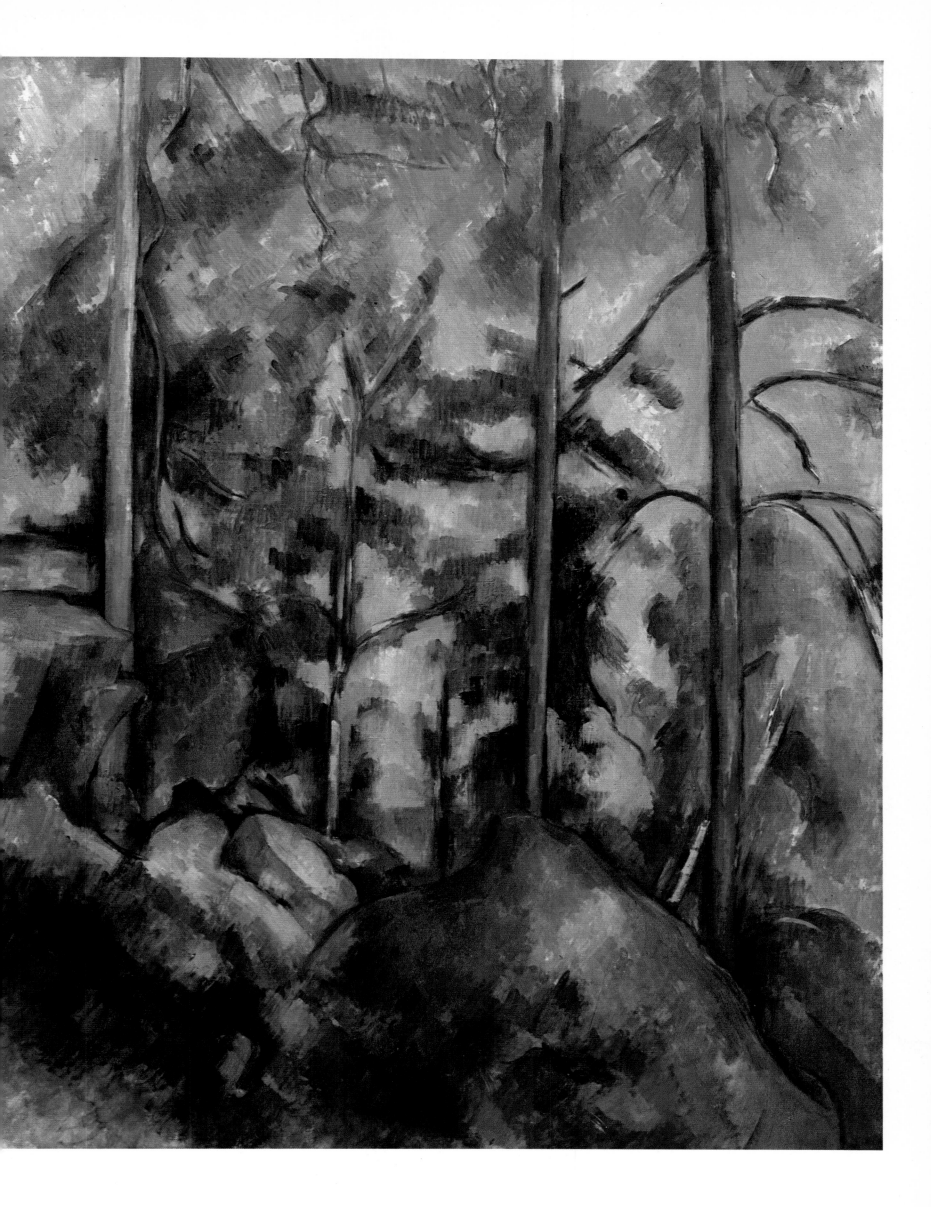

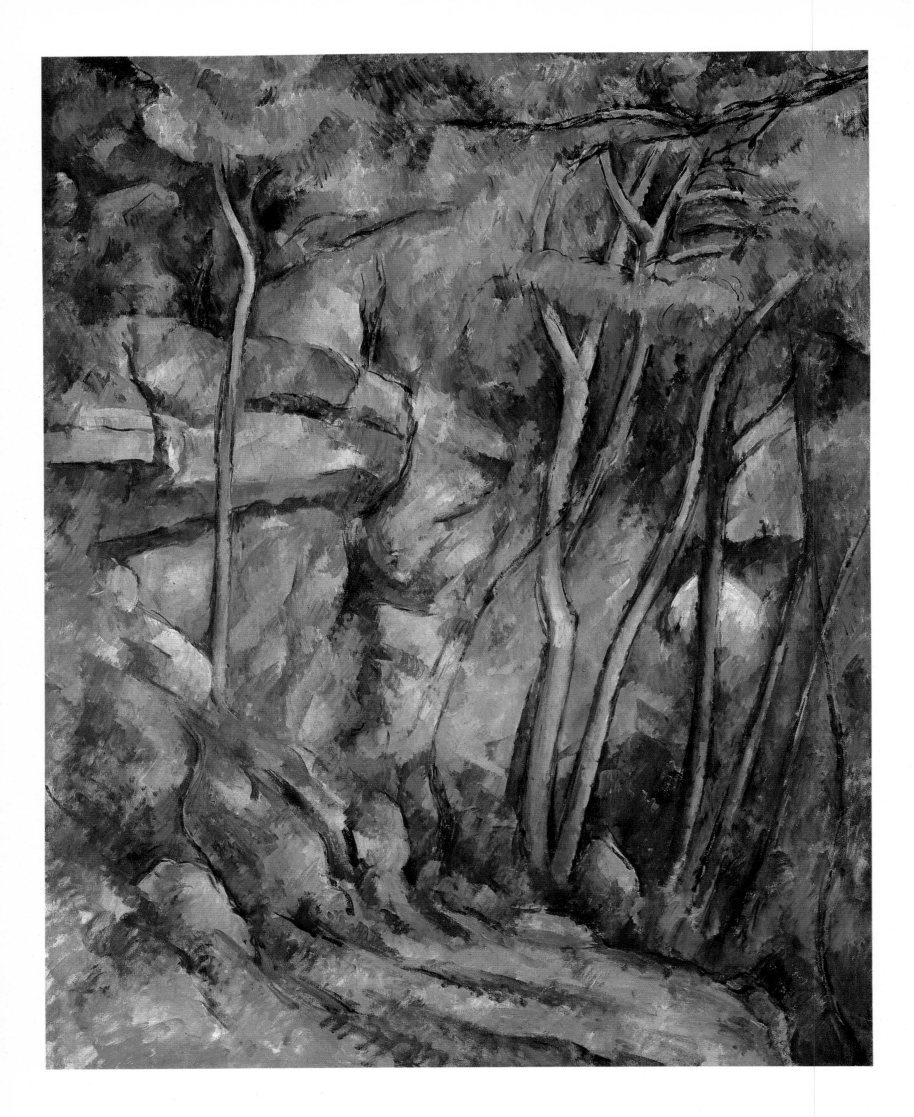

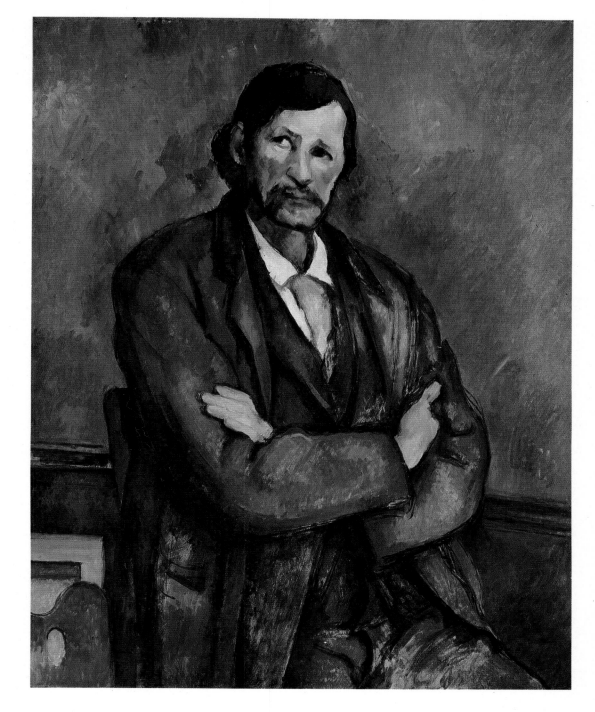

In the Park of the Château Noir,
c. 1898

Oil on canvas
36¼×28¾ inches (92×73 cm)
Musée de l'Orangerie, Paris
Venturi 779

The Château Noir was a farmhouse on the road from Aix to Le Tholonet. Cézanne so admired the view and the situation of the house that he tried to buy it. The owner refused to sell, but allowed the artist to work in the grounds and to use one of its rooms as a studio. Cézanne obviously felt at home here and produced a wide variety of work, diverse in purpose and technique. This example is one of the most densely worked of the paintings he produced of the park. Any hint of sky is obliterated by the rocks and trees, and nothing disturbs the solid packing of forms that stretch from top to bottom and from side to side of the canvas. Shadows of tree trunks fall across the immediate foreground, bleeding into the lines that define the strata of the rock and echoing the delicately observed and strongly drawn outlines of the trees themselves. Lines are traced with the tip of a soft (probably sable) brush to create an equivalent to the tensile qualities of the trees. These contour lines are modulated with innumerable hatchings of color in a prolonged series of refining touches, a never-ending process. As Cézanne worked slowly on his canvas, a dense web of line and color developed. Remnants of former descisions might be blocked out, over-painted or simply ignored, leaving ghostly trunks with no substance, branches that hang in mid-air. The result is transfixing; the strong movements of the central trees recalls the ceaseless movement of natural things, the constant shifting of light and shade and the dynamic effects of actual vision.

Man with Crossed Arms, c. 1899

Oil on canvas
36¼×28⅝ inches (92×72.7 cm)
Collection, Solomon R Guggenheim Museum, New York
Venturi 689

This painting and its companion-piece, now in an American private collection, is sometimes referred to as the Clockmaker, although there are no grounds for believing that the sitter was in fact a horologer. Both paintings are rather unusual in Cézanne's oeuvre because they reveal something of the sitter's restless temperament. In this example the man is shown seated in an ambiguous space. He turns his head to look out towards the upper left of the canvas and is seen by the viewer in a pose which allows the artist to make much of the angularity of his boney face. As with so many of Cézanne's late paintings, the composition is stripped down to essentials. The inner tension of the model is suggested by his folded arms, the apparently restless hands held locked against his sides. Like Rembrandt and Van Gogh, Cézanne had a special interest in his sitters' hands and gave them a prominent role in any portrait.

The disquiet expressed in the figure is reflected in the lack of continuity in the space he inhabits. His figure stands out against the wall behind him, and Cézanne's continual reworkings of the painting have led to odd distortions; most noticeably in the illogical breaking of the dado rail, which drops dramatically on his left-hand side. This has the effect of giving a dynamic charge to the space around the figure, making it respond to the sitter's presence within it. In the lower left of the canvas a stretcher and palette identify the setting as the artist's studio. The paint is thinly applied across the canvas and the artist has restricted his colors to a limited range of browns, greens and ochers although within that band a surprisingly wide range of hues may be discerned. The light is generalized and is used for dramatic rather than descriptive purposes.

Millstone in the Park of the Château Noir, c. 1898-1900

Oil on canvas
28¾×36¼ inches (73×92 cm)
Philadelphia Museum of Art
Venturi 768

In his essay on Cézanne published in 1947, Adrian Stokes wrote, 'His was the most direct homage ever paid to the infinite coherence of the visual world'. When Vollard was posing for his portrait, he noticed that Cézanne applied his colors in light touches, the pigment diluted to the consistency of watercolor; as the paint dried almost immediately, he was able to place a further modifying touch over it almost at once, thus building up a patchwork of separate notations. These veil-like touches combine with fuller brushmarks to create a surface of varying thicknesses. Ridges often appear where separate touches have been overlaid, frequently alongside a contour line, modifying its position and its relationship to the surrounding area. This technique, present to some degree from the 1870s, becomes most apparent in works such as this from the 1890s. The circular mass of the millstone and the shaped stone blocks that lie strewn beneath the canopy of the trees give weight and substance to the near- to mid-ground of the painting. The trees and the rising ground block out the sky, which allows the artist to exclude blue from his palette. The ridges of the landscape and the structure of the trees form a scaffolding upon and between which Cézanne charts the color modulations of the foliage as it catches the light. The predominant harmony is created by the combination of orange-ocher and green set against the violet tones of the trees and stone. The artist's touch is as sensitive as ever, marking with each small dash of the brush the structure and color of the object depicted. Contour lines shift and are obliterated, re-drawn and re-considered. This constant weave of definition and re-definition creates an image as complex as nature itself.

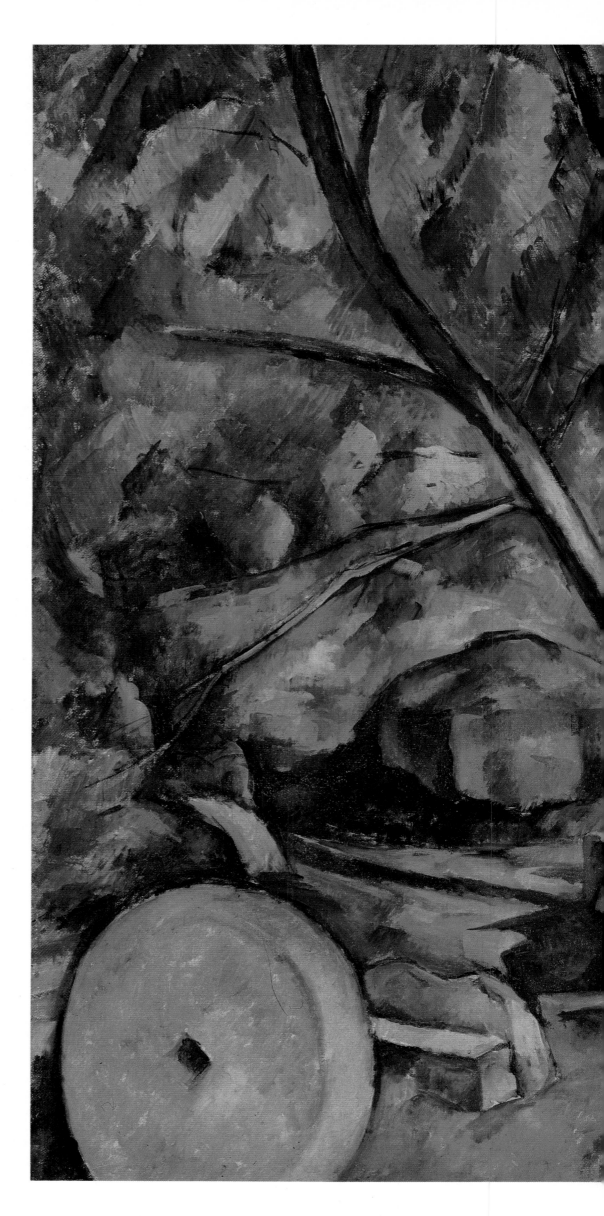

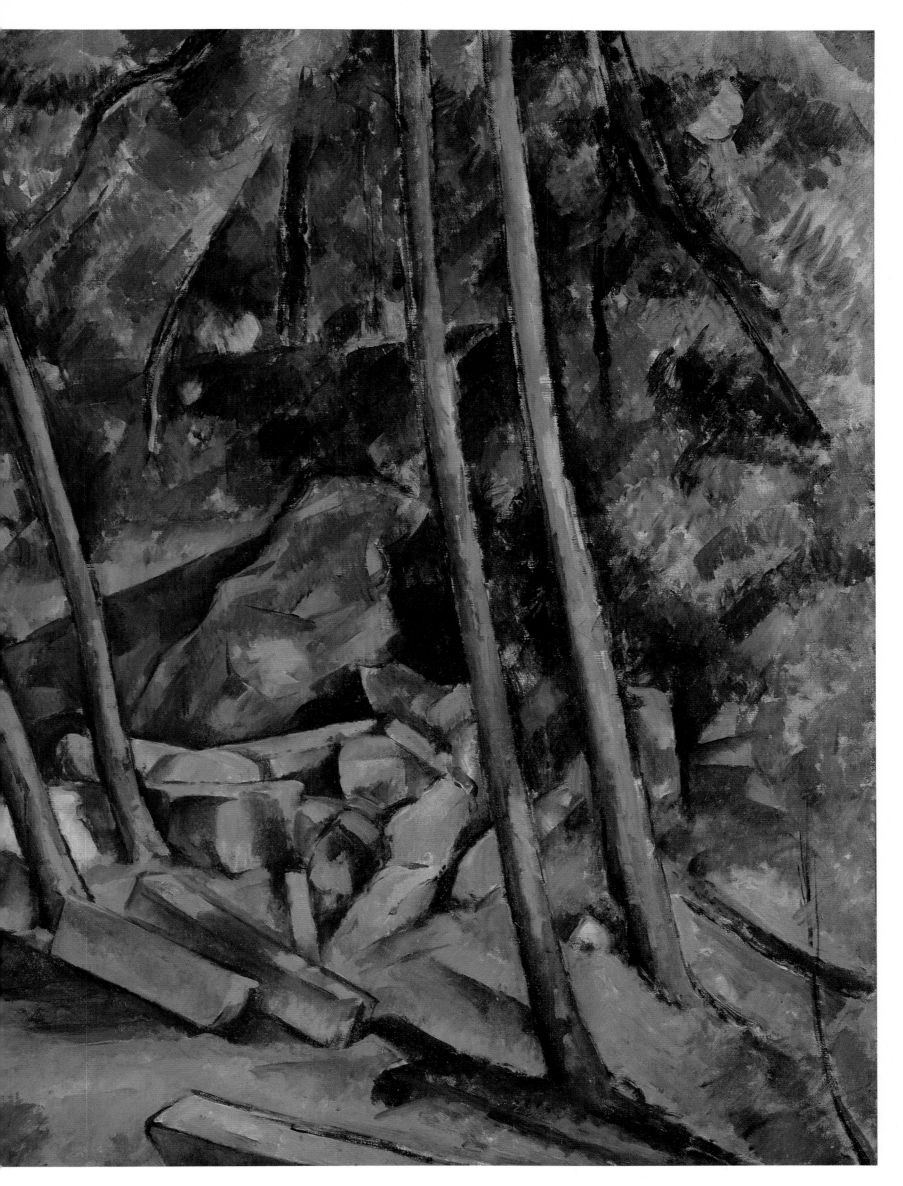

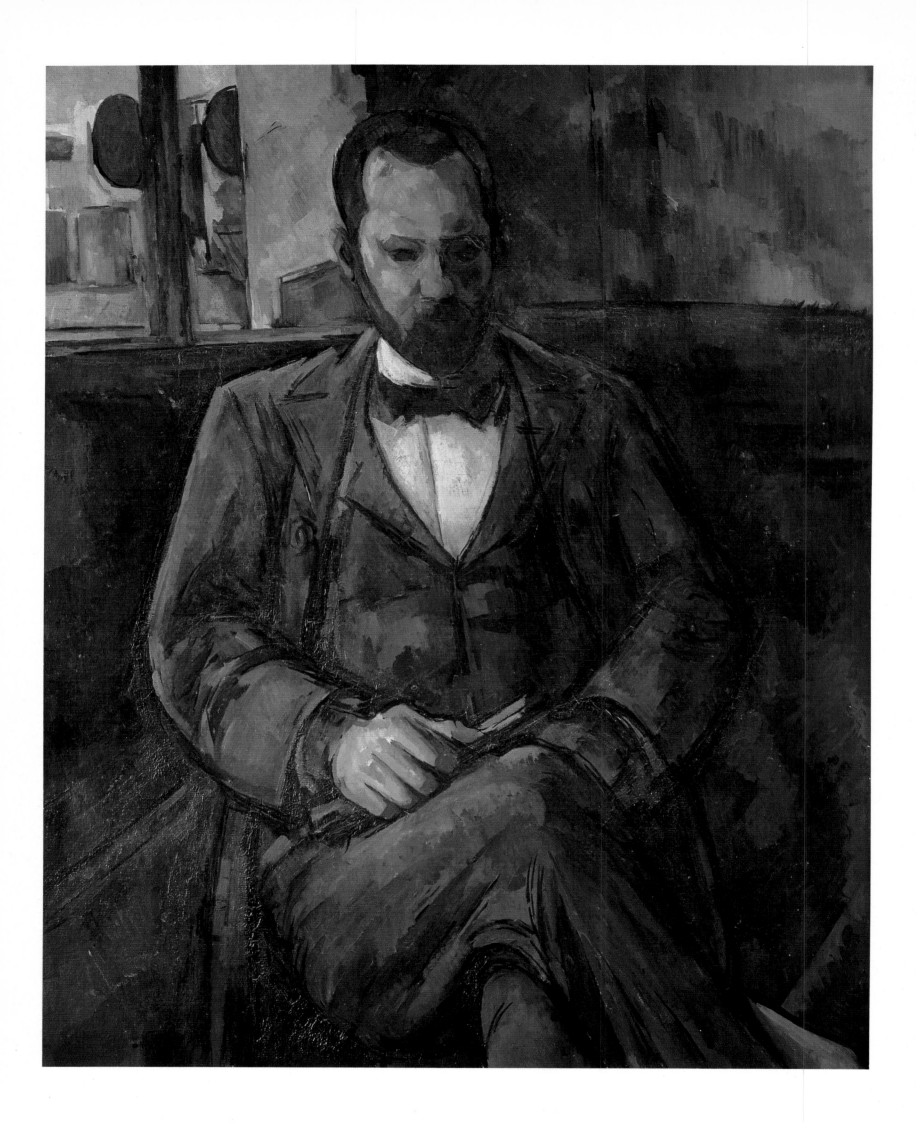

Portrait of Ambroise Vollard,

1899

Oil on canvas
39⅜×31⅞ inches (100×81 cm)
Petit Palais, Paris
Venturi 696

This dark and forbidding canvas, with its heavily worked surface, is a testimony to Vollard's account of its creation and eventual abandonment. 'Upon arriving I saw a chair in the middle of the studio, arranged on a packing case, which was in turn supported by four rickety legs. I surveyed this platform with some misgiving . . . I sat (on the chair) absolutely motionless; but my very immobility brought on in the end a drowsiness against which I successfully struggled a long time. At last, however, my head dropped on my shoulder, the balance was destroyed, and the chair, packing case and I all crashed to the floor together! Cézanne pounced upon me. "You wretch! You've destroyed the pose. Do I have to tell you again you must sit like an apple? Does an apple move?"'

The sittings began at 8.00 am and lasted three and a half hours until 11.30. In the afternoon Cézanne would visit the Louvre or the statues in the Trocadéro plaster cast museum. Vollard continued his account, 'In my portrait there are two little spots of canvas on the hand which are not covered,

I called Cézanne's attention to them. "If the copy I'm doing at the Louvre turns out well," he replied, "perhaps I will be able tomorrow to find the exact tone to cover those spots. Don't you see, Monsieur Vollard, that if I put something there by guesswork, I might have to paint the whole canvas over starting from that point?" The prospect made me tremble.' As is well known, after 114 sittings the portrait was abandoned, Cézanne admitting to the sitter that 'I am quite pleased with the front of the shirt'.

The canvas is heavily worked, although the 'spots', which may be those referred to by the sitter, still feature prominently on the sitter's right hand. Despite its unfinished state, a condition shared by many of Cézanne's canvases, the famous dealer's face and stance are unmistakeable, as may be judged from the many portraits of Vollard by Renoir, Picasso and others. At the top of the canvas appear two enigmatic matching silhouettes, echoing the rounded form of Vollard's head, but defying any precise reading.

Still Life with Curtain and Flowered Pitcher, c. 1899

Oil on canvas
21¼×28¾ inches (54×73 cm)
Hermitage Museum, Leningrad
Venturi 731

Superficially this painting is almost identical to *Apples and Oranges* (page 138) but, although it has the same grandeur, the impact of the work is much more theatrical. The artist has produced his painting as a director might produce a play; the raised curtain reveals the objects on the table, the familiar flowered jug and two dishes of fruit resting on the opulent folds of a white table cloth.

The painting openly proclaims the substances from which it has been composed, and the manipulation of the pigment can be clearly appreciated. A more conventionally painted image would not keep our attention for long; we have become so used to the illusionistic tricks of western realism that our response to the significance of the painted image may have become somewhat blunted. By deliberately eschewing traditional finish, Cézanne has subverted the inherited schemata for still life painting in order to allow the viewer to see these simple objects with a fresh eye. His use of discontinuous form, heightened color and the illogical rendering of space invite the viewer to question the means by which these powerful visualizations have been constructed. Perhaps it is these qualities as much as anything that make Cézanne's work so intriguing and give it its intangible but undeniable sense of honesty. He exposes the complicated procedures by which images of reality are constructed without losing a sense of their physical presence, and by doing so enriches our experience of both painting and the world beyond the confines of the canvas.

150

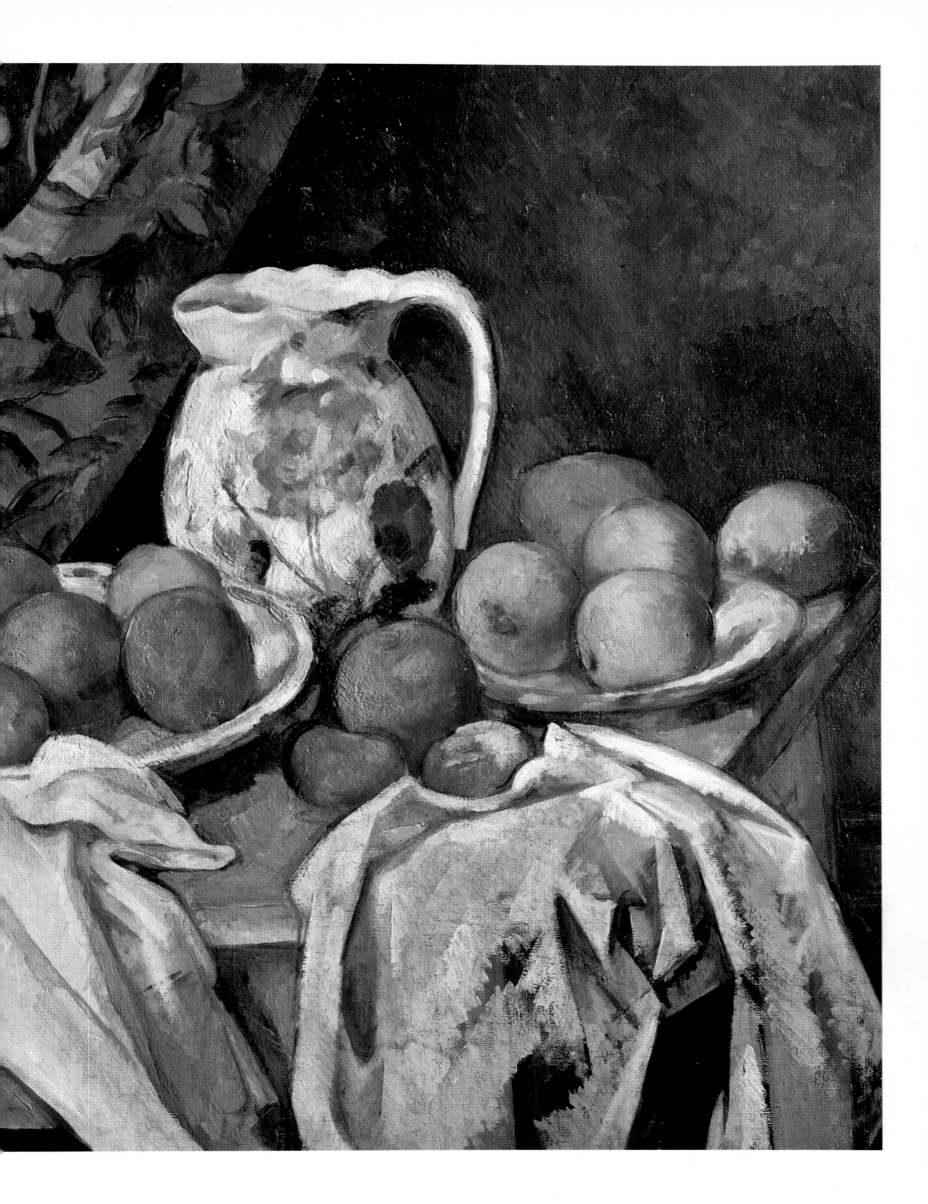

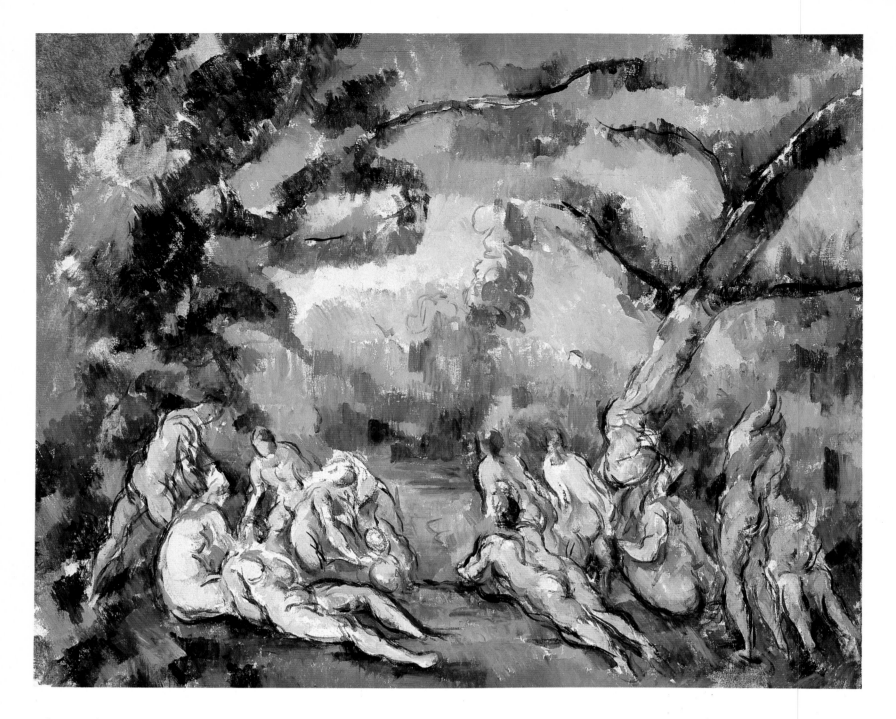

The Bathers, 1899-1904
Oil on canvas
20¼×24¼ inches (51.3×61.7 cm)
Chicago Art Institute
Venturi 722

Cézanne always went his own way, but after the death of his father in the 1880s he had the wealth and the freedom to spend his time doing precisely as he wished. These three large compositions of Bathers occupied much of his time during the last six or seven years of his life. From his earliest years as an artist he had been obsessed by the subject, and by the time he began working on these canvases he had produced a large number of very different variations on the theme. None of his three major efforts was finished at his death and they serve as memorials to Cézanne's attempt to sustain the idea of a Grand Tradition of painting by the use of traditional 'classical' subjects.

These problematic pictures can probably best be interpreted as his private conversations with the Old Masters whose works he had spent a lifetime studying. The theme is a classic one, intimately linked with the Grand Tradition as exemplified in the art of Giorgione, Titian, Rubens, Poussin and others. More recently it had been used by Ingres and the popular academic painters of the nineteenth century. Thomas Couture's *Romans of the Decadence*, reproduced on page 10, is one example. Courbet and Manet had attempted to subvert that tradition and make it once more a subject that a modern painter could treat in a modern way; Manet's *Olympia* and *Déjeuner sur l'Herbe*,

reproduced on pages 9 and 19 respectively, represent a radical and, at the time, controversial reinterpretation of the theme. Monet, Degas and for a time, Renoir had all tried to find equivalents for it in the modern life of Paris, exchanging the mythic element inherent in such subjects for alternatives taken from everyday life.

What is the subject of these paintings? Has Cézanne deliberately abandoned the heroic subversions of Manet and Degas which helped to make the nude a 'modern' subject once more, and instead sided with the arch enemy – the academic painters whose nudes populated the walls of the Salon? The mythic paintings, not only of Cézanne but also of Renoir, Gauguin and

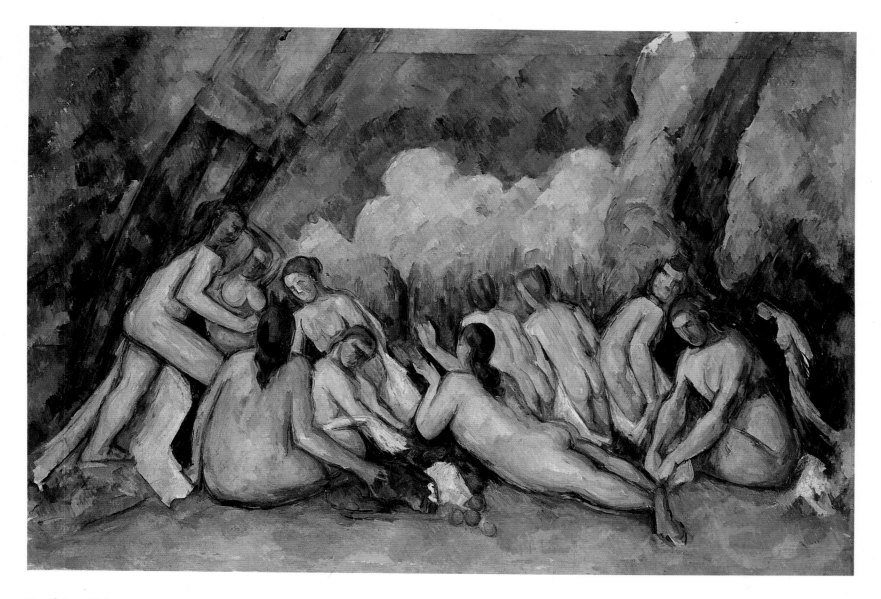

Bathing Women, 1900-5
Oil on canvas
51¼×76¾ inches (130×195 cm)
National Gallery, London
Venturi 721

others, question our too simplistic divisions of painting into such artificial polarities.

Certainly Cézanne's nude bathing women can be seen as some kind of generalized reference to the myths of Greece and Rome, but it is more likely that for him these late paintings, while intimately connected with the memories of his youth, are also recapitulations of a particular artistic heritage. His figures are usually stripped of any sense of individuality and certainly fall into no easily accepted category of physical beauty. They are the creations of an old man obsessed by painting and, in all probability, by sex. They were based on drawings he made in the Paris museums, on magazines and prints,

brought together within the confines of the studio. These are difficult paintings, and the Chicago example, with its awkward power and heavy re-working, suggests that a final resolution to his problems had not yet been secured. The artist wrote, 'Will I ever attain the end for which I have striven so much and for so long?'

When Picasso was asked what quality he most admired about Cézanne's work, he replied, 'His anxiety'. Cézanne was a man for whom visual contact with natural objects was immensely important and he spent a great deal of time walking and working in the open air; but these are studio creations, worked and re-worked, and finally left unfinished at his death.

They present a challenge to any one interested in painting. Perhaps their awkwardness is evidence of the impossibility of a happy interaction between humans and the natural environment. Or, more likely perhaps, they represent the difficulty of adapting this great traditional subject to the modern age; a problem that was to obsess artists like Picasso and Matisse and many of our own time. They are like fragments, brought together with a great concentration of effort and will; like ancient Greek marbles, they are battered and broken, yet are none the less magical for that. They are miraculous survivors of an unrealistic dream wrought into physical being.

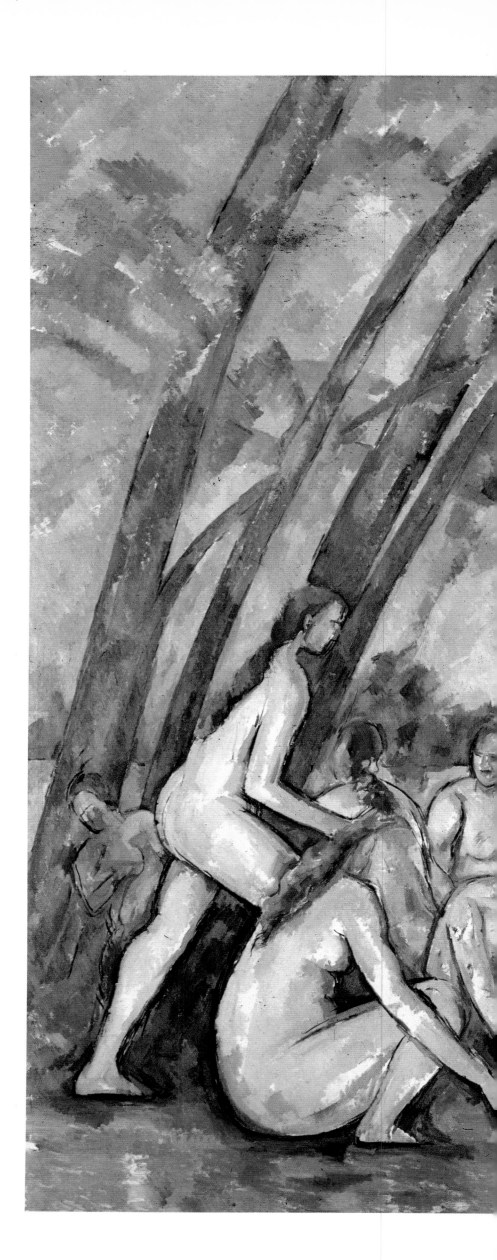

The Large Bathers, 1906
Oil on canvas
81⅞×98 inches (208×249 cm)
Museum of Art, Philadelphia
Venturi 719

154

The Three Skulls, c. 1900

Oil on canvas
13¾×24 inches (35×61.5 cm)
Detroit Institute of Arts
Venturi 1567

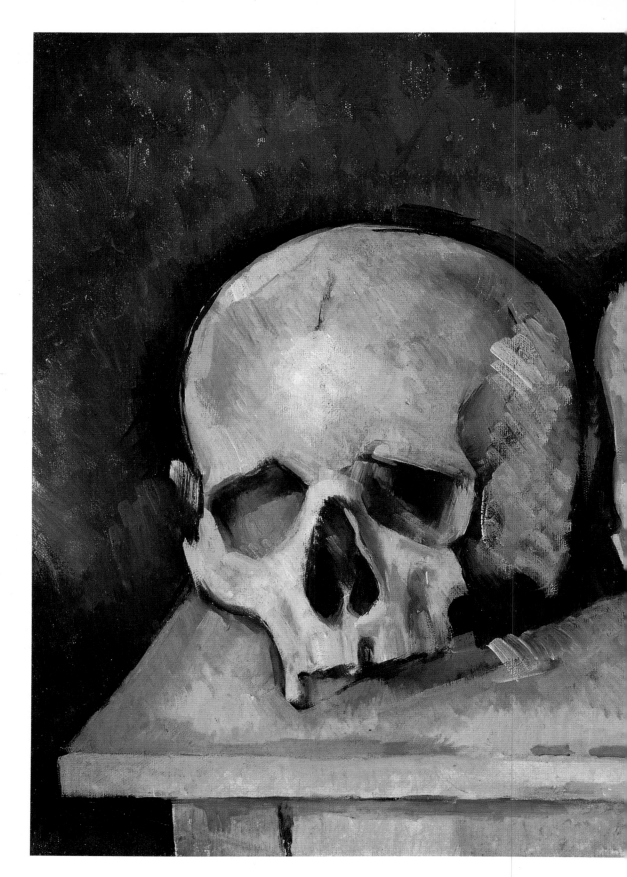

One of the hallmarks of Cézanne's art is the penetrating visual analysis that he brought to bear on his chosen repertoire of objects. This potentially gruesome subject matter, laden with cultural significance, is subjected to the same cool analysis as the artist might have applied to a bowl of fruit. Still life painting, whether of flowers, fruit or skulls, has long been regarded as a metaphor for the passage of time and the inevitability of decay and death. Cézanne had consciously used such objects in this way before; particularly in his early works (page 28). The result of the artist's analytical approach is that his still lifes attain the grandeur and breadth of his landscapes. Emile Bernard observed Cézanne painting a still life of three skulls, perhaps this very one, and later wrote that it. '. . . changed color and form nearly every day . . . his manner of study was meditation, brush in hand'.

With his habitual disregard for the conventional rules of drawing, composition and organization of light and shade, Cézanne has patiently built up the image by his 'sensations colorantes', that is, the suggestion of modeling by the application of small separate touches of color. The effects of light and dark are matched by a series of small delicate touches of paint. The cooler the tone, the darker the shade; the warmer the tone, the stronger the presence of light. Such techniques, acquired painfully over a long period of time, give Cézanne's paintings a sense of honesty, even of a painfully achieved 'truth', that more conventional paintings lack. Some of this sense of honesty is the result of his lack of a definitive system and his willingness to modify his techniques in the light of experience: 'If they try and create a school in my name, tell them they never understood, or liked, what I was doing'.

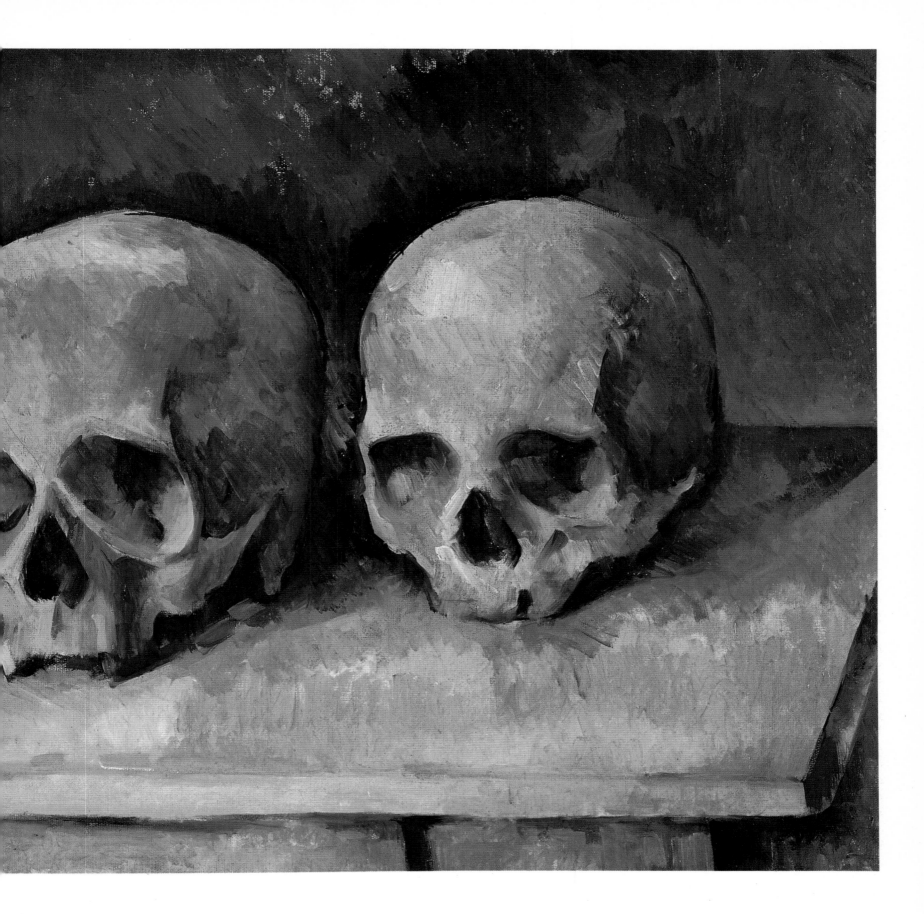

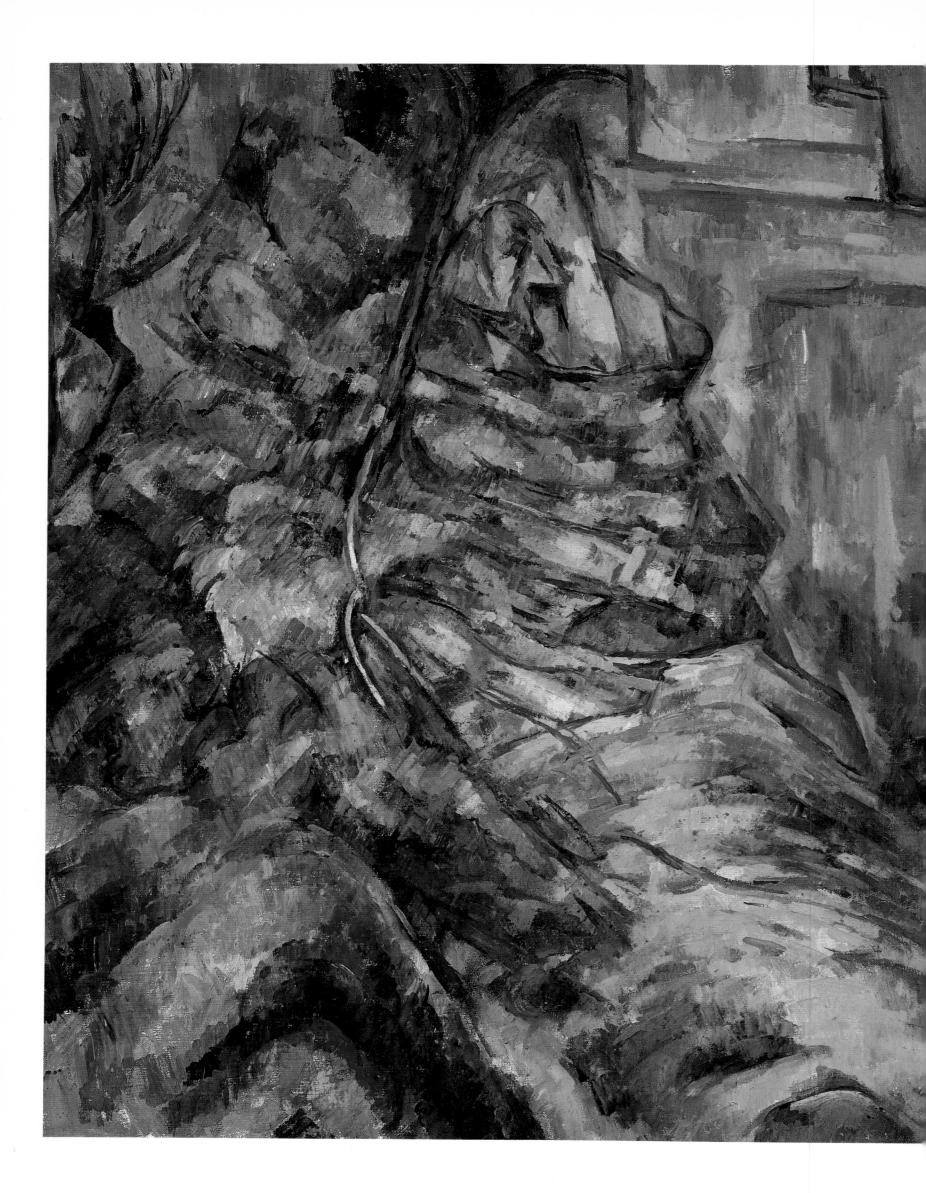

Rocks and Branches at Bibémus,

1900-4

Oil on canvas
24×19¾ inches (61×50 cm)
Petit Palais, Paris
Venturi 785

This densely worked canvas is difficult to read; in some publications it has been reproduced lying on its side, but close examination shows that the painting is meant to be read as here. The main subject of the canvas is the dramatic contrast between the inert mass of the cut rock and the tremulous organic forms of a fallen tree which hangs down the rock face of the quarry; to the upper left another tree sends out its branches towards the sky, as if to intensify the romantic image of death and re-birth.

The quarries at Bibémus held a particular fascination for the artist. They are situated to the east of Aix and were as overgrown and neglected in Cézanne's day as they are now. His many images of the deserted site not only suggest the beauty of the place, but also arouse in the viewer a profound sense of solitude. He had visited the quarries as a youth and from the mid 1890s had begun to paint the geometrical patterns formed by the excavation of its stone. The steep surfaces which blot out the sky and the interplay of vegetation and rock naturally eliminated the recessional qualities normally associated with landscape. By closing off the blue of the sky, Cézanne could reduce the range of local color within the scene and also the focal range of the picture. The wall of the quarry stands roughly parallel with the picture surface and allows the artist the opportunity to create rich contrasts of form and texture within a shallow picture space.

Cézanne never abandoned drawing; it was always an integral part of his art. In this painting the branches of the trees are drawn with a series of fine blue lines, a feature common in Cézanne's mature works, as blue may be considered the closest representative of the coloration of the atmosphere. Deep brilliant greens and blues act in conjunction with earth colors – burnt siennas, yellow ochers and orange-reds – in a cascade of varied brushstrokes describing the different forms within the picture. The entire canvas area is activated by Cézanne's masterly manipulation of forms, colors and textures.

Flowers, 1902-4

Oil on canvas
30¼×25¼ inches (77.4×65.2 cm)
Pushkin Museum, Moscow
Venturi 754

This canvas is a free interpretation of a highly finished watercolor by Eugène Delacroix which was owned by the artist. There is a sheet from a Cézanne sketchbook in which a drawing of his wife Hortense is placed next to a considered watercolor study of a bloom of hortensia. Visual puns occur sporadically throughout Cézanne's work, as in the Achille Emperaire portrait (page 38). The presence of these flowers in the Delacroix watercolor may have struck a special chord with Cézanne as Delacroix was one of the artists he most admired. The watercolor was one that Delacroix held in special regard, and at his death it passed to the collection of Victor Chocquet. In his article in the *Mercure de France* of 1907, Emile Bernard recorded Cézanne's admiration for the painting, described by Delacroix as 'flowers arranged haphazardly on a gray background.' Later it was acquired by Cézanne's dealer Ambroise Vollard and was then given to Cézanne himself. It is thought that he kept it in his bedroom at the rue Boulegon in Aix.

Throughout his life Cézanne loved the work of Delacroix, and in his later years he was much occupied with painting an *Apotheosis of Delacroix* (page 133), which remained unfinished at his death. When Cézanne was in Paris during the early 1860s he witnessed the sale of the contents of Delacroix's studio and would have known the many works available in the Paris museums, public buildings and churches. Like so many other artists Cézanne admired Delacroix's late murals at the church of Saint Sulpice, finished two years before the master's death in 1861. In these works Delacroix developed a manner of 'constructing' with color, instead of the time-honored system of *chiaroscuro*. Hatchings of brilliant color create a rich regular weave across the wall or canvas area in Delacroix's paintings, just as they do in Cézanne's work. These strokes were not merely a technical refinement of Delacroix's stylistic repertoire; he referred to them in his journals as '*hachures de sentiment*'. As with Cézanne, much of Delacroix's radical art practice came from his reinterpretation of the work of the Venetian and Baroque masters and, like so many artists since, Cézanne was aware of the significance of Delacroix's technical and artistic achievements, as he made clear when he said 'We are all in Delacroix'.

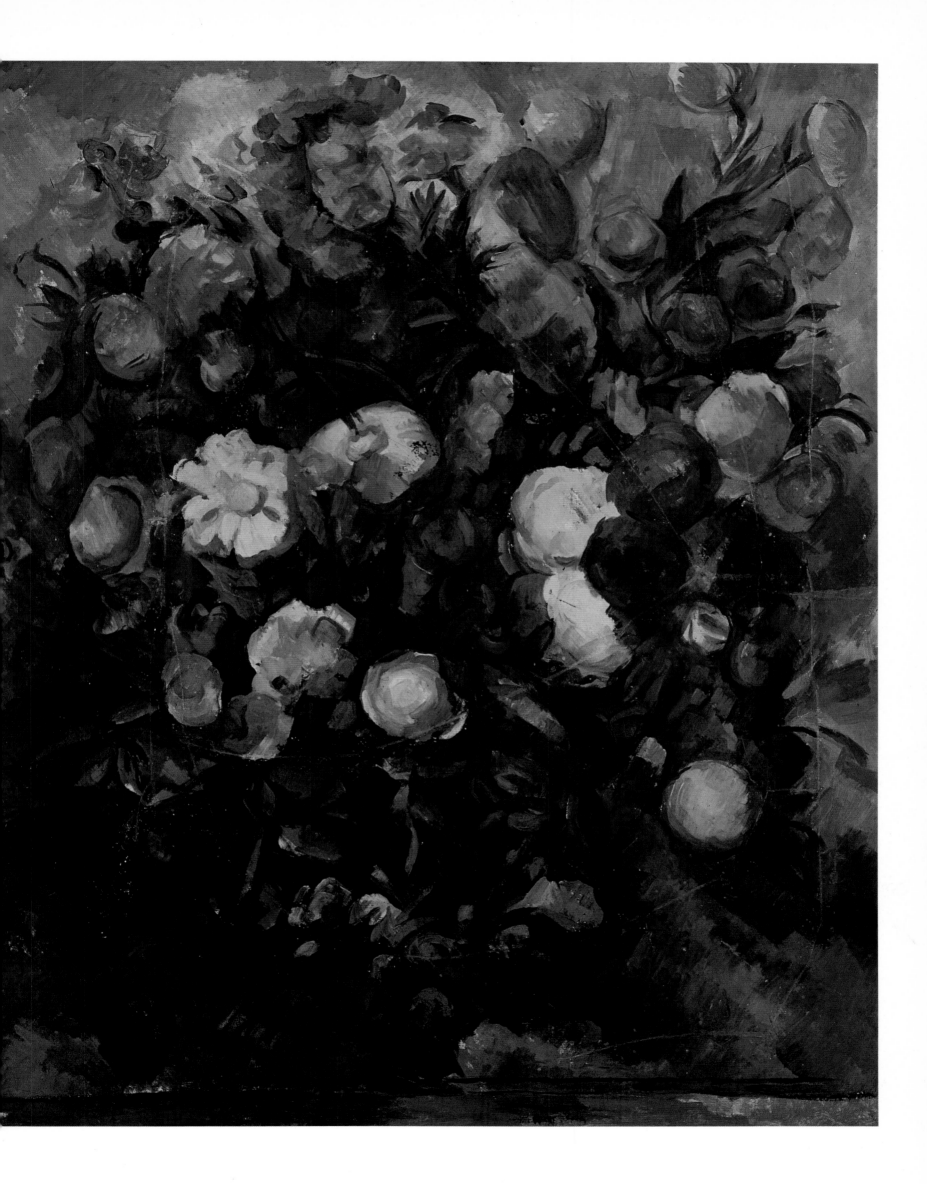

The Château Noir, 1904

Oil on canvas
28¾×36¼ inches (73×92 cm)
Oskar Reinhardt Collection, 'Am
Römerholz', Winterthur
Venturi 796

The Château Noir was built around the middle of the nineteenth century and left incomplete. Cézanne's view shows its dramatic silhouette, the distinctive red door, and the 'gothic' windows through which the blue of the sky may be seen. Cézanne was fascinated by the building and the estate surrounding it, and in the last years of his life he painted and drew the building and woodland many times. Like his paintings of Mont Sainte-Victoire and bathing figures, these vary much in character and mood. The large rectangular door, though infiltrated by the distinctive yellowish color of the local stone from which the building was constructed, asserts its primacy as the dominant note within the picture.

The broken geometry of the unfinished building is set within a framework of branches and foliage. The greens of the pines, flecked with nuances of yellows, ochers and blues, make a strong formal and coloristic contrast with the rich warm tones of the building. The angular forms of the trees form a screen of anchor points in a sea of movement, dominant motifs that tie the composition together and emphasize the importance of line in the picture.

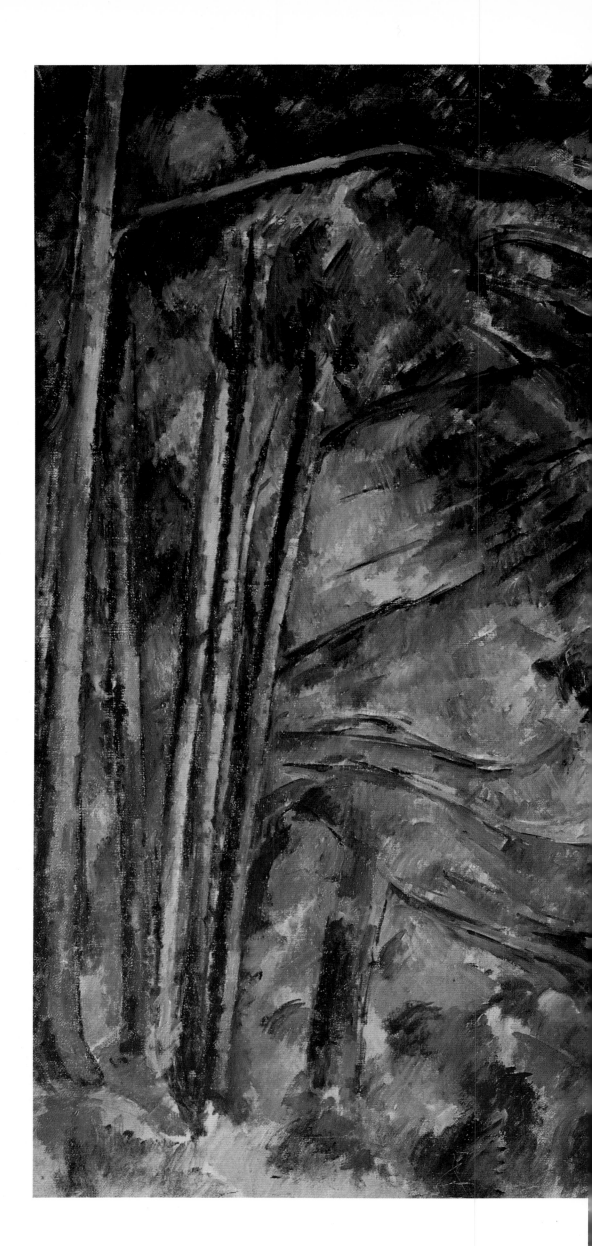

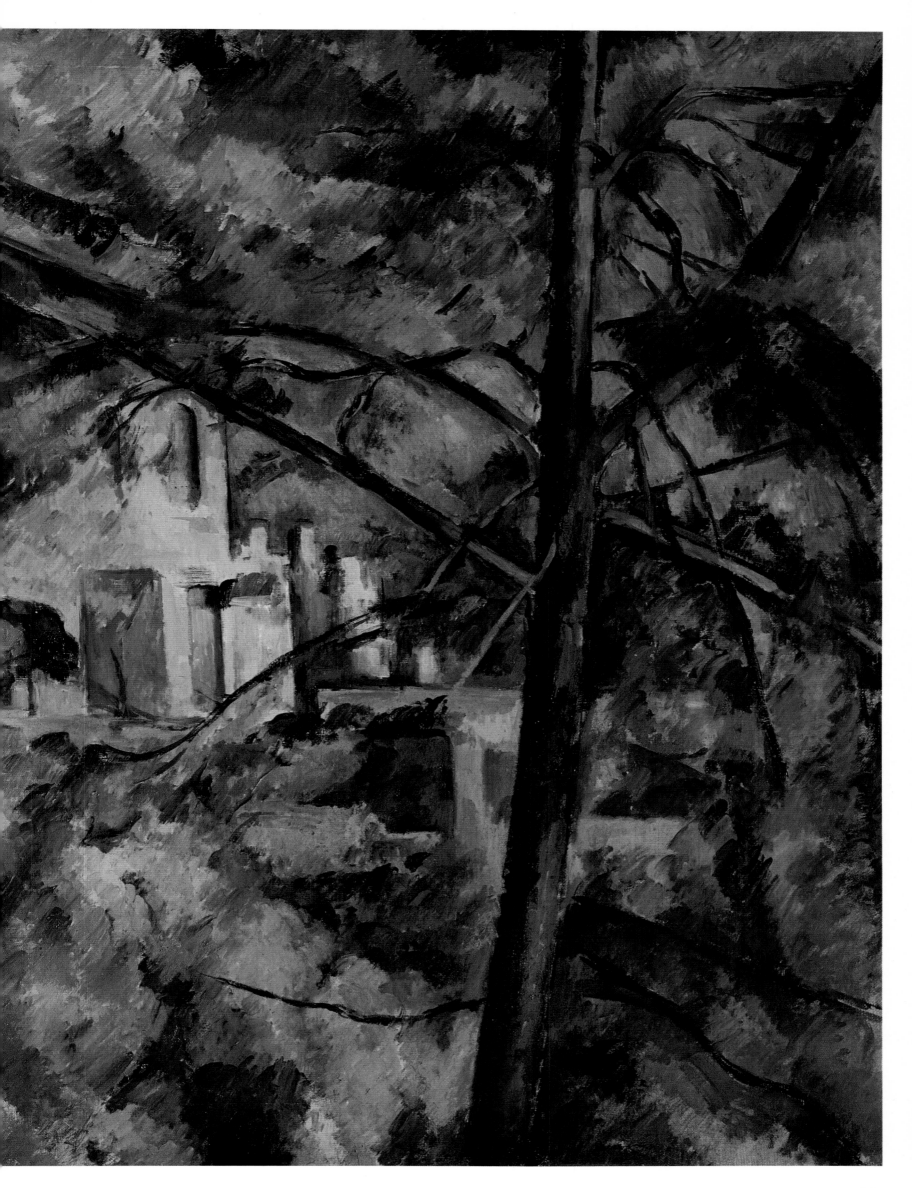

163

Mont Sainte-Victoire, 1904-6

Oil on canvas
21¼×28¾ inches (54×73 cm)
Galerie Beyeler, Basle

Cézanne's affinity with Chinese painters in certain of his late paintings has frequently and justifiably been cited by many commentators. Whether he would have known any of these works is debatable, but their closeness in spirit is undeniable. We are used to considering the rectangle of the picture surface as a window through which we look out onto the world. Alternatively it may be thought of as a flat surface covered by colors laid on in a certain order. There is, however, a further way of considering the blankness of the canvas; in Chinese paintings the emptiness of the canvas is symbolic of the void, to be disturbed with caution. In his final paintings Cézanne's empty canvas became a metaphor for boundless space, freed from the shackles of mathematical formulae.

Cézanne's achievement is all the greater given that he created these transcendental metaphors for our experience before nature without the benefit of hundreds of years of tradition and scores of years of training. Single-handed, working from painting to painting, never compromising his art or his attitude toward nature, he developed his many technical innovations until he reached this sublime level of vision and artistic accomplishment. Each of his paintings has its particular merits, and his early works often contain rewards as rich, for the interested viewer, as his late masterpieces, and yet there is something truly awesome about the immensity of his realization in pictures such as this. The four-hundred-year-old tradition of linear perspective has been supplanted by the use of modulated patches of color which, by their opposition and spacing, suggest depth of field. Unfinished or not, the cream of the canvas priming suggests the atmosphere that envelops the objects, modifying our perception of them. Things are not seen as fixed, but as being part of an endlessly changing cycle of transmutations; what seems permanent to us, a huge rock mass dominating a plain, is in fact as transitory a thing as the clouds that pass over its bulk.

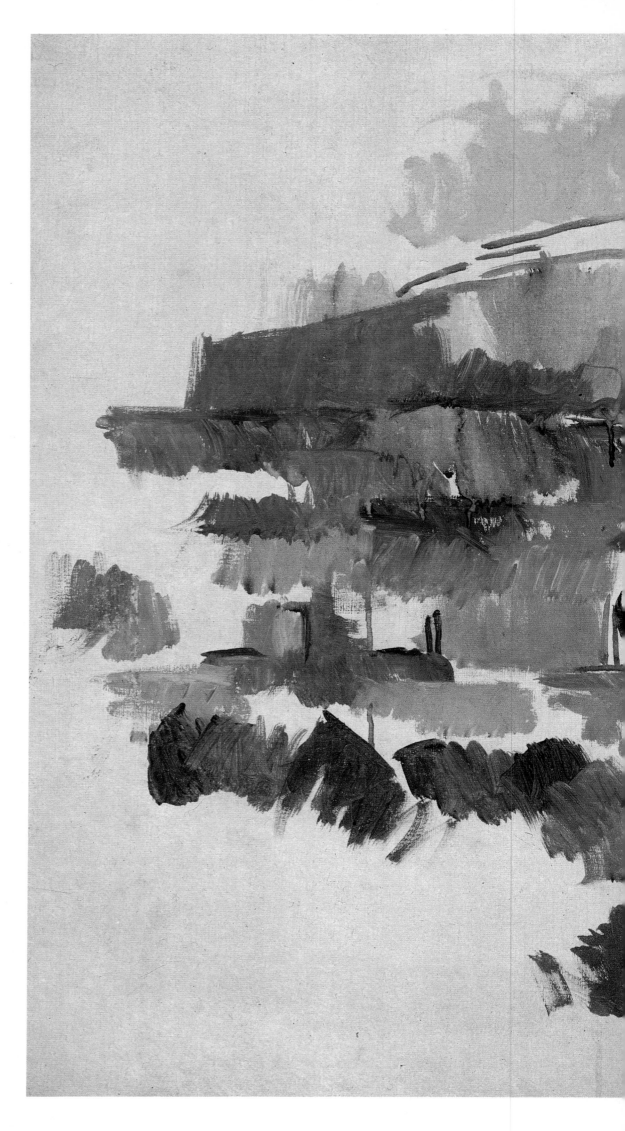

164

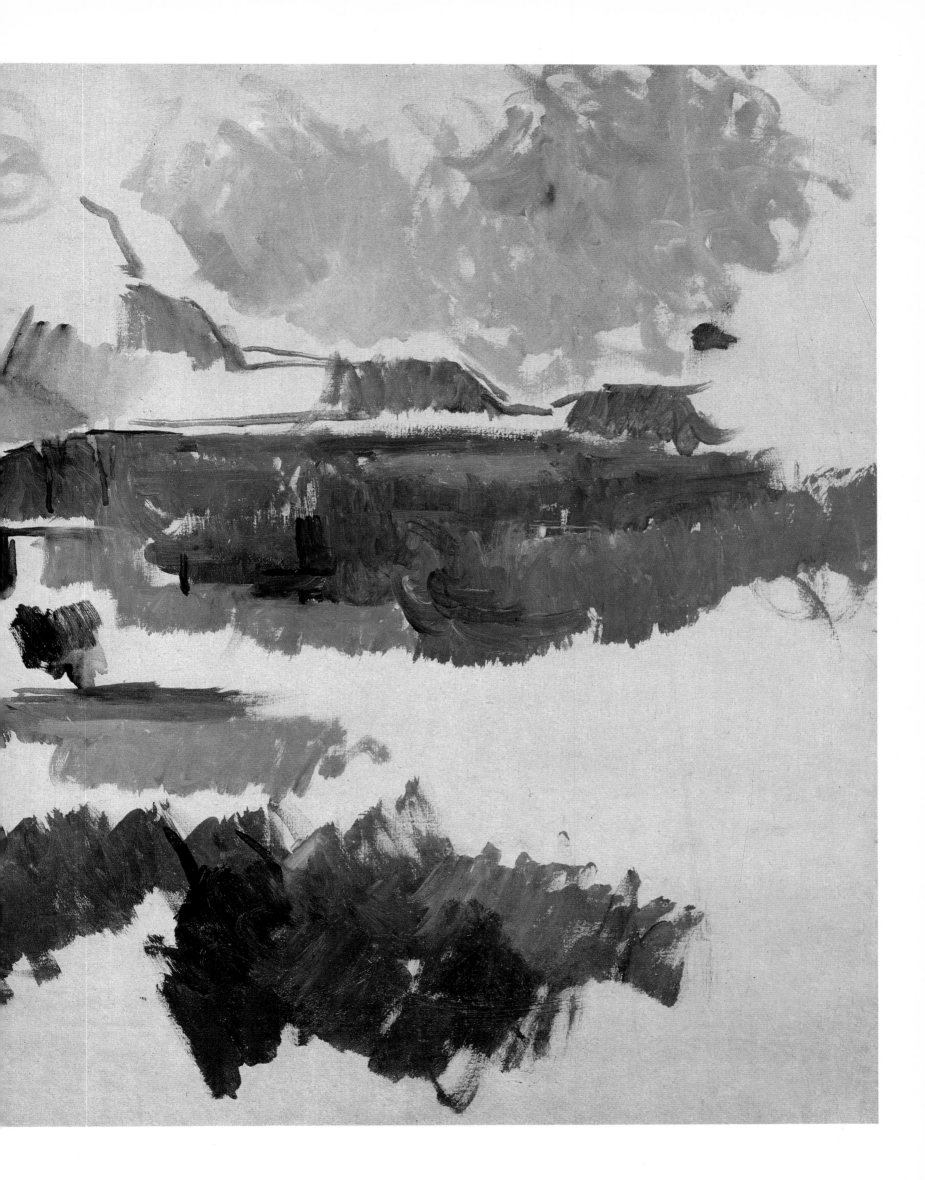

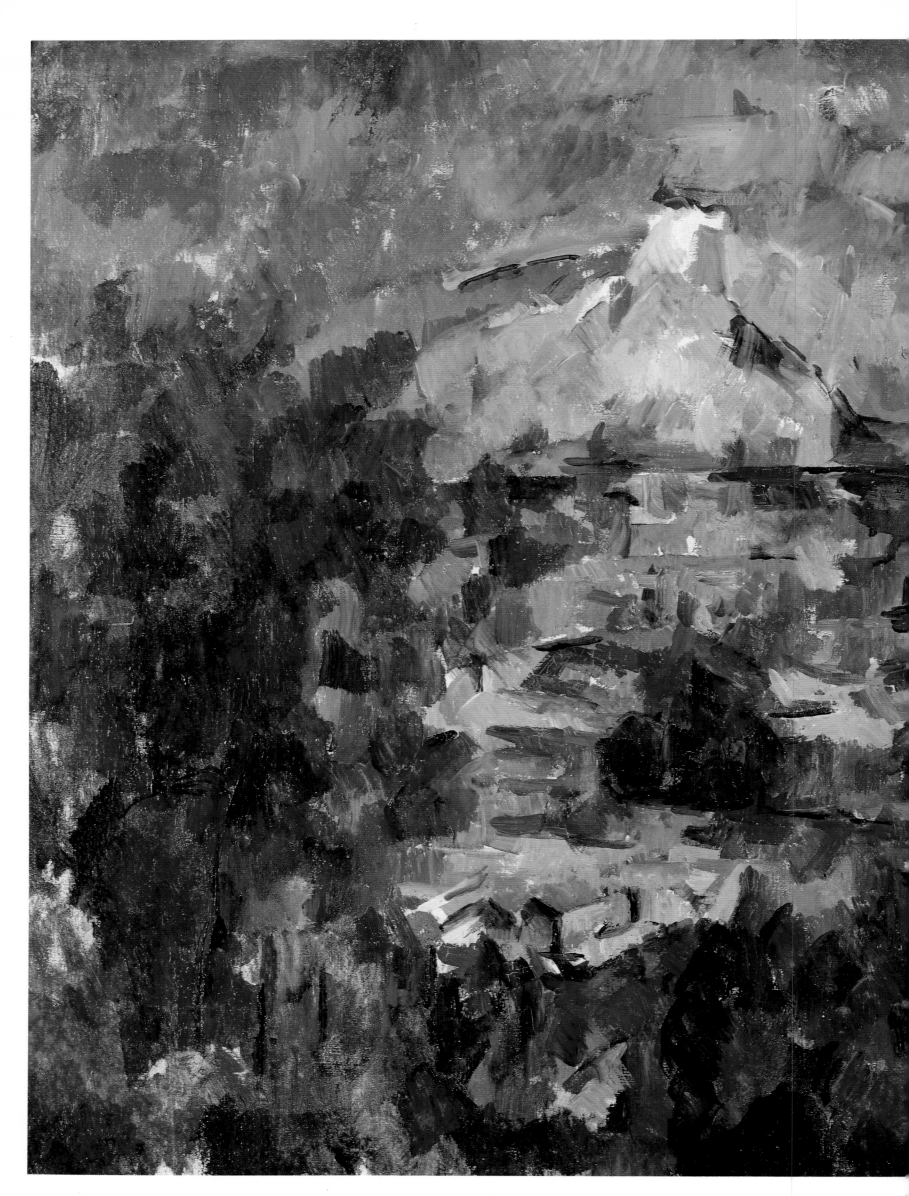

Mont Sainte-Victoire, 1904-6

Oil on canvas
23⅝×27½ inches (60×70 cm)
Öffentliche Kunstsammlung
Kupferstichkabinert, Basle
Venturi 1529

This canvas is unfinished – the very summit of the mountain remains untouched – and for this reason it provides a good example of Cézanne's working practices. The trees that occupy the foreground stretch to the sky and bleed into the landscape, knotting the panorama of the valley into a single unified weave of marks. An area of jagged blue on the lower left is repeated in lighter tones across the valley floor until it reaches the mountain itself and splinters into the sky, which contains hues of the colors used to express the phsyical facts of the valley. A few homesteads can be made out, their cubic constructions almost indistinguishable from the marks that envelop them. The horizontal bands are firmly stated with sharp lines that cut across the canvas area, a scaffolding upon which to place the initial thin swathes of paint, which became swamped by thicker pigment as the painting progressed. Cézanne produced a varied and rich surface of textures and colors as he balanced and organized these elements across the whole canvas area, placing cool hues against warm hues, massing together areas of color to suggest the density of foliage or the depth of open space, in contrast to the enclosed light-filled spaces of his woodland scenes.

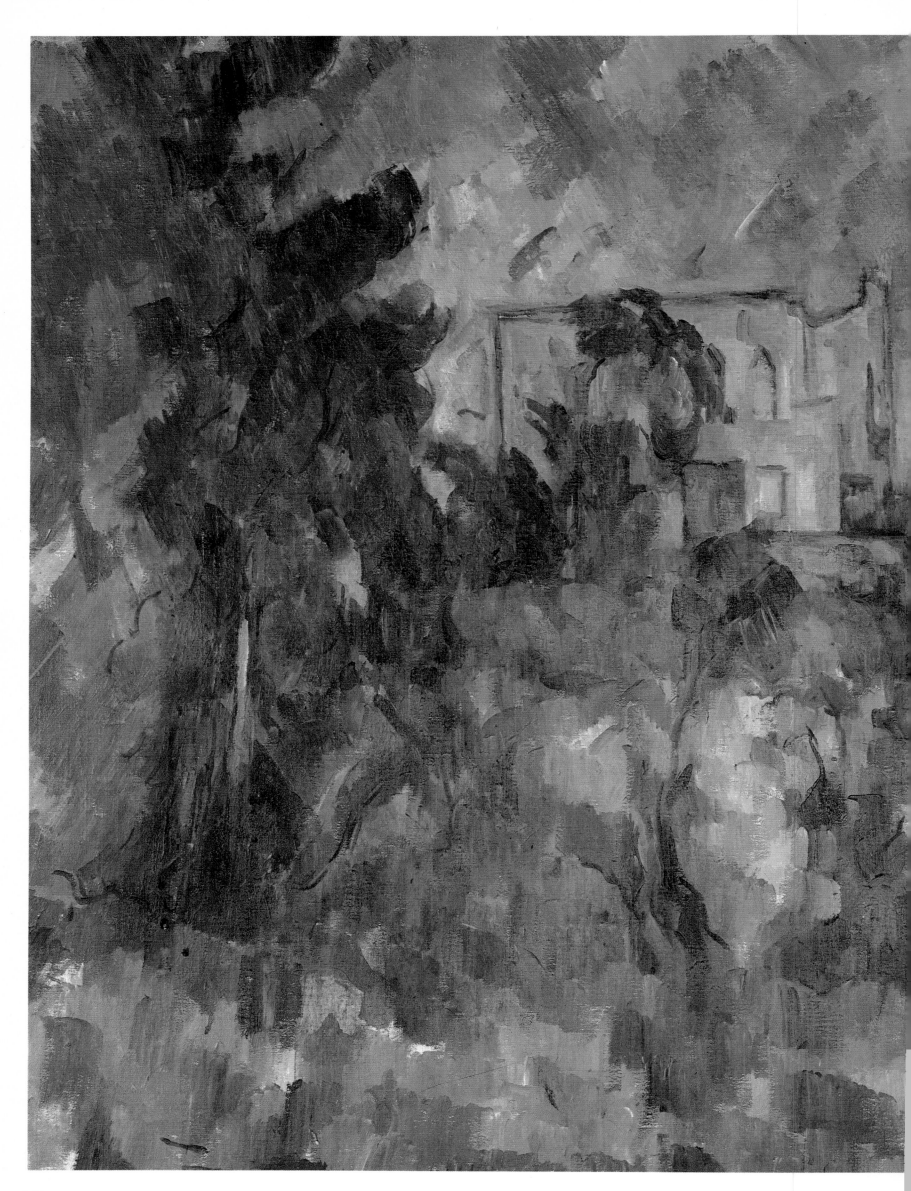

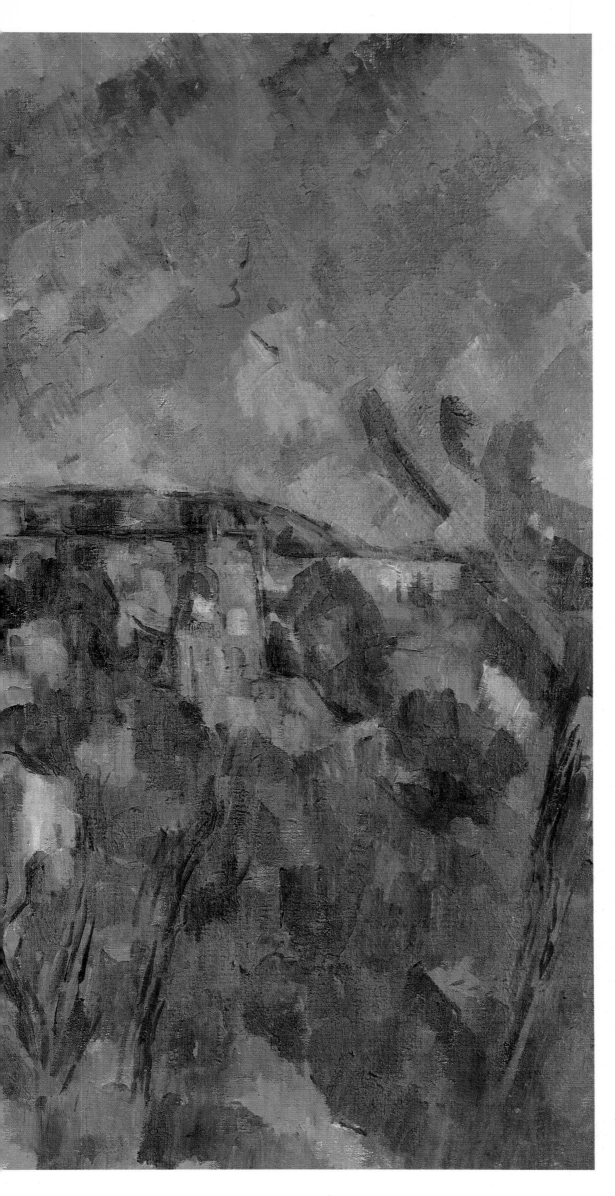

The Château Noir, 1904-6

Oil on canvas
28¾×36¼ inches (73×92 cm)
Musée d'Orsay, Paris
Venturi 795

This canvas was once owned by Picasso and was given by him as a gift to the Louvre. It now hangs in the Musée d'Orsay. Cézanne has taken a few steps back down the hill from the vantage point used in the previous picture; here the Château Noir is seen through a network of foliage. In this painting the verdure forms a series of mainly cool rectangular shapes, interspersed with a delicate tracery of barely visible lines which are grouped together to suggest the trunks of small trees. To the left the major mass of woodland fills the entire canvas edge, its strong diagonal movements continued in thinner hatched paint. Cold blues, greens and lilacs fill the sky area around the warm reddish ochers of the chateau. The simple geometric structure of the building, partly hidden by a mass of blue-green foliage, stands raised to a height just above the halfway point of the canvas. Behind it the deep blues used for the mid-ground foliage are used again to suggest the form of Mont Sainte-Victoire, which plays very much a secondary role in the painting compared with the monumental bulk of the building. The thickness of the paint varies across the canvas, as Cézanne has worked some areas to a greater degree of finish than others. In the foreground area many of the patches of colour are still edged by bare canvas. Each mark is the particular response to a certain moment of sensation, marked down in coloristic terms to link with its neighbor and to create a harmonious ensemble parallel to that which the artist believed to exist in nature. The broken outline of the building, its pseudo-gothic embellishments merely hinted at, break what would otherwise be a harsh transition from building to sky and its forms seep into the landscape that supports it.

Cézanne's methodical manner of working, his marks relating both to his perception of the subject and to the overall harmonies of the picture, meant that at whatever stage the painting was left, it was fully charged with order and life and, in the most complete sense of the word, finished. He had no desire to copy nature, although he passionately loved the countryside around his native town; instead he has left a record of his own profound meditations.

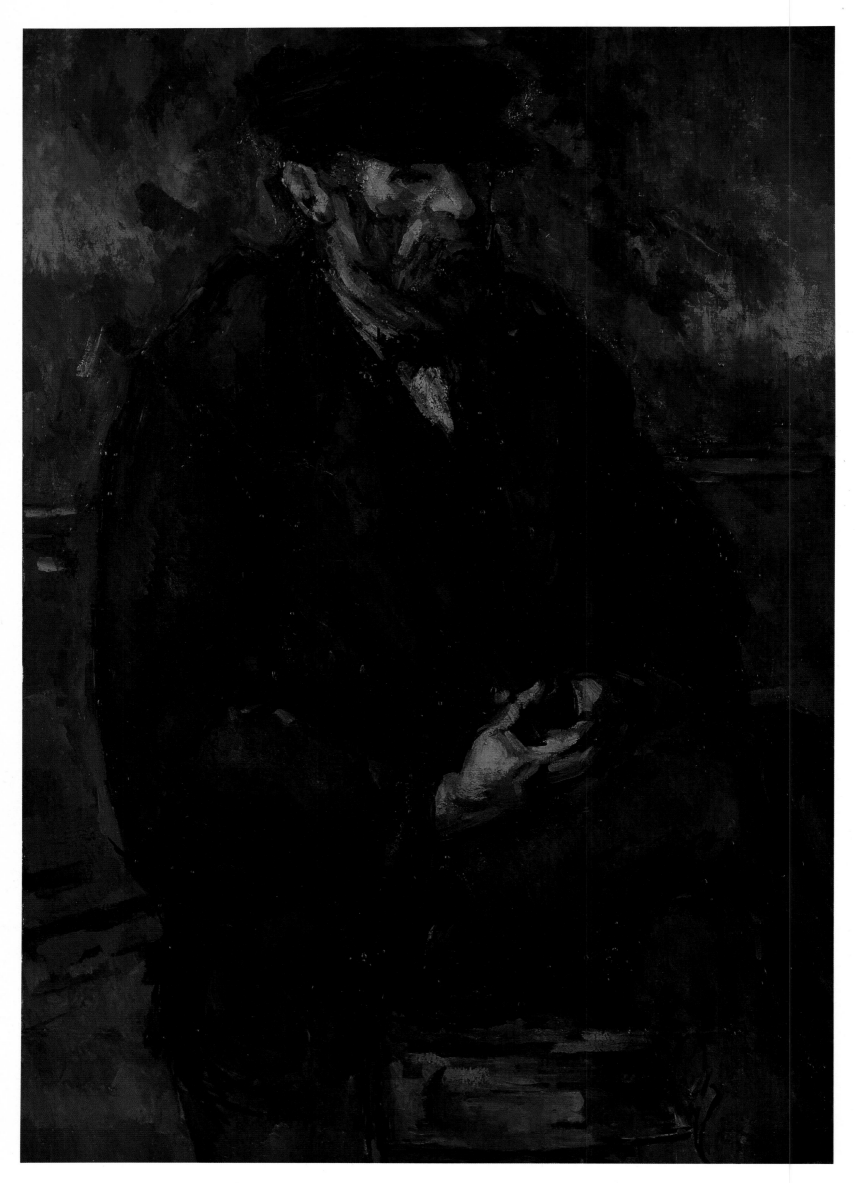

The Gardener Vallier, c. 1905

Oil on canvas
42¼×29⅜ inches (107.4×74.5 cm)
National Gallery of Art, Washington
Venturi 716

The rugged grandeur and awesome monumentality of Cézanne's interpretations of Mont Sainte-Victoire reappear in a group of portraits done in the last years of his life. Tradition has it that it was one of these portraits that received the last touch of Cézanne's brush before his death on 22 October, 1906.

The painting represents Cézanne's gardener, Vallier, his pipe supported in his lightly clasped hands, sitting on the terrace of Les Lauves. The monumental qualities of his other late paintings are found here, while the blankness of expression found in some of his portraits is replaced with a certain amount of characterization. The set features of the old man are clearly discernible; like a statue rough-hewn from granite, Vallier looks grimly out of the painting. The *terribilità* of an old man has replaced the impatience of his youth.

Vallier's pose is that set by Cézanne for the dealer Vollard (page 148) six or seven years earlier, seen from a different angle.

Unlike that portrait, the overall effect here is of a smouldering incandescence, although the coloration is somber and dark. The paint has been laid on extremely thickly, with the energy of his early works, layer upon layer, until the painting has evolved a surface landscape of hills and valleys of pigment as color relationships and contour lines have been defined and re-defined. Firmly applied strokes of purples, blacks and blues overlap throughout the figure, whose hands, collar and face, worked in the same brick-like colors as the chair, stand out against the dense mass of the figure framed by the rich greens of the background. At a late stage in the painting Cézanne added a strip of canvas to the bottom. Previously the jacket and trousers would have formed a strong stable base line for the composition; by introducing the chair Cézanne has considerably lightened the effect of the canvas, without losing anything of its Michelangelesque authority.

171

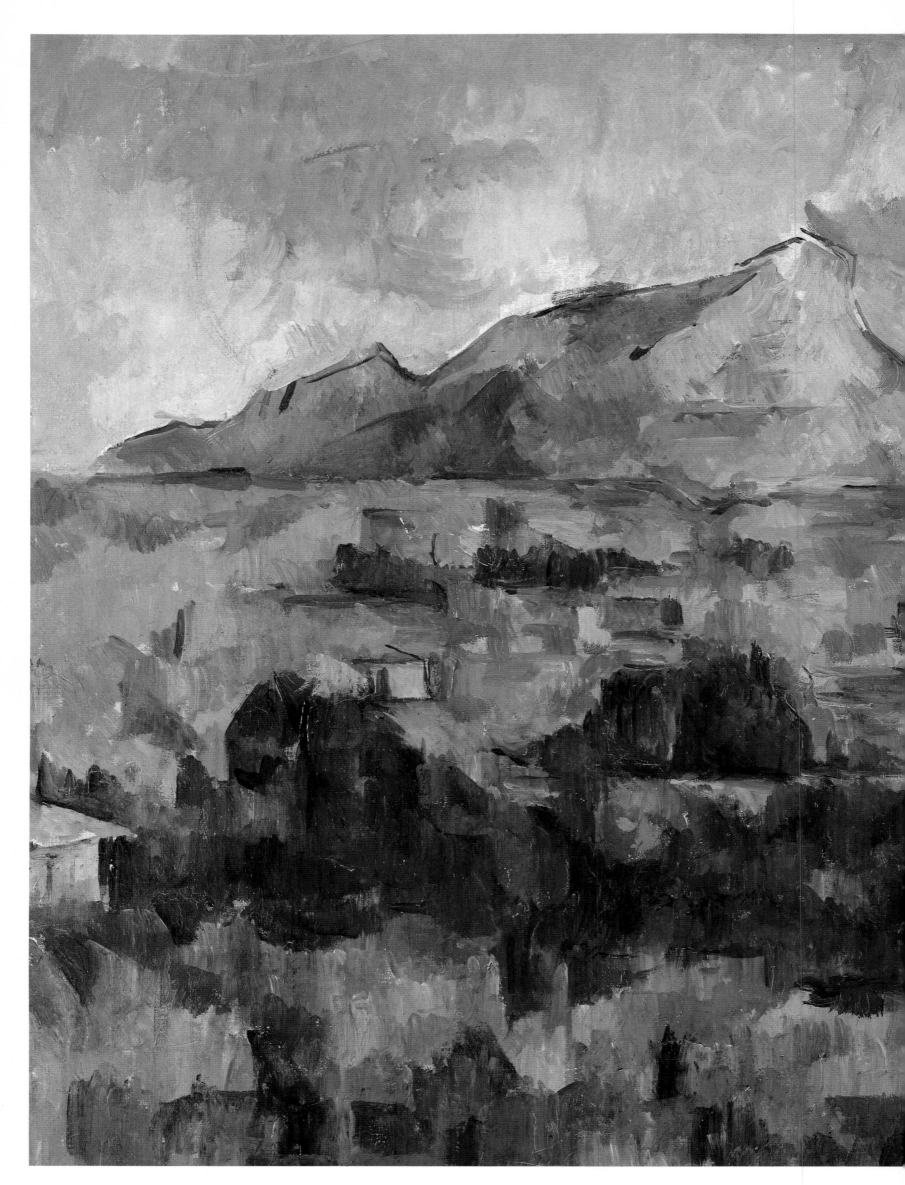

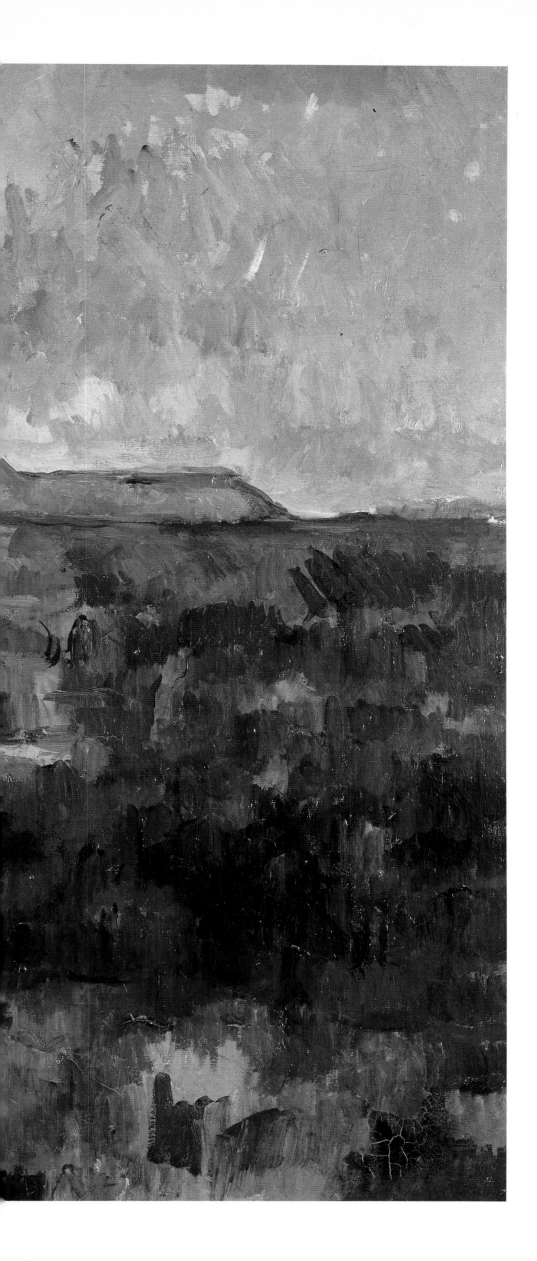

Mont Sainte-Victoire, 1905-6

Oil on canvas
25½×31⅞ inches (65×81 cm)
Private collection, Switzerland
Venturi 802

The famous profile of Mont Sainte-Victoire dominates the flat plains that surround the city of Aix. It is celebrated again and again in the paintings of the last 20 years of the artist's life. This version was probably painted in about 1905-6. The view sweeps out above the trees that line the lower edge of the canvas and over the plain towards the wedge-like mass of the mountain that lurches uneasily on the horizon line.

The painter Maurice Denis records Cézanne as saying, 'I wanted to copy nature, I couldn't. But I was pleased with myself when I discovered that the sun, for example, could not be *reproduced* but that it must be *represented* by something else, by color for instance'. This statement, and the evidence of his paintings, show that the artist had recognized the impossibility of painting nature directly and the necessity of creating an analogy for sense experience through the use of paint. The colors are not restricted to describing the local colors of exact forms – violets, greens, ochers and blues are repeated throughout the entire surface of the painting; patches of color that describe the mountain are used elsewhere to describe the air that surrounds it and the plain below. Cézanne has not painted a particular moment but has created an analogy for the dynamism of nature in all its forms; the rock that makes up the mountain is expressed in the same manner and with the same force as the foliage. All the forms of existence are meshed together in a single highly charged rhythmic pattern, broken into three horizontal bands. On this densely worked surface, overlaid with irregular ragged shards of color, Cézanne has charted a series of encounters with external reality woven into a single pictorial unit. The result is a mystical expression of the unity and power of nature and a monument to the mysterious and unfathomable way in which a human can, through the agency of art, express the essential oneness of the world.

173

Index

Figures in *italics* refer to illustrations; all works of art are by Cézanne unless otherwise indicated.

Académie Suisse 8, 36
Affaire Caillebotte, L'(1894) 21
Afternoon in Naples, An 72
Aix-en-Provence 7, 8, 15, 16, 18, 19, 20, 21, 23, 25, 26, 28, 36, 37, 39, 42, 78, 109, 117, 120, 127, 145, 159, 160, 173
Album Stock 11, *11*
Alexis, Paul *48-49, 49*
Anna the Javanese by Gauguin 39
Apotheosis of Delacroix 133
Apotheosis of Henri IV by Rubens 46, 133
Apotheosis of Homer by Ingres 133
Apples and Oranges 18, *138-39, 150*, 160
Artist's Father, The 32-33, 39
Artist's Son, The 100
Artiste, L', magazine 10, 34
Auvers, Panoramic View 66-67
Auvers-sur-Oise 12, 14, 58, *58-59, 64-65, 65*, 66, *66-67, 83*, 87

Baille, Baptistin 8, 92
Barbizon school 13, 142
Bather and Rocks 27
Bathers, The 152
Bathers at Asnières by Seurat 52
bathing figures paintings 19, *19*, 27, 46, *50-51, 68-69, 88-89*, 113, 129, 131, *152, 153, 154-55*
Bathing Women 153
Batignolles group
 at the Café Guerbois 8, 9, 11, 12, 52
 at the Café La Nouvelle Athnes 14
Battle of Cascina by Michelangelo 68
Battle of Love 92-93
Baudelaire, Charles 11, 28, 42, 46, 52, 133
Bazille, Frédéric 8
Bernard, Emile 19, 21, 22, 23, 25, 133, 156, 160
birth and family background of Cézanne 7
Black Marble Clock, The 45
Blue Vase 99
Bonnard, Pierre 22
Boy in a Red Waistcoat 127
Braque, Georges 17, *18*, 54, 129
Brémande, Madame, Cézanne's housekeeper 25

Café Guerbois 8, 9, 11, 12, 14, 52
Café La Nouvelle-Athènes 14, 15
Caillebotte, Gustave 15, 21, 22
Camoëns on his Deathbed at the Hospital at Lisbon, The by Parade 36
Caravaggesque school 11
Card Players, The, c.1890-2 *118-19*
Card Players, The, c.1892 *130-31*
Cézanne family
 Anne-Elisabeth-Honorine, mother 8, 18, 19, 127
 Hortense, wife 12, 15, 16, 18, 19, 25, 74, *74-75, 126*, 127, 160
 Louis-Auguste, father 7, 8, 16, 18, 26, 31, 32, *32-33*, 39, 42, 127
 Marie, sister 8, 18, 25, 127
 Paul, son 6, 12, 15, 16, 18, 22, 98, *98*, 100, *100*, 113, *113*
Chardin, Jean Baptiste 17, 73, 76, 139

Château Noir, farmhouse, Aix-en-Provence 25, 65, 78, *136-37, 144*, 145, *146-47*, 162, *162-63, 168-69*
Château Noir, The, 1904 25, 65, *162-63*
Château Noir, The, 1904-06 25, 65, 78, *168-69*
Chinese painters, Cézanne's affinity with 25, 164
Chocquet, Victor 15, 16, 21, 22, 65, 82, *82*, 133, 160
Commune of Paris (1871) 12
Confession of Claude, The, novel 8
Corot, Camille 13, 65, 66
Couples Relaxing by a Pond 9, 46, *52-53*
Courbet, Gustave 8, 9, 11, 13, 15, 17, 27, 28, 46, 50, 52, 65, 70, 77, 92, 95
Couture, Thomas 10, 40, 112, 152
Cubism 17, 54

Daumier, Honoré 11, 32, 112
death of Cézanne 25, 171
Death of Sardanapalus by Eugène Delacroix 9
Degas, Edgar 20, 22, 52, 77, 95, 115, 122, 135, 152
Déjeuner sur L'Herbe by Manet 8, 13, *19*, 50, 152
Delacroix, Eugène *9*, 11, 15, 37, 40, 46, 72, 82, 95, 115, 133, 160
Demoiselles d'Avignon, Les by Picasso 25
Denis, Maurice 21, 22, *22*, 23, 76, 173
d'Hervilly, E 15
Dish of Peaches 120-21
Doria, Count 14, 65
Duqueylar, Paulin 26
Durand-Ruel, Paul 22
Duranty, Edmond 8, 15, 135
Duret, Théodore 15

Emperaire, Achille 11, 32, *38*, 39, 120, 160
Etang des Soeurs, Osny, L' 70-71
Evenement, L', newspaper 9, 10
exhibitions
 Exposition Universelle, 1889 16
 First Exhibition of the Limited Company of Artists, Painters, Sculptors and Engravers, 1874 14-15
 Impressionist Exhibitions, 1874 16, 65, 135; 1876 15; 1877 15, 82; 1880 135
 Manet and the Post-Impressionists 1910, 95
 one-man shows of Cézanne's work, 1895 20, 40; 1907 25, 74; 1978 142
 Salon d'Automne, 1904, 1905, 1906 25
 Salon des Refuss, 1863 8-9, 10
 Salon system 8, 10, 11, 14, 15, 16, 32, 34, 39, 42, 68, 72, 92
 watercolors by Cézanne, Gallery Bernheim-Jeune, 1907 22, 25
Exposition Universelle, 1889 16

Farmyard at Auvers 14, 16, *83*
Fauchier, Laurent 120
Femmes d'Algers by Delacroix 72
Fiquet, Hortense (later Hortense Cézanne) 12, 15, 16, 18, 19, 25, 74, *74-75, 126*, 127, 160
First Exhibition of the Limited Company of Artists, Painters, Sculptors and Engravers, 1874 14-15
Fishing by Manet 52
Flaubert, Gustave 40, 46
Flayed Ox by Rembrandt 30

Flowers 160-61
Fontainebleau *90-91*, 91, 142
Four Seasons, The, Autumn 26
Four Women 16
Fruit and Vase 114-15
Fruit, Still Life 117
Fry, Roger 95

Gachet, Dr Paul 11, 14, 66, 127
Gallery Bernheim-Jeune 22, 25
Gardanne 16-17, *106-07*, 107
Gardener Vallier, The 25, *170-71*
Gasquet, Joachim 23, 106, 140
Gauguin, Paul 11, 20, 21, 22, 23, 39, 42, 76, 87, 98, 100, 122, 152
Gavarni, Paul *15*, 118
Geffroy, Gustave 23, 135, *135*
Gericault, Théodore 36
Gide, André 22
Gigou, Paul 11
Giverny 16, 20, 36
Gowing, Sir Lawrence 27, 30, 45
Goya 30
Grafton Gallery 95
Grand Jatte by Seurat 52
Guillaume, Louis 113, *113*
Guillaumin, Armand 8, 15, 62, 72
Guillemet, Antoine 16

Harlequin 112, 131
Hommage à Cézanne by Maurice Denis 22, *22*, 76
House of the Hanged Man, Auvers/Oise 13, 14, 16, 21, *64-65*
Houses at l'Estaque by Georges Braque *18*

Impressionist Exhibitions
 First, 1874 16, 65, 135; Second, 1876 15; Third, 1877 15, 82; Fifth, 1880 135
Impressionists 7, 13, 15, 16, 20, 21, 22, 23, 44, 66, 70, 82
In the Park of Château Noir 144-45
Ingres, Jean 26, 39, 101, 133, 152
Isaac de Camondo, Count 21

Jacob Wrestling with the Angel by Delacroix 37
Jas de Bouffan, Cézanne family home 16, 18, 19, 25, 26, 27, 42, *104-05*, 125, 131, 140
Jupiter and Thetis by Ingres 26

La Grenouillère paintings 13, 92
Landscape, Auvers 58-59
Landscape with Trees 15
Lantier, Charles, fictional painter 10, 18
Large Bathers 154-55
Lauves, Les, Cézanne's studio 25, 171
Lawrence, D H 77
Léger, Fernand 118
L'Estaque 12, *12*, 15, *18*, 54, *54-55*, 78, *78-79, 108-09*, 109
Letters on Cézanne, writings by Rainer Maria Rilke 74
Lewis, Mary 37
Louvre Museum, Paris 8, 11, 17, 19, 30, 46, 60, 76, 113, 131, 149, 169

Luncheon of the Boating Party by Renoir 52
Lyons school 26

Madame Cézanne in a Red Armchair 74-75
Madame Cézanne in Yellow Armchair 126-27
Man with Crossed Arms 122, *145*
Manet, Edouard 8, 9, *9*, 10, 11, 13, 14, 16, 17, *19*, 28, 32, 44, 46, 49, 50, 52, 60, 92, 152
Manet and the Post-Impressionists Exhibition, Grafton Gallery, 1910 95
Mardi-Gras 20, *113*, 131
Mariage d'Amour, Un, serial 10, 34
Marriage Feast of Cana by Veronese 10
marriage of Cézanne to Hortense Fiquet 18, 127
Martyrdom of Saint Catherine by Neapolitan painter of seventeenth century 7
Matisse, Henri 17, 23, 39, 42, 89, 92, 153
Maus, Octave 19
Melting Snow at Fontainebleau 90-91
Melting Snow at l'Estaque 22, *54-55*
Michelangelo 11, 68, 92, 133, 139, 171
Michelangelo in his Studio by Delacroix 46
Millet, Jean-François 34, 83
Millstone in the Park of the Château Noir 146-47
Mirabeau, Octave 22
Modern Olympia, A 9, 14, *60-61*
Monet, Claude 8, 11, 13, 16, 20, 22, 36, 50, 52, 66, 82, 87, 91, 133, 152
Mont Sainte-Victoire 6, 7, *21*, 23, 24, *24*, 25, 37, *37*, 102, *102-03*, 162, *164-65*, *166-67*, 169, 171, *172-73*, *173*
Mont Sainte-Victoire, 1904-6 23, *24*, *166-67*
Mont Sainte-Victoire, 1904-6 24, *164-65*
Mont Sainte-Victoire, 1905-6 23, *172-73*
Montagne Sainte-Victoire 102-03
Monticelli, Adolphe 11, 31
Moore, George 15
Morisot, Berthe 15
Morstatt, Heinrich 42
Mountains at l'Estaque 16, *108-09*
Murder, The 11, *34-35*
Muse d'Orsay, Paris 21, 40, 49, 169
Muse Granet, Aix 11, 21, 26, 36, 120

Nadar, Flix 14
National Gallery of Berlin 21, 122
Negro Scipion, The 22, *36*
Neo-Impressionists 23
Nouvelle-Athènes circle 14, 15
nude in the landscape setting theme 6, 19, 27, 92

Oeuvre, L' (The Masterpiece), novel 10, 18
Old Woman with a Rosary, An 122, *140-41*
Olympia by Manet 9, 14, 28, 60, 152
one-man shows of Cézanne's work
 Vollard's Gallery, 1895 20, 40; 1907 25, 74
 The Late Work, 1978 142
Orgy, The 40-41

Ossian Singing a Funeral Lament by Duqueylar 26

Parade, Lestang 36
Paris, Cézanne in 7, 8, 9, 10, 11, 12, 14, 15, 16, 20, 21, 23, 52, 127, 160
Pastorale or Idyll 50-51
Paul Alexis Reading to Emile Zola 48-49
Picasso, Pablo 17, *25*, 54, 92, 112, 149, 153, 169
Pigeon Tower at Bellevue, The 132
Pines and Rocks (Fontainebleau) 142-43
Pipe Smoker, The 122-23
Pissarro, Camille 6, 8, 12-13, *13*, 14, 15, 16, 20, 21, 22, 52, 54, 65, 66, 70, 76, 82, 83, 87, 133
Plate of Apples 73
plein-airism 11, 13, 65, 83
Pontier, Henri-Modeste 21
Pontoise 13, *13*, 14, 16, 87
Portrait of a Woman by Gauguin *20*
Portrait of Achille Emperaire 11, *38-39*
Portrait of Ambroise Vollard 20, *148-49*
Portrait of Anthony Valabrègue 44
Portrait of Gustave Geffroy 135
Portrait of Marie Derrien 76
Portrait of the Artist's Son, Paul 98
Pots of Flowers, The 94-95
Poussin, Nicolas 11, 92, 109, 133, 152

Raft of the Medusa, The by Gericault 36
Railway Cutting, The 102
Ranson, Paul 22
Rape, The 23, 37, 102
Reclining Nude 11
Red Dining Room, The by Matisse 23
Redon, Odilon 22
Reff, Theodore 122
Rembrandt 30, 118, 122, 140, 145
Renoir, Auguste 8, 13, 15, 16, 19, 20, 22, 50, 52, 66, 82, 92, 149, 152
Rewald, John 142
Ribot, Théodore 11
Rilke, Rainer Maria 74
Rivière, Georges 15
Rocks and Branches at Bibémus 158-59
Rodin, Auguste 20-21
Romans of the Decadence by Couture *10*, 40
Rousseau, Théodore 142
Rubens, Peter 11, 40, 46, 50, 92, 133, 152

Salon d'Automne, 1904, 1905, 1906 25
Salon des Indépendants, 1901 22
Salon des Refusés, 1863 8-9, 10
Salon state-sanctioned system 8, 10, 11, 14, 15, 16, 32, 34, 39, 42, 68, 72, 92
Seine at Bercy, The 56-57
Self-Portrait with Palette 101
Self-Portrait, 1873-6 12, *62-63*
Self-Portrait, 1878-80 80-81
Self-Portrait, c.1879-80 84-85

Sente de la Justice in Pontoise by Pissarro 14
Sisley, Alfred 8, 22
Solari, Philippe 12
still life studies, Cézanne's approach to 17, 20, 76, 111, 134
Still Life 110-11
Still Life with Apples 77
Still Life with Curtain and Flowered Pitcher 150-51
Still Life with Ginger Pot 116
Still Life with Glass, Fruit and Knife 21, 22, *22*, 76
Still Life with Plaster Cast 134
Still Life with Pomegranate by Courbet 77
Still Life with Sheep's Head by Goya 30
Still Life with Soup Tureen 96-97
Still Life: Bread and Leg of Lamb 30
Still Life: Skull with Candlestick 28-29
Still Life: Sugar Pot, Pears and Blue Cup 31
Stokes, Adrian 146
Symbolists 21, 39

Tall Trees at the Jas de Bouffan 104-05
Tanguy, 'Père' 15, 20, 21
Temptation of Saint Anthony, The 46-47
themes in Cézanne's work 6
Thérèse Raquin, novel 10-11, 34, 49
Three Bathers 46, *68-69*
Three Skulls, The 156-57
Three Women Bathing 88-89
Titian 60, 152
Turn in the Road 86-87

Valabrègue, Anthony 44, *44*
Vallier, Cézanne's gardener *170*, 171
Van Gogh 14, 21, 23, 83, 127, 145
Ventre de Paris, Le (The Belly of Paris), novel 10
Venus of Urbino by Titian 60
Veronese, Paul *10*, 11, 40
Victor Choquet Seated 82
View of Mont Marseilleveyre and the Isle of Maire (l'Estaque) 15, *78-79*
Village of Gardanne, The 106-07
Village seen through Trees 128-29
Vingt, Les 19
Vollard, Ambroise 20, 21, 22, 25, 76, 95, 146, *148*, 149, 160, 171
Vuillard, Edouard 22, 42
Wagner, Richard 28, 42, 46
Watteau, Jean 50, 52, 112
Woman Diving into the Water 19
Woman with the Coffee Pot 124-25
Woodland Path at the Château Noir 136-37

Young Girl at the Piano: Overture to Tannhäuser 42-43

Zola, Emile 8, 9, 10-11, 15, 16, 18, 21, 23, 32, 37, 44, 45, 48-49, *49*, 92
 novels 8, 10-11, 18, 34, 49

Acknowledgments

The publisher would like to thank Martin Bristow who designed this book; Jessica Orebi Gann, the editor; and Maria Costantino, the picture researcher. We would also like to thank the following museums, individuals and agencies for the illustrations:

Courtesy of the Art Institute of Chicago, (c) 1989 The Art Institute of Chicago, all rights reserved: page 12(top) (The Arthur Heun Fund, 1951.1. page 14 verso); page 15(below) (The Arthur Heun Fund, 1951.1 page 31 verso); page 20(below) (The Joseph Winterbotham Collection, 1925.753); pages 66-7 (Mr and Mrs Lewis Larned Coburn Memorial Collection, 1933.422); page 73 (Gift of Kate L Brewster, 1949.512); page 126 (Wilson L Mead Fund, 1948.54); page 152 (The Amy McCormick Memorial Collection, 1942.457)

Collection of the Australian National Gallery, Canberra: page 72

The Barnes Foundation, Pennsylvania/Photograph (c) 1989 by The Barnes Foundation: page 16

The Brooklyn Museum: page 107 (Ella C Woodward and Augustus T White Memorial Funds, 23.105)

The Chrysler Museum, Norfolk, Va: page 27 (Gift of Walter P Chrysler Jr)

The Cleveland Museum of Art, Ohio: page 132 (James M Corrigan Memorial, 36.19)

Columbus Museum of Art, Ohio: page 82 (Museum Purchase: Howald Fund)

Courtauld Institute Galleries, London (Courtauld Collection): pages 70-1; 102-3; 104-5; 134

The Detroit Institute of Arts: pages 156-7 (Bequest of Robert H Tannahill)

By permission of the Provost and Fellows of Kings College, Cambridge, Keynes Collection on loan to the Fitzwilliam Museum, Cambridge: pages 37; 77

Foundation E.G. Bührle Collection/Photos W. Drayer, Zurich: pages 2; 46-7; 101; 127

Galerie Beyeler, Basle: pages 137; 164-5

Hamburger Kunsthalle/Photos Elke Walford: pages 56-7

Hermitage Museum, Leningrad/Photos SCALA: pages 23((c) Succession Henri Matisse/DACS, 1990); pages 42-3; 150-1

The J Paul Getty Museum: page 44

Kunsthalle Bremen: pages 128-9

Kunsthaus Zurich: page 30

Kunstmuseum Bern: Hermann and Margrit Rupf-Stiftung/(c) ADAGP, Paris and DACS, London, 1990: page 18(top)

Memphis Brooks Museum of Art, Memphis: page 14(top) (Gift of Mr and Mrs Hugo M Dixon, 53.60)

Memorial Art Gallery of the University of Rochester: Photo James M Via: pages 78-9 (anonymous gift in tribute to Edward Harris and in memory of H R Stirlin of Switzerland)

The Metropolitan Museum of Art, New York: pages 130-1 (Bequest of Stephen C Clark, 1960)

Musée de l'Orangerie, Paris/Photos (c) Réunion des Musées Nationaux: pages 98; 144 (Collection: Jean Walters et Paul Guillaume)

Musée d'Orsay, Paris/Photos (c) Réunion des Musées Nationaux: pages 9(below); 10(top); 18; 19; 22; 31 (on deposit with Musée Granet); 38; 50-1; 60-1; 64-5; 68-9; 83; 96-7; 116; 118-9; 124; 135 (private collection on loan to Musée d'Orsay); 138-9; 168-9

Musée du Louvre, Paris, Cabinet des Dessins/ Photo Roger-Viollet: page 6; Photo (c) Réunion des Musées Nationaux: page 14(below); Photo Weidenfeld Archive: page 20(top)

Musée du Louvre, Paris/Photos (c) Réunion des Musées Nationaux: pages 9(top); 10(below); 12; 63

Musée Granet, Aix-en-Provence/Photos Bernard Terlay, Aix: pages 7(below), 133

Collection of the Museu de Arte de São Paulo, Brazil/Photos Luiz Hossaka: pages 36; 48-9

Courtesy of the Museum of Fine Arts, Boston: pages 52-3 (Tompkins Collection); 75 (Bequest of Robert Treat Paine II); 86-7 (Bequest of John T. Spaulding)

Collection of the Museum of Modern Art, New York: pages 25 (acquired through the Lillie P Bliss Bequest/(c) DACS, London 1990); 90-1 (Gift of André Meyer); 143 (Lillie P Bliss Collection)

Nasjonalgalleriet, Oslo/Photo Jacques Lathion: pages 110-1

National Gallery of Art, Washington, DC: pages 33 and 112 (Collection of Mr and Mrs Paul Mellon); 92-3 (Gift of the W Averell Harriman Foundation in memory of Marie N Harriman); 100 (Chester Dale Collection); 170 (Gift of Eugene and Agnes Meyer)

National Gallery, London: pages 141; 153

National Gallery of Ireland: page 7(top)

National Museums and Galleries on Merseyside: The Walker Art Gallery, Liverpool: pages 34-5

National Museum of Wales: pages 1; 9(top); 108-9

Öffentliche Kunstsammlung, Kupferstichkabinett Basel: page 8

Öffentliche Kunstsammlung Basel, Kunstmuseum/Photo Colorphoto Hans Hinz: pages 166-7

Petit Palais, Paris/Photos Musées de la Ville de Paris, (c) SPADEM 1990: pages 26; 88-9; 148; 158

Philadelphia Museum of Art: pages 58-9 (Samuel S White III and Vera White Collection); 146-7 (The Mr and Mrs Carroll S Tyson Collection); 154-5 (Purchased: W P Wilstach Collection)

The Phillips Collection, Washington, DC: page 80

Private Collection on loan to the National Gallery, London: page 117

Private Collection/Photo Bridgeman Art Library: pages 41; 45; 76

Private Collection, Switzerland: pages 28-9

Private Collection, Switzerland/Photos H Humm: pages 54-5; 94-5; 172-3

Pushkin Museum, Moscow/Photos SCALA: pages 113; 123; 161

Roger-Viollet: pages 13(top); 17(below) (c) Harlingue-Viollet

Sammlung Oskar Reinhart "Am Römerholz", Winterthur: pages 84; 120-1; 162-3

The Collection of the Solomon R Guggenheim Museum, New York/Photo Carmelo Guadagno: page 145

Staatliche Museen zu Berlin, Hauptstadt der DDR: pages 114-5

Weidenfeld Archive: pages 13(below) (Collection Jean Hecquet); 17(top) (with permission of Mr and Mrs John Rewald); 21